Reading the Rabbit

Reading the
Rabbit

Explorations in
Warner Bros. Animation

<small>EDITED BY</small>
<small>KEVIN S. SANDLER</small>

RUTGERS UNIVERSITY PRESS
New Brunswick, New Jersey, and London

Library of Congress Cataloging-in-Publication Data

Reading the rabbit : explorations in Warner Bros. animation / edited
 by Kevin S. Sandler.
 p. cm.
 Includes bibliographical references and index.
 ISBN 0-8135-2537-3 (cloth : alk. paper). — ISBN 0-8135-2538-1
(pbk. : alk. paper)
 1. Warner Bros. 2. Looney tunes. 3. Bugs Bunny (Fictitious
character) 4. Popular culture—United States. I. Sandler, Kevin S.,
1969– .
NC1766.U52W37365 1998
791.43'3—dc21 97-39174
 CIP

British Cataloging-in-Publication data for this book is available from the British Library

Manufactured in the United States of America

*To Mom and Dad
for never subscribing
to the Disney Channel*

Contents

Acknowledgments *ix*

Introduction: Looney Tunes and Merry Metonyms *1*
KEVIN S. SANDLER

A Short Critical History of Warner Bros. Cartoons *29*
BARRY PUTTERMAN

From Disney to Warner Bros.: The Critical Shift *38*
TIMOTHY R. WHITE

Charlie Thorson and the Temporary Disneyfication
of Warner Bros. Cartoons *49*
GENE WALZ

From Vaudeville to Hollywood, from Silence to Sound:
Warner Bros. Cartoons of the Early Sound Era *67*
HANK SARTIN

The Image of the Hillbilly in Warner Bros. Cartoons
of the Thirties *86*
MICHAEL FRIERSON

The View from Termite Terrace: Caricature and Parody
in Warner Bros. Animation *101*
DONALD CRAFTON

Darker Shades of Animation: African-American
Images in the Warner Bros. Cartoon *121*
TERRY LINDVALL AND BEN FRASER

"Ah Love! Zee Grand Illusion!": Pepé le Pew,
Narcissism, and Cats in the Casbah *137*
KIRSTEN MOANA THOMPSON

Gendered Evasion: Bugs Bunny in Drag *154*
KEVIN S. SANDLER

Selling Bugs Bunny: Warner Bros. and Character
Merchandising in the Nineties *172*
LINDA SIMENSKY

Fans versus Time Warner: Who Owns Looney Tunes? *193*
BILL MIKULAK

Hybrid Cinema: *The Mask*, Masques, and Tex Avery *209*
NORMAN M. KLEIN

Notes *221*
List of Contributors *257*
Index *261*

Acknowledgments

PHALANXES of people assisted in the publication of this book. My most sincere thanks go to all the authors of the essays. Your patience and sacrifice for me is manifest on every page. I also want to thank those who contributed essays not represented here. Your ideas and thoughts are woven within the pages here as well.

Supreme thanks are extended to Kirsten Moana Thompson. Without her, this collection would still be drifting in proposal limbo. Her aid contributed immensely to the constitution and structure of this book.

I am grateful to John Libbey and Company, Limited for allowing me to reprint Donald Crafton's essay from *Film History* 5 (June 1993) and Timothy R. White for giving me permission to reprint his essay from *Film Criticism* 16 (spring 1992).

Various people have lent intellectual, emotional, and/or spiritual support during the creation of this book. You know who you are and what you did: Darren Abrahams, Richard Allen, Ashley Bloch, Bryan Beckerman, Sarah Crook, Andy Darley, Deb Gelfand, Ilana Gilbert, Lowell Harris, Amy Holberg, Richard Maltby, Steve Neale, Dennis Nybach, Beth Ouradnik, Charlotte Pagni, Tim Retzloff, John Robie, Michelle Rosenthal, Maher Safi, Terri Sarris, Linda Simensky, Francie Stevens, Chris Straayer, Haidee Wasson, Julia Werdigier, Tony Worren, and to all my students in Speech 101.

I also thank the authors who paved the animation path before me. They provided the historical and theoretical tools to help legitimize animation as an object worthy of critical valuation. Special thanks go to Jerry Beck, Elizabeth Bell, Sybil Delgaudio, Steve Schneider, and Eric Smoodin.

My gratitude is extended to Richard Leskosky and the Society for Animation Studies. They have encouraged my work on Warner Bros. by giving me numerous grants and awards.

I am most indebted to Robert Eberwein, whose friendship, reassurance, and inspiration give me the courage and confidence to achieve success as a writer and academic.

Thanks to Leslie Mitchner for taking a chance on a twenty-five-year-old grad student. Her advice and keen eye can be seen everywhere in this book. Send her your own manuscripts. You won't find a better editor or supporter.

Most of all, I thank my mother and father, Sharon and David, for letting their son pursue his dreams. I will be forever content if I can give my own children even half the blessings you have given me.

Reading the Rabbit

Introduction

KEVIN S. SANDLER

*In the Disney cartoons, there's a kind of sweet harmony.
The conflicts were pretend conflicts. With the Warner
characters . . . you know they really mean it.*
　　　　　　　　—STEVEN SPIELBERG

Looney Tunes and Merry Metonyms

IN THE FALL of 1996, the Prince Charles Cinema in London, England, presented *The Bad Bugs Bunny Show* in a return engagement, together with its new sequel, *The Bad Bugs Bunny Show 2*. This "feast of politically incorrect cartoons," as the advertisement described it, featured many shorts from Fleischer, Disney, and MGM studios, but the festival's main attraction, as the name makes clear, was Bugs Bunny. Sold-out audiences saw—many of them for the very first time— the original black-caricatured version of *All This and Rabbit Stew* (1941), the uncut *Fresh Hare* (1942), and the wartime *Bugs Bunny Nips the Nips* (1943) and *Herr Meets Hare* (1945). Also included in the program was the racist, though aesthetically brilliant, parody of Snow White, *Coal Black and de Sebben Dwarfs* (1943). This exhibition of Dennis Nybach's collection of "offensive" cartoons acknowledged animation's ugly past, an ignoble history of political, racial, ethnic, and sexual insensitivity. Oddly enough, the film was rated "18" in England (only eighteen or older admitted), a designation usually reserved for extreme violence (*Natural Born Killers*, 1994) or adult sexual matter (*The Pillow Book*, 1997), and not for cartoons produced almost fifty years ago.

At the same time across the Atlantic Ocean, the United States Postal Service (USPS) unveiled at the Warner Bros. Studio Store in Manhattan, the thirty-two-cent Bugs Bunny postage stamp. Recruited for a new national campaign to lure children to the ailing hobby of stamp collecting, Bugs would serve as the federal agency's "ambassador" for Stampers, the USPS's new stamp collecting program for kids. To explain Bugs's universal appeal, the Postal Service's chief marketing officer says, "Bugs Bunny crosses all generations from the 1940s to the 1950s. It is our hope that he can bring parents and grandparents together with children and grandchildren to enjoy the hobby of stamp collecting."[1]

I

THE PRINCE CHARLES CINEMA PROUDLY PRESENTS
A FEAST OF
POLITICALLY INCORRECT CARTOONS

The *original* **The Bad Bugs**

Bunny Show (18) *is back!*

THURS 03 OCT @ 4PM - £1.75

TUES 15 OCT @ 9PM - £3.50

PRINCE CHARLES CINEMA:LONDON

7 Leicester Place, off Leicester Square, London
 0171 437 7003

The flier distributed for *The Bad Bugs Bunny Show* at the Prince
Charles Cinema in London, England.

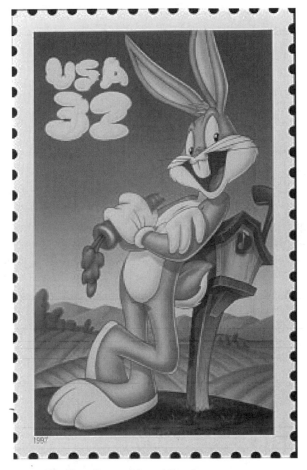

The Bugs Bunny United States postage stamp.

This was not the first time Bugs served his country. During World War II, he helped promote the war bond effort with the short *Any Bonds Today?* (1942), was awarded a service record by the United States Marine Corps, and was adopted as an official member of the Seabees.[2] In the late eighties, Bugs also did a series of public service announcements for the government, on topics ranging from constitutional amendments to the environment. Continuing this tradition, the Bugs Bunny stamp became available in May 1997 and will be followed in 1998 by commemorative stamps of Tweety and Sylvester and other Looney Tunes characters.

This anthology examines the iconic spectrum of Warner Bros. animation represented by these two antithetical but not entirely incongruous events: the showing of *The Bad Bugs Bunny Show* and its sequel, and the issuing of the Bugs

Bunny stamp. Although each essay differs in critical method and focus, they all attempt to map the theoretical and historical implications of Warner Bros. animation, in terms of its place not only in animation history but also in American cinema and popular culture. From the doors of Termite Terrace to the Warner Bros. Studio Stores, from Looney Tunes to *Space Jam* (1996), this volume, like a cultural navigator, explores territories of animation production and economy, and their relationship to discourses of power, identity, and spectacle.

Reading the Rabbit follows the intellectual tracks laid down by Danny and Gerald Peary in their seminal 1980 collection, *The American Animated Cartoon*, then fortified in the nineties by the edited collections of Alan Cholodenko's *The Illusion of Life* (1991), Eric Smoodin's *Disney Discourse* (1994), and Elizabeth Bell, Lynda Haas, and Laura Sells's *From Mouse to Mermaid* (1995). Apart from some essays in the Peary and Peary and Cholodenko collections, and Hugh Kenner's *Chuck Jones: A Flurry of Drawings* (1994), the new wave of critical attention on animation did not extend to Warner Bros., instead focusing mainly on the work of Walt Disney. *Disney Discourse* and *From Mouse to Mermaid* proficiently demonstrated, as the editors of the latter volume put it, that Disney is no longer the "ugly stepsister unfit for the glass slipper of high theory";[3] Warner Bros., on the other hand, has yet to find its fairy godmother. This collection, I hope, will at least send Warner Bros. to the ball.

The political, historical, and social context that led to the production of *Bugs Bunny Nips the Nips* and other "politically incorrect" cartoons is of little concern to media conglomerates like the Walt Disney Company and Time Warner. When boycott or embarrassment threaten present-day company profit and image, Disney and Time Warner must meticulously manage the dissemination of potentially controversial matter to the public. The cultural iconography and ideology associated with their main assets, Mickey Mouse and Bugs Bunny, must be vigilantly controlled. When Donald Duck celebrated his fiftieth birthday in 1984, the Academy Award–winning *Der Fuehrer's Face* (1943), which satirically presents Donald hailing the Third Reich, was omitted from commemorative videotapes.[4] Disney's *Song of the South* (1946) has neither been shown in theaters since 1982 nor been released on video in the United States because of its racial stereotypes. The careful policing by the Walt Disney Company of the founder's name even extends to the publication of books critical of Walt Disney, the person,[5] and books bearing the Disney name.[6]

As an ideological construct of specific values, knowledge, and desires, Disney signifies unproblematic innocence to the general public. The above publications challenge this cultural assumption and contest the mythical status of Walt Disney himself. Yet, as Henry A. Giroux points out in "Memory and Pedagogy in the 'Wonderful World of Disney,'" Disney is not ignorant of the "politics of representation." Disney knowingly assumes the role of a "pedagogical police,"

structuring and ordering, defining and delimiting, representations of the Disney name and the Disney characters. Subversive elements from Disney's past are either suppressed or excluded from the public sphere; in the process, its history, suggests Giroux, is "both rewritten and purged of its seamy side."[7]

Rewriting history serves Disney in two ways. First, by policing memory, Disney can construct and control popular memory; forgetting the past becomes a means of moblilizing its image of childhood innocence. Second, by securing memory, Disney "commodifies" memory; cultural consumption of its products marks and legitimizes the virtues of American fun, innocence, and identity.

If Disney, as Giroux claims, mobilizes popular memory to incorporate a "politics of forgetting" that produces a particular worldview,[8] another animated text, Batman, incorporates what I would call a "politics of remembering" for its popular and polysemic appeal. In "Batman: The Movie, Narrative: The Hyperconscious," Jim Collins argues that Batman narratives in their various formats of films, comic books, graphic novels, and novelizations presuppose a cultural memory of earlier Batman texts.[9] Audience fascination and pleasure reside in the hybridization of divergent narrative elements of present and past texts, allowing each member of the audience to form his or her own unique paradigm of Batman as cultural icon.[10] Present negotiation of earlier representations, explains Collins, "does not destabilize [what Umberto Eco calls] the *already said* as much as it reveals its fluidity, the absence of any kind of unseen hand or unitary hierarchy that might still delimit the appropriate subject matter, function, and audience for different forms of cultural production."[11] Reconfiguration of the "already said" dispels notions of any univocal quality attributed to a hyperconscious text like Batman, a text which functions neither as national myth nor as subcultural semiotic, but as individual amalgamation.

This assemblage of conflicting images, or what Eileen R. Meehan calls the "complex web of cross-references" generated by all the Batman texts, creates an intertext where audience members can position themselves alongside the Batman character and myth to suit their own particular purposes and needs.[12] The merchandising success of Tim Burton's *Batman* (1989), claims Meehan, resulted from the combination of a contradictory and conflicting set of representations established through the film's advertising and licensing toward various demographic markets: camp motifs of the sixties *Batman* series alongside the noirlike qualities of Burton's production, cartooning with live-action, utopian visions of justice with dystopian visions of corruption in the United States.[13] The commodification of the Burton text and the array of intertextual narratives and allusions associated with its popularity can best be understood as the interpenetration of various media industries in search of more profitable and cost-efficient ways to manufacture culture.[14] At this juncture, *Batman* gloriously celebrates and satisfies the desires of both consumer and corporation.

Hybridized narratives and representations like *Batman* and the Batman icon are popular because their discursive discontinuity sells a medley of ideologies. Walt Disney narratives and the iconic status of Mickey Mouse, on the other hand, rely on their discursive homogeneity, predictability, and stability. Instead of allowing an array of visual codes to tell its "story," Disney delimits the circulation of contradictory material that may lead to the "paradigmatic disarray" of its texts, Mickey Mouse, and its "wholesome" corporate image. Lynn Spigel and Henry Jenkins suggest that historical contradictions in the memory of one's cultural past make way for remembrances that favor the past as a "purer, less complex time" than the present. People remember textual information that confirms these suppositions and forget those that challenge them.[15] Knowing how memory is reworked for contemporary purposes, Disney, it can be argued, polices the content of the "already said," for instances of sexuality, violence, or morality incompatible with its corporate image of family, patriotism, free enterprise, and innocence. By repressing its own historical discourse, not only through simplification or reduction but through elimination, Disney rectifies the "already said" as the "never said." Hence, its iconography can remain stabilized for present and future generations.

If the enjoyment of Disney lies in viewer assumption of iconic stability and predictability neither guaranteed in Batman texts nor expected by its fans, where does that place Time Warner, Warner Bros. animation, and its star, Bugs Bunny? Does Warner Bros. remain a metaphor, a symbol, for example, of "America's resistance to Hitler,"[16] with Bugs painted on Allied bombers?[17] Or has Warner Bros. animation become, like Disney, a metonym for the nation, with Bugs replacing the bald eagle, as Bell, Haas, and Sells suggest, and standing alongside the "equally iconic and symbolically loaded Mickey Mouse"?[18] Does Warner Bros. animation encapsulate a "politics of remembering" or a "politics of forgetting," a cultural metaphor of the forties and fifties or a corporate metonym of the nineties?

For many critics and fans, comparing Mickey Mouse to Bugs Bunny is like comparing Mickey Rooney to James Cagney. The two characters and their corresponding studios have completely distinct styles, personalities, and modes of production. This was not so during the dawn of the Hollywood animated cartoon. Until the midthirties, Looney Tunes and Merrie Melodies in many ways mimicked Disney's Mickey Mouse and Silly Symphonies cartoons: formula characters performed formulaic gags organized around a musical score.[19] Not until Tex Avery, Robert Clampett, and Frank Tashlin became directors did Warner Bros. animation begin to break free of the Disney mold. While the Fleischer brothers filled the frame with the fantastic and the impossible, and Disney saturated the screen with sentimentality and hyperrealism, Warner Bros., notes Steve Schneider, dealt in a zany universe somewhere between the two extremes.

The Warner cartoonists took the Disney style of personality anima-
tion . . . to a different and eminently hipper level. The turnabout could
not have been more extreme: where cartoons had been soft and
frolicsome, Warner's made them hard and brassy and confrontational.
An ideal of charm and gentle humor yielded to shameless slapstick and
mordant satire. The innocence of the forest was supplanted by the savvy
of the city. . . . Fairy-tale timelessness gave way to constant visual and
verbal reference to topical matter and "real life concerns."[20]

The raucous and rude cartoons of Avery, Clampett, and Tashlin made way
for the character studies of Chuck Jones, Robert McKimson, and Friz Freleng of
the midforties to midsixties.[21] The Bugs Bunnys, Daffy Ducks, and Porky Pigs
of the Jones-McKimson-Freleng period are their character personae today. In
his description of the Road Runner series, which could easily apply to other
Warner Bros. cartoons of the era, Chuck Jones comments that a character's be-
havior must appear logical, with the same logistics of a live-action sequence:
"We must believe in a logically illogical way that this is really happening to a
character . . . that we have learned to know and sympathize with."[22] However,
the controlled lunacy that characterizes Warner Bros. animation is in danger of
becoming an endearing afterthought to the retail buck.

A historical look at the ideological significance of Bugs Bunny may help
illustrate Warner Bros.' evolution (or devolution) from metaphor to metonym.
After a period of experimentation from 1938 to 1940, Bugs Bunny developed
certain traits and behaviors following U.S. entry into World War II. At this time,
Looney Tunes surpassed Disney's Silly Symphonies to become the number-one
short subject during the war years.[23] Bugs's unruliness and flippancy more accu-
rately reflected the mood of the country than the "maternal security" of Mickey
Mouse.[24] Bugs even received more whistles than Betty Grable.[25] He embodied
the cockiness of the country with his unwillingness to back down from the en-
emy and his determination to do what he thought was right. The Bugs cartoons
of this time—among others, *Super Rabbit* (1943), *Little Red Riding Rabbit* (1943),
and *Hare Force* (1944)—feature a more violent rabbit with a more sadistic and
mocking agenda, a manifestation of tomfoolery and not the benevolence evinced
in the postwar years.[26] Animation historian Will Friedwald believes that the Bugs
Bunny cartoons of this period, particularly Clampett's, push Bugs's "three dimen-
sionality to the limits" by subjecting him to "situations of extreme violence, sex,
racism, and embarrassment."[27]

As he matured, the Jones-Freleng-McKimson Bugs Bunny, states George W.
Woolery, was never "mischievous without reason."[28] He was neither a rebel nor
an "innocent bystander" but what Chuck Jones calls a "counterrevolutionary"
or what Lloyd Rose refers to as a "gentleman anarchist."[29] "Bugs must always be
a winner," says Rose, "but a winner in contests he clearly views as idiotic."[30] He

insists on victory if you insist on war.[31] Jones's "Rabbit Season" trilogy—*Rabbit Fire* (1951), *Rabbit Seasoning* (1952), and *Duck! Rabbit! Duck!* (1953)—captures the definitive Bugs, Daffy Duck, and Elmer Fudd between World War II and the recent present: winner, loser, and dupe.

However, "furry woodland creature" is no longer a befitting description for the nineties Bugs Bunny—the rabbit of Nike Hare Jordan commercials and *Space Jam*. Gone is the scheming and gung-ho patriotic character from the war years. Gone is the wry, ambiguously sexualized rabbit protecting his home from Elmer Fudd and the "Unga-Bunga-Bunga" man from *Bushy Hare* (1950). Gone are the separate universes that the cast of Looney Tunes inhabited in the shorts.

Instead, *Space Jam* presents "an extension of Looney Tunes," states Mark Matheny, managing director of Warner Bros. Consumer Products, an attempt to "enhance the characters and entertainment."[32] Welcome a kinder, gentler rabbit and his pseudofeminist female distraction, Lola "Don't call me doll" Bunny. They and several other "enhanced" classic characters—the "Tune Squad"—must win a basketball game against the "Monstars" to secure their freedom from Swackhammer, a belligerent alien who wants to make them an attraction at his outer-space theme park. However, the "Monstars" have siphoned talent from NBA stars, and, as stated in the *Space Jam* Web site, "when Bugs does discover what he's up against, he knows he needs some serious help."[33] Enter Michael Jordan. This plot point led one critic to write: "The very idea that Bugs Bunny would feel he needed Michael Jordan's help to win a basketball game—even a game against invincible space thugs—runs contrary to everything we know about him."[34] Another sequence has Bugs and Daffy enter the live-action world to retrieve Jordan's University of North Carolina basketball shorts and shoes, dramaturgy that's a far cry from the elocutionary wordplay of "Should you shoot him now or wait till you get home?"[35] The onetime anarchist in *Rabbit Seasoning* turns errand boy in *Space Jam*. Wabbit season makes way for basketball season. Where the Looney Tunes style was once characterized by irreverence and nuance, it becomes in *Space Jam*, according to Mike Clark of *USA Today*, "undeniably affable" and "tolerant."[36] *Time*'s Richard Corliss calls the Bugs Bunny/Michael Jordan feature "less a good movie than a safe place to park the kids on a mall afternoon."[37]

Clark's and Corliss's choice of words seems more applicable to a Disney feature film than to a Warner Bros. cartoon. Yet, their remarks reflect how the metonymic and monolithic construction of Disney has begun to rub off on Warner Bros. Popular representations of its Looney Tunes characters, like the Disney characters, are now at the forefront of its marketing and corporate identity. "*Space Jam* isn't a movie," states Time Warner chairman Gerald Levin. "It's a marketing event."[38] In the world of "entertainment retailing,"[39] every product sold at a Warner Bros. Studio Store or Disney Store, every kids' meal bought at

McDonalds or Burger King, and every movie ticket purchased tie in with and bolster another product line elsewhere in the vast corporate empire of Time Warner and the Walt Disney Company.[40] Everything sells everything else. And "iconography," says Richard Corliss, has been "retooled for fun and profit."[41] For example, although Time Warner lets the United States Postal Service print and circulate stamps of Bugs Bunny and other Looney Tunes characters without paying royalties, Time Warner profits from merchandise bearing the stamps' image and from the exposure of the characters to millions of people everyday.[42] Bugs Bunny has also become a "trademark" for Time Warner that appears at the beginning of the company's feature films; the previously speechless (although songful) Michigan J. Frog is now the eloquently talkative mascot of the WB network; Lola Bunny was created as a female merchandising counterpart to Bugs Bunny.

Unfortunately, when shareholders have more influence than tradition, corporate image supersedes and preempts character personality. Director Darrel Van Citters encountered this friction between corporation and artist during production of *Box Office Bunny* (1990): "There is always a fine line when you try to put your own sensibility into something. Sometimes you would like to go further than the company would be comfortable with. It's a tricky line making the corporation happy with what you do as well as trying to stretch things."[43] Unprofitable and potentially damaging idiosyncrasies, flaws, or representations in Warner Bros. characters or texts must be contained for cultural consumption. Conflict and unpredictability, the banes of metonymy, have to be eliminated. Yet, "conflict," contends Chuck Jones, "is the source of the comedy" in the Warner Bros. cartoons. "If you take out the action, what do you have left?"[44] What's left are pale imitations of Bugs Bunny, Daffy Duck, Tweety Bird, and Sylvester, assemblages of cartoons past reconfigured as unproblematic corporate commodities. Memory for the "already said" of Termite Terrace is quickly becoming the "never said" of Time Warner.

The mobilization and policing of memory of Looney Tunes characters and cartoons can be traced back as early as 1968, when Warner Bros. first colorized its black-and-white cartoons by hand (later, it computer-colorized them). The studio, states Schneider, felt that "the cartoons would be more marketable when Porky was pink, and not ashen gray."[45] Then, in the seventies, censors of children's television singled out *The Bugs Bunny/Road Runner Show* as overly violent and demanded that certain cartoons be edited. Warner Bros. acquiesced, making cuts to numerous cartoons, a practice that continued into the eighties and nineties. Cut were scenes in which characters engaged in gunplay, ingested motor fuel, drank alcoholic beverages, used cowboy-and-Indian gags or racial humor, and received electrical shocks; violence was also toned down (for example, a fight scene in *Cat Feud* [1958] was edited from six hits in the face to two).[46] Astonishingly, Warner Bros. even approached some directors in 1988 to

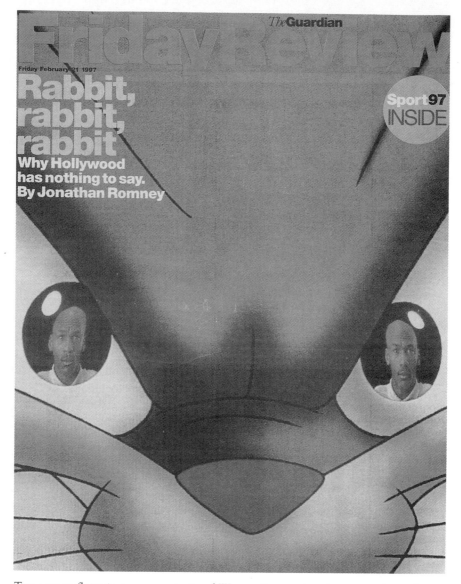

Two not-so-flattering cover portraits of Warner Bros. animation, appearing only one month apart in the Friday Review section of the London newspaper the *Guardian*.

reanimate the ending of *The Scarlet Pumpernickel* (1950) in which Daffy Duck commits suicide—"It's getting so you have to kill yourself to sell a story around here." Fortunately, however, no one would dishonor and tamper with Jones's magnificent creation. The cartoon currently stands as originally intended.

Whole cartoons incompatible with a "politically correct" corporate image

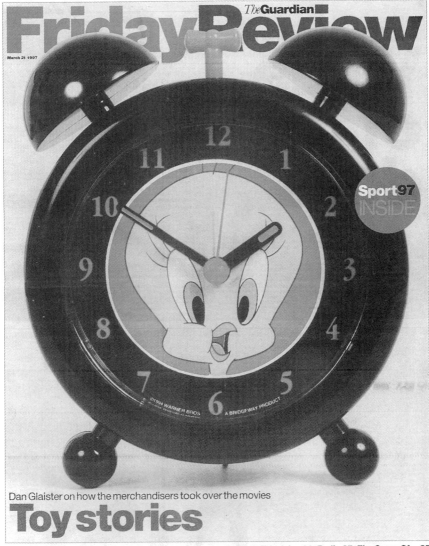

The **Guardian**

Friday Review

March 21 1997

Sport 97 INSIDE

Dan Glaister on how the merchandisers took over the movies

Toy stories

Soap wars 4 | Film reviews 6 | Music 14 | Cronenberg on Crash 8 | Television 26 | Radio 27 | The Curse Of... 28

have also been eliminated from cultural circulation out of fear they will contribute to the "paradigmatic disarray" of Warner Bros. animation. Turner, which owned many of the pre-1949 cartoons prior to its merger with Time Warner,[47] banished from the video shelves in 1995 one of the cartoons featured in Nybach's *The Bad Bugs Bunny Show 2* program: *Bugs Bunny Nips the Nips*. The cartoon appeared in the "Golden Age of Looney Tunes" collection, a packaging of pre-1949 Warner Bros. cartoons.[48] A single complaint about its racial insensitivity

from the Japanese-American Citizens League prompted its removal from store shelves,[49] although the cartoon had been available in American video shops since 1991. Intended solely to boost Allied morale during World War II, *Bugs Bunny Nips the Nips* features Bugs Bunny calling the Japanese "slant-eyes" and "monkey face"; Bugs even sells them ice cream bars with grenades in them, a gag, as one critic notes, that makes the film "the most sadistic and unsettling of all the war cartoons."[50] Eliminating the cartoon from the collection was but a small price to pay in order to avoid a public relations nightmare: "Bugs Bunny Is a Racist" would scream the headlines.

Aside from the unauthorized *The Bad Bugs Bunny Show*, public performances of *Coal Black and the Sebben Dwarfs* and other equally egregious cartoons like *Tokio Jokio* (1943) and *The Ducktators* (1942), depicting racial insensitivity toward blacks and the Japanese, can only be seen in university classrooms or in museum retrospectives like the American Museum of the Moving Image's 1989 tribute to Bob Clampett. These cartoons, including the majority of those in the video collection *Bugs Bunny Goes to War*, have not been aired on American television for years, if ever. The black stereotype Bosko, a onetime poster child for Nickelodeon when the network first emerged on cable, is no longer shown on television; ditto for his white counterpart, Buddy. The CBS special *Happy Birthday Bugs: 50 Looney Years* (1990), needless to say, did not feature any of Bugs Bunny's more "questionable" performances in the early to middle forties. Critics may view these cartoons as cultural artifacts of a time gone by; the corporation views them as toxins, ideological contaminants that must be suppressed from popular discourse. The conspicuous downplaying of the Mexican Speedy Gonzales in *Space Jam*—he appears twice briefly in a locker room scene and once on the Toon Squad basketball bench, each time without dialogue—when every other major character is featured, may be an implementation of a Warner Bros. policy to remove ethnic representations from its cartoons.[51]

Like Disney, Warner Bros. has purged itself of its history, liquidating those memories of theatrical and television cartoon images of the past that challenge present discursive formations of its Looney Tunes characters. Warner Bros. simultaneously "commodifies memory" as well as Disney does. Yet, Warner Bros. did not fully exploit the Looney Tunes characters in its merchandising, its Six Flags theme parks, or its five feature-length films until 1989, when Time Inc. merged with Warner Communications.[52] After the merchandising bonanza of *Batman* and the licensing of the Saturday morning cartoon series *Beetlejuice* in 1989, the corporate giant Time Warner realized merchandising sells movies. The biggest lesson learned from *Batman* and *Beetlejuice*, says Dan Romanelli, president of Warner Bros. Consumer Products, "is that movie marketing and merchandising can exist hand in hand. Before, that was not the case."[53]

Almost a decade later, Warner Bros. emerged as a international leader in

Everyone's Unique
&
Th-Th-That's Good Folks!

Disneyfication at work: Looney Tunes turns "powitically cowwect" in this downloadable poster from the KidsWB! Web site. Copyright Warner Bros., Inc.

cross-promotion—the movie tie-in business is now estimated to be valued at $10 billion annually in retail sales.[54] Some of its marketing opportunities are as follows: There is the Warner Bros. Studio Store Catalog, which developed into the worldwide chain of hi-tech studio stores. The amusement park Warner Bros. Movie World has branches in Australia and Germany, and Six Flags licenses the Looney Tunes characters for its amusement parks in the United States. Tyson Foods produced TV dinners of Wile E. Coyote pizza and Bugs Bunny chicken chunks in 1990. In the late eighties AMC Theaters showed classic Warner Bros. cartoons before every movie feature. A Pepsi ad in the midnineties features a duel between Wile E. Coyote and Deion Sanders standing in for the Road Runner. New animated shorts—*Chariots of Fur* (1994), *Another Froggy Evening* (1995), and *Carrotblanca* (1995)—showcase classic Looney Tunes characters. Warner Bros. Street can be found in Tokyo, Japan, with a giant mural of the Looney Tunes characters painted on the outside wall of the Sima Creative House. As noted earlier, the U.S. Postal Service circulates a series of commemorative stamps with Looney Tunes characters. Steven Spielberg serves as executive producer for four Warner Bros. television series: *Animaniacs*, its spinoff, *Pinky and the Brain*, *Freakazoid!* and *Tiny Toon Adventures*. "What we've done to the old

Looney Tune spirit," says Spielberg about *Tiny Toons*, "is sweeten it a little, without making it saccharine. There's a little more morality, a little more sense of wholesome family entertainment."[55]

"Morality"? "Wholesomeness"? "Family entertainment"? These words may aptly describe *Tiny Toon Adventures*, an afternoon television cartoon show specifically created for children, but the creators of Looney Tunes never had such intentions in mind for Bugs Bunny or Sylvester. Tex Avery claims he "leaned more toward the adult audience,"[56] and Jones vehemently maintains "they were absolutely made for adults."[57] Yet, Time Warner is now appropriating these adult characters to attract the family dollar, literally following the lead of the Walt Disney Company by co-opting its methodology. Bugs Bunny and the rest of the Looney Tunes menagerie replaced Mickey and Minnie Mouse on Premier Cruise Lines, forging an alliance in 1993. Looney Tunes merchandise is sold in gift shops on the boats, and the characters interact with the guests.[58] The Warner Bros. Studio Store, opening four years after the Disney Store, has quickly become a tourist destination in cities worldwide, with the New York store now enlarged into a nine-story theme park/shopping center. Warner Bros.' global expansion continued as Warner Bros. Movie World opened in Australia and Germany to compete for the international family dollar with Disneyland Paris (previously EuroDisney) and Tokyo Disneyland.

Even with a corporate and global mind-set, Warner Bros., until the midnineties, never trifled with the personalities of its Looney Tunes characters. Yet, recent commercials with Nike, Visa, and 7–11, new Saturday morning cartoon series, the theatrical short *Carrotblanca*, and the feature *Space Jam* appear to have replaced identity and irreverence with milquetoast and merchandising. Presently, comedy in Warner Bros. animation no longer springs from a conflict between opposing personalities, like Bugs Bunny and Baby Face Finster in the wonderful *Baby Buggy Bunny* (1954). Instead, the comedy comes from the characters going *out* of character or from the characters reprising old scenes *out of context*. The gag of Bugs Bunny insouciantly kissing his opponents is combined with an odd sense of adoration as he plants one on Michael Jordan in *Space Jam*; the erstwhile guileless Tweety becomes Peter Lorre in *Carrotblanca* or Jackie Chan in *Space Jam*; Pepé le Pew is inexplicably "deodorized" in *Carrotblanca*; and in *Space Jam*, Wile E. Coyote's Acme explosives actually work. Tweety and Sylvester, after almost forty years of predation, miraculously discover they possess a strange knack for detective work in the Saturday morning cartoon series *Sylvester and Tweety Mysteries* (Yosemite Sam and Elmer Fudd even have cameos as villains!). The most egregious of alterations occurs in *Space Jam*, where Yosemite Sam and Elmer Fudd are no longer villains of Bugs and Daffy but cohorts and next-door neighbors, affectionate residents of "Looney Tunes Land,"[59]

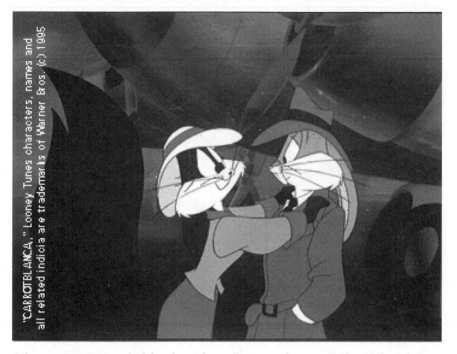

A Looney Tunes reprisal of the classic farewell moment between Rick and Ilsa, à la Bugs Bunny and Kitty in *Carrotblanca* (1995). Copyright Warner Bros., Inc.

a nation quite similar to *Tiny Toons*' Acme Acres.[60] As corporate symbols, a big happy community of toons reflects a more familial image than "Would I throw a lighted match in the stove if my pal Rocky was in there?"[61] Better to homogenize the Looney Tunes characters, placing Bugs Bunny and Tweety into rejected *Scooby Doo* and *X-Files* scripts, than risk alienating the consumer.

Two Warner Bros. cartoons, directed by the team of Greg Ford and Terry Lennon, parodied and subsequently predicted the "Disneyfication" and "commodification" of the Looney Tunes characters. *Invasion of the Bunny Snatchers* (1992), which appeared on the prime-time special *Bugs Bunny's Creature Features* and can now be seen in syndication,[62] has the following story line: Elmer Fudd, Yosemite Sam, and Daffy Duck eat some mysterious glowing carrots and are turned into what Bugs calls "unreasonable facsimiles thereof" of their former selves. As in *Space Jam*, all conflict is removed from these characters' personalities, as evidenced by the following exchange in which the "new and improved" Elmer tries to get Bugs to eat a carrot.

> *Bugs:* Don't you want to chase me?
> *Elmer:* Hello. I want to spread sunshine whenever I can.

Daffy kisses up to boss Leon Schlesinger in Friz Freleng's *You Ought to Be in Pictures* (1940). Copyright Warner Bros., Inc.

> *Bugs:* Let me get this straight. No more competition? No more adversarial interaction? No more battle of wits?
> *Elmer:* Bring home one of these strange lookin' carrots and all your troubles will be put to rest.
> *Bugs:* Thanks anyway, but I'll stick to my own brand.

Elmer is reduced to a pale stereotype of his former self. All that remains of him and the other characters are their tag lines: Elmer's "I'm hunting wabbits"; Sam's "Wrackin, frackin, varmit"; and Daffy's "You're dethpicable"—which they all repeat with robotic glee. When Bugs discovers that these redrawn and rewritten characters come from the planet Nudnick, he declares, "It's a corporate takeover." This satirical jab at the recent merger of Time and Warner Communications mirrors the self-conscious gags against management in early Looney Tunes cartoons like *You Ought to Be in Pictures* (1940) and *The Big Snooze* (1946). Like those cartoons of Termite Terrace, the animated characters in *Invasion of the Bunny Snatchers* eventually have the last word over management when the genuine Bugs is finally moved to exclaim, "I never realized how lucky I was that so many people wanted to kill me." Unfortunately, these "bunny snatchers" would not be so unsuccessful a second time around in *Space Jam*.

The other Ford and Lennon self-reflexive collaboration was *Blooper Bunny*, a stylish parody of Warner Bros.' redundant and uninspired TV specials and anniversary shows in the seventies and eighties. Finished in 1991, *Blooper Bunny* humorously attacks the corporate mentality overtaking and Disneyfying the Looney Tunes characters in the early nineties. The cartoon adopts a behind-the-scenes look at Bugs, Elmer, Yosemite Sam, and Daffy rehearsing for Bugs Bunny's *Fifty-first and a Half Anniversary Spectacular*. *Blooper Bunny* begins with the actual performance, a five-rocket salute to Bugs from his pals Daffy, Yosemite Sam, and Elmer, who even carries a gun loaded with a "bang" flag for Bugs's protection. The opening, states Ford, simulates "the way you can imagine licensing people would *want* you to see the characters all the time."[63] The cartoon then cuts to a flashback earlier in the day, when the fake camaraderie reveals itself as outright hostility. Elmer loads his gun with real ammunition so he can have an easy shot at Bugs. Yosemite Sam yells to the gaffers, "Bugs Bunny. He's fifty-one and a half. Who cares?" Daffy also expresses condemnation for the anniversary show: "Fifty-first and a half Anniversary. Who writes this slop? . . . The next thing you know they'll stick me with three snot-nosed nephews. I wouldn't put it past them. . . . Warner Bros. doesn't have an original bone in its . . ." This behind-the-scenes approach reveals the characters for who they really are. As Lennon remarks, "On-camera, they've got their big marketing grins on their face; off-camera, they want to kill each other."[64]

What makes *Blooper Bunny* a remarkable achievement is its ability to remain true to the characters' personalities within a domain of self-reflexive parody, and a caustic one at that. As in *Duck Amuck* (1953), when Daffy Duck "remains Daffy Duck" on an empty screen, even without setting or sound,[65] Daffy in *Blooper Bunny* still remains Daffy Duck "behind the scenes." His trademark line to Bugs, "You're dethpicable," becomes "You smug son of a . . . ," which is probably what Daffy would say to Bugs anyway when the camera is turned off. As for the other characters, Elmer is concerned about baldness, Yosemite Sam is an ill-tempered pain in the ass, and Bugs is a consummate professional. Ironically, *Blooper Bunny*'s mockery of wholesome Warner Bros. family entertainment is more consistent with the characters' personalities than *Space Jam*.

Unfortunately, *Blooper Bunny*'s corporate irreverence proved to be its downfall. Time Warner delayed the cartoon's release in theaters, on video, or on television for six years, until 1997.[66] Possibly believing that *Blooper Bunny*'s combination of hyperbole, innuendo, profanity, and wickedness might contribute to the "paradigmatic disarray" of the now-watered-down Looney Tunes characters, the heads of Time Warner in 1991 decided to shelve *Blooper Bunny* rather than risk potential public outcry. A 1992 release of *Blooper Bunny* might have set a new precedent for Looney Tunes characters, making and keeping Bugs, Daffy, Elmer, and the rest of the gang positively adult and therefore distinct from

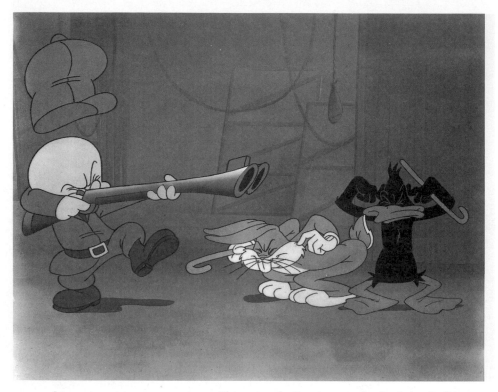

Live ammunition on a movie set: Elmer aims for Bugs but mistakenly alights Daffy's crop in *Blooper Bunny* (1991). Copyright Warner Bros., Inc.

Disney. In its stead, *Space Jam* was born, a by-product of the popularity of Nike's Hare Jordan commercial in 1992.

In addition, no economic incentive existed for Time Warner to release *Blooper Bunny* because the corporation recouped the cartoon's cost by selling off its cels. Cels from the cartoons were mistakenly sent to the Warner Bros. Studio Stores for sale, without the consent of the studio heads. Entitled "Commercial," the cels now reside in an art dealer's collection or hang on a fan's wall. If Time Warner had continued to enforce a Disneylike "politics of forgetting," few people might have ever known the origin of these cels or *Blooper Bunny*'s testament to Warner Bros. animation history.

Yet, despite a movement toward the homogenization of its Looney Tunes characters, the heads of Time Warner gave permission to the Cartoon Network to air *Blooper Bunny* during the cable station's forty-eight-hour Bugs Bunny Marathon—"June Bugs"—on June 13–15, 1997.[67] Now owned by Time Warner after its merger with Turner in 1996, the Cartoon Network premiered *Blooper Bunny* amid little fanfare and publicity besides commercials on its own station.

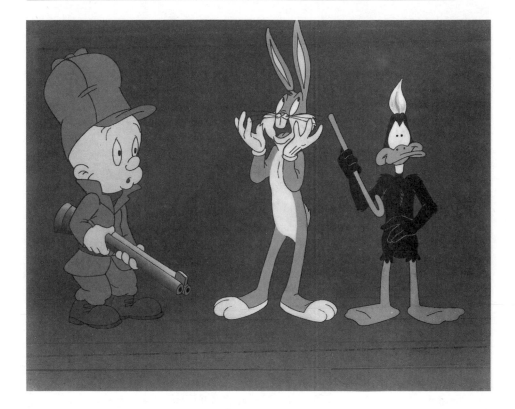

Following the airing, the company received no complaints about the cartoon's ostensibly questionable subject matter. It remains to be seen how the powers that be will use *Blooper Bunny* in the future. Will it be discarded as just a short-lived publicity stunt for the Cartoon Network, or will the film finally take its place alongside the other shorts in a regular rotation?

Time Warner's release of *Blooper Bunny* may indicate that the corporation is less precious about its animation history than Disney. However, the humor in *Blooper Bunny*—a sassiness which has always demarcated the style of Warner Bros. animated films (including the hybrid *Space Jam*) from the *Robin Hoods* and *Lion Kings* of Disney—is no more and possibly even less rancorous than that expressed in much of today's animation. Concerns about releasing *Blooper Bunny* in 1991, although unfounded now, may have appeared very real at the time. Little new animation was being produced in the early nineties; controversial series like *The Simpsons* and *Ren and Stimpy* had not yet demonstrated their longevity. By 1997, the producers and the audience were more receptive to such irreverent material. Daffy's *Space Jam* declaration about not seeing any money from Warner

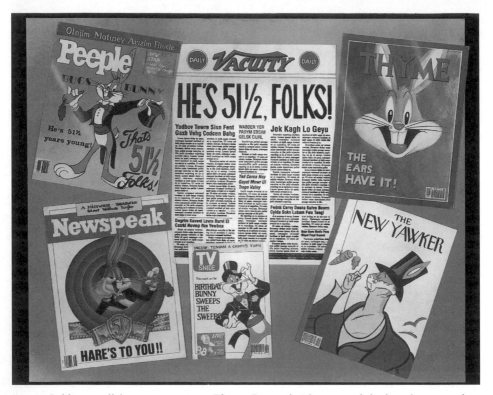

Publicity still from a sequence in *Blooper Bunny* that lampooned the hoopla surrounding Bugs Bunny's fiftieth birthday. Copyright Warner Bros., Inc.

Bros. merchandising ("We need new agents. We're getting screwed!") and *Blooper Bunny*'s sarcastic one-liners are compatible with quips on *Tiny Toon Adventures* and *Animaniacs*, but pale in comparison to the nihilistic natterings of the misanthropic *Beavis and Butthead* and *South Park* or the apocalyptic Japanese manga cartoons. What, then, does the release of *Blooper Bunny* say, if anything, about the direction of Warner Bros. animation as it approaches the millennium?

First, the Cartoon Network's investment in the *history* of cartoons validates the channel as a site for classic or *historical* Warner Bros. cartoons. Reconfigured as a member of this history, *Blooper Bunny*, it probably was assumed, would pose no threat to the current remodeling of the Looney Tunes/*Space Jam* characters as corporate symbols. Any concerns for the "paradigmatic disarray" of the classic characters could now be alleviated by compartmentalizing them into new and old "arrays" or clusters: the "classics" over here and the new homogenous residents of "Looney Tunes Land" over there. Thus, releasing *Blooper Bunny* under the aegis of the Cartoon Network ensured that the cartoon would not be mis-

taken for those new Bugs Bunny or Looney Tunes cartoons currently being produced to accompany feature films.

Second, Time Warner's decidedly lackluster support for *Blooper Bunny* mirrors the corporation's support for its new animated shorts. Regrettably, few people even realize that new Looney Tunes theatrical cartoons are currently being produced since Time Warner couples them with inferior and/or underpublicized films. Such feeble pairing was not the modus operandi when Warner Bros. resumed production of theatrical shorts in the late eighties. Codirectors Greg Ford and Terry Lennon made *The Duxorcist* (1987) and *Night of the Living Duck* (1988), the first new theatrical Looney Tunes shorts in over twenty years. Both cartoons enjoyed an entirely different distribution system than today's wave of shorts, largely because of the studio's benign neglect. *The Duxorcist* could precede any feature the exhibitor opted for; *Night of the Living Duck* premiered on opening night at the 1988 New York Film Festival and was later attached to *Daffy Duck's Quackbusters* (1989). The press widely reviewed and praised both the cartoons.[68] Warner Bros. gladly stood by and allowed word of mouth and critical approval to guide public perception of the regenerated Daffy Duck character.

Yet, all the frenzy over new theatrical Looney Tunes shorts like *The Duxorcist* and *Night of the Living Duck* occurred shortly before the marketing success of *Batman* in 1989 reshaped Warner Bros.' approach to its animation characters. After the merger, the new regime at Time Warner basically showed indifference, perhaps disregard, for the release of new shorts before feature films. In 1992, Van Citters reflected on the studio's indecisiveness two years earlier regarding *Box Office Bunny*, the first Looney Tune released by Time Warner and the first Bugs Bunny theatrical short in twenty-six years.

> It was put "in the refrigerator" for six or nine months while the studio tried to figure out what to do with it. They had talked about several different films to release it on, but as each one looked like it wasn't going to do the anticipated box office, they decided not to put our cartoon on it. The film they finally put it on [*The NeverEnding Story II: The Next Chapter*], I don't think really showcased the short anyway.[69]

The animation directors who followed Van Citters most likely shared in his disappointment as Time Warner continued its practice of coupling shorts with Grade B family entertainment features. Time Warner attached *Chariots of Fur* to *Richie Rich* (1994), *Carrotblanca* to *The Amazing Panda Adventure* (1995), *Superior Duck* to *Carpool* (1996), and *Pullet Surprise* to *Cats Don't Dance* (1997).

The staff of Chuck Jones Film Productions who completed *Chariots of Fur*, *Superior Duck*, and *Pullet Surprise* can offer no explanation for these ghastly pairings except that the cartoon shorts are possibly being used to attract an audience to hard-to-market films.[70] A more precise account could be that Time

Warner had nothing to gain monetarily by promoting these shorts. In the thirties and forties, cartoons, along with a newsreel and/or a travelogue, were added attractions that preceded the feature film. People paid for the entire program, so a cartoon's actual economic benefit to the studio could never be accurately calculated. Now that consumer purchase of original cel art from animated shorts will always recover the cost of producing them, why should Time Warner spend extra money on publicizing them if the audience no longer expects the shorts as part of the theatrical show and no further economic gain is to be had?

Warner Bros.' lack of concern for the fate of these new theatrical shorts and *Blooper Bunny* invariably begs the question, "Why make them at all?" Perhaps keeping up a tradition or repaying a debt to Chuck Jones (who receives no ancillary revenue from his creations) is the explanation for the "uneventfulness" of these new Warner Bros. shorts. Whatever the case, a big change is in the works: Warner Bros. now intends to cut back and possibly eliminate the production of future Looney Tunes shorts at Chuck Jones Film Productions. In an Internet posting by Joe Alaskey, who does the voices of Plucky Duck in *Tiny Toon Adventures* and of the current Daffy Duck, Sylvester, and Tweety, he urges fans to write to Warner Bros. to show their support for Jones's work and their interest in the manufacturing of new Looney Tunes.[71] Around the same time, *Variety* announces the development of a new theatrical feature entitled *What's Up, Bugs?*—another *Space Jam* combination of live-action and animation.[72] Clearly, Warner Bros. animation is at a crossroads, torn between dedication and corporatization. Can the classic characters have it both ways?

THIS COLLECTION SPANS the entire history of Warner Bros. animation to illustrate how the studio reached this point of corporate turmoil and indecisiveness. The contributing authors consider the institutional changes that have occurred at Warner Bros. over the past sixty-plus years and analyze the shifting political and cultural economies that invariably mediate the semiotic and ideological resonance of the Looney Tunes text. Barry Putterman provides a map for this journey in "A Short Critical History of Warner Bros. Cartoons." He outlines the studio's key attributes—its animated stars, its personnel, and its unique brand of style—laying the necessary groundwork for the essays that follow.

In "From Disney to Warner Bros.: The Critical Shift," Timothy R. White examines how the initial wave of valorization of Warner Bros. cartoons coincided with the championing of European art cinema during the sixties. For White, critical appreciation of Disney animation for its craftsmanship and realism—conventions of the classical Hollywood cinema—was replaced, albeit temporarily, by admiration for Warner Bros. cartoons and the characteristics it shared with the European art film. Unlike Disney, which represented to the critic at that time, "a mark of corporate blandness and the absence of expression of the

individual artist," Warner Bros. personified inventiveness and unconventionality, a result of the directorial control over the finished cartoon. Jones, Avery, Tashlin, and Clampett were auteurs in every sense equal to Buñuel, Godard, Resnais, and Antonioni. However, the decline of art cinema and the critical shift away from auteurism in the seventies led to a resurgence in Disney scholarship which continues to this day.

Gene Walz challenges the emphasis placed on the director-auteur that currently dominates Warner Bros. animation scholarship by acknowledging and uncovering the contributions of character designer Charlie Thorson. In "Charlie Thorson and the Temporary Disneyfication of Warner Bros. Cartoons," Walz demonstrates how the hiring of Thorson away from Disney in 1937 temporarily "Disneyfied" Warner Bros. cartoons until 1939, bringing "cuteness," sentimentality, and natural "realism" to Termite Terrace. Thorson's character designs for Inki in *Little Lion Hunter* (1939) and Sniffles in *Naughty But Mice* (1939)—themselves direct imitations of his drawings for Disney's *Little Hiawatha* (1937) and *The Country Cousin* (1936), respectively—introduced "more intimate and sympathetic moments" between cartoon characters and audience in the work of Chuck Jones. Additionally, Walz documents Thorson's role in the development of Bugs Bunny. Not only did Thorson design the rabbit in the formulative Bugs Bunny cartoons—*Hare-um Scare-um* (1939), *Presto Change-o* (1939), and *Elmer's Candid Camera* (1940)—but Bob Givens's designs of Bugs Bunny for Avery's *A Wild Hare* (1940), which many historians consider to be the first "true" Bugs Bunny cartoon, were themselves adapted from Thorson's Max Hare drawings in Disney's *Toby Tortoise Returns* (1936). This modification, argues Walz, ironically changed the direction of Warner Bros. cartoons toward sharper comedy and sarcasm, signaling the end of the temporary Disneyfication of the studio.

While Walz dispels the notion of Warner Bros. cartoons as animated extensions and validations of the auteur theory in live-action cinema, Hank Sartin views them as "negotiators" in the transition to "talking pictures" in the late twenties. In "From Vaudeville to Hollywood, from Silence to Sound: Warner Bros. Cartoons of the Early Sound Era," Sartin rescues from obscurity and critical disfavor the early thirties Warner Bros. musical cartoons, claiming that they provided temporary solutions to the problem that sound created for the movie audience and technicians. By adopting what Henry Jenkins calls the "vaudeville aesthetic," Warner Bros. confronted the resistance to the new technology of "talking pictures" by explicitly dramatizing this uncertainty in its musical cartoons. Stressing performance over narrative, cartoons such as *You Don't Know What You're Doin'* (1931) celebrated a more participatory relationship between the audience and entertainment to reflect anxiety about the shifting standard of conduct in movie theaters. Lifeless dolls and mannequins suddenly bursting into improvisational song in *Red-Headed Baby* (1931) and *Shuffle Off the Buffalo*

(1933) demonstrated how the "threatening mechanical reproduction of sound" allowed for new forms of creativity and performance.

Although replaced by the "chase" in the midthirties as the dominant narrative structure of the Warner Bros. cartoons, the musical cartoons displayed a "make-do spirit" of improvisation, Sartin notes, which resonated with depression-era viewers. The hillbilly icon, argues Michael Frierson in "The Image of the Hillbilly in Warner Bros. Cartoons of the Thirties," also provided a form of re-assurance for many urban Americans who feared a return to the "rural subsistence hell" of the early thirties. Frierson closely analyzes three cartoons of the middle to late thirties from three different directors: Freleng's *When I Yoo Hoo* (1936), Avery's *A Feud There Was* (1938), and Clampett's *Naughty Neighbors* (1939). This discussion demonstrates how audiences could wistfully and disdain-fully "point and laugh" at the "barefooted, shabby, black-bearded mountain hayseed" content with economic hardship and unsophistication. Hillbillies rep-resented an "atavistic" society to urban audiences, an earlier preindustrial rural subculture that was socially sanctioned for lampooning and satirizing in the name of "entertainment."

Entertainment and "fun," however, notes Donald Crafton in "The View from Termite Terrace: Caricature and Parody in Warner Bros. Animation," are "not neutral ideological turf." Caricature and parody of ethnic and social groups al-ways reveal and unravel relationships between the economically powerful and the powerless. Frustrated by the limits imposed on their creativity and by their low salaries, the Warner Bros. cartoonists vented their grievances through indi-rect references in the studio newsletter, *The Exposure Sheet*, and in *Hollywood Steps Out* (1941), *Swooner Crooner* (1944), and other cartoons caricaturing and parodying Hollywood, Hollywood films, and Hollywood society. Although these cartoons promoted the film industry and particularly Warner Bros.' live-action stars like Humphrey Bogart and Lauren Bacall, they also performed a subver-sive function as a counterdiscourse, with double-edged expressions of anger and resentment toward a system that not only privileged live stars over animated ones but claimed animation work to be aesthetically and intellectually inferior to live-action cinema. Caricature and parody, states Crafton, became a symbolic form of resistance to the Hollywood machine; these comically exaggerated draw-ings "reduced actors and actresses to drawings, meeting them on a level playing field. . . . The view of the animators [was] not from the perspective of the po-litically oppressed but from that of the aesthetically misunderstood and economi-cally disenfranchised."

However, the playing field was never level for the representations of blacks in live-action and animated films. As the politically oppressed, blacks could never mediate nor challenge social constructions of their own images because they were essentially excluded from the industry. They could not "control the illusion" of

their images. Unlike movie star caricatures whose playful comic exaggerations were balanced with their multifarious and positive live-action portrayals, black caricatures imitated stupid and negative live-action black characters like Stepin Fetchit and the superstitious churchgoer. In fact, black caricatures could best be understood not as caricatures at all but as easily recognizable character types that stood in for the entire black community.

Terry Lindvall and Ben Fraser in "Darker Shades of Animation: African-American Images in the Warner Bros. Cartoon" explore the dominant types of black representations in Warner Bros. animation. They acknowledge that Warner Bros. accommodated and perpetuated prevailing black stereotypes in the Bosko and Buddy series and in cartoons such as *All This and Rabbit Stew* and *Goldilocks and the Jivin' Bears* (1944). Yet, Lindvall and Fraser argue that the directors did not have any malicious intent or animosity toward their subjects, but rather a "cultural naïveté" that led them to use the prevailing media stereotypes in their cartoons. And, according to Lindvall and Fraser, many Warner Bros. directors, particularly Clampett, celebrated black culture rather than exploited it—in sharp contrast to the hostile imagery used to depict Japanese and German characters in cartoons of the World War II era. Clampett's *Coal Black and de Sebben Dwarfs* and *Tin Pan Alley Cats* (1943) are parodic testaments to jazz and gospel music, "adoring tributes of a truly animated culture [rather] than racist disparagement." Although "crude, base, and vulgar," black representations in Clampett's films, like other ethnic representations in cartoons, embodied the irreverence that typified Warner Bros. animation.

Clampett's work remains unique among Warner Bros. cartoons for its libidinous energy and raw satire. His cartoons are exhilarating, says Mike Barrier, because "they invite a physical response."[73] Chuck Jones, however, was Clampett's cerebral doppelganger, a master, according to Kirsten Moana Thompson, of rhetorical wordplay and comedic subtlety who "narrativized the least cock of the eyebrow." In her essay "Ah Love! Zee Grand Illusion!": Pepé le Pew, Narcissism, and Cats in the Casbah," Thompson examines the Pepé le Pew series, Jones's and Warner Bros.' most self-reflexive parody of heterosexual romance. For Thompson, Pepé's relentless Parisian pursuits of a cat mistakenly painted with a white stripe—"zee king sized belle femme skunk fatale"—foregrounds the performative and discursive dimensions of heterosexual fantasy and the "exotic." Constructed as an invulnerable ego-ideal, Pepé operates as an "ideological safety valve" for the spectator, simultaneously allowing for absorption in and identification with Pepé's narcissistic fantasies ("Pepé is a fearless lover") while disavowing his inevitable rejection through comic distanciation ("Pepé is a foolish skunk"). Through the spectacularization of Hollywood and oriental romantic discourses, laughter at Pepé's unfailing beliefs in his own desirability helps the spectator to "overcome" the reality of his or her own fears of rejection.

The Pepé le Pew series is unique in the Warner Bros. canon. The sexual dimension of the chase between Pepé and "Cherie" substitutes for the predatory relationship between cat/bird (Sylvester/Tweety), chicken/chicken hawk (Foghorn Leghorn/Henery Hawk), and duck/hunter (Daffy Duck/Elmer Fudd). However, the performative nature of gender and sexuality satirized and then appeased in the Pepé le Pew series dramatically resurfaces in the Bugs Bunny cartoons featuring cross-dressing, known as "temporary transvestite cartoons." In "Gendered Evasion: Bugs Bunny in Drag," I examine each of the 168 Bugs Bunny cartoons theatrically released between 1940 and 1964. These cartoons, I suggest, are part of a larger cultural fiction that regulates gender performance and reproduces the illusion of a "real" gendered identity. With Judith Butler's contention that gender repetition and compulsion produce "naturalness" and "normality," and Marjorie Garber's claim that the transvestite is an indicator of a "category crisis," I argue that the Bugs Bunny temporary transvestite cartoons restabilize and reinforce the alignment of gender, sex, and sexuality ideals by first denaturalizing and defamiliarizing those signs through gender transgression. As with Pepé's narcissism, Bugs is rarely ridiculed for "cross-gendering"; the spectator can vicariously experience a temporary trespassing of gender roles without societal admonishment. Bugs always reverts back to his heterosexual masculine self by the end of the cartoons, resolving the ideological threat of gender instability embodied by the transvestite.

As comedies of disavowal, the Pepé le Pew series and the Bugs Bunny temporary transvestite cartoons remain popular across generations because they treat everyday cultural anxieties as gags, gags free of the shame and embarrassment that usually accompany transgressions in the real world. As a result, Warner Bros. characters have evolved into cultural icons, enjoying worldwide popularity by fans who identify with a particular star's defining characteristics: Pepé's romanticism, Bugs's competence, Daffy's will, or Taz's id. In her essay "Selling Bugs Bunny: Warner Bros. and Character Merchandising in the Nineties," Linda Simensky considers the business side of Warner Bros. iconography: merchandising and licensing. By first examining the history of Warner Bros. character licensing, from early unsystematic licensing efforts of Bosko and Porky Pig in the thirties to the creation of the Warner Bros. Studio Store Catalog of the late eighties, Simensky explains the marketing and character development philosophies behind the Warner Bros. Studio Store chain. Included in this discussion are interviews with animation historians like Jerry Beck and Mark Newgarden, and Warner Bros. Studio Store personnel such as Ruth Clampett, the director of creative design, who provide valuable insights into the increasingly important collaboration between animation merchandising and production, a topic rarely explored with critical and historical authority. Simensky ends her discussion by drawing comparisons with the Disney Store and analyzing *Space Jam*,

starring Bugs Bunny and Michael Jordan. This film marked Warner Bros.' successful return to feature-length film production, and many believe it will change the face of Warner Bros. animation in the coming years.

Nevertheless, the appropriation of cartoon images extends far beyond that of Foghorn Leghorn T-shirts and Bugs Bunny pasta bowls for some fans of Warner Bros. animation. Bill Mikulak, in his essay "Fans versus Time Warner: Who Owns Looney Tunes?," identifies those consumers who produce artwork, criticisms, and narratives of their favorite Warner Bros. characters in cyberspace and the challenge they pose to Time Warner as the intellectual property owner of these characters. Mikulak's discussion revolves around Henry Jenkins's notion of "textual poaching" and issues regarding who can "legitimately produce, transform, and disseminate culture" via computer. These computer denizens—"furries" as the fans describe themselves—are an electronic community on the Internet who design elaborate Web pages, compile detailed reference works, and write episodes suitable for television production. Mikulak closely examines one subset of this fan art and fiction—the sexually explicit use of characters, particularly those of Minerva Mink from *Animaniacs* and Babs and Buster Bunny from *Tiny Toon Adventures*. These pornographic and nonpornographic images have attracted the attention of Time Warner; the company accuses such fans of violating copyright and trademark laws. However, what Time Warner views as a loss of profit and corporate control, fans see as enthusiastic and authorized acts of consumption and reproduction.

The very nature of the environment of the Internet, dominated by witty pseudonyms and cybernetic phantasms, invariably erases or multiplies the users' "true" identity or identities. The masquerade is what fuels the interactivity among users: performance over performer, sensation over fear. Special effects and applied animation in films, argues Norman M. Klein in "Hybrid Cinema: *The Mask*, Masques, and Tex Avery," accomplish a similar task, taking the spectator on an interactive journey. But *The Mask* (1994) and other hybrid forms of live-action and animated cinema, Klein points out, signal and reflect the invasion of the self, a loss of privacy and intimacy that mirrors the outside world. Influenced by the congested chase cartoons of Tex Avery, these hybrid films—for which dramatic characters are merely vessels for the effects within or around them—are allegories about the audience. More specifically, they are "allegor[ies] about diminished individualism, that the self, as an industrial myth about freedom, cannot survive the effects of the electronic workplace." In the wake of the megasuccess of *Independence Day* (1996), Klein calls for a new theory of hybrid cinema to examine the relationship between audience and special effect in the computer era. He stresses that with these new forms of visuality and thrill, not only is the ride more important than the story; "the ride is the story."

The Mask reminds us of the Golden Age of lunacy at the Warner Bros. mill:

ducks amuck, rabbits rampaging, and birds anonymous. Now that Time Warner has acquired Turner, which owned the rights to almost all Looney Tunes and Merrie Melodies before September 1, 1948,[74] the corporation controls all cartoons in circulation, eliminating the threat of any "paradigmatic disarray" of its iconography. Two often repeated anecdotes by Chuck Jones seem fitting for this transitional period in Warner Bros. animation and the direction the classic Looney Tunes characters are headed. The first is of boss Harry Warner, who had no idea where the animation studio was on the Warner Bros. lot. In fact, he said, "The only thing I know is that we make Mickey Mouse."[75] The other story is about Eddie Selzer, who replaced Leon Schlesinger as producer after Schlesinger sold his studio to Warner Bros. Upon seeing animators laughing over a storyboard, Selzer demanded, "Just what the hell does all this laughter got to do with the making of animated cartoons?"[76] Let's hope that Warner Bros. animation does not lead Termite Terrace to the Magic Kingdom, stressing civility over impertinence; pleasantries over hilarity. The lukewarm success and critical failure of *Space Jam* raise the important question: Are the Looney Tunes characters headed in the right direction? Time Warner should take the advice of one of its own: Bugs Bunny. In *Invasion of the Bunny Snatchers*, Bugs wonders, "Maybe if I get rid of these robot retreads, then the genuine articles would come back." Heed the lagomorph's wise recommendation. The day may soon come when "That's All Folks!" becomes a reality.

A Short Critical History of Warner Bros. Cartoons

BARRY PUTTERMAN

WHEN AL JOLSON uttered his famous catchphrase "You ain't heard nothing yet" in *The Jazz Singer* (1927), he not only offered a poetically just introduction to film's sound era but also set in motion the dynamics that would ultimately lead to the birth of Warner Bros. cartoons in 1930.

For as Richard Barrios documents in his book *A Song in the Dark*, the early talkie mania for musicals in every shape, form, and size also provided the major studios with one of their first artifacts of Hollywood's current corporate engine—ancillaries.[1] By opening music publishing divisions, the studios could cash in on the sheet music, radio airplay, and recording royalties of every song that their payrolled tunesmiths could shoehorn into each production. Thus, the studios routinely replaced the established musical numbers from the Broadway productions they filmed with new songs by their hired hands to increase their take from these lucrative markets.

These facts were not lost on a low-rent mogul in the film advertising trade, Leon Schlesinger, owner of Pacific Art & Title. Nor were they lost on a pair of ambitious ex-Disney animators named Hugh Harman and Rudolf Ising, who, probably as much taken with the way their names blended as by any kind of artistic bond, set up their independent Harman-Ising Productions. An important early contributor to the vintage Harman-Ising efforts was one Isadore "Friz" Freleng, himself an ex-Disney animator, whose name would be linked with Warner Bros. cartoons for many decades to come.

In 1929, Harman-Ising Productions fabricated a short test film animated by Harman, Freleng, and Max Maxwell, entitled *Bosko the Talk-Ink Kid*. The film, perhaps the very first where actual prerecorded dialogue (as opposed to Disney's *Steamboat Willie's* [1928] random "moos," "meows," "oinks," and such) was

synchronized with animation, featured a newborn Harman-Ising creation named Bosko emerging from the inkwell—à la Koko the Klown—to talk and cavort with Rudy Ising. As a character, Bosko could be vaguely identified as a human being but was neither young nor old and displayed no distinctive personality traits beyond a bland cheeriness. One could be generous and call him a scamp—an imp representing the spirit of cartoon playfulness. Or one could be cruel and call him a blatant rip-off of Mickey Mouse or an ambiguously caricatured African American. Either way, Bosko soon became the first animated "star" at Warner Bros.

In 1930, Harman and Ising, peddling their Bosko test-reel to various distributors, found an eager buyer in Leon Schlesinger. Schlesinger had contacts at Warner Bros. and took the Bosko film there in hopes of landing a production deal. Flushed with pride at being the "inventors" of talking pictures, Warner Bros. was in the midst of an ambitious expansion program which included the acquisition of the First National movie studio and theater chain. They agreed to underwrite and release the Harman-Ising productions provided that each cartoon include at least one singing chorus of a song from the Warner Bros. publishing library.

So Harman-Ising set up shop under Schlesinger's management and began producing a series of Bosko cartoons for Warner Bros., which they titled Looney Tunes. By mid-1931, they also launched a parallel series of individual story cartoons with no continuing characters but plenty of Warner Bros. music, which became known as Merrie Melodies. In both cases the similarity in title to Disney's established Silly Symphonies series was not lost on the industry or the public.

By 1934, the cartoon had become so well established as a standard part of the package of short subjects accompanying main feature pictures that every major studio had its own animation division except staid MGM (which had been merely subreleasing Ub Iwerks's independently produced "Flip the Frog" cartoons). And MGM promptly rectified that situation by offering Harman-Ising bigger budgets and higher salaries to initiate its Happy Harmonies series. Since Bosko also made the trip over to MGM, Schlesinger was left with little besides the series titles to carry on with at Warner Bros.

The Harman-Ising films were low-octane Disney imitations, but their utterly sincere dinkiness did have a certain inexplicable charm. After Harman and Ising left Warner Bros., the Merrie Melodies remained pretty stable under the guidance of former Harman and Ising mainstay Friz Freleng. But while in some instances (e.g., 1934's How Do I Know It's Sunday? and The Girl at the Ironing Board) one might say that the product markedly improved, and while other entries (e.g., 1935's Billboard Frolics) now had the added benefit of being produced in color, it was pretty clear that Merrie Melodies were not about to set the world on fire. And the situation was even grimmer in the Looney Tunes department.

The second-string Disney hands brought in by Schlesinger began churning out bland and haphazard Harman-Ising imitations that had no form whatsoever. Unfortunately, the new Looney Tunes star turned out to be one Buddy, a "white-face," lifeless clone of Bosko.

By the middle of 1935, the Warner Bros. cartoons, particularly the Looney Tunes, had reached such a creative nadir that even Schlesinger realized that a new direction was imperative. Whether it was skill, fate, or sheer dumb luck is open to interpretation, but what followed was the importation in rapid succession of a series of key players who would quickly transform the tone of the studio's cartoons into what everybody now remembers them to be.

The midthirties was the time when a musical style of orchestrated jazz suddenly galvanized the United States, quickening its gait, creating pulsating new dance movements, and providing the historical name "The Swing Era," which became the shorthand catchphrase for the sassy new viewpoint that became our national mood. And the parallel transformation of Warner Bros. cartoons took them from being the nambiest of pambies to the most dynamic embodiment of swing in the American cinema as quickly as the music itself took hold of the nation.

First and foremost in spearheading this movement was a novice director hired off of Universal's payroll named Fred "Tex" Avery. Exactly what Schlesinger saw in the unproven Avery has never been satisfactorily explained, but Avery was given a director's chair, assigned a staff of young turks (namely, Robert Clampett, Bob Cannon, and Charles "Chuck" Jones) who were in open rebellion against the current studio product, and housed away from the other cartoon units in a ramshackle bungalow on the Warner Bros. lot which was quickly christened "Termite Terrace."

Avery and company immediately began to infuse the cartoons with the kind of anarchic irony of anti-intellectual knowingness that has become the hallmark of twentieth-century American humor. Building gags based on contrasts in speed both of motion and speech, puns derived from visual and verbal juxtapositions, and the kind of abstract analysis of the production's own self-admitted theatrical artifice (a practice pioneered in George M. Cohan's turn-of-the-century musicals and a longtime tradition in vaudeville and on radio), the cartoons began structuring layers of references and suggesting a world of infinite behavioral possibilities. Offered this escape from the studio's safe fantasyland, Freleng's Merrie Melodies quickly seized on all these techniques, and the Warner Bros. cartoons now embarked on a quest to create a parallel cartoon world, an evil empire to battle Disneyland.

Since the cartoons were still tied to the Warner Bros. song publishing library, it was necessary for music to philosophically keep up with the new, jazzier rhythms of the images. And in 1936, former Disney musical director Carl Stalling

became the right person at the right time to help shape the new Warner Bros. concept. With sly wit, Stalling intricately altered the tempo in his samplings of Warner Bros. songs and deftly entered them into the mix with his own original melodies, driving the rhythm of the films to a consistently crisper pace.

And since the new concept depended on more distinctively psychologically flawed and idiosyncratic characters, the cartoons needed to be voiced by actors who were more adept and attuned to the spirit of the proceedings. Buddy had by now been jettisoned from the Looney Tunes roster, and the character who emerged as his replacement was the stuttering, wide-eyed Porky Pig. Porky was first glimpsed among a motley group of classroom kids in Friz Freleng's 1935 Merrie Melodie, *I Haven't Got a Hat,* but the whole idea of Avery seeking out this stuttering pig, of all things, and selecting him for stardom, was a bold stroke. To bring Porky and other new eccentric characters to life, Avery and Freleng prevailed on Schlesinger to hire the final 1936 newcomer, voice actor Mel Blanc. Blanc quickly established Porky's vocal character from amid a smorgasbord of early experimental models and went on to provide his masterful line-readings and multitudinous accents for the majority of Warner Bros. cartoons well into the sixties.

Throughout the late thirties, Warner Bros. continued to mature and expand on the inventive ideas pioneered in 1936 as what were to become the familiar cast of characters began making their way into the cartoons. Daffy Duck was introduced as Porky's antagonist in a Tex Avery 1937 Looney Tune called *Porky's Duck Hunt.* The duck's obvious compatibility with Warner Bros.' emerging style soon had him starring in numerous Looney Tunes as well as some Merrie Melodies (e.g., Avery's *Daffy Duck and Egghead* and *Daffy Duck in Hollywood,* both from 1938), which were now beginning to break away from their reliance on Warner Bros. songs to delve further into continuous character animation.

A 1938 Porky Pig Looney Tune called *Porky's Hare Hunt* introduced a wacky rabbit character who was linked to writer-director Ben "Bugs" Hardaway, and the first tentative steps toward what would eventually become Bugs Bunny were taken. Bugs Bunny underwent various modifications of physical appearance, character movement, and vocal inflection before Mel Blanc gave him his classic Bronx/Brooklyn accent and Tex Avery gave him his playfully aggressive attitude in the 1940 cartoon *A Wild Hare.* Indeed, it was also in that film that Bugs was first hunted by Elmer Fudd, a character who had also had a long evolutionary journey from his origins in a somewhat disquieting Tex Avery figure known as Egghead.

When Avery left Warner Bros. in early 1942 to achieve even greater artistic triumphs at MGM, U.S. involvement in World War II was but a few months old. The anxieties and tragedies of the war fostered a more ferocious national mood which, ironically, favored the philosophical direction of Warner Bros. car-

toons in general, the cocky character attributes of Bugs Bunny in particular, and the radical directorial mannerisms of Robert Clampett.

Bob Clampett had joined Harman-Ising while still a teenager in the early thirties and became an important figure among the rebels who formed Avery's unit. In late 1937 he was given a unit of his own and directed the bulk of black-and-white Porky Looney Tunes until Avery's departure. By then, the distinction between the two cartoon series was fading, and in 1943, when the Looney Tunes went to color, the only differences between the two series were the titles and the theme music. What was now distinct were the three mainstay directorial units headed by Clampett, Friz Freleng, and Chuck Jones (who had been promoted to director in late 1938). These three directors had their permanent staffs of animators, which gave each unit's cartoons a unique signature look, and each director was paired with a specific writer—Clampett with Warren Foster, Freleng with Michael Maltese, and Jones with Tedd Pierce—which gave each unit a distinct sound and attitude as well.

With the master Avery gone, Clampett's pictures took on a renewed vigor. Now working in color and having inherited key Avery animators Robert McKimson and Rod Scribner, Clampett was free to explore his major preoccupation, an almost transcendentally romantic yearning to escape human limitations through animated physical transformation. Certain Clampett cartoons, such as 1946's *Baby Bottleneck* and *The Great Piggy Bank Robbery*, which showcase a fantastically elastic Daffy Duck rendered in rudely rubberized fashion by animator Scribner, seem to strive toward every level of hysteria. At the same time Clampett developed a kind of jump-cut style of eliminating the transitions between extreme poses as the pace of the change-of-speed gags accelerated and the infantile-cum-homicidal characters bent and stretched toward a third dimension.

Timing of action, probably more than anything else, was what finally distinguished Warner Bros. animation from its competition, particularly from Disney, which had for years dominated the field artistically and commercially. It was the oddly syncopated *rhythm* of Chuck Jones's toucanlike Mynah Bird, after all, that first focused *New Republic* critic Manny Farber's attention on Warner Bros. cartoons and led him in 1943 to toss off a phrase like "their superiority over Disney's product," undoubtedly the first time anything of the sort was ever captured in print.[2] Freleng's timing experiments in music extravaganzas like 1941's *Rhapsody in Rivets* (which one critic later dubbed "a working class *Fantasia*")[3] and 1943's "Three Little Pigs" parody *Pigs in a Polka* led to new forms of eccentrically timed, stop-and-start action that were noticeably nonnaturalistic and pointedly anti-Disney. The selection of these pictures as early Warner Bros. Oscar nominees must have, in itself, made a dent in Disney's armor. And, for numerous critics today, these radical stylistic departures in graphics, content, and, especially, timing, which persevered at Warner Bros. throughout the early forties

on a studiowide basis, crystallize most compellingly in Clampett's Daffy Duck and his all-stops-out direction of this infinitely malleable mallard.

Daffy Duck became Clampett's character par excellence, but it was Bugs Bunny who, in the words of a 1942 Jones cartoon, became the "rabbit of tomorrow."[4] His woodland underdog status, his working-class street smarts, and his absolute joy in playing the game and bamboozling his opponent all struck a resonant chord with a nation drawn into war. It was during these war years, and because of the enormous public response to cartoons such as Freleng's *Little Red Riding Rabbit* (1943) and *Baseball Bugs* (1946), Jones's *Super Rabbit* (1943) and *Hair-Raising Hare* (1946), and Clampett's *Wabbit Twouble* (1941) and *The Big Snooze* (1946), that Bugs surpassed Mickey Mouse in the realm of short-subject popularity and Warner Bros. cartoons succeeded Disney's as our national favorites.

When Clampett left Warner Bros. in 1946, eventually settling into television with his *Beany and Cecil* puppet show, it was part of a much larger transformation for both the studio and the country. Leon Schlesinger had sold his interest to Warner Bros. in 1944, and his tightfisted but artistically laissez-faire approach to the staff was replaced by a more corporate control under the supervision of one Eddie Selzer.

The country was also adjusting to a much different world in the war's wake. Although we remain an adolescent nation obsessed with a perceived loss of innocence, we were at that time grappling with such new moral ambiguities as sudden superpowerdom, reconstruction responsibilities, and the Cold War. The fierce energy of the war effort was being rechanneled, and swing was being replaced by bebop, a more intricate and abstract form of jazz primarily designed for contemplative listening rather than pulsating dancing.

While animator Robert McKimson succeeded Clampett as the director of his unit, it was Chuck Jones who succeeded Clampett as the creative spearhead of the studio. In some respects, Jones was the superego to Clampett's id. If Clampett was about the heroic possibilities of transformation through animation, Jones was about the failure of grand schemes through the flaws of human execution. If Clampett yearned for liberation from the human condition through impossible movement, Jones displayed an enormous empathy for our all-too-human limitations through small gestures and expressions.

Jones redefined our understanding of Bugs and Daffy in a series of costarring cartoons where Bugs's self-knowing stasis constantly defeats Daffy's frenetic overreaching (e.g., 1955's *Beanstalk Bunny* and 1957's *Ali Baba Bunny*). Yet it was Jones's depiction of Daffy's multifaceted reaction to his continuous cycle of inspiration and humiliation in the fifties "Rabbit Season" trilogy *Rabbit Fire*, *Rabbit Seasoning*, and *Duck! Rabbit! Duck!* that drew most of the attention and sympathy.

Now partnered with Michael Maltese (Foster went with Freleng, Pierce with

McKimson), Jones made cartoons that concentrated their energies on the comic eccentricities of the recurring stars, a psychology-driven approach which, not coincidentally, set off a studiowide emphasis on the creation of new characters. Many of the figures we now associate with Warner Bros. cartoons, Jones's Pepé le Pew and Road Runner and Coyote, Freleng's Tweety and Sylvester and Yosemite Sam, and McKimson's Foghorn Leghorn, matured and prospered during the immediate postwar decade. The minor characters—Jones's Marc Anthony and Pussyfoot, Claude Cat and Frisky Puppy, and Charlie Dog, and Freleng's Spike and Chester and Rocky and Mugsy—were sparkling appendages to this "Golden Age" of Warner Bros. animation.

Jones's most famous Road Runner outings include the debut vehicle *Fast and Furryous* (1949), *Stop, Look, and Hasten* (1954), and *Zoom and Bored* (1957); his most memorable Pepé cartoons include *For Scent-imental Reasons* (1949), *Little Beau Pepé* (1952), and *A Scent of the Matterhorn* (1961). *Tweetie Pie* (1947), *Ain't She Tweet* (1952), and the "Lost Weekend"–like *Birds Anonymous* (1957) comprise a few of Friz Freleng's best-known Tweety and Sylvester pics, while his *High Diving Hare* (1948), *Roman Legion Hare* (1955), *Sahara Hare* (1955), and *Knighty-Knight Bugs* (1958) might belong on someone's "best of Yosemite Sam" list. Among the greatest barnyard achievements of McKimson's Foghorn Leghorn are most likely *Walky Talky Hawky* (1946) and *A Fractured Leghorn* (1950).

When MGM closed its animation department in 1956, it was not only puss who got the boot but also his creators, Bill Hanna and Joe Barbera. The pair then took UPA's artistic principles of economy of expression drawings they called "limited animation" and used them as a shortcut to mass-produce animation for series television. Their immediate financial success with this strategy unalterably changed the direction of Hollywood studio animation.

The pre-1949 Warner Bros. cartoons were already running in syndicated packages for use on local stations' kiddie shows. But in 1960 the studio officially entered the direct-to-television market with ABC's primetime *The Bugs Bunny Show*, featuring post-1948 cartoons with new bridging material created by Chuck Jones and Friz Freleng. In many ways, the new animation, which put all the characters in a showbiz setting (based on Freleng's 1957 *Show Biz Bugs*), was the last hurrah for the traditional Warner Bros. cartoons. The bridging material put the characters' personality quirks in a new context that showcased the Looney Tunes characters as a collective body.

Mainstay writers Maltese and Foster had gone over to Hanna-Barbera and given such characters as Mr. Jinks and Yogi Bear verbal patter that kept current with late-fifties attitudes and offered some compensation for the studio's visual flatness. On the other hand, while the best of the Warner Bros. theatricals were taking some fascinating trips into a more abstract visual style, their comedic rhythms, which had been in such harmonic touch with the national mood for

The vaudevillian *Show Biz Bugs* (1957): the inspirational framework for *The Bugs Bunny Show* television series. Copyright Warner Bros., Inc.

the previous two decades, rapidly lost the beat. Unfortunately, Warner Bros. animation never learned to rock and roll. By the time the studio shut down its theatrical cartoon division in 1964, the films no longer bore any resemblance to the midthirties to late-fifties classics that dominate our memories.

The past thirty years have seen periodic attempts to reignite some semblance of Warner Bros. cartoondom. There was the late-sixties catastrophe of new theatrical cartoons produced by Bill Hendricks, featuring such Trivial Pursuits answers as Cool Cat, Merlin the Magical Mouse, and Bunny and Claude as the star characters. There were the middling late-seventies to late-eighties feature films and television specials in *The Bugs Bunny Show* style of resurrecting classic cartoons with new bridging material, such as *The Bugs Bunny/Road Runner Movie* (1979) and *Bugs Bunny's Mad World of Television* (1982).

And there have been a spate of post–*Who Framed Roger Rabbit?* (1988) stabs at riding the gravy train, ranging from a handful of Greg Ford and Terry Lennon–directed shorts including 1988's *Night of the Living Duck* and 1992's *Invasion of*

Is this the end of Looney tunes? A perturbed Bugs Bunny appears during the mock de-nouement of *Invasion of the Bunny Snatchers* (1992). Copyright Warner Bros., Inc.

the Bunny Snatchers (thus far, the only post-1960 work along with Darrell Van Citters's 1990 *Box Office Bunny* to capture the essence of the studio's classic characters and infuse them with a contemporary sensibility) to overinflated corporate cash cows like *Space Jam* (1996).

In fact, the Warner Bros. cartoons might be said to have come full cycle, having started out as a promotional tool for ancillary income and now existing as ancillaries themselves. The mainstay characters now exist primarily as corporate logos, greeters at the Time Warner theme parks, and advertising shills for credit cards and such.

One might think of this as a sad end for the once mighty Warner Bros. cartoons, but no metamorphosis is permanent and "nothing is impossible for Duck Twacy."[5] The past is prelude; the future is undecided.

From Disney to
Warner Bros.

TIMOTHY R. WHITE

The Critical Shift

Changing fashions in both popular and academic film criticism have led to a variety of justifications for a preference for one sort of motion picture (whether national cinema, mode of film practice, film style, the work of a particular director, etc.) over others. And, in general, film critics have often written as if they were slightly embarrassed by their trade—as if films somehow are less worthy of the effort it takes to discuss them than are the other arts. Therefore, although film critics traditionally have made gestures toward regarding film as an autonomous art form, they have been prone to justify the valorization of a film on the grounds that it is similar to an already established work of art: a particular novel, play, painting, and so forth. If this is true of the critics of live-action cinema, it is even truer of critics of animation; if film critics have felt uncomfortable discussing films as art, those critics who discuss animation have felt even more uneasy, and even defensive, promoting their chosen film mode.[1] This situation has manifested itself in a number of ways, and the methods by which animation critics have justified their preferences may be traced historically.

The animation of the Walt Disney studio, especially the feature-length cartoons of the thirties and forties (1937's *Snow White and the Seven Dwarfs*, 1940's *Fantasia*, 1941's *Dumbo*, etc.) but also the shorts, enjoyed a high degree of critical respect from the thirties to the sixties. In fact, they often were regarded as "art" as opposed to the less respected products of Warner Bros. and MGM, which were considered "mere cartoons." However, in the sixties, critical opinion began to shift away from Disney and toward Warner Bros. and, to a lesser extent, MGM (especially the cartoons of Tex Avery). This shift, which continued into the seventies, has been attributed to the general irreverence and "antiestablish-

38

ment" attitudes of the sixties and early seventies, which seemed better suited to the non-Disney animation.

However, the shift also coincided with a similar shift in critical opinion away from the films of the classical Hollywood cinema and toward those of the European art cinema. As David Bordwell points out, "The 'rereading' of Hollywood, which has been so central to film theory in recent years, has its roots in the schemata of European 'artistic' filmmaking."[2]

In this essay, I explore such a rereading as it was applied to animation; my thesis is that many critics, consciously or otherwise, valorized the Warner Bros. and MGM cartoons for the same reasons they championed the European art cinema, and that their critical rhetoric reflects this. In other words, these critics justified their preference for the Warner Bros. cartoons on the grounds that they were "just like" the art cinema of Buñuel, Godard, and the like. If the promoters of UPA animation could compare cartoons featuring Gerald McBoing Boing and Mr. Magoo to works of modern art, so too could the supporters of Bugs Bunny and Screwy Squirrel; however, the comparison in this case was to works of modern art that were European films. Before a discussion of this critical rereading can take place, we need to examine the earlier critical discourse on animation to help put this shift in historical perspective.

Early Animation Criticism

During the thirties and forties, Walt Disney was almost universally praised; he was loved by the public, popular journalists and critics, and even academics and "serious" artists.[3] For example, British critic David Low regarded Disney "not as a draftsman but as an artist . . . , the most significant figure in graphic art since Leonardo."[4] More interesting are the few formalist analyses of Disney's work that appeared in these early years; most important among them, of course, is that of Sergei Eisenstein, who called Disney "the brilliant master and unsurpassed genius in the creation of audiovisual equivalents in music of the independent movement of lines and a graphic interpretation of the inner flow of the music."[5]

Another early formalist critic of the Disney studio's animation was the painter Jean Charlot, who in 1939 rhapsodized about Disney's cartoons, using this category strictly as a critical construct for his formal analysis and ignoring the irrelevant issue of Walt Disney's personal involvement (or lack of involvement) in their creation. According to Charlot, Disney's *The Ugly Duckling* (1939) is a veritable ballet of shifting points of view and classical shapes: "We get out of this thorough observation of its illusive and complex volume the same esthetic enjoyment we should derive from handling and petting an African carving." Charlot marveled at Disney's merger of form, function, and beauty, and

concluded his analysis with an appropriately sublime tribute: "We bow to this newly created pantheon of animal godlings, Mickey Mouse et al., for they are different from us, godlike, irrational."[6]

British critic Paul Nash took an approach to Disney that seems an odd combination of auteurist and formalist. Although he approved of "the early Disney cartoons, which I believe to be authentic Disney . . . truly sensitive drawings charged with a rather pale bright colour, reminiscent of certain drawings by William Blake," he found less satisfactory those cartoons made at the Disney studio when, according to Nash, "individual manifestations were allowed free expression within the general control. Sometimes this resulted in new and valuable contributions; now and then it tended to produce ideas of poorer quality rather crudely realized, but probably containing some element which made them popular with simple-minded audiences."[7] In general, however, Nash was impressed by the formal and strictly decorative qualities of the cartoons; he praised "exciting patterns made by enraged bees or indignant gnats . . . lovely little arabesques of clouds and birds . . . [and] occasions of expressive colour";[8] he found *Mickey's Garden* (1935) "a kind of surrealist extravaganza full of imagination, and heightened at every point by rich outrageous colour."[9]

A common thread running through the early appraisals of the Disney studio cartoons is praise for the work on the level of sheer craftsmanship. Although approving of neither Snow White, who is "far too doll-like and pretty-pretty, nor . . . the dwarfs, needlessly ugly with their bulbous red noses," British critic Charles Davy nonetheless found Walt Disney an accomplished artisan: "Disney has an extraordinary talent; he and his multitudinous helpers are marvelous craftsmen, incredibly skillful and patient."[10] Alberto Cavalcanti also praised the creativity of the entire Disney staff and argued that the formal elements of sound and color had been used more successfully in the cartoons of Disney and the Fleischer studio than they had in live-action feature films.[11] Likewise, Gilbert Seldes asserted that Disney's Silly Symphonies "have reached a point toward which the photographed and dramatic moving picture should be tending, in which, as in the silent pictures, everything possible is expressed in movement and the sound is used for support and clarification and for contrast."[12]

Early discussions of Warner Bros. animation, on the other hand, are hard to find. Not only were these cartoons largely ignored, when they were discussed they were either dismissed or condemned.[13] For example, in 1951, British critic Richard Winnington lamented the fact that the "magic" had left the Disney studio, whose cartoon characters had "been ousted by the commando-trained creatures of the M.G.M. and Warner cartoons"; he found these newcomers rough, noisy, and "deficient in grace."[14] The only critic who proposed a serious and positive assessment of Warner Bros. cartoons before the fifties was Manny Farber. In 1943, Farber praised the Warner Bros. cartoons for both their visual style,

with "flat, stylized, posterlike representations," and their "cold-blooded" humor: "The famous Bugs Bunny is Schlesinger's one-animal advertisement of the moral that unadulterated torturing of your fellow men pays off." Farber also condemned Disney's products, with their "straight, insipid realism."[15] However, this hardly marks a turning point in critical opinion of American animation; as Gregory Waller points out, "For almost all critics and journalists and reviewers of the thirties and early forties, the animated cartoon was quite literally Disney's land."[16]

The Critical Shift

But by 1965, Walt Disney, his studio, and his cartoons were fair game. Frances C. Sayers, a noted children's librarian, made a comment on Disney's work that would have been unthinkable twenty years earlier: "I find genuine feeling ignored, the imagination of children bludgeoned with mediocrity, and much of it overcast by vulgarity." She went on to describe Tinker Bell as "that wretched sprite with the wand and the oversized buttocks . . . a vulgar little thing, who has been too long at the sugar bowls," and called the Mouseketeers a "terrible organization of children . . . which makes me cringe."[17]

Why had critical opinion changed so dramatically during those years? Changes in the cartoons themselves are a possible answer. According to Richard Schickel, "The freshness, the sense of excitement . . . [and] . . . the quality of the humor" of Disney's animation diminished after World War II.[18] The Disney cartoons, "slower, less wildly inventive" than the Warner Bros. cartoons, lost the "popularity contest" to the products of MGM and Warner Bros. Although Schickel regards MGM's Tom and Jerry as "mindlessly sadistic," he finds that Bugs Bunny's "personality perfectly suited his times."[19] However, "the times" of Disney's critical decline were not the postwar years but the sixties.[20] Animation historian Steve Schneider claims that by the sixties, "the anarchic brashness of Warner animation was speaking to a new generation."[21] Frank Thomas, a Disney animator, called the studio's fall a symptom of the times: "See, this was in the '60s, and remember, that was 'the now generation' and 'Tell it like it is, baby' and the Vietnam War and things like that."[22] Chuck Jones's 1939 patriotic cartoon *Old Glory* is described by Schneider as "a favorite at New York's Fillmore East rock-concert house, where it would be screened between acts. The late-sixties audiences, it seems, enjoyed a film that ends with a pig saluting the flag."[23]

Although the public may switch allegiance from one group of cartoons to another due to "the times," this could hardly suffice for a film critic. No self-respecting scholar or critic would admit to following fashion (either popular or academic) or wanting to "tell it like it is, baby." The reasons critics now preferred Warner Bros. cartoons over those of the Disney studio were loftier: Warner

Bros. cartoons were seen as similar to the European art films that, coinciden-
tally, gained favor at the same time. Disney's work, on the other hand, was too
much like the classical Hollywood cinema, which could be defended only when,
through "rereading," it could be compared to the European films playing at the
local art house. This complaint about Disney could be seen as early as 1945,
when John Mason Brown, a staunch Disney defender, admitted that the studio's
products were not what they had once been; he found *The Three Caballeros*
(1945) "disquietingly bad," "violently inartistic," and, significantly, "cheaply
Hollywood."[24]

The charge of making "Hollywood" films by many critics was the ultimate
insult they could use against a director in the sixties. Richard Schickel was most
blatant in condemning this aspect of Disney's work.

> The editing principles applied to *Snow White* were those of the conven-
> tionally well-made commercial film of the time. There was nothing
> particularly daring about the way it was put together. . . . a scene would
> open with an establishing or master shot, then proceed to an intermedi-
> ate shot, then to close-ups of the various participants, with conventional
> cut-aways to various details of scenery or decor as needed. Confusing
> flashbacks or dream sequences were avoided. . . . in recent years, a far
> more flexible editing principle has come into play, particularly in the
> foreign films. It has been discouraging to see the Disney Studio cling to
> the old conventions of telling a story on film, particularly when the
> animated film and the stories it usually adapts seem particularly suited to
> the deftly allusive new style, with its bold leaps through time and space,
> its sudden juxtapositions of seemingly unrelated material, its quickness
> of mind and spirit, its sheer pleasure in the film as film.[25]

Note that, for Schickel, continuity editing is not just conventional but is based
on "old" conventions (which apparently are more conventional than are "new"
conventions) seen in "commercial" films; the editing of foreign films is "flex-
ible," not conventional. And, according to Schickel, these foreign films them-
selves are not conventional; they just happen to share unique characteristics,
such as being "deftly allusive," discontinuous with spatial and temporal relations,
and self-reflexive.

The charge of conventionality was echoed in a pair of observations by Steve
Schneider:

> Disney preferred to make animation function as an extension of
> Hollywood live-action cinema, with increasingly "realistic" settings and
> character movement.

> [Disney] felt an ever greater need to keep his work within the bounds of
> straightforward storytelling, creating fantasies that would envelop

viewers through traditional narrative means. For Disney, this meant suppressing many of the signals that would remind audiences that what they were watching was, in fact, a cartoon.[26]

The emphasis on continuity editing and the use of the narrative conventions of the classical Hollywood cinema in Disney's films certainly have as much to do with the studio's simultaneous shift of emphasis to feature-length films as they do with an attempt at realism. It is one thing for a cartoon to be abstract, experimental, and "deftly allusive" for seven minutes; it is quite another thing to do it for ninety minutes.[27] As Kristin Thompson and Jonathan Rosenbaum point out, the trend toward realism in Disney's work occurred mostly in the studio's feature-length animation, not the cartoon shorts; this distinction was not often made by critics who complained about the realism and the use of Hollywood conventions in Disney films.[28] But the conventions of the Hollywood film were not in critical fashion in the sixties and early seventies; the conventions of the European art film were.[29]

The European art cinema brought with it not just a new set of narrative conventions, of course, but a new critical approach—the "auteur theory." The name of Walt Disney, to the public a guarantee of quality, became, to the critic, a mark of corporate blandness and the absence of expression of the individual artist. As Schickel points out, "The period of Disney's greatest economic success, his greatest personal power, coincided with the decline of interest in him in the intellectual community. . . . When Disney ceased to make any claims as an artist they dropped him."[30]

Although there is an unmistakable "Disney style" (a style seen in the products of the Disney studio even years after Walt Disney's death), there have always been much debate and confusion over exactly what role was played by Walt Disney himself at the studio.[31] The sheer size and industrialization of the Disney studio were enough to condemn his products as the work not of an artist but of a "factory."[32] The Disney studio previously had been praised as a closely knit unit of creative artists,[33] compared favorably to a medieval guild,[34] and, not surprisingly, referred to by Eisenstein as a harmonious "collective."[35] But by the sixties, the studio was regarded in a much different light: According to critic Howard Junker, "In the days of the Disney factory, animation was unquestionably a craft, not an art. The animator was fitted in somewhere along the assembly line."[36] Walt Disney himself was no longer regarded as an artist nor even as a craftsman; he was now seen as just a "technician."[37] Even more damning was the charge made by Roy Armes: "Disney was not really an artist but a businessman like Thomas Edison or Henry Ford."[38] Donald Barr went so far as to conclude that "one must think of 'Disney' as an *it*, for Disney no longer conveys any sense of a person to whom ideas and taste can be attributed."[39] According

to Jonathan Rosenbaum, "By the middle Sixties, one could say that [Disney] was more generally regarded as anything *but* an artist."[40]

The animation of Warner Bros. and the auteurs of these cartoons, on the other hand, were quite different. In 1964, introducing a special animation issue of *Film Quarterly*, Ernest Callenbach compared post-Disney animation to post-war European cinema—specifically the films of Godard and Antonioni.[41] In the article that followed Callenbach's introduction, French critic Robert Benayoun discussed animation as an art form, not a medium; Disney was not mentioned, but Avery, Jones, and Freleng were.[42]

One of the attractions of the Warner Bros. cartoons for critics who promoted the European art cinema was the assignability of authorship to these cartoons. Unlike those of the Disney studio, Warner Bros. cartoons were identified with individual directors as authors, whether Tex Avery, Chuck Jones, Robert Clampett, or Frank Tashlin. According to Steve Schneider, a champion of Warner Bros. cartoons:

> Without question, the principal responsibility for the finished film lay
> with the director. Animation is probably the ultimate "auteurist"
> cinema, as its directors can control every element of their films' content
> with a precision that extends down to the individual frame. And this
> was certainly the case at Warner's, where the directors were given
> virtually absolute control of their material.[43]

Another Warner Bros. supporter, Joe Adamson, praising the studio's support staff, nonetheless made clear that the cartoon was a director's medium: "While the animation director bears heavy burdens of responsibility and is granted in return an uncommon measure of control, he is dependent every step of the way on a battery of story men, animators, and graphic designers to bring his vision to fruition."[44] Never mind that production credits are difficult to pin down for Warner Bros. cartoons;[45] the auteur critic had found his cartoon auteurs at Warner Bros.

Certainly, the organizational structure at Warner Bros. was looser than that of the highly regimented Disney studio, but production was nonetheless a group project, and similarities among cartoons may be the product of any number of factors and craftsmen. Still, as with the critics who applied art cinema criteria to the films of John Ford, Alfred Hitchcock, and Howard Hawks, "the critic," explains David Bordwell, "did not usually bother to explain how individual expression seeped into the Hollywood commodity."[46]

For example, contrasting Chuck Jones's work to that of the Disney studio, Jay Cocks found Jones's cartoons "perhaps . . . not as innovative, but they are funnier, madder, certainly more deeply and consistently personal. . . . Jones

worked on the story with the writer, made all the important drawings himself, supervised the background painting, even collaborated on the sound effects and music."[47] Heck Allen, a writer for Tex Avery at MGM's animation studio, denied that Jones did much himself,[48] but asserted that Avery, on the other hand, "was always totally in charge of anything he ever did. . . . He laid out the pictures for the goddamn background man; he did everything for the so-called character man. . . . Tex did it all."[49] This led Win Sharples to proclaim Avery "a genuine 'auteur' of the Hollywood cartoon," despite the fact, as Sharples admits, that Avery couldn't draw.[50]

For these critics and scholars, the directors at Warner Bros. and MGM were not just auteurs; they were remarkably like European art film directors. According to Ronnie Scheib, Tex Avery, the master of self-reflexivity (an innovation, evidently, not of comedy but of art cinema), "joins such live-action directors as Buñuel, Rossellini, Fuller, and Godard in the elaboration of a modernist film vocabulary, disjointing narrative linearity, isolating libidinal forces, dislocating sound and image, piling up the excesses of multi-layered contradiction, denormalizing the whole process of linkage articulating the absurdities of Our Daily Lives."[51] Avery was often compared to Buñuel; for example, Jonathan Rosenbaum found that *The Shooting of Dan McGoo* (1945) "recalls some of the finer excesses in *L'Age d'Or*" (1930);[52] Greg Ford also compared Avery to Buñuel and called him "a Walt Disney who has read Kafka."[53] Joe Adamson also compared the work of Avery to the films of Buñuel and, to a lesser extent, those of Godard and Eisenstein; but, paradoxically, he expressed hostility for the "asthmatic college professors" who preferred European live-action films and animation to Hollywood films and sought to distance himself from them by equating Avery's cartoons with "obsessionist studies like Hitchcock's *Vertigo* [1958] [and] Kubrick's *Lolita* [1962]."[54]

If Tex Avery is Luis Buñuel, Frank Tashlin is Jean-Luc Godard; both Tashlin and Godard are, after all, "Brechtian."[55] Several critics have commented on Godard's admiration for Tashlin's live-action films for their "cartoony qualities";[56] J. Hoberman saw the influence of Tashlin in Godard's films and traced this to the influence of Tex Avery on Tashlin's animated works.[57] Certainly it is not hard to make a case, for example, that the ejaculating milk bottle in Tashlin's *The Girl Can't Help It* (1956) is a by-product of Tashlin's years with Avery; this sort of influence in the films of Godard would, I think, be more difficult to trace. At any rate, a connection was made between the Warner Bros. cartoons and the work of Godard, arguably the most "difficult" (and therefore respectable) of the European auteurs.

Perhaps the most obvious equation of Warner Bros. animation with art cinema came in Richard Thompson's well-known 1971 article "Meep Meep!" We

know we are in the presence of a knowledgeable scholar of the European art cinema when, early in his essay, Thompson casually throws out the names Alain Resnais and Michelangelo Antonioni.[58] Discussing the Road Runner cartoons, Thompson says, "Time is not an issue; only logical sequence. Plot has been superseded. Road Runner films rank among the most austerely pared-down works of modern art. As in New Wave theory, situation and character fill the vacuum left by plot."[59] We may overlook Thompson's murky use of the term "plot" (surely he means "story"; the plots of the Road Runner cartoons are actually quite elaborate)[60] and his reference to something he calls "New Wave theory" (and its relation to plot, character, and situation); the point is simply that he is valorizing these cartoons for what he sees as their similarity to European art films.

Finally, if Avery is Buñuel and Tashlin is Godard, Chuck Jones is none other than Alain Resnais; Thompson compared the epitome of the European art cinema to the work of Jones: "It is clear that *Last Year at Marienbad* [1961] is a ritzed up live-action no-violence child of the Road Runner series; and that the same key unlocks them both."[61] But perhaps Jones is instead the metaphysicist and high priest of the art cinema, Ingmar Bergman; after all, according to Jay Cocks, Jones's *Duck Amuck* (1953) is the "*Persona* [1966] of animated cartoons."[62]

The Advent of Symptomatic Criticism

In the seventies, even as such critics as Richard Thompson continued to compare Warner Bros. cartoons to the European art cinema, the emphasis of academic criticism shifted from the auteur- and humanist-centered approaches of the sixties to more symptomatic readings of filmic texts; it is no coincidence that this shift, as David Bordwell points out, "paralleled the waning of the art cinema and the avant-garde."[63]

With this further shift, it once more became acceptable to discuss Disney cartoons. This is not to say that critics valorized Disney or his work; it is not often part of the symptomatic project to valorize Hollywood films. This willingness to discuss the Disney studio's products as symptoms of a society, an industry, or even "Uncle Walt" himself, had in fact begun as early as 1968, when Richard Schickel, although maintaining that overspecialization had eliminated "the artist's personality" from the animation of the Disney studio, nonetheless made a case for interpreting these cartoons as manifestations of Walt Disney's subconscious interest in buttocks.[64] Picking up the cue, Patrick MacFadden gleefully explained Disney's business dealings and both Disneyland and Disney World, as well as the cartoons, in terms of "anal retentive and eliminative modes."[65] And, of course, Warner Bros. cartoons have received their share of symptomatic readings.[66]

Conclusion: A Return to Formalism

By 1975, many of the critics who had valorized the Warner Bros. and MGM cartoons for their similarity to the European cinema, perhaps in response to the decline of art cinema or to a perceived increase in respect for animation, no longer felt the need for such comparisons to justify their preference for the work of Avery, Jones, and others. For example, Richard Thompson analyzed *Duck Amuck* without a mention of the New Wave, Resnais, or the art cinema.[67]

At the same time, there has been a small but promising resurgence of formal analysis of animation. In 1976, Michael Gould analyzed *Bambi* (1942) and *Sleeping Beauty* (1959), two of the Disney works found most offensive by the critics of the sixties and early seventies, in terms of aesthetic effect and its relation to thematics.[68] In the same year, Colin L. Westerbeck provided an analysis of Disney animation that focused less on the "sunny side" of Disney's work (Mickey Mouse and company) and more on his "earthy side." This portion of the studio's output began with 1929's *Skeleton Dance* and continued with the Silly Symphonies series, which "embodied a more abstract and free-form kind of Disney fancy that was keyed to the non-visual inspirations of music"; it culminated in what Westerbeck called "perhaps Disney's greatest work: *Fantasia*."[69] From this point of view, Disney's *Fantasia* became for Westerbeck not an aberration but a central work, successfully synthesizing both sides of the artistic personality of the Disney studio. Recalling Eisenstein and Charlot, Westerbeck dismissed auteurist arguments against Disney's work as well as the charge of commercialism.

> It could be argued that the Disney cartoon features were the quintessence of commercial moviemaking, for such moviemaking is by nature a collaborative effort and nowhere more so than in Disney's films. But with a collaborative effort you can make a wide range of products—a Detroit automobile, for instance, or a Gothic cathedral. *Fantasia* was part of Disney's work that fell more on the side of the Gothic cathedral.

And J. Hoberman, despite his earlier praise of Tashlin on the grounds that he had influenced Godard, by 1984 defended his preference for Avery's "formalist extravaganzas" over Disney's "sweetness-and-light" not by invoking the art cinema, but by praising Avery for "stepping up the pace and raising the noise quotient of American studio animation with a high-powered dose of sex, violence, and hyperbole."[71]

But perhaps the most satisfactory formal analysis of the products of the Disney and Warner Bros. animation units comes from David Bordwell and Kristin Thompson, who, in their introductory text on film form, compare and contrast

Disney's *Clock Cleaners* (1937) and Chuck Jones's *Duck Amuck,* noting their op-
positional relationship in terms of style.[72] Bordwell and Thompson discuss these
styles in relation to the history of Hollywood film style in general and that of
comedy and animation in particular; they neither condemn Disney for his clas-
sical Hollywood filmmaking nor praise Jones as a closet Resnais.

 Those of us who write about and teach our students about animation could
do worse than to follow their example; to compare Road Runner cartoons to
Last Year at Marienbad may help illustrate the formal options available to a film-
maker but hardly provides a set of reasonable criteria for making aesthetic evalu-
ations. A comparison of the products of Disney to those of Warner Bros. need
not result in the wholesale condemnation of one or the other but can be used
to help us establish the set of options available to the animated filmmaker dur-
ing different periods of film history. Although we may prefer the cartoons of Tex
Avery over those of the Disney studio, we hardly need to justify this predilec-
tion by invoking the art cinema; likewise, there are probably better ways to spend
our time than in speculation about Walt Disney's affection for buttocks. Instead,
we can explore the relationships among the animated works of Warner Bros.,
Disney, and other studios. As Jack Ellis put it, "For better or worse the standard
techniques and predominant styles of animation were established at the Disney
studio during the thirties. Everything that has happened in animation since has
either grown out of that work or been a conscious reaction against it."[73]

Charlie Thorson and the Temporary Disneyfication of Warner Bros. Cartoons

GENE WALZ

We all borrow from each other in this business.
—FILM DIRECTOR MICHAEL POWELL

IN THE SPRING of 1938, Charlie Thorson left a secure position at MGM's cartoon division to move to Warner Bros.[1] The *Hollywood Reporter*, a movie industry newspaper, chose to chronicle the news with a two-column headline and a succinct announcement: "Charles Thorson, formerly with Disney, has been signed to a five year contract by Leon Schlesinger as a character model man for Looney Tunes and Merrie Melodies."[2] Thorson had indeed worked for Disney Studios; for two years (1935–1937) he had been responsible for designing characters for many of that studio's most memorable Silly Symphonies: *Elmer Elephant* (1936), *Toby Tortoise Returns* (1936), *Little Hiawatha* (1937), *Wynken, Blynken, and Nod* (1938), and the two Academy Award winners *The Country Cousin* (1936) and *The Old Mill* (1937), among others. Afterward, at MGM, Thorson had worked mainly on *The Captain and The Kids* (1938–1939), a much less successful series. It is no surprise, therefore, that the newspaper article omits any mention of MGM, but the emphasis on the Disney connection probably reveals as much about Leon Schlesinger and his plans for Warner Bros.' "animation factory" as it does about Thorson's newfound employment there.[3]

At the time of Thorson's hiring, Warner Bros. had spent its entire eight-year existence in the considerable shadow of Walt Disney. Beginning in 1931–1932 with *Flowers and Trees*, Disney Studios had won eight straight Academy Awards in the "Short Subjects: Cartoons" category; it was even given a special Oscar for creating Mickey Mouse.[4] Warner Bros., on the other hand, had not yet received a single statuette and had garnered only one nomination for the Friz Freleng–animated/Rudolf Ising–directed *It's Got Me Again* (1932). Then in December of 1937 came the enormous critical and popular success of *Snow White and the Seven Dwarfs* (1937). Unlike the Fleischer brothers, who decided to

Self-portrait of Charlie Thorson. Courtesy of Dr. Stephen Thorson.

compete with Disney at the feature–film level, Schlesinger chose instead to increase the number of short films that his company released. By the end of 1938, Schlesinger became the most prolific supplier of animated shorts in the business, superseding the output of the Fleischer brothers' new production facility in Miami and more than doubling the number of Disney cartoons released.[5] However, for Schlesinger, quantity was often at the expense of quality and even distinctiveness. While Walt Disney himself was personally spearheading a drive to make cartoons that were models of consistency and innovation, Warner Bros. cartoons, under Schlesinger's more laissez-faire management, had not yet developed a style of their own. To complicate matters, Friz Freleng and Frank Tashlin, two of the studio's more experienced animation supervisors, had just decamped for greener pastures.[6] Schlesinger, in hiring Charlie Thorson and promoting three young employees to fill the positions for the departed Freleng and Tashlin, set the stage for the temporary "Disneyfication" of Warner Bros. cartoons in 1939 and 1940. Ironically, he was also, unwittingly, laying the groundwork for the development of the unique characters and distinctive style that have so captivated audiences since then.[7]

Disneyfication, or Disnification, as it is sometimes spelled, is a term that has reemerged with a vengeance since the recent release of *Pocahontas* (1995) and *The Hunchback of Notre Dame* (1996) and the battle over a proposed Disney theme park in Virginia. Often used pejoratively, it denotes the company's bowdlerization of literature, myth, and/or history in a simplified, sentimentalized, programmatic way. Perhaps its most notorious usage is Ariel Dorfman and Armand Mattelart's Marxist condemnation of the "imperialist ideology" of Disney in *How to Read Donald Duck*. They argue that the seemingly innocuous and even purportedly educational comic books about Disney characters' adventures in foreign lands usually defile and ridicule those lands. For Dorfman and Mattelart, "Disnification is Dollarfication. . . . For Disney, history exists in order to be demolished, in order to be turned into the dollar which gave it birth and lays it to rest. Disney even kills archaeology, the science of artifacts."[8]

A similar theme is sounded in some critiques of *The Hunchback of Notre Dame*, based on Victor Hugo's angry, pessimistic story of the grotesquely deformed Quasimodo. "In Disney's version," according to Colin MacLean, "the lonely bell ringer becomes cute 'Quasi,' the cuddly gnome."[9] Disneyfication, for MacLean, regularly reduces complex characters and grand narratives to predigested formulas.

In the late thirties, Disney cartoons had not yet congealed into these rigid formulas. The studio was developing the new technologies of sound and Technicolor faster and better than its competitors. It was also pioneering the art of personality animation and the famous "illusion of life" visual style.[10] So Disney's rivals gladly accepted the challenge of conforming to Disney-orchestrated

audience expectations and adopting Disney methods and formulas. Rather than product differentiation, the competition opted for product duplication with only minor variations. In the late fifties, most automobile manufacturers followed the lead of General Motors and put masses of chrome and aerodynamically irrelevant fins on their cars. After 1935, most animation factories conformed to the latest developments in Disney-style personality animation with its precise, sentimentalized graphics.

If one word can be used to capture the essence of the Disney aesthetic of the time, it would be "cute" or, perhaps, "charming." "Cute" is so often repeated in the story sessions for Disney's first feature film, *Snow White and the Seven Dwarfs*, that it is impossible to overestimate its importance.[11] The word applies to the look of the dwarfs, to the behavior of the forest animals, and to many of the anecdotal moments in the film. Since many of the Silly Symphonies during Thorson's tenure at Disney Studios were testing grounds for *Snow White*, the "cuteness" factor at Disney was overpowering. Impossibly precocious and cherubic infants plus cuddly anthropomorphized animals predominate, all of them with large, expressive eyes for communicating varying degrees of wonderment, apprehensiveness, and sensitivity. Most of them have heads as big as their bodies, which are built on pear-shaped or vertical dumbbell-shaped armatures, their shape readily connoting vulnerability and equipoise, symmetry and instability. The characters in the Disney cartoons of this era are not just the center of the films' stories; they *are* the stories. From their first appearances they set the parameters of plot-line possibility. Just as John Wayne is a metonym for the Western, Disney-style infants and anthropomorphized animals "incorporate" (in the primary definition of that word) their cartoon stories. Cute looking means cute acting; nothing more, nothing less.

Thorson quickly became an expert at this kind of cuteness. Although his pre-animation career as an advertising illustrator provided him with the training needed to draw precise, attractive images, it was really another innovation of Disney's that allowed him to fully realize his talents. Disney refined the assembly-line methods used in other industries for the production of his cartoons. As his studio evolved, especially in response to the demands of feature filmmaking, Disney created new positions and job descriptions. The division of cartoon labor became even more defined as inkers, in-betweeners, inspirational artists, background painters, and character designers were added. In 1935, Charlie Thorson started as a member of the story department. By the time he left in 1937, he was in the newly created position of character designer, or character model man. While working under Joe Grant, Thorson was responsible for much of the design work on Disney's animated shorts during the time when others were busy with *Snow White*.

Combining the talents of a casting director, a costume designer, and a

makeup artist from live-action movies, with the precision of a portrait painter and the imagination of a sculptor, the character designer had to create distinctive anthropomorphized animal characters or recognizable caricatures to bring to life the written or spoken story ideas or rough sketches provided by the writers. Sometimes the final design of the characters was determined by studio competitions; several employees would submit drawings of the proposed characters, and the winning design would be chosen by formal or informal voting. Usually, the character designer simply consulted with the unit supervisors.[12]

After the "cast" was chosen, the character designer provided model sheets, or action sheets, for the film's animators and in-betweeners. These model sheets delineated the underlying geometries of circles and lines that defined a character's size and shape. They included close-ups and/or written instructions for the precise details of costume and expression. They also provided all of the various poses (front views, side views, and back views, if necessary) required by the action. With so many different hands involved in drawing up to five thousand cels per seven-minute film, the character designer was responsible not just for designing the characters that would best embody the story but also for drawing enough reference points so that even a "left-handed plumber" could make a mistake-free contribution to the enterprise.[13] Along with the storyboard, a model sheet was (and today often still is) the indispensable architectural plan behind the completed animation. For personality animation, and especially at studios trying to create animation stars to rival Mickey Mouse and Donald Duck, the character designer took on an added importance.

Leon Schlesinger undoubtedly hired Thorson to keep up with Walt Disney, intending him to be a resource for the entire studio. An older, experienced hand (he was forty-eight, twice the average age of the other employees), Thorson would provide special help for the two new animation units, one headed by Chuck Jones and the other by the team of Cal Dalton and Ben "Bugs" Hardaway.[14] Precisely which films he started on is difficult to ascertain,[15] but Thorson's initial influence on Chuck Jones is undeniable. Jones himself acknowledged the influence in a 1971 interview: "Charlie Thorson, who was working for me . . . had actually designed Hiawatha for Disney, so he was instrumental to a certain extent in forming the Disney style. He infected our style somewhat. I didn't draw very well at that time. . . . But I designed all my later characters and had some effect on the earlier ones."[16] As I will show, Thorson's role in the direction that Warner Bros. was to take over the next two years (1939–1940) was much more substantial than Jones was willing to admit.

The most recognizably "Disneyfied" Warner Bros. animated films of this period are the ones featuring Sniffles the Mouse, Jones's first choice as a recurring character and potential star. Sniffles is a pinched version of Abner Countrymouse from Disney's Academy Award–winning and very influential short *The Country*

Cousin. Both Abner and Sniffles were designed by Charlie Thorson to be more human looking than Disney's other mouse, Mickey; their ears are where humans' ears are (if somewhat bigger), their faces are flatter, and their noses and jawlines have human size and proportion. For Sniffles, Thorson altered Abner's costume; both mice wear long blue pants and tan boots, but instead of a small, straw, farmer's hat, Sniffles wears a large blue sailor cap with a black stripe. Instead of suspenders, Sniffles has a red shirt and a long yellow scarf. This slight costume change does not alter the essential features of both characters: naïveté, vulnerability, and cuteness. It's as if Disney loaned Abner to Warner Bros. (as other studios regularly did with their live-action stars) or Warner Bros. found his slightly thinner twin. The costume may change, maybe even the plot, but the character and his appeal to audiences remain constant.

The appropriation and Disneyfication of the Sniffles cartoons go beyond the main characters. The first Sniffles cartoon, *Naughty But Mice* (1939), has similar secondary characters as well, especially the antagonists—two look-alike black cats—as well as the same narrative structure as *The Country Cousin.* The cartoon repeats its predecessor's major story elements. Both movies are fish-out-of-water stories about tiny, unsophisticated creatures venturing into oversized human terrain with all of its dangerous trappings. Both of them even feature extended intoxication scenes: Abner getting drunk on champagne, Sniffles on alcohol-fortified cough medicine. Since *Naughty But Mice* had a smaller budget and had to be finished more quickly than the Disney film, it is neither as elaborate nor as inventive in its animation as *The Country Cousin.* Therefore, because it is not as rich a visual experience, the more universally obvious Disney elements stand out—the charm of its central character (which goes back to the character design) and the familiar nostalgia for a preindustrial, uncomplicated life.

Another Disneyfied Jones cartoon that Thorson worked on, *The Curious Puppy* (1939), is a simple story about a cute white-and-black-spotted puppy who has a series of amusing misadventures in an empty amusement park. Although the puppy's facial features do not indicate a distinctive breed, it still possesses the familiar infantile naïveté and sensitivity of all Disney's anthropomorphized animals. In one typical incident, the curious puppy stops to watch one of the amusement park rides. In close-up, his eyes alone follow the back-and-forth oscillations and then the full-circle revolution of the ride. The animation is simple, and the incident is nondramatic and could be easily excised from the story. However, it's the sweet vapidity of expression that carries the shot, courtesy of Thorson's careful design of the close-up of the dog's "face," a device generally eschewed at Warner Bros. Thorson's experience at Disney brought these more intimate and sympathetic moments into the repertoire of some Warner Bros. units, Jones's in particular.

"Sniffles" the mouse

Sniffles the Mouse. Original drawings by Charlie Thorson. Courtesy of Dr. Stephen Thorson.

In his chapter on Warner Bros. in *Of Mice and Magic*, Leonard Maltin cites *Old Glory* (1939) as a film that was "far afield from . . . anything else in the Warners' bag of tricks."[17] It is Jones's story of Uncle Sam teaching Porky Pig the true meaning of the Pledge of Allegiance to the American flag. One of the reasons Maltin considers the cartoon "far afield" is that "character is presented somewhat differently than usual. Jones decided to use modeling on his Porky here and in other cartoons as well, to make him and other characters more dimensional and realistic. The addition of facial shadows and coloring nuances

The Lady Known as Lou from *Dangerous Dan McFoo* (1939). Original drawings by Charlie Thorson showing cuteness and facial modeling. Courtesy of Dr. Stephen Thorson.

gave Jones's early cartoons a unique appearance."[18] While it is as yet uncon-firmed that Charlie Thorson provided the model sheets for *Old Glory*,[19] it is clear from looking at his output at Disney, MGM, and other studios that modeling was something Thorson himself brought to their collaborations. Modeling—facial shadows and coloring nuances, realism and dimensionality—is the hallmark of all of Thorson's designs, not just for his work with Jones.[20]

Nowhere is this modeling effect more apparent than in one of Jones's most successful early films, *Little Lion Hunter* (1939). Even the title announces its Disneyfication. *Little Lion Hunter* is a virtual remake of *Little Hiawatha* (released two years earlier). *Little Hiawatha* was Thorson's favorite Disney project and a cartoon that his friend and coworker Walt Kelly (of Pogo fame) claimed was really a Thorson film.[21] The main character's nationality has been changed, as well as the locations and animal types, but there is no mistaking that Jones was consciously and carefully imitating the popular Disney classic in his film.

Little Hiawatha takes Longfellow's famous verse and infantilizes it. A baby-sized and baby-shaped Native American boy, with the improbable agility and alertness of a schoolchild and the independence of a teenager, paddles his tiny canoe through the wilderness as an offscreen narrator sets the scene. After a series of gently comic encounters with nature (two waterfalls, a whirlpool, a cur-rent), the boy pulls into shore and falls in the water. Wet and bedraggled, he is laughed at by a flock of wild animals.[22] Hiawatha begins to stalk two bunnies and a spitting grasshopper. While aiming his bow and arrow at a tiny, quivering bunny, he reluctantly abandons the confrontation when the bunny won't de-fend itself. Finally, the boy pursues a bear cub until he stumbles on its angry mother. The chase that ensues takes up the final third of the movie. Hiawatha is eventually saved by the intervention and clever teamwork of the wild animals.

Little Lion Hunter focuses on Hiawatha's instantly recognizable African fra-ternal twin, Inki, unnamed until his second movie, *Inki and the Lion* (1941). Dis-pensing with the Disney off-screen narrator and the animal preamble, Inki's story begins in medias res as he hurls his spear at a parrot, a giraffe, and a butterfly. A recurring but interrupted thread of the story involves an expressionless Mynah Bird, which hops to the accompanying background music (Mendelssohn's "Fingal's Cave") as it frustrates Inki's hunting tactics. Pursuit of the imperturb-able mynah brings Inki in conflict with a full-grown lion. The second half of the movie deals with Inki's efforts to escape from the lion. In the end, the boy is saved by the bird, which bests the lion in a noisy off-screen fight. The My-nah Bird then kicks Inki in the pants and hops away.

The correspondences between the two movies are so many and manifest that *Little Lion Hunter* almost seems like an homage to Disney rather than parody or plagiarism. But the similarities go beyond mere story echoes. Character poses (both Inki and Hiawatha respond to the first sighting of a strange footprint in

Model sheet of Inki by Charlie Thorson. Courtesy of Dr. Stephen Thorson.

exactly the same supine manner), behavior, and reactions are identical. Racial stereotyping is kept to a minimum (more so in the Disney film where Hiawatha could easily pass for white). The emphasis in both films is on universally recognizable awkwardness and vulnerability. In each, the humor is warm, the tone fanciful. Everything in these films is arranged to make the audience care for these two cute characters in a parental or protective way. But it all begins with, and is mainly communicated through, the character design of Thorson.

Model sheet of Mynah Bird by Charlie Thorson. Courtesy of Dr. Stephen Thorson.

Released almost a year after Jones's first supervisory effort, *The Night Watch-man* (1938), *Little Lion Hunter,* for all of its apparent Disneyfication, already shows a tendency to move beyond pure Disney imitation; it has somewhat more aggressive, offbeat humor as well as less moralizing and sentimentality. There are neither tears nor quivering in the Warner Bros. production, and the equation between infantile animals and the precocious hero is not as belabored as it is in Disney.[23] Most important, Inki is not as cloyingly cute as Hiawatha, whose pants keep falling down and whose headband repeatedly droops over his eyes at inopportune moments. This Disney tic could have been perfect grist for the satirist's mill at Warner Bros. Here, the closest Jones gets to ridiculing the Disney aesthetic is the dismissive boot in the childish hero's rear end delivered by the mysterious, blasé Mynah Bird at the end of the movie. But this is a punchline, not a wholesale dismissal of the Disney aesthetic.

According to Hugh Kenner, Jones was shortly to "struggle clear of the treacly Disney-esque."[24] By the midforties, he had moved on to the gag approach of cartooning that was eventually to be Warner Bros.' stock-in-trade. *Mighty Hunters* (1940), *Sniffles Takes a Trip* (1940), and *Tom Thumb in Trouble* (1940) marked Jones's waning efforts "to figure out the Disney formula."[25] By this time, Thorson's

influence had already diminished since the modeling effect which he so favored was giving way to a flatter, more schematic, character design. Revealingly, *Sniffles Takes a Trip*, while filled with scenes reminiscent of *Snow White*, rejects some of the comfortable Disneyisms of *The Country Cousin*, twisting things that had been copied straight only two years before. In an ending that is a tour de force of animation, Sniffles abandons the country and rushes headlong back to the city, reversing Disney's familiar midwestern nostalgia for uncomplicated, uncitified life and signaling the beginning of the end of Jones's Disneyfied period.

The other unit just beginning to produce animated films when Thorson arrived in 1938, the Cal Dalton–Ben Hardaway unit, was less obviously reliant on Disney material than Jones. When Thorson designed for the unit, however, the Disney influence is sometimes unmistakable. Two films stand out: *Hobo Gadget Band* (1939) and *Busy Bakers* (1940).

Hobo Gadget Band begins at dawn in a camp full of hobos. Portrayed as anthropomorphic adult dogs, these hobos walk erect but have faces and ears that are doglike. The hobos wake up and perform a series of cute, amusing variations on middle-class activity. They then hop a train, hobo style, for an amateur musical competition at which they win first prize.[26] In the end, they forgo an offered radio contract and head back to the train and carefree lifestyle of the hobo. The joke here is that the mute engineer of the train is an exact duplicate of Disney's famous canine-star Pluto. The first voice heard after "Pluto's" appearance sounds exactly like Goofy.[27] This amusing and affectionate tip of the hat to Disney is perhaps a clever acknowledgment of the filmmakers' indebtedness to his influential cartoons. In *Hobo Gadget Band*, Dalton and Hardaway reject the practice of conforming to a music-regulated story (a hallmark of Warner Bros. during the thirties) and instead "hop on the Disney train." More significantly, this small detail points to the film's dependence on character design and personality animation for its major effects. Like the Seven Dwarfs or the Three Little Pigs, each dog in *Hobo Gadget Band* has a unique look and particular mannerism, requirements for all Disney characters after 1932. Not surprisingly, Thorson did all of the character designs in this film.[28]

Busy Bakers is an indication that the Dalton-Hardaway unit was not always as reverential as Jones in its allusions to Disney. It tells the story of a poor baker named Mr. Swenson—a dead ringer for Geppetto from Disney's second feature, *Pinocchio* (released the same week as *Busy Bakers*). Swenson is saved from bankruptcy when a good deed he performs prompts a dozen helpers to refill his empty bakery with donuts, cakes and pies. Thorson did not have far to go for the inspiration for these characters. All the helpers look like the dwarfs from *Snow White* dressed up as bakers except one, who looks like Betty Boop with a mustache.[29] While the story has a familiar Disney morality and sentimentality to go with the Disney characters, the nod to the Fleischer brothers (with the Betty

Boop allusion) hints that *Busy Bakers* is by no means an homage to Disney. The cartoon evokes a sense of clever opportunism and sly parody rather than tribute.

If the Dalton-Hardaway unit, or for that matter Charlie Thorson, is known at all today, it is likely because of their roles in the development of Warner Bros.' biggest star, Bugs Bunny.[30] Ironically, Bugs, the character who seems most uniquely representative of Warner Bros., is also the most interesting example of the temporary Disneyfication of the studio.

The story of Bugs's genesis is perhaps familiar.[31] Encouraged by the success of Tex Avery's *Porky's Duck Hunt* (1937), the Dalton-Hardaway team decided, as Friz Freleng put it, to "dress the duck in a rabbit suit" for *Porky's Hare Hunt* (1938).[32] The rabbit in this new movie was a loony but featureless, two-dimensional figure. When the cartoon became an unforeseen success, Tedd Pierce, head of the studio's story department, approached Thorson and asked him to design a better rabbit for a follow-up film to be supervised by Dalton and Hardaway, whose nickname was "Bugs." Pierce was probably prompted by Thorson's drawings of Max Hare for Disney's *Toby Tortoise Returns* as well as work from Thorson's portfolio.[33] For Hardaway, Thorson created a model sheet with six different rabbit poses and wrote "Bug's Bunny" at the bottom of the sheet.[34] Not only was the design suitable, the name stuck too. The new rabbit was used in *Hare-um Scare-um* (1939). Revealingly, Jones also employed "close cousins" to this design for his films *Presto Change-o* (1939) and *Elmer's Candid Camera* (1940).

Not content with the direction the rabbit was headed, Avery asked another, younger character designer, Bob Givens, to remodel Bugs for his film *A Wild Hare* (1940). Givens's design is much closer to the current image of Bugs. Because of this, some dispute remains over when the "real" Bugs began. Some people trace his origin to *A Wild Hare*, ambiguously calling previous visualizations "formative" or "prenatal" Bugs Bunny.[35] Even the Bugs Bunny fiftieth birthday television special calculates his birth from this cartoon. Whatever the so-called birth moment might be, Thorson must be recognized in the paternity suit.

In fact, *both* model sheets of Bugs owe a debt to Disney. Thorson's original model sheet is a comic rendition of the stereotypical fuzzy bunny; there is the telltale pear-shaped body with a protruding rear end plus a flattened face with large, expressive eyes. For humorous effect, Thorson devised an exaggeratedly long neck, gloved hands with three Mickey Mouse–style fingers, oversized Chaplin-style feet, and a "smart-alex" grin (to use Thorson's own words) for the rabbit.[36] The end result: a squat "funny bunny" that was a slight twist on Disney's "animal as cute infant" model. Thorson resisted the impulse to merely recycle his Max Hare drawings. For the redrafted Avery version, however, Bob Givens ironically returned to Disney's Max Hare. His Bugs is more elongated, more erect, more poised, and ready for action. Simply, Thorson's Bugs is designed to be

ORIGINAL CHARACTERS
created by
CHARLES THORSON
for the
MERRY MELODIES STUDIOS
Hollywood, Calif.

Bugs
Bunny

Thorson's version of Bugs Bunny: this drawing probably inspired the look of the rabbit as he appeared in *Hare-um Scare-um* (1939). Courtesy of Dr. Stephen Thorson.

infantile, whereas Givens's Bugs (like Thorson's Max Hare) looks like an adolescent—and also acts like one.[37]

The modification of Bugs Bunny not only marks a crucial stage in his development as a character but also signals a major turning point, perhaps *the* major turning point in the history of Warner Bros. cartoons. Prior to 1940, the studio paid homage to Disney's artistic creations or used them in a lighthearted spirit of fun. After 1940, the animators felt free to satirize Disney characters and stories, to assume a position that was, for the most part, intellectually superior to Disney's sentimentality and artfulness. Warner Bros. animation after 1940 is animation with an attitude. Wisecracks replace winsomeness. Sharper comedy and sarcasm are now the order of the day. In short, Avery, who commissioned Givens to modify the Bugs Bunny drawings, changed the direction of Warner Bros. cartoons (even though he was soon to leave the studio for MGM) and ended the temporary Disneyfication of the studio.

Charlie Thorson's version of Bugs Bunny has been eclipsed. Inki has virtually disappeared, perhaps behind a curtain of embarrassment over its potentially racist condescension. Sniffles was not even considered good enough by Jones to be included in the Museum of Modern Art's tribute to him in 1977 or in the Academy of Motion Picture Arts and Sciences' tribute in 1981. The question is, then: Does anything remain *today* of Charlie Thorson's employment at Warner Bros. and the temporary Disneyfication of that studio?

The answer to that question is found in what may appear to be an unlikely place: Bugs Bunny's old nemesis, Elmer Fudd. Thorson designed him and based Elmer's design on familiar Disney characters.

Elmer evolved from a character named Egghead, a small, funny-looking man with a horizontal, egg-shaped head, bulbous nose, and derby hat. Egghead appeared in twelve films beginning in 1937, all but two of them supervised by Avery. In *A Feud There Was* (1938), he arrives at the site of the Hatfields-McCoys feud on a yellow motor scooter with the words "Elmer Fudd, Peacemaker" printed on the side. According to Bob Clampett, shortly after the release of this cartoon:

> Tex and I and one of the gag men had a session in which we talked about how to "cuten up" the character. . . . We used an earlier model sheet, and as we talked check[mark]s were put in the derby, the high collar and the clothes indicating they should be kept. But on the face you can see where Tex sketched a smaller nose and indicated other changes. This was the beginning of the final, "cuter" Elmer.[38]

The penultimate word in that quotation should be a dead giveaway. Whether Clampett had simply mistaken Thorson for the gag man he remembers at the session or whether the annotated model sheet they put checkmarks and sketches

Thorson's model sheet for Elmer Fudd. Courtesy of Dr. Stephen Thorson.

on was passed along to Thorson, will never be known. But there is no denying that the model sheet which defines Elmer to this day was executed by Thorson.[39]

Elmer is an adaptation of the lovable babies Thorson drew for *Wynken, Blynken, and Nod* at Disney in 1936. Elmer is the little Hiawatha who aged but never grew up—in size, shape, and speech impediment. Having brought these kinds of cute characters to Warner Bros. in his portfolio and given them a temporary foothold there, Thorson was now contributing, perhaps unwittingly, to the studio's dismissal of the Disney aesthetic. As Elmer is the naïve, infantile foil to Bugs Bunny's irreverent adolescent and the butt of all Bugs's jokes and aggression, he is also the visual signpost of a change in the Warner Bros. approach to animation.

That change was spearheaded by Avery. His *A Gander at Mother Goose* (1940) contains a thirty-second black-out sketch that takes a potshot at *Little Hiawatha*. Freleng, whose sabbatical from Warner Bros. coincided with the Disneyfication period, continued the assault in 1941 with *Hiawatha's Rabbit Hunt*.[40] Avery then took deadly aim at one of Disney's many Academy Award winners by lampooning *The Tortoise and the Hare* (1934) with *Tortoise Beats Hare* (1941). Even Jones was beginning to establish some distance between himself and Disney. Jones's *Inki and the Lion* and a Sniffles vehicle, *The Brave Little Bat*

(1941), emphasize gags rather than cuteness. The characters are now flatter and more two-dimensional in their design (there is no modeling) and decidedly un-Thorson-like.

By this time (all the above films were released in late 1940 and 1941), Charlie Thorson was long gone from Warner Bros. Although the *Hollywood Reporter* indicated he had signed a five-year contract, the Fleischer brothers lured him to Miami. Thorson worked on the adaptation of Raggedy Ann and Andy for the screen, contributed to *Gulliver's Travels* (1939; primarily the Twinkletoes character), and began designing the more than one hundred cute dinosaurs and other characters he supplied to the ill-fated *Stone Age* cartoon series there.

Ten years after Thorson left Warner Bros., he was profiled in a Toronto newspaper.[41] The article cited an editor's note in Thorson's children's book, *Keeko*,[42] which said that he had created Bugs Bunny. Somehow the book or the newspaper article got back to Edward Selzer, then (1949) president of Warner Bros.' cartoon division. At that time, almost everybody at the studio, even Mel Blanc, was claiming sole credit for creating Bugs. Selzer wrote to Thorson asking for an explanation. Thorson sent back a single-spaced, two-page response. In it, he referred to a copyright infringement lawsuit regarding Bugs; Thorson pointed out that Warner Bros. called *him* in to testify as to Bugs Bunny's authenticity.

> I defintely [sic] did create the original pictures of "Bugs Bunny" and these pictures were made solely by myself and without the assistance or direction of anyone else. The same applies to "Sniffles", and every other cartoon character I claim to have originated.
>
> At the same time, I do not claim and I never have claimed the full credit for the popularity of "Bugs Bunny", "Sniffles", or any other character whose pictures I have created. And I have on every occasion that I have been questioned regarding "Bugs Bunny", clearly stated that it was the funny voice, the funny story situations he was placed in, and the funny animation—all of these qualities combined made "Bugs Bunny" popular. And I have also added that since I made his original pictures, he has changed somewhat—his figure has been streamlined and his expression exaggerated by the animator.
>
> In other words, I claim to have created the pictures of the characters I have made for screen productions, but I do not claim credit for the personality qualities as supplied by the story men, the animators, and others who contribute to its personality. I would like to add, however, that in most cases, the drawings I made of a character were calculated to establish that character's personality.
>
> In the case of "Bugs Bunny", the first drawings I made were calculated to show a smart alex type of a rabbit with a cocky personality such as "Bugs Bunny" now has and my contribution towards his popularity should not be minimized.[43]

Although Thorson's tenure at Warner Bros. was brief, he was there at a crucial time, perhaps the most crucial period, a crossroads in the studio's development. He was much in demand, and handsomely compensated, there and elsewhere. So his contribution was not minimal.

Merrie Melodies of this brief period (he contributed to very few Looney Tunes) do not have the same narrative snap, frame-by-frame virtuosity, or smart-alec humor of the later gag-oriented works that characterize Warner Bros. animation. The Disneyfied Merrie Melodies are more sentimentalized and old-fashioned in their aesthetic appeal, and the characters are more textured, softer, and three-dimensional than the flatter, more stylized characters of the midforties onward. The pace is more leisurely; the tone is droll rather than antic. For these reasons, the cartoons are undervalued and rarely seen. This is unfortunate. For because of Schlesinger's notorious penny-pinching and disregard for art, their virtuosity and craftsmanship are unequaled.

Thorson's role in all this was not as peripheral as auteur- or star-centered studies have up to now allowed. He created scores of distinctive characters with recognizable personalities. To assist in the animation, he likely drafted hundreds of model sheets with hundreds of poses. Thorson helped launch the career of Chuck Jones, who went on to become, arguably, the most famous force in Hollywood cartooning after Disney himself; his work also sustained the brief directorial careers of Ben Hardaway and Cal Dalton, two of Warner Bros.' least understood animation supervisors. And Thorson joined with dozens of other uncelebrated craftspeople—writers, animators, gag men, inkers, in-betweeners, and other character designers—to entertain and perhaps alter the lives of people around the world. Yet, until the precise contributions of many more of these coworkers are documented, the full extent of Thorson's contribution will not be completely understood.

From Vaudeville to Hollywood, from Silence to Sound

HANK SARTIN

Warner Bros. Cartoons of the Early Sound Era

W<small>HILE EARLY</small> live-action sound films celebrated the ability to record speech, the first synchronized sound cartoons were far more interested in the ability to coordinate action and music. While Jolson burst on the scene by speaking and singing, Mickey Mouse's debut featured Mickey bobbing and walking in time to music and whistling. When Disney launched a whole series of cartoons to take advantage of sound, the series was called Silly Symphonies, emphasizing the centrality of music. Throughout the early thirties, Disney divided its production fairly evenly between Mickey Mouse cartoons and Silly Symphonies.[1]

Many studios foregrounded music in their cartoons, but the connections at Warner Bros. were particularly emphatic. For the first half of the thirties, music provided one of the main sources of structure in Warner Bros. cartoons. *Sinkin' in the Bathtub* (1930), the first Looney Tune, derives its title from a popular song, and music motivates the entire cartoon. Directors Hugh Harman and Rudolf Ising and animator Isadore "Friz" Freleng followed the pattern established by Walt Disney in *Steamboat Willie* (1928), showcasing music and letting songs dictate the development of the cartoon. Bosko sings and bounces around to the musical track, which includes several Warner Bros.–owned songs. Of course, the studio was interested in establishing recurring characters, as shown by its devotion to Bosko and later Buddy.[2] Even in these cartoons, music motivates the action.

After the success of the Looney Tunes series, producer Leon Schlesinger convinced Warner Bros. to finance a second series early in 1931, also to be supervised by Harman and Ising. Music played an even greater role in the Merrie Melodies series than in Looney Tunes. The contract for Merrie Melodies explicitly stated that each cartoon would include "a performance of at least one complete chorus of a Warner-owned tune."[3] For Warner Bros., the cartoons

"LOONEY TUNES"
N2/ "SINKIN' IN THE BATHTUB" VITAPHONE #1735
 REL #4127

The first Looney Tune: *Sinkin' in the Bathtub* (1930). Copyright Warner Bros., Inc.

provided a useful promotion of songs included in the holdings of the sheet mu-
sic companies it had recently acquired. Naturally, this contractual obligation
strongly influenced the structure of the cartoons.

Cartoon historians often describe these early thirties musical cartoons in a
negative light, in part because they want to describe the history of this period
as a steady development toward the recognized narrative structure of "Golden
Age" Hollywood cartoons. In their view, the musical cartoons are a dead-end
experiment. Leonard Maltin says, "The serious fault with the Harman-Ising car-
toons was that they did not innovate or improve."[4] Norman Klein remarks that

> these little cartoon operettas seem painfully maudlin today. . . . Filmic
> story is turned into a sentimental interlude. . . . Most of these cartoons
> were devoted to interpreting the music and little else. They toss in an
> endangered hen house, or evil creatures in bookland, but it is mostly to
> hang the crescendos on, and rather elliptically at that. One can expect a
> kidnapped chick somewhere, or an affianced girl bee carried away like
> Lindbergh's baby, and so on. Then the hive rallies, kicks the varmints
> out, and saves Sue Bee, all to a rousing symphonic finish.[5]

Both Maltin and Klein complain that these cartoons have "thin story lines,"
with narrative an afterthought to the interpretation of music. These early musi-
cal cartoons leave Maltin and Klein dissatisfied because of their loose associa-

tive structure. Much as early "actuality" films were treated in some histories of the early cinema, these cartoons have fallen from favor in part because of their peculiarly weak narratives.[6]

If we examine the beginnings of Warner Bros. animation from a different perspective, though, we find that these films are in fact a very important part of cartoon history. In these musical cartoons, Warner Bros., like other cartoon studios, negotiated the transition from silence to sound, a transition that was as difficult for audiences as it was for technicians. Although some histories suggest that audiences and exhibitors immediately embraced sound, Henry Jenkins argues that a significant resistance to talking pictures actually occurred. The trade papers noted that many audiences still "wanted sound limited to orchestral scores and sound effects."[7] Filmmakers, under pressure to find a formula that would win audiences, engaged in an extended period of experimentation in the uses of sound.

In cartoons, some of the key conventions, such as the use of musical instruments for sound effects, were established fairly early.[8] However, the role of sound in determining cartoon structure and subject matter remained unstable for a rather long time. As Klein suggests, a lengthy transitional period continued until as late as 1933 before cartoons established the patterns, such as the chase structure, that would dominate for the rest of the studio era.[9] One might further argue that the conventions for sound synchronization first deployed in the early Merrie Melodies, far from being a dead-end sidetrack in cartoon history, became so assimilated in the later Warner Bros. cartoons and so fully incorporated into the "house style" as to eventually be wholly taken for granted and therefore rendered invisible. This conclusion is suggested by the heavy involvement of Friz Freleng in the vast majority of the early Harman-Ising efforts surveyed in this essay.[10] Freleng, who went on to become one of the top cartoon directors at Warner Bros. during the studio's "Golden Age," was also an active participant in the studio's earliest experiments with sound.

In Warner Bros. cartoons, this transition into sound involved a change in source materials. In the early thirties, Warner Bros. animators relied on vaudeville and comic strips as source material, a strategy similar to Hollywood's turn to vaudeville and Broadway for actors and scripts. During the early period of experimentation, animators used vaudeville performer types and adopted what Jenkins terms a "vaudeville aesthetic," which emphasized virtuosity of performance, flat, staged compositions, and the emotional immediacy of the entertainment. Vaudeville and its performance traditions were a temporary solution to the problem of how to use sound and how sound might change the structure of cartoons. By the midthirties, the animators had rejected, or at least adapted, the vaudeville influence and had come to depend on Hollywood as a source for both structure and humor. However, the influence of vaudeville would continue

to be felt in frequent joking references in films from the studio's more mature period, especially those directed by Friz Freleng.[11] These continued nostalgic references suggest the profound importance of vaudeville to the animators, who had relied on the form in the rough transition to sound.

During this transitional period, the cartoons raised sound as an explicit issue and reflected some of the uncertainty about the role of sound in film. In the reliance on vaudeville, in the representation of audiences' relationships to entertainment, and in the figure of the "improvising machines," we can see the tentative steps taken toward adapting to the presence of sound in cartoons.

Vaudeville as Source

Hollywood cartoons had always quoted other popular forms, particularly vaudeville. Cartoons regularly relied on a gag structure that was borrowed from live entertainment. Klein argues that the gags of cartoons are derived more from vaudeville than from silent film, and suggests that cartoons were marketed and exhibited "as a variation of the vaudeville or the circus act."[12] Cartoons were advertised as visual novelties similar to live entertainments like lightning sketch artists and monologists.[13] As Klein, Donald Crafton, and others have noted, early cartoonists were, of course, no strangers to the vaudeville circuit. Winsor McCay traveled the circuit, and the lightning sketch acts of McCay, Stuart Blackton, Emile Cohl, and Méliès were a familiar vaudeville routine.[14]

While Klein may underestimate the degree to which silent slapstick comedy shared the features he describes, the fact remains that cartoons of this period, like many vaudeville acts, deployed a "fractured use of story,"[15] and they emphasized carnivalesque rather than narrative pleasures. As Maltin and Klein both suggest, the attractions of comic routines and synchronized cartoon singers mattered more than an economical, causal narrative. Borrowing from vaudeville, these cartoons presented a series of bits, often only loosely associated, and a variety of characters who were recognizable performer types from vaudeville.

The cartoons of the early thirties, like vaudeville acts, were woven together from isolated bits or gags. These bits could be detached from the context of an act and reused in a different context. As Jenkins says in describing vaudeville, "The comic sketch or monologue depended more upon the comic 'bits,' the component parts, than upon the sense of the whole."[16] The "bits" included topical references, physical gags, ethnic jokes, and short verbal sparring routines. Similarly, animators frequently built cartoons around a series of "bits" loosely strung together by some common theme. In the early thirties, this gag structure was informed by music.

The humor in these musical cartoons often derived from the interpretation of the lyrics in a new context. *One Step Ahead of My Shadow* (1933) sets the

action in China and presents a series of what we would now consider patently racist jokes featuring two Chinese children, while the lyrics are sung with "a Chinese accent," exchanging *r*s for *l*s and so forth. *A Great Big Bunch of You* (1932) features a lead character who is literally a great big bunch of junk. *One More Time* (1931) converts the title song, about a lover who pleas "One more time / let me do the things I used to do / let me sit down to some tea for two," into a song about a policeman. The lyrics of the popular song are changed to reflect the problems of a beat cop, in a loosely connected series of episodes that do not amount to a plot in the conventional sense. The cop meets various adventures and characters on his beat, allowing for a range of slapstick humor.

The Queen Was in the Parlor (1932) takes its cue from the title song, which allows a series of jokes about medieval settings as well as more topical jokes. The song "The Queen Was in the Parlor" expands on the old cliché that the home is a man's castle, and offers a series of images of domestic life, but with a king and queen as the husband and wife. The lyrics describe the queen in the parlor, pressing Papa's pants, and other typical bits of domestic life. The cartoon literalizes the metaphor of the castle, setting the cartoon in an actual castle. "Patching Papa's coat" and "pressing Papa's pants" are visually represented by a girl riveting bolts into a suit of armor and steamrollering it to "press" it. For audiences, this refiguring of a familiar song was surely entertaining, particularly because the cartoon calls attention to and plays on the tension created by the home/castle, queen/wife metaphor at the center of the song.

Vaudeville also relied on a group of stock characters set in formulaic plots. What constituted excellence in vaudeville performance was the ability of a performer to excel at a type and bring enough differentiation to interest audiences while still working within that quickly recognizable type. Because vaudeville acts lasted under twenty minutes, performers did not have sufficient time to establish fully rounded characters.

Cartoons of the twenties and early thirties similarly depended on a limited character typology. Characters were drawn from a recognizable vocabulary of popular types, like the rascal child (Bobby Bumps) or the playful animal vagabond (Felix the Cat, Oswald the Lucky Rabbit, and later Mickey Mouse). Studios explored variation within a strictly limited range, attempting to differentiate their cartoons from others while offering up a familiar type. For instance, following the popularity of Felix the Cat, other studios quickly produced obvious imitations, clever trickster cats drawn in simple black lines. Since a cartoon had under ten minutes to entertain, easily recognizable characters and simple plots were desirable, if not crucial.

From the very beginning, Warner Bros. animators were interested in establishing recurring characters. The international marketing success of Felix the Cat had demonstrated the possibilities of a recurring character as a moneymaker.

In addition, recurring characters also greatly simplified the challenge of creating new cartoons on a regular schedule.[17] Animators did not have to spend time designing new characters, bits could be standardized, and footage could be recycled.

When Rudolf Ising and Hugh Harman set out to establish themselves as cartoon producers in 1929, naturally they tried to copy the success of Walt Disney's Mickey Mouse. Both had worked with Disney on the Alice and Oswald cartoons in the twenties, where they had learned his methods. After Charles Mintz and Margaret Winkler took the rights to Oswald away from Disney, they worked briefly for the Winkler Studio animating Oswald cartoons.[18] Like Disney, Harman and Ising eschewed comic strip graphics, which had inspired characters like Felix and the Fleischers' Koko the Klown, and chose to look to live theater as an alternative source for their characters. They designed Bosko the Talk-Ink Kid, a character who, following the pattern of Mickey Mouse, draws on a stage tradition of blackface representation.

Though we often associate blackface with the late-nineteenth-century minstrel shows, blackface performance remained common well into the thirties. In the early years of that decade, Eddie Cantor and Al Jolson brought blackface to the movies from vaudeville by way of Broadway. Bosko and his girlfriend, Honey, and later Foxy, were recognizable character types derived from a stage tradition of blackface. Even Buddy, Bosko's replacement in 1933, was so clearly drawn from a blackface character that animator Bob Clampett referred to him as "Bosko in whiteface."[19]

Bosko displays many signifiers of blackface performance, which was still a part of vaudeville throughout the twenties.[20] Bosko wears oversized white gloves and a bowler hat. Honey has a polka-dot bow tied to one strand of hair, which stands up from her head. Honey is also sometimes drawn with ridge lines on her head, which seem to signify a short-cropped Afro haircut. Harman and Ising drew Bosko's head as a simple plane of black ink, with the lower face left white and only outlined, echoing the exaggerated white lips of stage blackface. This drawing style of the face was an established conventional representation of blackness, or at least blackness filtered through blackface, in cartoons of the twenties. For instance, the cannibals in Disney's Alice Cans the Cannibals (1925) have the same round heads and outlined white lower faces that Harman and Ising used for Bosko.

Blackface performance often emphasized musical talent, playing on strong cultural associations of blacks and music. As one contemporary audience member recalls in explaining the appeal of black and blackface performance: "They were loose on their emotions. . . . it was a free thing, they had voices, they could deliver the song."[21] Consistent with cultural myths of the era, this typical audience member assumes that blacks have a more immediate access to music, which

he associates with primitive, uninhibited emotion. Both Bosko and Mickey share this primitive, immediate relationship to music. They approach life as a perpetual song, dancing and singing their way through their adventures to a soundtrack of "jazz."[22] It should come as no surprise that the second Looney Tunes cartoon was *Congo Jazz* (1930). In this cartoon, Bosko finds the origins of jazz in the jungle, where he makes music with the animals, using found objects as instruments.

In addition to blackface characters, the Warner Bros. cartoons often presented characters derived from the vaudeville tradition of the multitalented performer. Vaudeville performers tried to develop as many skills as possible, so that their acts would often involve singing, acrobatics, some jokes, a little soft shoe, and perhaps some juggling.[23] In the theater, such performers were becoming virtual one-man shows. Several vaudevillians moved from vaudeville to Broadway by showcasing their multiple talents. Eddie Cantor and Ed Wynn both were featured in Broadway shows that showcased them as all-around performers.[24]

Multitalented performer characters appear in several Warner Bros. cartoons, including *A Great Big Bunch of You, Goopy Geer* (1932), *The Queen Was in the Parlor*, and *We're in the Money* (1933). In *Goopy Geer*, Goopy sings, plays piano, plays straight man in a comic exchange, and dances. In the course of *The Queen Was in the Parlor*, Goopy Geer does imitations of Amos 'n' Andy and Walter Winchell, as well as doing slapstick comedy and battling a villain. The gags emphasize sound, and not just slapstick, as part of Goopy's interest as a performer. This amazing range of performance skills links him and other cartoon entertainers to vaudeville performers, who often made a living out of displaying multiple talents. For audiences, Geer was recognizably a descendant of vaudevillians like W. C. Fields and Wynn.

Motivated Musical Performances

Rick Altman argues that Hollywood musicals, particularly the category he terms "show musicals" (which involve the characters putting on a show), rely heavily on vaudeville. Early musicals often showcased vaudeville talent, such as Cantor and Jimmy Durante. They also featured a format that alternated among comedy, acrobatics, and music. In fact, though Altman chooses not to discuss them at length, many early musical films were revues, compiling musical numbers and comedy routines with little or no plot connecting them. *The King of Jazz* (1932), for example, strings together a variety of acts, mostly drawn directly from vaudeville, regularly punctuated with performances by Paul Whiteman and his orchestra.

Throughout the early thirties, Warner Bros. frequently plotted the cartoons to feature diegetic shows to justify musical numbers. Performances for the diegetic audience (the audience within the film) justified the presentation of a variety of acts for the extradiegetic audience (we, the spectators). *Lady, Play Your*

Goopy Geer as a court jester in *The Queen Was in the Parlor* (1932). Copyright Warner Bros., Inc.

Mandolin (1931), the first Merrie Melodie, was set in a Mexican saloon. Other cartoons were set in vaudeville theaters (*You Don't Know What You're Doin'*, 1931) or nightclubs (*Goopy Geer*), where the performance of songs was logical.

The presence of the diegetic audience serves to provide not only a justification for the performance of songs but also a diegetic relay for our pleasure. For Altman, the shows within the films allow spectatorial interest in the private world of backstage. "In theater, everything takes place on stage; in a backstage musical the stage is instead the intersection of the audience's gaze and the actors' backstage efforts." Following a long tradition of film theory regarding the gaze in cinema, Altman goes on to suggest that the diegetic audience functions as an alibi for our scopophilic pleasure. "In other words, the show musical camera becomes an agent of voyeurism."[25]

In this schema, the diegetic audiences pictured in musicals act as a relay of identification, both justifying our voyeurism and allowing us to enjoy our superior position. Part of our pleasure derives from our ability to see the things that the diegetic audience cannot. Though these audiences serve an important function, they usually remain an anonymous mass, shown only briefly when they applaud appreciatively. Spectators are not allowed to identify with the diegetic

audience in any very specific way, because this would detract from our attention to the real focus, the performers putting on the show.

However, in musical cartoons of the early thirties, the distinction between performer and audience within the diegesis frequently becomes unclear. The diegetic audiences regularly become the focus of attention, because they enter into the show, singing and performing. These audiences, unlike the anonymous audiences of *42nd Street* (1933) and *Dames* (1934), are not passive consumers but active participants in the spectacle. Everyone in the cartoon is a potential performer, and singing and dancing are an integrated part of normal experience. This sense of singing and dancing integrated into everyday life aligns these cartoons with Altman's category of "folk musicals," like *Oklahoma* (1955), which do not rely on diegetic shows to motivate performance.

You Don't Know What You're Doin' offers a fairly typical example of these early musical cartoons and their representation of performance. The cartoon opens with a lion conducting a theater orchestra. No audience is shown, and the conductor is drawn frontally, so that the spectators identify themselves with the implied theater audience of the diegesis. The title song is introduced with one sung chorus, while the image cuts to an exterior shot, with crowds pouring into the theater. The crowd and the buildings in the background all throb rhythmically in time to the music.

In the next shot, Piggy, a Bosko-like pig drawn very much in the Disney style of the time, is going to pick up his girlfriend Fluffy. Piggy, along with his motorcycle and the entire city, pulse in time to the music. When he arrives at Fluffy's apartment, she is shown in silhouette behind a window shade, putting on makeup and singing along with the music, which has been continuous across the edits. In a shot justified by Piggy's gaze, we watch the brief spectacle of the silhouetted woman before Piggy rings her doorbell.

Once Piggy and Fluffy arrive at the theater, they are briefly detained by a doorman but go through his legs. Piggy's motorcycle backfires, blowing smoke in the doorman's face, and the doorman is transformed into a blackface character, who exclaims "Mammy!" Inside the theater, Piggy immediately begins mocking the orchestra, pulling the dickey of a musician like a window blind. At the break in the music, he criticizes, "Aw, you don't know what you're doin'." He leaves his seat to play a saxophone in competition with the trombone player. The two use their instruments to make sounds that roughly simulate speech, like an argument on muted brass. Soon, Piggy is on the stage and has become the center of the show.

A group of rowdy, drinking patrons in the balcony begin to taunt Piggy, warning him, "Give us something for our money / For the only thing you give us is a pain." At this point, the diegetic audience applauds the balcony critics,

and one of them, attempting a bow, falls out of the balcony and onto the stage, where he now becomes the object of attention. He breathes heavily on Piggy, which sets up the final drunken sequence of the cartoon, in which Piggy drives drunkenly through a snaking, whirling landscape.

This cartoon depends upon a constantly shifting set of relationships between audience and performer. Piggy begins as part of the critical audience but quickly becomes a performer; the drunken patron follows a similar trajectory. The audience, rather than functioning merely as a relay for us and a justification for the performance, is constantly becoming a part of the entertainment. Though we clearly enjoy our identification with the camera's ability to see everything, we are also asked to imagine an audience relationship to the spectacle that is quite different from the detached gaze. In its place, the cartoon offers a model of audience participation as a spectatorial practice.

The rowdy drunks in the balcony signal the origins of this different audience relationship to entertainment. This cartoon nostalgically points to an earlier era in American entertainment, when audience participation was a larger part of the show. This interactive tradition, it should be stressed, does not refer to the vaudeville theater as it was in the twenties. Though vaudeville audiences were still certainly more vocal and engaged than audiences of serious theater, audiences of all kinds of theater, like audiences of film, were being taught a new, more subdued standard of behavior as early as the turn of the century.[26] The rowdy audience that becomes involved in the show was in many ways a throwback to a much earlier popular image of audience.

We see the myth of unruly film audiences in such films as Thomas Edison's *Uncle Josh at the Moving Picture Show* (1902). Like Uncle Josh, Piggy and the drunk who falls to the stage disrupt the entertainment and become the spectacle themselves. However, where *Uncle Josh* imagines the interloper as a rube who cannot differentiate illusion and reality, Piggy and the drunk are both celebrated by the diegetic audience for interpolating themselves into the performance. While Josh's interventions distract from the entertainment, Piggy's and the drunk's interventions enhance the stage show.

According to Miriam Hansen, *Uncle Josh* allows the spectator of 1902 the mastery of knowing better than the naive Uncle Josh, whose behavior was something of a holdover, even in 1902.[27] The naïveté of the earlier audience reaction becomes a source of pleasure, because the audience can enjoy a position of superiority. In *You Don't Know What You're Doin'*, the diegetic audience also disrupts the show and becomes the spectacle. However, far from ruining the pleasure of others, Piggy and the on-stage drunk present a performance more entertaining than that which has been offered by the "professional entertainers" in the cartoon. When Piggy takes the stage, he is certainly as entertaining as the music that has come before, and his battle with all the drunks in the

balcony ends up providing the diegetic audience with a performance in close three-part harmony (the drunks' first chorus) as well as Piggy's later drunken antics.

While the drunken patrons in the balcony are clearly set up as opponents to Piggy, they are not criticized for their disruption of the performance. Their participation, like Piggy's, is accepted as a normal piece of audience behavior. The problem with the drunks is that they criticize without offering their own alternative performance. Though their criticism is sung, it is marked as a negative engagement with the performance, rather than a positive, participatory reaction. Once the drunk who falls to the stage becomes part of the show, the diegetic audience accepts him just as they have accepted Piggy.

In other similar cartoons, audience involvement in the entertainment is represented in an even more positive light. In *Lady, Play Your Mandolin*, the patrons in a saloon happily sing the title song in the opening shot. A gorilla waiter moves among the various tables of patrons performing in close harmony. Throughout *Lady*, the participation of the diegetic audience in the entertainment is presented as a normal occurrence. Similarly, in *Goopy Geer*, the audience in the nightclub becomes actively involved in the show.

These cartoons, like many live-action musicals, celebrate spontaneity, imagining a world that is entirely transformable into a space of limitless entertainment. They indulge a utopian fantasy based on a nostalgic relation to earlier forms of popular entertainment. Like Altman's category of folk musicals, they look to the American past for a possible utopian model of entertainment. Altman defines the folk musical as proposing a utopian world in which music is naturally integrated into everyday experience. Richard Dyer suggests that the utopian fantasy of entertainment in musicals is both determined by but also helps to define the dominant ideology of the society. "That is, while entertainment is responding to needs that are real, at the same time it is defining and delimiting what constitute the legitimate needs of people in this society."[28] In Dyer's view, the ideals of entertainment offer a set of desires that capitalism can satisfy. Dyer goes on to note that the one desire created in musicals that capitalism might not be able to fulfill is the desire for community.

Notably, the fantasies of popular entertainments in these musical cartoons suggest that community too might be offered by capitalism. Though the drunken patrons demand that Piggy "give us something for our money," what he gives, and what these diegetic performances regularly give, is a sense of community among the diegetic audience, who become part of the performance. Given that cartoons had been closely linked to sing-alongs in the twenties, it is perhaps not too great a stretch to suggest that the actual audiences of the early thirties would still associate cartoons with a communal, participatory part of the filmgoing experience.

Much recent scholarship has suggested that the filmgoing experience in the

twenties and thirties, far from being a silent, passive experience, was a much more active and complicated experience of various spectatorial and participatory positions. As Eric Smoodin carefully documents, patrons at movie theaters enjoyed a varied bill of programming.

> With the movies, and particularly with first-run theaters, spectators attended modern, public spaces which seemed to present views of everything: various forms of fiction (including the cartoon), education (scientific short subjects, for instance, or travelogues), stage shows, and so on. Public entertainment brought together within a single space all spaces to be seen and appreciated.[29]

In addition to the varied films and stage shows, the movie theater was likely to have more participatory entertainments, like sing-alongs and giveaways.[30] In this context, the nostalgic reference to the lively audiences of music halls seems far more logical. Though film audiences of the thirties could not achieve the interactive relationship Piggy and his likes have to commodified entertainments, they were far closer to this relationship than many film histories would lead one to believe.

But clearly, the arrival of sound precipitated a dramatic shift in filmgoing practice. Though there were still sing-alongs and other participatory practices, sound film demanded a far greater degree of quiet and decorum. To hear dialogue, audiences had to be quieter, particularly given the poor quality of early sound technology. The limits of technology actually resulted in the absence of background music from feature films for almost half a decade. Though audiences were used to musical accompaniment of silent films, they saw features that did not have background music between 1928 and 1933.[31] In a space that had long been alive with musical accompaniment, the coming of sound ironically limited the presence of music to musicals and cartoons.

Just as early silent film frequently represented the rube audiences who did not understand the appropriate response to film, these early sound cartoons seem to reflect anxiety about the once again shifting standards of conduct in movie theaters. The cartoons nostalgically celebrate a noisier, more participatory relationship between audience and entertainment. This celebration is most striking when set in contrast with later Warner Bros. cartoons that represent audience. By the late thirties, Warner Bros. cartoons represent noise and interaction in the audience as a disruption and source of comic annoyance. In Freleng's *She Was an Acrobat's Daughter* (1937), the audience at a movie theater includes a hippo who keeps switching seats and a goose who talks through the picture. In Robert Clampett's *Bacall to Arms* (1946)—which reuses much of the animation from the earlier Freleng picture—a wolf disrupts a screening of *To Have and Have Not* (1944) by whistling and howling at Lauren Bacall. In these

later cartoons, the more active audiences are depicted as a nuisance, distracting from the entertainment.

By contrast, the cartoons of the early thirties imagine a happy relationship between audience and spectacle. This fantasy of audience participation is facilitated by music, which functions as the connection between audience and spectacle. As noted earlier, the new technology of recorded sound forced a more disciplined, silent experience of cinema-going. However, the early Warner Bros. cartoons use this new technology to present nostalgic images of a livelier, participatory model of public entertainments. The close synchronization of movement in these cartoons, long after Mickey's miraculous pulsing in *Steamboat Willie*, continues to emphasize the very fact of the recorded music, making that recorded music the occasion for a spontaneous, interactive relationship between audience and spectacle.

For audiences still adjusting to the new conventions of the presence of sound in film and the need for silence in theaters, this image of a noisier, more rambunctious relationship must have been reassuring. In particular, cartoons were able to exploit this image because they relied less heavily on imposed silence. The rowdy diegetic audiences of the cartoons might well be matched to some degree by the film audience, for whom the cartoon was an occasion for laughter and more noise than the feature films encouraged.

Improvisation and the Machine

In many of the Warner Bros. cartoons of the early thirties, dolls and toys come to life when humans are not present, usually after hours, at midnight, in a fantasy secret world outside normal human experience. In *Red-Headed Baby* (1931), the toys in a toy shop come to life after the toy maker goes to sleep, and dance and sing to the music on the radio. Often, these musical performances rely on an improvisational use of found objects. In *We're in the Money*, toy soldiers use bellows to pump air into a trumpet. In *A Great Big Bunch of You*, a discarded department store mannequin makes music in the junkyard, using bedsprings as piano strings. A second mannequin makes a trap drum kit out of garbage, while a vacuum cleaner becomes a set of bagpipes. Whether it is the after-hours toy shop, the junkyard, or *The Shanty Where Santy Claus Lives* (1933), these cartoons represent a world in which ordinary objects are refigured and reutilized as the materials of performance.

In his essay on the uncanny, Sigmund Freud identifies as quintessentially uncanny, "doubts whether an apparently animate being is really alive; or conversely, whether a lifeless object might not be in fact animate."[32] Freud argues that the uncanny effect relates to the revitalization of infantile anxieties and beliefs. He notes that fantasies of animate dolls do not necessarily create an

uncanny effect, and claims that these fantasies can be a source of childlike plea-
sure. Nevertheless, he suggests, such fantasies always involve a return to infan-
tile, animistic beliefs, which leave a vague trace of uncanniness.

In the course of the essay, Freud refers several times to automata, along with
dolls, as an example of the uncanny. Automata were elaborate mechanical dolls
first produced in the eighteenth century, which simulated human motion, often
accompanied by music. Automata continued to be a popular novelty in the late
nineteenth and early twentieth centuries. The older idea of the automata as
musical toy was revitalized and modified in the teens and twenties with the craze
for robots, which was often tinged with anxiety.

Peter Wollen points to the ambivalence and anxiety surrounding robots in
Karel Capek's play R.U.R. (1922), about robot revolt. Capek imagines robots
as a cheaply produced labor supply, without emotions. The robots are simulta-
neously superior to humans and devoted to "an orgy of senseless productivity. It
is as though the robots . . . are projections of human sadism and aggression which
have become, so to speak, sedimented in machines."[33] The robots are joyless
workers, who figure the dehumanizing of labor in factories.

These robots are models of streamlined efficiency. As one robot explains,
"A working machine must not want to play the fiddle, must not feel happy, must
not do a whole lot of other things. A petrol motor must not have tassels or or-
naments."[34] The robots of Capek are laborers stripped of the unnecessary, here
imagined as the desire to play the fiddle.

Both Freud's account of animate dolls and Capek's vision of the robot revo-
lution manifest a deep sense of anxiety around the border between the human
and the nonhuman, between the animate and the inanimate. These robots and
dolls are disturbing precisely inasmuch as they blur the distinctions between these
seemingly discrete categories.

At the same time, Taylorization was drawing attention not only to the im-
age of the robot made human but also to the human as a machine. As Peter
Wollen notes, the robot "is, of course, a metaphorical extension of the posi-
tion of the worker in a Taylorist and Fordist system."[35] Frederick Winslow
Taylor's The Principles of Scientific Management (1911) imagines the body as a
machine that can be trained to produce maximum efficiency. In Shifting Gears,
Cecelia Tichi argues that efficiency and mechanization of action transform the
way people perceive themselves and their world. Tichi traces the trope of the
mechanized body across popular discourse, suggesting that the machine becomes
a prominent metaphorical structure for mapping experience.[36]

Michael Wassenaar finds this fixation on machinery in the Fleischers'
Popeye cartoons. Wassenaar sees in Popeye cartoons a "thematics of engineer-
ing and economy," in which the human body is regularly rendered as a machine.

Following Tichi's lead, Wassenaar argues that "the underlying trope in all these examples of Popeye's body transforming into machines is the body as machine or a system of machines and its parts as *useful tools*."[37]

In this cultural climate, according to Wassenaar, Popeye, who converts spinach into energy and in the course of the conversion is himself transformed into a machine, represents the ideal of the human as machine. "What marks Popeye cartoons in this period as unique is the way the human body is represented through graphic metaphor as a conglomeration of inorganic systems."[38] For Wassenaar, this conglomeration of human and machine is vaguely ominous, with suggestions of oppressive economic relations and a fascist celebration of the powerful body.

The animate dolls and the robotlike mannequins of the Warner Bros. cartoons offer a variation on these visions of the animate inanimate. While many popular images of robots and machines focused on the role of machines in the labor of production, the dolls and machines of the Warner Bros. cartoons are machines of entertainment. Contrary to the vision of *R.U.R.*, the pseudomechanical men and dolls of the Warner Bros. cartoons exist precisely to "play the fiddle, to feel happy, to do a whole lot of other things." In these cartoons, machines and technology are neither the dehumanizing nightmare of *Modern Times* (1936) nor the efficient human engines of Popeye cartoons.

The Warner Bros. machines and animate dolls figure for the audience a benign relation to technology which emphasizes spontaneity and performance through the image of musical machines. In a period when new recording technologies were making filmgoing an experience that reemphasized the technical apparatus of cinema, the cartoons transform recorded sound into spontaneous, improvised, Rube Goldberg technology that domesticates the potentially threatening mechanical reproduction of sound.

In *Red-Headed Baby*, for instance, the eponymous doll sings and dances along with the radio. In the finale, she sings the title song with two curly-headed topsy dolls as back-up singers, who imitate the close harmonies and jazzy delivery of the Boswell Sisters and other popular singers of the era. Throughout, the mechanically reproduced music is transformed into a spontaneous performance.

Though the music is initially justified by the turning on of the radio, this conceit is quickly abandoned as the music shifts from tune to tune in an associative chain that links the events of the cartoon. When the spider, the late-arriving villain of the piece, finally appears, the music becomes menacing, and during a chase sequence the tempo speeds up. Throughout, the initial image of sound produced by technological apparatus, here figured as the radio, quickly becomes "detechnified," as the characters in the cartoon seem to control and produce the lyrics, which specifically match the events of the cartoon diegesis.

When Napoleon appeals, "Red-Headed Baby, oh won't you be mine," the car-
toon seems to suggest that, far from singing along with the radio, Napoleon is
the source of the music.

In *A Great Big Bunch of You*, a department store mannequin is thrown on
the city dump and immediately comes to life as a multitalented performer. He
quickly displays his musical talents, playing a piano with bedsprings for strings,
dancing, and imitating Maurice Chevalier and Ted Lewis. He briefly romances
a dressmaker's dummy and is joined in his music by dancing shoes and a chicken
skeleton. As in *Red-Headed Baby*, the world of the cartoon is imagined as a land-
scape of musical possibilities in which the dolls and mannequins creatively use
the things they find. These cartoons celebrate the virtue of improvisation.

For Walter Benjamin, this liberatory fantasy of the mannequins and dolls
as daring bricoleurs provides a metaphor for the possibility of new relations be-
tween humans and machines. Benjamin argues that the technology of film of-
fers the chance for a shared world, the "figures of a collective dream."[39] In this
collective experience, Benjamin sees the possibility of a cathartic laughter which
would address the psychosis being produced by the new technological society.
Benjamin melds a profound anxiety about the effect of new technology with a
degree of optimism about the way new technology might heal.

We see this doubleness in Benjamin's discussions of Mickey Mouse. Ben-
jamin celebrates Mickey Mouse because he works miracles that "all emanate,
without machinery and improvised, from the body of the Mickey Mouse, her/
his/its partisans and pursuers, from the most quotidian furniture just as from trees,
clouds, or a lake."[40] Benjamin sees Mickey Mouse as an almost surrealist figure,
turning the tedium of people's normal relation to technology into a happier se-
ries of loose improvisations. While Benjamin seems to celebrate the lack of ma-
chinery, it is also clear that part of what fascinates Benjamin here is the way
Mickey becomes a kind of machine, integrated into a larger, benign machine of
the cartoon world. In this world, Mickey, trees, and quotidian furniture are all
energized with a mechanical spirit. As Miriam Hansen puts it, "As he [Benja-
min] had stressed in the 1931 fragment, the Mickey Mouse films engage tech-
nology not as an external force, in a literal or formal rendering of 'mechanization,'
but as a hidden 'figure': they hyperbolize the historical imbrication of nature and
technology through humor and parody." Mickey Mouse, Hansen continues,
merges technology and nature in a set of seeming improvisations, which, for Ben-
jamin, prefigure "the utopian potential of technology for reorganizing the rela-
tions between human beings and nature."[41]

To extend Benjamin's argument from Mickey Mouse to the Warner Bros.
cartoons: These anthropomorphized dolls and mannequins once again figure the
improvisatory aspect that Benjamin sees in Mickey Mouse, but complicate the
mythologizing of the technological as "natural." While Mickey tames the tech-

nological aspect by giving us a natural figure of identification, the dolls and mannequins provide a more difficult object of identification. First of all, these cartoons always begin by stressing the initial inanimate state of the dolls and mannequins. In *Red-Headed Baby*, *The Shanty Where Santy Claus Lives*, and *A Great Big Bunch of You*, the cartoons start with images of the lifelessness of these objects. By whatever magic (Santa Claus, the stroke of midnight, or simply the absence of humans), the inanimate is then made "animated." For spectators, these newly animated figures are a more problematic figure of identification than Mickey, who, though a mouse, is always already anthropomorphized.

Second, these figures are difficult to identify with because of the emphatically presentational, performative nature of the cartoons. Mickey Mouse certainly performs, whistling and humming as he goes through whatever adventures are provided, but his performance is always woven into a narrative, however thin. In *Steamboat Willie*, while there is barely any plot to speak of, Mickey "performs" only as he goes about his daily routine, driving the steamboat and romancing Minnie.

By contrast, the Warner Bros. cartoons clearly stress performance over narrative. As noted earlier, the characters perform in a frontal style that emphasizes a relationship to the spectator over any relationships within the diegesis. Even when Napoleon is singing to the Red-Headed Baby, the drawing style suggests a stage performance, drawn frontally, with the large open-handed gestures reminiscent of Jolson and other stage performers.

To further complicate an account of these cartoons, we might focus further on the particular historical circumstances of their production and release. In the mechanical men and dolls, and in the Rube Goldberg machines of other Warner Bros. cartoons of the early thirties, we might see a metaphor of the mode of production. Donald Crafton has demonstrated the presence of a persistent theme of self-figuration in animation, which he traces from the earliest lightning sketch cartoons through the Out of the Inkwell cartoons to the recurring images of rebellion and chaos in silent cartoons.[42] Similarly, the early sound cartoons imagine a world of "entertainment machines," whether the mannequins and dolls or the bizarre, improvised machines.

The Rube Goldberg machines and the rapid improvisations of these cartoon musicals might be read as figures of cartoon production. Both the animators and the press liked to describe the cartoon studios as chaotic, miraculous places that relied on improvised technology. Animators' accounts of life in the studios are peppered with stories of makeshift camera stands, a freewheeling approach to cartoon structure, and a rebellious stand in relation to Hollywood at large. The popular press was happy to perpetuate these myths of the rebellious, marginalized auteurs of the cartoon studio.

In fact, Rube Goldberg–style machines are a frequent theme even in

cartoons that do not feature inanimate dolls coming to life. *Shuffle Off to Buffalo* (1933) takes place in a "factory" that produces babies. Amid the various ethnic jokes about kosher babies and a blackface choir of "tarbabies," the cartoon spends a great deal of time showing the elaborate machinery used to feed, diaper, and bathe the babies. This sort of elaborate but improvised machinery seems to suggest a myth of the mode of production, in which the cartoons are only partially an industrialized product. The cartoon studios, like the Rube Goldberg machines, escape the shadow of industrial assembly-line production because the assembly line is always imagined as a sloppy, human, jerry-built affair.

These elaborate semiefficient assembly lines also turn the streamlined industry into a source of fun by setting a juvenilized version of the assembly line to work doing mundane tasks, such as feeding and diapering babies. The baby factory here does not convey horror at the dehumanization of everyday activities, as in the more negative fantasies of a technologized world, but a happier celebration of a world of technological contingency, in which the machines, in their precarious success, point to their human, fallible makers.

The make-do mannequins and elaborate machines turn the world of found objects into newly useful sources of entertainment. This kind of transformation echoes the popular descriptions of cartoon production at the time, which emphasize the ability of the animators to turn "lifeless" ink into cartoons.

Of course, this make-do spirit, and the idea of reutilizing found objects, had a particular resonance in the early thirties. The Great Depression was deepening, and thrift and frugality were quite suddenly important ideas. Images of making do show up frequently in the films of these years. *Roman Scandals* (1931) includes an elaborate musical number called "We Can Build a Little Home," in which Eddie Cantor cheers up a chorus of newly homeless people by imagining that they can build a home out-of-doors, making the sky their ceiling. During the number, Cantor explores the streetside homeless camp, where people are making do with jury-rigged showers and various clever new uses of the things at hand. The Warner Bros. cartoon musicals similarly transform trash into entertainment, celebrating the new ethic of frugality. The discarded mannequins and vacuum cleaners become part of a musical attraction.

The cartoons imagine a relationship to technology that is particularly about sound. These images of mechanical beings making improvised music turn the new technology of mechanically reproduced sound into a means to allow new creativity and performance. The mechanical men and the found objects transformed into musical instruments become a figure of a domesticated technology. In the mannequin musicians and singing dolls, the machinery of the production of sound is granted a curious, limited agency, not quite human but clearly not inanimate. We might read these partial agents as figures of the new sound technology itself, which was regularly anthropomorphized in descriptions in the

popular press. Popular reviews of early sound films regularly refer to the sound apparatus as "performing well."[43] This partially humanized technology offers audiences a reassuring image of a technology that is made more human, more haphazard, but also made into an engine not for industry but for entertainment.

The early thirties were a period of transition in popular entertainment, not only from live entertainment forms to film but also from silent to sound cinema. The Warner Bros. cartoons used the new technology of recorded synchronous sound to revitalize a fantasy of liveness and spontaneity as the ultimate possibility in cartoon entertainment. It was a move that would quickly be replaced by the recurring character and the chase as the dominant modes, but this period of experimentation was crucial in getting animators—and audiences—used to the new possibilities of sound.

The Image of the Hillbilly in Warner Bros. Cartoons of the Thirties

MICHAEL FRIERSON

FILM AND TELEVISION images of the American South are pervasive and varied. "Hick flicks" like *Thunder Road* (1958), riverboat musicals like *Show Boat* (1929, 1936, and 1951), and plantation films like *Uncle Tom's Cabin* (1903) are all subgenres of motion pictures that present views of the American South. Central among these is the plantation film—the archetypal location of the South's filmic image—cemented by two immensely popular and historically significant films: D. W. Griffith's *Birth of a Nation* (1915) and David O. Selznick's *Gone With the Wind* (1939). Both films defined the plantation as the centerpiece of "the cinematic mythology of a grand Old South" permeated with moonlight, magnolias, and the peculiar historical institution of slavery.[1] The plantation film furthered the fantasy of a genteel, cavalier southern society built on the backs of happy slaves loyal to their masters. The image of the plantation in motion pictures has had a profound impact on the perception of the South and southerners. Plantation films mythologize the low country South, the coastal and flatland areas of the region. But what image does Hollywood give of the southern highlands?

Less studied but equally enduring is the "hillbilly film," exemplified in a range of live-action films and television shows from the Nickelodeon era to the present. The word "hillbillie" first appeared in the print medium in 1900, when the *New York Journal* defined the type as "a free and untrammeled white citizen of Alabama, who lives in the hills, has no means to speak of, dresses as he can, talks as he pleases, drinks whiskey when he gets it, and fires off his revolver as the fancy takes him."[2] In the film medium, the Biograph studio's *The Moonshiner* (1905) and *Kentucky Feud* (1905) quickly established the backwoods settings and major themes of the hillbilly genre. J. W. Williamson's *Hillbillyland*

documents how quickly representations of feuding and moonshining spread into motion pictures, with over three hundred films from 1910 to 1916 containing these topics. What these early films had not established were the corporeal characteristics of the classic hillbilly: the barefooted, shabby, black-bearded mountain hayseed with the slouch hat. Filmic representations of this classic hillbilly stereotype date to the First National feature *Rainbow Riley* (1926),[3] and continue in a steady assortment from *Kentucky Kernals* (1934), *Spitfire* (1934), and *Kentucky Moonshine* (1938) to the Ma and Pa Kettle films (1947–1954) to television's *The Andy Griffith Show*, *The Beverly Hillbillies*, and *Green Acres* in the sixties and seventies.

The Hillbilly Image in the Depression Decade

The hillbilly flourished as a cultural icon, particularly in the turbulent decade of the thirties. Three print cartoons satirizing hillbilly culture premiered in 1934 alone. That year, Paul Webb launched in the pages of *Esquire* magazine his long-running "Mountain Boys" series, which codified the classic hillbilly persona and was collected into a popular book in 1938.[4] Webb's imagery was starkly rendered in black and white, with a deeply sarcastic edge that attacked the mores and attitudes of hillbilly culture. Less biting, and lacking the classic bearded mountain man, Billy De Beck's *Snuffy Smith* and Al Capp's *Li'l Abner* nevertheless brought moonshining, backwoods types, and mountain humor to newspaper audiences beginning that same year. Is there a connection between the surge of hillbilly humor and the collective state of mind of the United States at the height of the Great Depression? One answer, according to Williamson, is that "the early 1930s forced middle-class urban Americans to consider seriously the unthinkable possibility that the whole damn shooting match of the American economic system itself was about to land them back in Rural Subsistence Hell."[5]

In his book *The Nickel and Dime Decade*, Gary Best echoes that idea, arguing that while the thirties defies easy characterization, the single consistent factor that Americans faced throughout the decade was unemployment.

> With between 14.3 per cent (1937) and 25.2 per cent (1933) of the work force unemployed during the 1930s, many others employed for shorter hours due to an absence of work or because of work sharing, and still others insecure about the future of their own jobs, the reality or specter of unemployment was obviously an important influence on American behavior during the decade. . . . No economic recession of recent times brought workers and their families face to face with a sense of shame at their idleness and dependence on charity as did the Great Depression. The precedent of the 1930s has, in fact, served to ameliorate for later generations much that was extremely traumatic for workers and their families during the Great Depression.[6]

According to Best, any study of American popular culture in the thirties is thus an examination of the effects of this overwhelming economic trauma on leisure-time pursuits. As Americans faced the ego assault of unemployment on their self-esteem and social status, classic Freudian defense mechanisms emerged in their leisure pursuits, so much so that "comprehensive studies of ego defenses . . . read like a catalog of popular culture in the 1930s."[7]

Best argues that repression (the assignment of unpleasant ideas to the unconscious) and regression (the reversion to an earlier stage of development to escape from stress) are the two most prominent Freudian defenses that leisure pursuits of the thirties exhibit. Regardless of whether Best's claim can be supported, the notion that many pop culture phenomena of the thirties exhibit a childlike, escapist quality is commonplace. Calling this tendency "regressive" here for short seems equally reasonable. Jigsaw puzzles, miniature golf, the "knock knock" joke, and the Hollywood musical are a few phenomena of the decade that suggest regression may have been at work.

With these two factors—namely, the flourish of print cartoons in 1934 featuring hillbilly culture and the pervasiveness of regressive depression-era entertainments—as a jumping-off point, the appearance of the hillbilly in three Warner Bros. cartoons at about the same time is provocative. Friz Freleng's *When I Yoo Hoo* (1936) Tex Avery's *A Feud There Was* (1938), and Bob Clampett's *Naughty Neighbors* (1939) represent early instances of the hillbilly image in the American studio cartoon. These three cartoons are chosen for analysis here because they offer an opportunity to examine a broad, stylized image of the hillbilly stereotype constructed by one studio cartoon unit within a narrow time period.[8] Moreover, even though the hillbilly image endured in late Warner Bros. cartoons like Art Davis's *Holiday for Drumsticks* (1949) and Robert McKimson's *Hillbilly Hare* (1950) and *Backwoods Bunny* (1959), the sudden flourish of hillbilly imagery in print and motion picture cartoons of the thirties suggests that the decade bears special scrutiny. All three cartoons negotiate a number of discourses from the decade: principally the issue of the failing economy in the early thirties and the impending war in Europe in the later thirties; secondarily, the gay male, commercial radio, the thirties craze for mountain music, and contemporary big-budget Hollywood spectaculars. Central to all these cartoons is the feud as the basic plot device in which to embed cartoon slapstick and sight gags.

Mountain music, the hillbilly roots of the larger genre we know as country music, is prominent to all of the cartoons at hand. By the thirties, mountain music had grown into something of a craze. Hillbilly bands were finding their way into mainstream culture through a wide range of media, particularly radio. The rise of hillbilly music is often dated to Okeh Records' sale of over five hundred thousand copies of a "Fiddlin' John" Carson phonograph record in 1923. In the thirties, Montgomery Ward was offering "hillbilly records" in its catalogs,

while the Weaver Brothers and Elviry made several movies for Republic Pictures that featured their hillbilly band. Bob Burns, the "Arkansas Traveler," also brought hillbilly music to motion pictures in films like *Rhythm on the Range* (1936), *Guns and Guitars* (1936), and *Mountain Music* (1937). In addition, the *Grand Ole Opry*, the nation's most popular country music radio show, started at Nashville's WSM in 1926 and was heard nationwide after the station gained a clear channel license in 1932. It competed with other hillbilly music shows: *National Barn Dance* (WLS–Chicago, Illinois, in 1924), the *World's Original WWVA Jamboree* (WWVA–Wheeling, West Virginia, in 1926), and *Midwest Hayride* (WLW–Cincinnati, Ohio, in 1937). And though it did not feature hillbilly music, *Lum and Abner*, a hugely popular radio show that began in 1931, also brought the Jot 'Em Down Store of mythical Pine Ridge, Arkansas, into American homes for over two decades. Consequently, all three Warner Bros. cartoons incorporated hillbilly music to capitalize on its growing popularity throughout the thirties.[9]

Yet the deep economic troubles associated with the era, and particularly with the South—"The nation's number one economic problem," as Franklin Delano Roosevelt described the region in 1938—suggest that the cartoons' presentation of hillbilly music and feuding mountain hillbillies had a particular appeal for depression audiences. Hillbillies represented a regressive or atavistic culture, a group less sophisticated and poorer than themselves, in which urban audiences could take smug pleasure in—"point and laugh," if you will. Every urban society has its "hillbilly," its country bumpkin, a figure that encodes its distant rural past, looked back upon wistfully, humorously, disdainfully. For Americans, cartoon hillbillies represent a rural subculture that existed before the dominant, urban/industrial society. As such, thirties urban Americans (as a class) could look at their "primitive predecessors" (as a class) as retrogressive and comic. Gilbert Seldes's assessment of the state of humor in the United States in the thirties suggests that Americans were doing just that. Writing in 1932, Seldes criticized American humor's increasing "sophistication" as misdirected: "Under the influence of [H. L.] Mencken and Sinclair Lewis the American humorist still jeers at the stupidities of the stupid, and seems not aware of the fact that a prime object of satire is the stupidity of the intelligent."[10] The regressive attraction of the comic hillbilly lies in the opportunity for urban audiences to observe their country cousins "outrageously out of step with modern life," says Williamson, "[but] somehow at rest in the universe, utterly at home, blessedly oblivious . . . accepting their fate with placid equanimity and resiliency."[11] Urban audiences could not only look down at hillbillies but also look backward to a milieu where feuding, based on the clan as the significant social unit, was the violent, preindustrial mode of conflict resolution. Thus, the hillbilly peels back the veneer of modernity to show us a past that our civilized society believes it has left

behind. But as we shall see in *Naughty Neighbors*, where feuding clans satirize the growing conflagration in Europe in 1939, cute cartoon versions of the atavistic hillbilly can be used to hold up a mirror to the pointless, recurring violence of our own modern industrial society.

This sense of the term "regressive" or "atavistic" is implicit in Williamson's account of the function that mass media stereotypes of hillbillies serve even today.

> Many hillbillies in the mass media are there to make the normative middle-class urban spectator feel better about the system of money and power that has him or her in his grasp. Someone is always beneath us, lending proof that the twig on which we stand is really the rung of a ladder leading upward to something we must defend with our lives.
>
> For the English, the class on the lower rung was the Irish; for the Irish it was the lowland Scots. For the lowland Scots, once they got to America, it was the Indians. . . . middle Europe has the mountain-dwelling Slovaks, the Iranians and the Iraqis have the mountain Kurds. And so on. . . . What all such characterizations share, whether applied by urban outsiders or worn as self-defining and defiant badges by the rural folks themselves, is a common need for economic reassurance through the spectacle of want.[12]

I will argue that these hillbillies stand as humorous, broad renditions of a group living in economic hardship, who are sleepy, idle, out of step with the modern world, but placid and accepting of severe economic hardship. Examining these cartoons will reveal how their visual representation of the "otherness" of hillbillies constructs mountain stereotypes congruent with long-standing southern stereotypes, particularly the lack of southern intellect, the peculiarity of southern speech, the slow pace of southern life, and the South as a more lawless region.

When I Yoo Hoo

Released June 27, 1936, Freleng's *When I Yoo Hoo* tells the story of the feuding Weavers and Mathews, whose shacks face each other across Hickory Holler. Separating the motley Weaver and Mathew tribes is a train track that forms a boundary line, a motif central to feuding.[13] Opposing clans of goats, cows, dogs, and pigs play mountain music and spit tobacco from the archetypal stage for hillbilly culture: the front porch. Later, the Mathews sleep in their cabin. Two dogs sleep at opposite ends of the bed, blowing the bed covers back and forth with their snoring. The Weavers strike up the hillbilly favorite "When I Yoo Hoo" with its frequent chorus, "When I yoo hoo in the valley, to my Lou Lou in the hills, she will answer with her yodel-lee-hee-hay-hee-hoo."

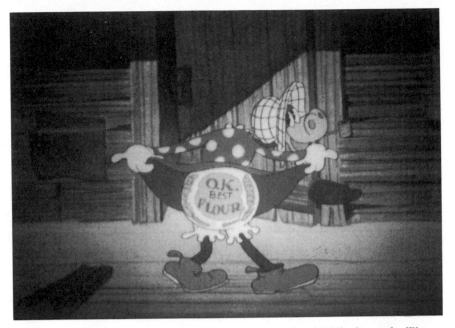

Hillbilly poverty: flour sack underwear in *When I Yoo Hoo* (1936). Copyright Warner Bros., Inc.

Indigent hillbilly critters continually pick and sing as a series of sight gags unfolds, depicting the other principal pursuits of hillbilly culture: dancing, sleeping, and shooting. A cow comes out on the porch to clog. Turning away from the camera, she reveals her underwear, made from a flour sack inscribed "OK Best Flour," perhaps the most direct reference to mountain poverty. When the shooting starts, Freleng trots out a couple of sight gags. A lazy mountaineer lies on his bed, hands propped behind his head, shooting out his bedroom window with his feet. A coonskin cap hit by rifle fire yelps and hops around the cabin floor.

Into these idle backwoods comes a representative of more mainstream culture who will ultimately be subverted by feud violence: the county sheriff in his modern, rattletrap jalopy. He braves the crossfire to hang a notice: "For the peace of the valley, the Weavers and Mathews will settle their feud by a rooster fight to be held at Higgins barn. Loser will leave the county. J. Botz, Sheriff." The scene fades with a Mathew running homeward shouting, "Hey Lem, get the old red rooster! We're going to beat those Weavers."

Later that night, the families crowd around the ring as two cocks enter the ring to do battle. Freleng establishes this climactic one-on-one battle as the solution to the larger issue. The cocks fight more or less evenly matched, until one rooster takes a slug from a jug of moonshine and proceeds to beat the feathers

off the other. The sheriff attempts to declare the Weaver cock the winner, but while holding up the arm of the victor, he is met with a hail of bullets from the opposing family. Eyeing the bullet holes through his hat, the sheriff does an about-face, declaring the Mathew rooster the winner, which brings a second fusillade from the Weavers.[14] The sheriff's diplomatic solution is to declare a draw, whereupon the families themselves dive headlong into the ring, fighting furiously. The film closes with a sly pan to the left and right of the ring where we see the opposing roosters sitting in the grandstand enjoying the fray.

Feuding hillbillies, whose disputes even the local sheriff cannot contain to a boxing ring, reinforce, if even in a small way, the long-standing view in films of a violent and lawless South. Moreover, as we shall see, feud violence ultimately subverts elements within the cartoon representing more modern, mainstream culture in all three of the cartoons examined here.

A Feud There Was

A Feud There Was, released on September 24, 1938, is a typical Tex Avery cartoon in its fast pace, topical humor, and heavy reliance on sight gags, including self-referential and context-shattering ones. Avery pushes the studio cartoon to the limit; his style is immediately recognizable. Likewise, his treatment of hillbilly subject matter is the most extreme of the Warner Bros. cartoons examined here. Avery uses *human* caricatures as vehicles for classic hillbilly features—drooping hats, patched overalls, giant bare feet, bowed legs, and scraggly black beards that reach almost to the knee. These caricatures mark a departure from other Warner Bros. directors, who use barnyard *animals* to play hillbilly roles, as we have seen in Freleng's *When I Yoo Hoo* and will see in Clampett's *Naughty Neighbors*.

Avery's male hillbillies are lazy drunks, and even the women smoke corncob pipes. These mountaineers are visually similar to Paul Webb's *Esquire* work, sharing such design elements as scrawny bodies, big noses, big feet, and long beards. However, Avery's designs lack the edge of a Webb cartoon. Where Avery's hillbillies are scrawny and rounded, Webb's are scrawny, angular, and bony. Where Avery's hillbillies have big clownish noses and broad eyes, Webb's appear more menacing with eyes closely set in hollow, blank faces. Where Avery's hillbillies are bowlegged with curvilinear extremities, Webb's are more extended in length and uniformly narrow in width. More important, Avery's work is energetically animated in bright colors to lively music that is upbeat and happy, without the dour tone and biting sarcasm of Webb's work. Webb's mountaineers are profoundly trashy "white trash," scrawny and fecund, lecherous and lazy. They sprawl on their front porches with their big, bare feet and speak unabashedly about indelicate topics.

A Feud There Was opens on a mountain cabin; five hillbillies sleep in various beds together, their snoring creating a tremendous ebb and flow of wind that flaps curtains and swings the hanging lamp. A cuckoo clock opens and the bird announces, "That's powerful snoring. Just like a hurricane." And then shifting to a British accent, "From the motion picture by the same name," most likely a gag reference to the high-budget spectacle directed by John Ford the previous year.[15] The cuckoo pops the cork on a jug of moonshine, the wake-up call for the sleeping mountain men. More sight gags follow. Two hillbillies sleep on opposite sides of a log, their snoring propelling the crosscut saw back and forth by sail power. A drunken hillbilly sleeps under an apple tree, a jug for his pillow. Hit by a falling apple, he moves like molasses, raising his head in slow motion to mutter "ouch." Another slow-motion shot follows as a sleepy cat and a lethargic dog confront each other with a sluggish "bow . . . wow" and "hissssss." These two images are the most overt references to the odd speech patterns and slack minds of southerners: in Dixie, even the domesticated animals are slow.

Avery's trademark fast pacing is evident in the next scene, as he spoofs the craze for mountain music. Several hillbillies sleep in a heap on the front porch. A radio station microphone unexpectedly descends into the shot, and the hillbillies rocket to attention and begin singing a rousing fiddle tune, "Let's get out the shootin' iron, and start right in a' firin.'"[16] Between verses they drop like rocks into a snoring heap, while an effeminate announcer jumps in with a live spot advertisement: "Do you need money? Borrow on your old shotgun, paid for or not. Call Gladstone 4131 and a personal representative will call at your home or office." The sleeping hillbillies then rocket back to attention to complete the song. This is the central reference in the film to the economic hardships of the period, directly spoofing pawnshop ads on the radio.

More important, *A Feud There Was* establishes a clear visual dissimilarity between the mountaineers and city folk. Avery's mountain men—their toes protruding from holes in their shoes, their baggy, patched trousers held up by rope, and their shootin' irons close at hand—sleep in a heap like scrawny, lethargic hound dogs. The citified announcer, by contrast, is overly groomed with a buzz cut, collared shirt and tie, buttoned sport coat, and cigar. The announcer is effeminate, neat, and thin, Hollywood's transparent stereotype of the gay male. Striking a winsome pose on the cabin's front porch, he is an agent of the radio station, the mass media conduit to the world outside the hills. He is the antithesis of the mountain male—groomed, civilized, and pert. The scene suggests that hillbillies may be sleepy and accepting of their lot in life, but given the chance to participate in "modern ways," they will literally jump at it. Both the announcer and the mountain band represent fairly cynical views of economic relations in the thirties: the announcer, whose humorous spot links the current economic anguish with the absurdity of borrowing on a shotgun; and the mountain band

The "citified" announcer and the "countrified" musicians in *A Feud There Was* (1938). Copyright Warner Bros., Inc.

anxious to prostitute itself for the network, literally at the beck and call of the commercial media. Audiences of the thirties, immersed in a sea of economic hardship and aware of the rising popularity of hillbilly music, would probably recognize the power relationships implicit in this scene; even hillbillies would hock their possessions and prostitute their music for commerce.

The shooting in *A Feud There Was* begins across a gully marked "Boundary Line," a hail of gunfire erupting between the red-bearded McCoys and the black-bearded Weavers. The film alternates between sides, showing a series of gags that center on the exchange of lead from shack to shack. One hillbilly shoots from a window, stopping to add up his hits on an adding machine. A McCoy woman hollers from her window, "Weavers is sissies!" Holding her coffeepot aloft, she uses the bullets that rain through her window in reply to punch holes in the vessel, creating a sprinkler which automatically fills five cups. Many of the gags are self-referential, Avery's signature method. Hillbillies turn toward the camera to comment, "In one of these here cartoon-y pictures, a body can get away with anything," and later, "Well, it sounded funny in rehearsal anyway." When a McCoy turns toward the camera and demands, "Is there a Weaver in the audience?" a silhouette of a hillbilly rises from the "theater audience" into the frame and shouts "Yeah ya' dope," then blasts the McCoy in the butt with a shotgun.

McCoys and Weavers loom over Egghead, the peacemaker, in A *Feud There Was*. Copyright Warner Bros., Inc.

As in *When I Yoo Hoo,* where the sheriff in his jalopy represents the mainstream element trying to end the regressive feuding, here Avery introduces Egghead as the civilizing influence on mountain culture. Egghead plays a kind of circuit preacher who rides in on a motor scooter, thus reiterating the association of a motor vehicle with the outsider who ventures into the backwoods. As Egghead yodels a chorus, the scooter bounces merrily into the hollow. The sign on his vehicle states "Elmer Fudd, Peacemaker" (the modern Elmer had yet to be developed). Egghead knocks on the door of the McCoy cabin and says in a pious voice, "Gentlemen. Let there be an end to this senseless massacre. Let there be peace. Good day." The McCoys' reply, as he exits the porch, is some buckshot to the seat of the pants. Egghead crosses the boundary line between the warring clans—in this cartoon, a gully between the cabins—and braves more gunfire to climb on the front porch to repeat his message of peace to the Weavers. Getting no response as the shooting and sight gags continue, he rides his scooter into the gully and whistles for a time-out. As the warring factions gather around him, Egghead implores, "Gentlemen. I begged and pleaded. Stop this useless slaughter. We must have peace." Symmetrical groups of red-bearded McCoys and black-bearded Weavers now loom over the demure Egghead, mumbling, "Peace is it?" The climactic scuffle breaks out, arms and legs flailing, a cloud of dust rising to obscure Egghead, then clearing to reveal the hillbillies

out cold and Egghead untouched. He begins to yodel a farewell to the audience and walks off toward the hills. However, feuding hillbillies again subvert a civilizing figure representing mainstream culture, as Egghead is shot in the posterior by the same silhouetted mountain man in the "theater audience."

Naughty Neighbors

Released November 4, 1939, Clampett's *Naughty Neighbors* stars Porky and Petunia Pig as respective heads of the McCoys and the Martins who, according to the front page of the *Ozark Bazooka*,[17] have just signed a nonaggression pact. The irony that this headline adds to the cartoon is clear, compelling, and analyzed later in this section. But first, an examination of the film's content is in order.

Naughty Neighbors opens to "When I Yoo Hoo" (recycling the title song to the 1936 Freleng cartoon) but quickly shifts to "Would You Like to Take a Walk?" as the star swine stroll and croon about the peaceful future of their clans. Porky sings, "Aren't you glad that we are friends, mmm?" Petunia sings back, "From now on the fighting ends, mmm. / No more sallies in the alley." And Porky replies, "Now we're pally-wallies." As Porky and Petunia's idealistic love song continues, so does the feuding, a string of sight gags providing a humorous contrast to undercut their fondness. A black duck says to a white duck standing on the other side of a boundary line, "Well Snuffy, who would've thought that after all our feudin' and shootin' you Martins and us McCoys would be friends."[18] After a beat, they both stand eyeball to eyeball and scream, "It'll never work!" In another gag that undercuts the cute duet, two ducks dance a dainty minuet, each standing on its respective side of the feud's borderline. They abruptly stop their elegant dancing and start body slamming each other to the ground. The strolling pigs admonish them in song to be friendly, and they return to their peaceful dance.

The cartoon continues with a recycled gag from *A Feud There Was*. Clampett shows a mother cat feeding her hungry litter by holding up a milk can which is quickly riddled with bullet holes, distributing a stream of milk to each kitten. The film concludes when Porky lobs a gas grenade covered with valentine hearts marked "Feud Pacifier" into a field of battling animals, changing the melee into a bucolic scene of maypole dancers. The grenade is but one of a number of topical visuals that allude to the current turmoil in Europe. Other visual references to the impending world war include a gas mask and a scene in which a cow's horn is blown like a bugle, causing a group of ducks to hatch from their eggs, emerging as a troop marching "eyes left" with eggshell fragments as helmets.

Naughty Neighbors, unlike the other cartoons under consideration here, is something of a "star vehicle" for Porky and Petunia, both key personalities in

The nonaggression pact between Petunia Pig Martin and Porky (the Real McCoy) is head-lined in *Naughty Neighbors* (1939). Copyright Warner Bros., Inc.

the Warner Bros. cartoon stable after Porky's introduction in 1935.[19] Porky emerged as a star in 1937 when Clampett and new studio voice talent Mel Blanc teamed to revitalize his persona into a funnier, more appealing character, immortalized through his closing Looney Tunes salute, "Th . . . Th . . . That's All Folks!" For the next three years, the Porky films were virtually all Clampett's, and this particular film plays on Porky and Petunia's cute romantic behavior in the same way that other live-action and cartoon couples of the period do. The pigs' duet as they promenade through the hills calls to mind a number of contemporaneous musical couples: Nelson Eddy and Jeanette McDonald—the "Singing Sweethearts"—who were paired together from 1935 to 1942; Fred Astaire and Ginger Rogers, who starred together in ten films beginning with *Flying Down to Rio* in 1933; even Mickey and Minnie Mouse, who were paired beginning with *Plane Crazy* in 1928.[20] Porky and Petunia's singing lends a saccharine tone to the film, which for today's audiences may be cute to the point of discomfort. The cartoon's abrupt end via Porky's "Feud Pacifier"—a sort of *deus ex grenade*—may be unsatisfying, but at least it puts an end to their singing.

If overly saccharine for modern audiences, the cartoon's opening reference to the Nonaggression Pact between Germany and the Soviet Union, which had been signed just two months earlier in August 1939, must have added a deeply ironic twist to the film for audiences of the day. That event adds a double edge

to both the hillbilly premise and the duet's coy lyrics. The Nonaggression Pact, whose full text was not disclosed until 1990, allowed the two countries, ideological enemies in public, to divide Poland in late September 1939, after the success of Germany's blitzkrieg and Russia's ensuing invasion. Secret protocols within the agreement established German and Soviet "spheres of influence" in Eastern Europe, dooming Estonia, Latvia, and Lithuania to Soviet domination for the next fifty years. Contemporary observers like British author Evelyn Waugh saw the pact as two evils allied, "huge and hateful, all disguise cast off."[21] Germany's subsequent invasion of Russia barely two years later showed how Hitler had betrayed Stalin. In light of these very current events, the acerbic satire of *Naughty Neighbors* is clear.

The film's use of the feud as a plot device, the nature of its title, and particularly the duet's lyrics coupled with the sight gags that undercut its peace-loving message, are the primary sources of the caustic mockery here. The film's plot premise—the feud—is commonly viewed as an unnecessary conflict extending over generations in which the participants have often forgotten the origin of the conflict and fight merely as a way of life. Two months before this cartoon was released, two "Naughty Neighbors" in Europe had destroyed and divided Poland, an event that horrified the world with its speed and brutality, and which quickly brought Britain and France to a declaration of war against Germany. That Porky and Petunia would sing of their nonaggression pact, "Our pals are playing fair," "From now on the fighting ends," "Now I feel so awfully pleased, Now that we are both appeased," was richly ironic at the time of the film's release. The declarations of war, the recognition that a widening conflict in Europe was unavoidable, add a profound sarcasm to the song's refrain, "Something good will come from that!"

Conclusion

Regressive entertainment seems to be a feature of the American landscape in the thirties. During the same period, cartoons from the Warner Bros. studio exhibit a similar appeal in their depiction of hillbilly culture. *When I Yoo Hoo, A Feud There Was,* and *Naughty Neighbors* all schematize the mountain feud that had been a part of American lore since the eastern Kentucky feuds of the late nineteenth century were sensationalized in newspapers and Paul Webb's "Mountain Boys" series. In its broadest outlines, the feud engages two mountain families in armed combat that produces a boundary line dividing the hills into "us and them." In the cartoons at hand, that boundary line is variously represented as a train track, a gully, and a white line on the ground.

Feuding and hillbillies were inexorably linked in the mass media, and thus in the public mind. Following the lead of feature films, magazines, and strip car-

toons of the day, the Warner Bros. cartoons people this schematic with classic stereotypes of hillbillies (primarily males), often transforming the bearded, barefoot bumpkin with moonshine jug, corncob pipe, and rifle at hand into a barnyard animal. Feud violence—intergenerational and thus, senseless almost by definition—feeds the hillbilly stereotype that brought derision and scorn to mountain people for the last hundred years or so. Here, feud violence becomes the source of gag material, often involving the method of firing rifles back and forth between houses. The feud is merely a plot mechanism for the incorporation of hillbilly stereotypes, often involving the humorous depiction of their violence, stupidity, odd speech, music, and laziness. As a result, Warner Bros. cartoons recycle rather than expand the stereotype.

Not surprisingly, this stereotype has little to do with the actuality of these feuds. According to mountain historian John Ed Pearce, "For the most part the feudists were ordinary Americans, surging across the Appalachian Mountains in the aftermath of the Revolutionary War, in which many of them had fought, trying in a harsh, raw land to establish an acceptable society in which to live and rear families."[22] No real common thread existed for these feuds but for a convergence of factors including post–Civil war violence, the slow growth of formal religion in the region, poverty, industrial colonialism from timber and mining companies, and even the growing resistance to whiskey as an acceptable social custom.[23] The hillbilly and the feud are, in many ways, simply media constructs of long standing, intended for spectacle or humor but reinforcing a negative image of mountain life. This image fits neatly within the broader mass media stereotypes of the South, which teach us that in addition to talking funny, southerners generally are slow, lazy, and quick to become violent.

What *is* surprising is how long the mountain stereotype endured in the Warner Bros. shorts. Karl Cohen has documented how racial stereotypes were abundant in the Warner Bros. cartoons through the fifties.[24] The year 1950 saw *Hillbilly Hare* featuring Pumpkinhead Martin and his brother, Curt, as the ignorant mountaineers who are led by Bugs into a violent square dance that moves through—among other locales—a pigsty. By 1959, the use of human characters as dumb hillbillies had perhaps gotten too touchy for the studio, so McKimson's *Backwoods Bunny* returns to animals—two hillbilly buzzards—as substitutes for the brothers.

During the depression, however, the hillbilly stereotype perhaps served more than one function. Depression audiences, faced with unprecedented unemployment, could look at hillbillies as throwbacks, as an atavistic society that accepted its economic hardship but feuded endlessly: the *primary* "stupidity of the stupid." For audiences of the thirties, this look at hillbillies, an opening into a forgotten past, was no doubt the source of laughs but also might be tinged with fear that a return to "Rural Subsistence Hell" could be in their future as well.

Hillbilly cartoons that simultaneously mock feuding, moonshine, and lying around the shack, while foiling the power of the local sheriff, and shooting the peace-loving preacher man in the seat of the pants, present the flip side to positive and widespread thirties movie images of the U.S. government and democracy: *Public Hero Number One* (1935), *G-Men* (1935), and the Capra films *Mr. Deeds Goes to Town* (1936) and *Mr. Smith Goes to Washington* (1939).[25] Even while these cartoons look down at cartoon hillbillies, Freleng, Avery, and Clampett highlight the mountaineers' rejection of urbanization—the lack of a work ethic, their illegal liquor, their lively picking and singing, and their untrammeled freedom to shoot at their neighbors *and* representatives of mainstream culture—as an anarchistic antidote to the more patriotic images Hollywood features were presenting concurrently. That Leon Schlesinger's Termite Terrace would provide this chaotic alternative vision from within the studio lot is one reason Warner Bros. cartoons have continued to appeal to contemporary audiences.

The View from Termite Terrace

DONALD CRAFTON

Caricature and Parody in Warner Bros. Animation

HOLLYWOOD STEPS OUT is a 1941 Tex Avery cartoon in which none of the "stars" from the Schlesinger/Warner Bros. roster appears. In lieu of Porky, Daffy, or Bugs, the characters are caricatures of Hollywood movie stars—with one notable exception. As the camera pans across celebrities enjoying the floor show at Ciro's nightclub, at one table we see the studio owner Leon Schlesinger and his business manager Henry Binder. The image is incongruous because neither Schlesinger nor, obviously, Binder was a star of the caliber of Gable, Garbo, Stewart, or the others present. Although Schlesinger had amassed modest wealth as the producer of Looney Tunes and Merrie Melodies under contract to Warner Bros., in the drawing he appears to be an uncomfortable interloper in the stellar crowd at Ciro's. His caricatured presence was clearly an in-joke. The thirty-three-year-old Avery and his animation unit were poking fun at their lisping, balding, overweight boss and his yes-man by picturing them surrounded by stars at a restaurant so expensive that dinners could be purchased on the installment plan. Schlesinger's presence, for those few who would have recognized him, was all in good fun.[1]

But "fun" is not neutral ideological turf. It may divert analysis and defuse "serious" interpretation, but a closer inspection always highlights fundamental relationships about economic power and social control. However ostensibly harmless it may seem, caricaturing the boss and his milieu inevitably makes a statement about the animation staff's self-representation as employees, as members of the film industry, and as jesting outside observers of Hollywood society. Failing to see beyond the innocuous or childlike nature of Hollywood animation simply perpetuates a fallacy of innocence. The myth of the classic cartoon as pure entertainment is unsupported by an examination of the industrial

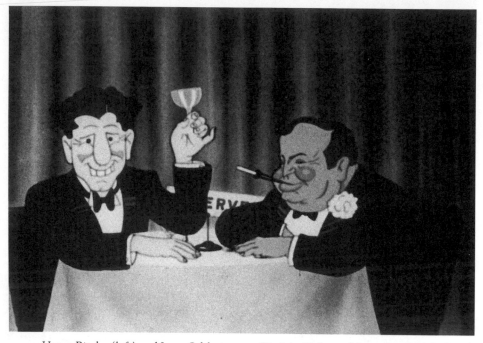

Henry Binder (left) and Leon Schlesinger at Ciro's in *Hollywood Steps Out* (1941). Copyright Warner Bros., Inc.

exigencies of the industry and the social position of the cartoonists, and ignores the messages readily discernible in the films' use of caricature and parody.

With very little reflection one can see that there are several levels of social criticism inherent in the caricatures of Schlesinger and Binder. Caricature is always double-edged. It confirms the celebrity, reinforces the popular recognition of the subject's "star" persona (even if represented as a villain). But it is also a personal and ideological assault. First, in the *Hollywood Steps Out* example, the men are being flattered by constructing "lifestyles of the rich and famous" for them. But the producers' desire to associate with stars and capitalize on their aura is also being satirized. In fact, Schlesinger, though he was probably never a millionaire, did attempt to lead the life of a movie mogul, for example, by ostentatiously traveling to New York to attend the theater, and sailing to Catalina on his yacht.[2] He also made well-publicized visits to the trendiest nightclubs: Ciro's, the Coconut Grove, and the Trocadero.[3] Not only does the caricature call attention to the inappropriate presence of the pretend moguls in this Mecca of conspicuous consumption, it also acknowledges the discrepancy between the bosses' extravagant dining habits and the long hours and low pay of the animators, writers, inkers, painters, musicians, and in-betweeners. The caricatural faces of Schlesinger and Binder also capture brilliantly the former's smugness and the

latter's vapidity, illustrating their outsider status—loose nuts in Hollywood's star machine.

As viewers, we feel several distinct pleasures here. We delight in the comic exaggeration of the physical features of the subjects—the definition of caricature.[4] We also read into the image a subversive commentary on a topical situation. The classic political caricatures of Daumier, Gill, and Nast, and the social *satire des moeurs* (satire of manners) of Gavarni, Held, and Thurber all give pleasure in skirting dangerous territory. There is a feeling that the artist and the viewer are in complicity, exposing themselves to some social risk (hence the term "risqué").

Warner Bros. cartoons, unlike Disney's, are full of caricatures, as well as parodies of movie subjects and Hollywood social life. As in nineteenth-century caricature, these representations of institutions from an outside perspective are based on a presumption of trouble in the works.

Termite Terrace

A genuine celebrity conspicuously absent from the many caricatured luminaries in *Hollywood Steps Out* is Walt Disney. In 1941, Schlesinger was outshone by Disney's dominance of the animation marketplace and his eminence as a popular culture deity. While Disney had his brand new state-of-the-animated-art studio in Burbank channeling its resources into features (although few knew that he was in a financial crisis), Schlesinger presided over crowded rented work spaces in a corner of the Warner Bros. Sunset lot. From 1933 to May 11, 1936, the staff worked in a back lot building.[5] Chuck Jones has described it as "an ancient bungalow faintly redolent of early Norma Talmadge and known accurately and affectionately as Termite Terrace."[6] Even after the move into larger quarters in 1936, the name of the original building was used metonymically for the entire operation.

Schlesinger's penurious attitude became part of his biographical legend. While Disney was experimenting with innovations like the multiplane camera, some Warner Bros. productions were so primitive that one can readily see dust specks on cels, smears from poorly washed reused cels, and, especially in panning shots over dark scenes, the distinct reflection of the animation camera and lens in the middle of the cel.[7] It was also common practice to recycle gags and entire sequences from earlier films in order to meet the quota of a six-to-eight-minute picture each week.[8]

Schlesinger succeeded, despite these constraints, because he benefited from block booking, the practice of packaging an entire season's output of shorts with features. But he also was able to attract a brilliant creative team of directors, animators, and writers, as well as vocal stylist Mel Blanc and composer Carl W.

Stalling. The bread and butter of the studio was its stable of toon stars, beginning with Porky Pig. Their "biographies" have constituted much of the critical reception of Warner Bros. cartoons. But films without trademark characters also constituted a significant portion of the studio output, and this neglected group provides a glimpse at the studio's caricatural sensibility.

Caricature in Cartoons

No particular director is associated with the films that feature caricatures. They crop up in films by Isadore "Friz" Freleng, Frank Tashlin, and Fred "Tex" Avery, among others. There is no particular time frame; films from the Harman and Ising period contain them, but they do seem to trail off after World War II. Surprisingly, though Looney Tunes and Merrie Melodies had a contractual mission to plug Warner Bros. products, the celebrities caricatured (and the films parodied) represent a cross-section of major studios. Some subjects are from radio (in which Warner Bros. did have an interest), nightclub culture, and current affairs. A partial list of examples includes: Al Jolson, Jimmy Durante, Aunt Jemima, Greta Garbo, Paul Whiteman, the Marx Brothers, Ed Wynn, Mahatma Gandhi, Laurel and Hardy, Nanook of the North, Eddie Cantor, Amos 'n' Andy, Adolph Hitler, Joseph Stalin, Benito Mussolini, Hirohito, Wheeler and Woolsey, Jimmy Cagney, Humphrey Bogart, Katharine Hepburn, Peter Lorre, Joan Blondell, Bing Crosby, Frank Sinatra, Maurice Chevalier, Marie Dressler, Joe E. Brown, Mae West, the Mills Brothers, W. C. Fields, Fats Waller, Edna Mae Oliver, Hugh Herbert, Lew Lehr, and "Nipper" the RCA dog.[9]

Some films are almost nothing but caricatures. Freleng's *Coo-Coo Nut Grove* (1936) is a procession of movie and song stars represented as animals. Tashlin's *The Woods Are Full of Cuckoos* (1937) is another typical example of the midthirties caricatural cartoon. There is no plot; celebrities caricatured as animals are gathered for a "Woodland Sing" in the manner of a radio variety show. Some of the stars are recognized by punning names supplied in the film, while others can be identified from the model sheets: Alexander Owlcott, Ben Birdie, Walter Finchell, Milton Squirrel, Eddie Gander, Sophie Turkey, W. C. Fieldmouse, Al Jolson "the Singing Kid," Fred McFurry, Bing Crowsby, Ruby Squealer, and so forth. Sometimes the humor derives from the recognition of the character's similarity to the animal referent—Fields compared to a rodent, for example; sometimes it derives from graphic distortion—Jolson's enlarged lower lip, Crosby's "bedroom" eyes.[10] Humorous references are also made to the subjects' distinctive voices (all, seemingly, impersonated), performance mannerisms, or to their association with a particular song.

This type of film exploits caricature's iconic function, that is, its conventional operation as a stand-in for a recognizable person. Iconic caricatures are

highly intertextual and depend on the viewer's ability to understand the character as a likeness of a specific individual, not just another character in the fiction. Thus for modern audiences, the references and the humor of these caricatures are frequently missing. *The Woods Are Full of Cuckoos* parodies the format of the radio broadcast by visualizing for the movie audience what had previously only been an acoustic space—the sounds of entertainers' distinctive voices and performances. Instead of the disembodied voices, it provides bodies and a setting. In this regard it is analogous to the "Big Broadcast" genre of movie features and shorts, but, as a cartoon, it is typically Aesopian. It anthropomorphizes animals by giving them recognizable human traits and by humanizing nature when it transforms the woods into a radio studio.

Basing a film on the exploitation of iconic caricature, however, causes problems in a medium that is supposed to tell a story. Caricatures are elements of spectacle, not readily assimilated into a narrative diegesis. This film attempts to solve the problem by establishing the narration in a magical moment. Twilight in the woods, when no "human" observers are present, is a time when the animals supernaturally abandon their bestiality to behave like people. Perhaps the prototype of this narrative effect would be found in children's literature, but one example many readers will recognize is Victor Herbert's "The Teddy Bears' Picnic" (1904):

> If you go down to the woods today,
> You're in for a big surprise.
> If you go down to the woods today,
> You'd better go in disguise.

We also find equivalents of this "magic moment" narrative in many other Warner Bros. (and Disney, and Van Beuren, etc.) cartoons, for example, *Billboard Frolics* (1935), and *Speaking of the Weather* (1937).

One cartoon that successfully narrativizes its caricatures is Tashlin's *Swooner Crooner* (1944). Porky is a chicken-farmer doing his bit for the war effort. His egg "factory" is a highly structured system of conveyor belt assembly lines, punch clocks, and Rube Goldberg contraptions for extracting maximum production from the beleaguered hen employees. Production is interrupted, however, when Frankie, a Sinatralike cockerel, appears on the scene and reduces the hens to screaming, wilting, and—most important—nonegg-laying bobby-soxers. Porky retaliates by advertising for a rooster which will make his hens productive again. The applicants include fowl-caricatures of Jolson, Durante, Nelson Eddy, and Cab Calloway. Porky settles on a Bing Crosby rooster whose soothing voice magically induces voluminous egg-laying in the hens, restoring a kind of order on the farm. When Porky asks how he does it, both roosters serenade him and he too produces a mountain of eggs.

The effect of Frankie's high notes in *Swooner Crooner* (1944). Copyright Warner Bros., Inc.

Because he appears so frequently as a caricature, one might think that Bing Crosby had an affection for these cartoon representations. Not so. After the release of *Bingo Crosbyana* in May 1936, the crooner tried unsuccessfully to have the film pulled, his lawyer stating, "The Crosby voice is imitated and the character of Bingo Crosbyana is shown as a 'vainglorious coward.'"[11] By the midforties, when their popularity was at its height, both Crosby and Sinatra were favorite targets for the animators' barbs.

Swooner Crooner, besides being a fine example of the caricaturist's ability to capture the essence of a personality in a fleeting sketch, gesture, or turn of a phrase, uses its caricatures to convey several pertinent wartime messages. One is that entertainers can serve in the war effort by relieving workers of stress, thereby making them more productive. This is an implicit defense of the motion picture industry's special status during the war, as well as entities like the USO. The animation studios, of course, contributed heavily to the war effort, both in the patriotic content of their product, and the service of employees in special military units.[12]

Of interest in this film, though, as a case study of how caricature can be integrated into narrative, is how the caricatured personalities mobilize the film's story. Crosby's and Sinatra's dueling crooning is motivated by the need to resolve the film's central narrative problem, how to turn the workers' inactivity

into wartime production. This is accomplished by the frankly sexual nature of the conflict. Sinatra's voice urges the women toward unproductive release, evoked in images of masturbatory gratification. One hen shoots upright, revealing a "bra" under her feathers, then collapses with a dull thud. Another melts into a creamy puddle. The ultimate image of Frankie's power of mass sex appeal is when the swooning hens are framed between his legs and, as he rises to his toes to hit a high note, his heel spurs elevate to rigid points. It's more than the hens can take.

Bing, on the other hand, provides erotic distraction, but its effects are channeled into egg-making. The hens' gargantuan achievements are accompanied by their clucks and sighs of orgasmic pleasure. The story seems to make a point about the social and military risks of excessive phallic power, represented by Frankie, on women. Crosby's fatherly, nonaggressive sexuality is preferable because it results in a socially tolerated sexual outlet for women: reproduction. But, disturbingly, the film leaves unresolved the problem of reproduction in a society with a diminished number of males, and then there's the question of how a porcine male mammal could lay eggs anyway. . . .

The film is decidedly masculine in its view of women as passive dupes of male sexual power. But the image of the factory as an essential military tool, disrupted by the whims of its female employees, also suggests a sexist distrust of the value of women as workers. The hens, caricatural "Rosie the Riveters," are lessons to female factory workers about their patriotic duty to industry and their domestic duty to resist erotic distractions.

Other examples that marshal caricature to motivate a plot are *The Birth of a Notion* (1947), with a Peter Lorre antagonist, and *Slick Hare* (1947), with Bogey demanding his dinner for "Baby" (Bacall). *Bacall to Arms* (1946) has Bogart and Bacall trying to act out their scenes from *To Have and Have Not* (1944) while a "wolf" in the audience keeps disrupting them. Bogey finally shoots him from the screen, but the movie-within-the-cartoon will never finish. Though predominantly spectacle, caricatures need not interrupt a narrative, but can complicate it by playing on the spectator's prior associations about character stereotypes and patterns of behavior, and already known plots.

Perhaps the most striking traditional caricatural styles are evident in Freleng's *Malibu Beach Party* (1940) and the already mentioned *Hollywood Steps Out*. The characters were based on drawings by Ben Shenkman.[13]

Shenkman's career was typical for the industry. In the late twenties he was working as an office boy at Columbia in New York. He aspired to be a cartoonist, and one of his sketches of the manager was published in the *Columbia Beacon*. The boss introduced Shenkman to Max Fleischer, whose animation studio was nearby, and he joined the ink-and-paint staff. He was soon laid off and returned to Columbia, but this time in Charles Mintz's cartoon unit. Mintz moved

Krazy Kat production to Hollywood in 1930 and invited sixteen-year-old Shenkman to join as an in-betweener, a job he accepted and held for nine years. But his talent as a caricaturist was well-known, and he was in demand as a designer of greeting cards, invitations, and occasional publicity drawings. Freleng, recently returned to Schlesinger's in mid-April 1939 from a stint at MGM, knew about Shenkman by way of his friend at Columbia, Art Davis, and invited him to work on *Malibu Beach Party*.[14]

The plot is very much like a Jack Benny radio program skit. Benny and his wife, Mary Livingston, are throwing a party for their Hollywood friends. The jokes revolve around Benny's stinginess and his penchant for playing the violin badly. Rochester (Eddie Anderson), the servant, is the butt of many of the gags. He is forced to dilute the guests' cocktails, and when they depart during the violin solo, he literally becomes the boss's captive audience when Benny sits on him. The other guests are given their own comic turns as well, rehearse lines from their classic film roles, or simply appear grotesque: Gable rows himself in the ocean with his enormous ears, Garbo water-skis on her big feet, Phil Harris's dark complexion is rendered almost as black as Eddie Anderson's, etc.

While Warner Bros. cartoons had caricatured stars for years, in productions such as *Coo-Coo Nut Grove* with drawings by T. Hee (Thornton Hee), this was a special effort requiring the celebrities' collaboration. Schlesinger had an agreement that Benny would have the right to approve the drawings and the film, and Mary Livingston, in fact, did insist that the caricaturist "do something about the nose" before filming commenced. The stars' studio photographs provided the basis for the sketches. Shenkman recalls that the principals' voices were recorded by the stars themselves, but some of the others might have been impersonated.

The success of his caricatures led to Shenkman's being hired by the studio in March 1940 as an animation assistant.[15] Avery had been working on *Hollywood Steps Out* well before Freleng's film was released, and immediately engaged Shenkman to do caricatures. Avery took him and a background artist to Ciro's to make notes and sketches of the decor and guests. Schlesinger probably had obtained permission from the restaurant. Shenkman made about fifty model sheets of celebrities, which the animators adapted for consistent head size, perspective rendering, and, of course, movement. Parts of the action were rotoscoped. In the scene in which Clark Gable and a mysterious lady do a Rhumba, Shenkman was filmed dancing with Mildred (Dixie) Mankemeyer (Paul Smith's future wife) on a Warner Bros. soundstage. The climactic scene with "Sally Strand" had been rotoscoped and reported in *The Exposure Sheet* the previous summer.

> It was surprising how many people needed change or had to telephone yesterday. Of course, the rotoscoping of a strip-tease artist in the

projection room wouldn't have anything to do with it, I'm sure! It was for an Avery picture, and even Tex was overwhelmed to find how many assistants he had in his unit![16]

The film's uncharacteristically long production time made it possible to advertise it as a special attraction. Ads were placed in the Sunday *Los Angeles Times* a month and a fortnight before the release.

Both these films have a bit of documentary quality about them, derived in no small part from Shenkman's hard-edged "photographic"-style caricatures. Benny's beach parties were legendary, and Ciro's, which opened in January 1940, was *the* place to be for the Hollywood colony. According to Jim Heimann, the place had a reputation for rowdiness (duly reported by the attending gossip columnists) and for its exorbitantly priced deluxe dinners ($7.50, including cover).[17]

Both films picture stars as though defining a cult of idiosyncratic excess. That is, each celebrity is identified by an "attribute," in the art-historical sense, a synecdoche in which that part represents the whole person. J. Edgar Hoover, the G-man, says nothing but "gee." The stars have only their public images, without any apparent existence in the private sphere. Cary Grant can only speak lines from his most popular movies. Jimmy Stewart, being too shy to dance with Dorothy Lamour, reverts to his Mr. Smith character and "goes to Washington." Mickey Rooney and Lewis Stone are locked into their Andy and Judge Hardy roles; Cagney, Raft, and Bogart are eternal Warner Bros. gangsters. The celebrities' personalities are as flat as their two-dimensional graphics. If we accept Richard DeCordova's definition of a star as an actor whose personal life affects his or her on-screen persona, then these films seem to neutralize that stardom by denying their off-screen existence as "ordinary" or "real" folks.[18]

Both films also construct a Hollywood that is marked by excess leisure, where the employees seemingly have nothing better to do than loll about Benny's beach and spend their excess wealth in nightclubs. The work of filmmaking is never alluded to, yet the stars are paragons of conspicuous consumption. (Benny's compulsive penny-pinching is funny because it is so obviously uncalled for, given his income and opulent surroundings.)

These two films typify the Warner Bros. caricatures' ambivalence. They promote the film industry, satisfying the demands of the Schlesinger studio's mission by glamorizing Hollywood and the star system. Yet they imply negatively (some might say, subversively) that the institution is shallow and infirm. The stars in the films are unified by their superior economic status and by their foibles and tag lines. This establishes a distance between stars and "ordinary" viewers, but also it emphasizes the gap between the live and the animated segments of the film industry, a perception which we find documented elsewhere, in the studio newsletter.

Inside Termite Terrace: The Exposure Sheet

We can glean a brief look at the demographics and everyday life of the rank and file at the Schlesinger studio in *The Exposure Sheet*, a few mimeographed pages published biweekly in 1939 and 1940.[19]

An anonymous description of "The Typical Schlesinger Employee" was printed in 1939. Though tongue-in-cheek, parts of it have a ring of demographic authenticity:

> He is twenty-nine years old, five feet nine, and weighs one hundred sixty-two pounds with a budding bay window. He is either married or is about to marry the girl he has gone with "since High School." She works at the Telephone Company or is secretary to Joe Breen [head of censorship at the Motion Picture Producers and Distributors of America organization]. He has one child, sex undeterminable. . . .
>
> He graduated from a local high school where he did a few desultory cartoons for the weekly, and was president of the Art Club in his Senior year—his lone achievements in four years. Otherwise he had a "C-" average and went out for the first few days of football in his Freshman year. After graduation he worked in a gas station for a year, then as a show-card writer until a friend got him a job at Universal as an opaquer, where he stayed until he came here by way of Mayfair.[20]

The image we have is of a typical "below-the-line" craft employee in the film industry of the thirties and forties.

Until the contract mandated forty hours, the employees worked forty-two and a half hours per week. Saturday hours and low pay discouraged a lot of socializing. Judging from the news items in *The Exposure Sheet* and interviews with animators, their pastimes seemed consistent with those of other Los Angeles residents in the same income bracket. Going to movies was very popular. Pool, bowling, and gambling were prevalent. There were picnics and family outings, for example, to the Venice Fun House. Much social activity seemed to revolve around the studio. There were Schlesinger bowling, baseball, and even dart teams. The boss hosted a Christmas party at the Florentine Gardens. This Hollywood Boulevard nightspot, which opened in December 1938, was popular with the animation staff throughout the year, but it was hardly on the same level as the top-notch clubs. It featured revues with "exotic" (i.e., topless) dancers, and a six-course meal for one dollar.[21] If nothing better was available, or if it was between paychecks—according to Martha Goldman Sigall, then an employee in the paint department—a widespread entertainment was "getting soused."

According to Steve Schneider, Schlesinger's gross on each cartoon was about $9,000, out of which all expenses, including the staff salaries, had to be paid.[22] After administrative expenses and profits, there was not much left for the

Wednesday afternoon payroll. For the staff, the $50 dinner advertised in *Hollywood Steps Out* (and even the real $7.50 dinner at Ciro's) was out of reach.

In contrast to the stars, the animation studio workers made a pittance. "Journeyman" painter Martha Goldman Sigall made $21 a week. In 1941, the animators put up a picket line and Schlesinger locked out the crew for three days. When the Screen Cartoonists Guild contract was ratified, it turned out that the Schlesinger animators were already making more than the minimum salary, and received no increases. But the technical staff received raises of $5 per week.[23]

But there is also a sentiment in *The Exposure Sheet* that some employees felt as though their careers were creatively, as well as financially, limited. One suggestive poem, published anonymously, hints at low morale:

> Ode to a Loan Company
> or
> Lament of a Story Man
>
> It was down in the Bronson Valley
> That me and my pal "Stew,"
> Wrote gags in the Termite Terrace
> With eight other punch-drunks too.
> We bought a cheap rug for the floor
> It was a thing divine;
> I know this—when I get fired,
> One-third of it is mine!
> On Wednesday night we get our checks
> And spend them on Martinis;
> While back at home the little wife
> Prepares baked beans and weenies.
> This desk of mine, they willed to me
> From someone's maiden aunt;
> They can't kid me—I know it's true:
> It came from U. S. Grant.
> "Condemned to death" are words that burn,
> And "Guilty"'s not so sunny;
> What really drives a guy insane
> Is this: "That's not so funny."
> Now some will have their big estates
> With pools where doves will flutter;
> But we know better than any seer,
> We're headed for the gutter.
> You'll find white marble on some graves,
> Or marble nice and new;
> But I'm afraid on *my* headstone
> The words will read: "Pee-yew!"[24]

Implicit in this doggerel lament (which is possibly by writer Mike Maltese) is a resignation that the author is in a dead-end job, and that remaining impoverished, getting fired or laid off was inevitable. This seems to be borne out in the comings and goings listed in *The Exposure Sheet*, suggesting a factory with a very high worker turnover (although it would take more research to compare the Schlesinger studio with other small businesses). The newsletter contains other references to the volatility of jobs. One joke, inspired by the song title "You Turned the Tables on Me," reads: "I'm sorry Mr. Binder, but we'll have to let you go."[25] There was also the spurious announcement that, to spare employees "the embarrassment, not to mention the inconvenience of leaving here for Fleischer's only to return in a few weeks," Schlesinger

> has just purchased Fleischer's with certain plans in mind. An underground tunnel will be built with a moving platform, enabling everyone to hop on and off at will. It was also suggested that stationary belts be installed for those making the customary round trip, as there is no need, really, even to get off the platform. . . .
> Truly, Mr. Schlesinger, we of the studio feel this is a very sensible step in the right direction.[26]

Another theme that runs through the newsletter touches on the frustration of artists who are working below their perceived level of talent and training. The biographies reveal that many of the employees had taken formal art training, albeit of the night-school variety. Several state that they had aspired to become commercial artists or designers before being hired by Schlesinger. Many continued to pursue "fine" arts and art photography as a hobby and some participated in an exhibition in 1940.[27]

Despite the absence of references to Disney in Warner Bros. caricatures, there was clearly an awareness of what the competition was up to in the studio. Disney and other "outside" cartoons were screened for the staff to criticize, and, in *The Exposure Sheet*, there are comparisons to the Warner Bros. product, as in this report on the reception of a Chuck Jones Merrie Melodie.

> Kay Vallejo was present at the Filmarte Theatre last Thursday evening, the Disney crowd's usual night for "pictures." Among other things shown, what should appear but "Robin Hood Makes Good." Kay tells us: "Naturally the Warner Brothers' insignia met with boos—but I'm happy to say that the applause at the end was great and without prejudice. A Donald Duck followed, and started out swell. Then the "horror stuff" began, and the audience groaned and winced with pain as Donald was slapped around and staggered under terrific clouts on the head. It goes to show that more than one audience (?) looks with distaste on that sadistic stuff!"[28]

Quite a few on the staff (notably Freleng) had worked for Disney at some point in their career, prompting editor Dave Mitchell (pseudonym of Milton Kahn) once to observe, "If Kansas City ever has old home week, half of Schlesinger's will be missing."[29] According to the "Typical Schlesinger Employee" sketch, the average worker thought that Disney's "quality" was attained at some cost to the employees.

> He [at Schlesinger's] thinks Disney cartoons are terrific even when they're not, but believes "we'd be right up there if we had better animation." He is positive he could do "just as good animation if I could spend the time those guys do on retakes." He is certain that the night work at Disney's is making a group of gibbering epileptics out of them. "You seen ol' Johnny Doakes lately? 'Member what a kid he was when he left here? Well, y'oughta see 'im now. Looks forty-five—no kiddin'."[30]

Mitchell submitted a cryptic poem that, appearing on the heels of *Snow White and the Seven Dwarfs* (1937), seems to allegorize some of Disney's labor troubles and sound a thinly disguised warning to Schlesinger and Binder:

> The Queen Can Do No Wrong!

A haughty Queen once ruled her land
With laws so very fearful;
And 'cause all merriment she banned
Her reign was far from cheerful.
She spent her days, and nights—I guess—
Just snoopin' round the castle,
So she could criticize the dress
Of every serf and vassal:
"Your petticoat is much too long!
You have your doublets cut all wrong!
You might try shaving, if you're able . . .
This is a castle, not a stable!
I don't like this!
I can't stand that!
It's hard to miss
Your awful hat!"
Her people all were genteel folk
And if she raved, they let her,
(As silently they bore the yoke)
Because she knew no better.
Then, when they talked about revolt
Each time the Queen drew nearer,
T'was then she had an awful jolt:
She looked into *her* mirror![31]

Daffy disrupts the studio equipment in *Daffy Duck in Hollywood* (1938). Copyright Warner Bros., Inc.

The labor of animated and live production is referred to in several films. *Daffy Duck in Hollywood* (1938) and *The Big Snooze* (1946) are good examples. *Daffy Duck in Hollywood* uses the standard gags of studio gate-crashing for a lesson on how films are made—as viewed by the animators: "If it's a good picture, it's a wonder." We see three levels of management, the producer (I. M. Stupendous), the director and his covey of yes-men, and the actors (Katharine Hepburn and Ronald Colman). The emphasis is on the incompetence and wastefulness of the German-accented director, Mark Hamburger, a caricature of Mark Hellinger. Daffy Duck provides an Eisensteinian alternative to the director's emphasis on mise-en-scène, cutting together bits of footage to produce a pastiche. In the inverted logic of cartoons, Daffy's film is a great success and the neophyte replaces the director.

Contrary to this affirmative scenario, *The Big Snooze*, like other Warner Bros. films of the early forties, raises the specter of job insecurity. Elmer's quitting the animation biz leaves Bugs in doubt about his own career (much as Bob Clampett's leaving Warner Bros. to start independent production must have concerned the team; this was his last cartoon for the studio). Bugs sets out to turn Elmer's dreams of retirement into a nightmare in order to induce him to return to work. His most convincing images are symbols of the animation process: millions of wabbit

pictures cranking out of Bugs's "multiplication" machine, and cycled repetitions of little Bugses forming the "Super Chief."

In 1946, there was a feeling of insecurity and unrest in the film industry and in the animation unit. There was an uneasy negotiation period following a strike (marked by a conflict between the Conference of Studio Unions and the IATSE [International Alliance of Theatrical Stage Employees]) that had closed the majors from May through October. In August 1946, the strike would resume. In 1944, Leon Schlesinger had sold the animation studio to Warner Bros. for $700,000. (That's why Elmer's contract is with "Mr. Warner," not Mr. Schlesinger.) At Termite Terrace there was dissatisfaction with Edward Selzer, Schlesinger's replacement as unit manager. Although block booking was still practiced until 1948, the producers of shorts knew that its demise would cause serious hardship. In short, labor trouble, the postwar recession, and other economic clouds were making the future hard to read. Not renewing a contract, or just contemplating it, must have provoked anxieties that became grist for the animation mill.

Unlike the 1938 film's parable of upward mobility—making Daffy comparable to Sammy Glick in *What Makes Sammy Run*, Budd Schulberg's novel—*The Big Snooze* is about being trapped in the system. It was common knowledge that even the real stars, like Bette Davis, could not get out of their Warner Bros. contracts. She was represented by a vacant table in *Hollywood Steps Out*. Elmer's shamefaced piecing together of his impulsively torn-up contract suggests a throwing-in of the towel, giving in to an unchangeable studio system.

Cartoons in Hollywood

Surely the most obvious sore spot was the competition against Disney for honors. In the Academy Awards, especially, Schlesinger complained that the animation awards were biased. He withdrew from competition in 1938.[32] The staff's pining for this recognition in 1940 was openly stated.

> Oh, for an Oscar!
> We are anxiously awaiting the outcome of the Motion Picture
> Academy's awards—particularly in the cartoon division.
> At the present writing, four cartoons are up for the award: One
> Schlesinger, two disney [sic], and an M.G.M.—in case you didn't know,
> the Schlesinger cartoon is "Detouring America" [dir. Avery]. Of course
> we don't wish Disney and M.G.M. any tough luck—but . . . well, you
> know how it is.[33]

The 1939 Oscar went to Disney for *The Ugly Duckling*. In the eight years of awards, it was Disney's eighth win.[34]

Consciousness about the studio's conspicuous lack of Academy Awards forms the basis of Clampett's *What's Cookin' Doc?* (1944). After a live-action newsreel-style introduction that builds suspense around who the nominee will be, we discover Bugs Bunny at his table. Montage strategies, intercutting the rabbit with live-action clips from the 1937 version of *A Star Is Born*, make a place for him in the Hollywood milieu and associate him with "real" stars: footprints at the Chinese theater, nightlife at the Trocadero and Coconut Grove. We learn he's been nominated for an award, but not in the animation category. He is competing with humans for best actor. Bugs's thespian talents are indisputable; he demonstrates that he cannot merely imitate celebrities, he can *become* Hepburn, DeMille, Robinson, Jerry Colonna, and Crosby. During the announcement of the winner's traits, Bugs shows they all apply to him. His plastic body changes to illustrate his dramatic acting, his refined comedy, his character roles (where he becomes Frankenstein's monster), and his prowess as a screen lover (where he becomes Charles Boyer, intimately romancing a carrot).

Bugs shows a clip from Freleng's *Hiawatha's Rabbit Hunt*, a 1941 Academy Award nominee (that lost to Disney's *Lend a Paw*.) After the excerpt Bugs campaigns directly to the "people," supposedly the spectators in the movie audience. His dispensing cigars, drum beating, and glad-handing get Bugs his Oscar, but it is a diminutive "booby prize," a second-class award like those miniature Oscars awarded to Disney for *Snow White*'s dwarfs. This suggests that the awards are given not necessarily to the most talented and deserving, but to those (presumably Disney) capable of lobbying and press-agentry. (Incidentally, *What's Cookin' Doc?* was *not* nominated by the Academy in 1944.)

The place of cartoons vis-à-vis Hollywood is remarkably demonstrated in Freleng's *She Was an Acrobat's Daughter* (1937). The film is a parody of an evening at the movies, with its full program of entertainments. The only thing missing from the movie smorgasbord is a cartoon. The focus is on the cinema's public sphere, focusing on the various distractions in the audience.

Of special interest are the in-jokes during the sing-along. The singing flea emerges from a dilapidated purse marked with the initials "J. W." and the acrobat's daughter is bitten by a lion named Jack, emphasizing the parsimonious and vindictive personality of Jack Warner. This joke, a reminder of Warner Bros.' famous feud with Bette Davis, sets us up for her big scene with Leslie Howard (both fine caricatures) in a send-up of Warner Bros.' big hit of 1936, *The Petrified Forest*, which is here ridiculed as "The Petrified Florist."

The only audience member who seems to miss the cartoon is a little duck who takes matters into his own hands (wings?). He interferes in the projection booth, but only succeeds in making the grown-ups' film funny by making it go forward and backward, fast and slow. Finally the apparatus destroys him by turning him into film stock and "projecting" him. There seem to be several cau-

Hitler is transformed by an oblique perspective in *She Was an Acrobat's Daughter* (1937).
Copyright Warner Bros., Inc.

tionary messages here. Children are untutored in how to be good film specta-
tors and can disrupt the program. But, since our sympathies are clearly with the
cute duck figure, is there an analogy between undisciplined moviegoers and the
"children" on the Warner Bros. lot, the animators, who have to keep their mischief-
making confined to the short-subject part of the program? Another message is
that toons pose a threat to live action, much as Daffy keeps harassing Katharine
Hepburn, Ann Sheridan, and Lauren Bacall in other films. We are not assured
that order will be restored.

Fun as a Weapon

Some of the most cogent theoretical points about caricature were made by Ernst
Kris, a friend of and collaborator with E. H. Gombrich, who was formulating
his ideas in the midthirties, coincidentally at the time of the classic animated
short. One does not need to subscribe to his Freudian psychoanalytic theory (to
which he was an early contributor) to see the saliency of several observations.
He argued convincingly in favor of "the aggressive nature of all caricature, which
seems to condition its mechanisms." For Kris, "Caricature *is* a broadside." Though
originating in a belief in the magic of images, modern caricature must always

be a joke, not a real taboo practice. Of key importance is Kris's idea that it is the spectator who is the real subject of caricature: "Caricature . . . tries to produce an effect, not, however, 'on' the person caricatured, but on the spectator, who is influenced to accomplish a particular effort of imagination."[35]

Bugs Bunny's use of caricature in *Hollywood Steps Out* could illustrate Kris's contention that it is a disguised insult, a "degradation." It is powerless itself, in fact it acknowledges the enemy's power, but it is an effective weapon because the spectator perceives the enemy or victim's weakness. "[The] victim appears transformed and reinterpreted and only this interpretation contains criticism. Aggression has remained in the aesthetic sphere and thus we react not with hostility, but with laughter."[36] Caricature thus constitutes a collective ideology to rally the out-group. It assumes a shared attitude toward a commonly perceived subject.

Kris was writing about classical political caricaturists such as Daumier, but the observation holds for caricature in animation as well. A strategy of the animators was to mock movie stars, the movie industry, and their own bosses under the guise of "fun." But the humor also reveals serious aspects in Hollywood's system, much as the crooner in the henhouse or the rabbit at the awards disrupted the representations of a smoothly running system. The animators seem to appeal to the spectator's desire to unmask Hollywood, which, if successful, would also reveal the injustice of their second-class status.

Richard Terdiman, in his discussion of "newspaper culture," argues that caricature was an example not only of a counterdiscourse standing up to authority but also of open anger felt by the antibourgeois toward the bourgeoisie.[37] This characterizes Warner Bros. animation as well. There was resentment toward the dominance of the Hollywood system that privileged live stars over animated ones, and Disney's (allegedly exploitive) product over Warner Bros.' (allegedly humane) cartoons. But there was also resentment toward the work of animation, which was frequently claimed to be intellectually stifling, and the animation studio, which was alluded to frequently as a nuthouse, and represented as an asylum in films like *A Cartoonist's Nightmare* (1935).

In their use of caricature, and in their parodies of live-action and animation studios, the animators were mounting a symbolic resistance. Though they had no real power in the Hollywood machine, nor the wealth required to enter Hollywood society, their drawings and stories gave them the illusion of control over their industrial and social environment. By representing them in their films, the animators reduced actors and actresses to drawings, meeting them on a level playing field, as it were, in order to expose their fundamental "two-dimensionality" in contrast to the toons' vitality and humanlike wit.

In some Warner Bros. cartoons the plot enacts a fantasy of revolution. In films like *A Cartoonist's Nightmare*, *The Big Snooze*, and *She Was an Acrobat's*

Daughter there are revolutions that fail; the toons cannot escape the system. But the endings of other films, notably *Daffy Duck in Hollywood*, are object lessons showing how "crazy" toons can exploit Hollywood's weaknesses—inefficient operations, egomaniacal directors, and philistine producers—not to overturn the system, but to become part of it.

This sentiment was confirmed graphically in 1944, when the Warner Bros.' acquisition of Schlesinger's animation unit was announced in the Warner Bros. company newsletter in the form of a cartoon showing the toon characters at the main gate. Bugs is saying, "Gate-Crashers Nothin', Doc—We're part of the family now!"[38]

The view of the animators is not from the perspective of the politically oppressed but from that of the aesthetically misunderstood and economically disenfranchised. Repeatedly in *The Exposure Sheet* we find paeans to the social and entertainment value of cartoons. Here is an example by Michael Maltese:

Cel Silly

Set aside your indignations
And regard the machinations
Of the animation industry with awe;
Nowhere else in all the nation
Will you find a near relation
To this abdication of all mental law.

Inbetweeners,
Idea weaners,
Celluloid cleaners...
 They're all here.

Animators,
Syncopaters,
Nut creators,
 Out of gear.

Bug assistants,
Lug insistants,
Jug persistants,
 Have a beer?

Big time bosses,
Small time bosses,
Card game losses,
 Shed a tear!

Cute opaquers,
Ink-line makers,

Picture takers . . .
 Give a cheer!

For 'tis they who bring you levity
In an animated brevity,
While you anchor gloom and worldly fears outside;
Knowing that your note of sadness,
Will be singing songs of gladness—
When their cartoons and your funnybone collide![39]

It would be misleading to speak of a real animators' revolution, but certainly the opportunity to symbolically represent their marginal standing in Hollywood must have been appealing. Perhaps the best image for their relation to the industry was the witty one they coined themselves: they were quite a bit like termites, minute pests, labor-intensively tunneling within the infrastructure of Hollywood.

This suggests a subversive reading of the famous Looney Tunes envois. For most viewers, the "real" movie began when the cartoon was over. Perhaps the strident declaration, "That's all, Folks!" was a provocation from the animators, an assertion that the interesting part of the evening's program was *already* over and the feature to follow was a mere anticlimax.

Darker Shades
of Animation

TERRY LINDVALL AND BEN FRASER

Producing images of blacks in a racist context is [always] politically charged.

—BELL HOOKS

African-American
Images in the Warner
Bros. Cartoon

Framing blackness in the midst of the hegemonic Hollywood film industry, Ed Guerrero recognizes how Hollywood comedies featuring blacks can "mask and express insurgent social truths and discontents" through satire and parody.[1] By doing so, Guerrero argues, films like *House Party* (1990), *White Men Can't Jump* (1992), and *Sister Act* (1992) can offer a delicate, multivalent balance that plays up and off of simplistic representations. In a similar vein, the animated film can be equally subversive and compromising. An accurate reading of black representation in any cartoon must be grounded in an understanding of that film's audience, context, author, and the cartoon's innate tendency to play havoc on formulaic themes and traits.

While images of blackness have received critical coverage in studies of the classical Hollywood cinema, they have been generally neglected in the often overlooked category of the animated film. Major texts and monographs on the representations of blacks in cinema have barely acknowledged the systematic iconography of blacks in the animated film, perhaps because, as Peter Noble prophetically suggested in 1937, "Despite their survival power, cartoons were only a minor thread of black culture."[2] Yet cartoons, paralleling their dramatic narrative counterparts, also inhere the ability to reflect the spirit of an age, to function as frozen or embalmed cultural artifacts that document the time and place from which they are retrieved.

Hollywood may claim to reflect what it perceives to be public attitudes in its portrayal of foreign or minority characters by translating those intuitive perceptions into concrete images. Nevertheless, be it dimwitted earnestness or ethnic insensitivity, the images of blacks in animated films contributed to an evolving mass popular folklore that propagated indiscriminating racist attitudes,

essentially placing a mediated image of a "foreign people," even a tribal people, before a xenophobic public eye. This essay seeks to extract and distill the dominant types of these black images in the realm of the Warner Bros. cartoon, a species of film that not only allowed caricature and exaggeration, satire and ridicule, but abetted, profited, and fed off them.

The nature of the cartoon is the portrayal of physical characteristics, usually outlining with humorous hyperbole the distinctive qualities of a person or group, including ethnic groups. This tendency has not changed throughout most of animation history. Irene Kotlarz convincingly argues that in relation to the issues of representation, one finds a clear "construction" or "creation" of types in "the drawn or modelled images of animation as opposed to photographic images of 'real' people."[3] The image on the screen is invented by an act of human consciousness and intent; it is a rhetorical expression of an individual imagination and corporate cultural hegemony. Consequently, the creators of these systematic illusions truly reflect the times in which they make their films; the cultural context shapes the perceptions and inventions of the artist. While we recognize that any work of art is a deliberate and conscious construction, we must also recognize the involvement of nondeliberate and unconscious or subconscious factors in any art form. Since artists are captives of the larger culture in which they work, they are not always culpable on the individual level for those invisible prevailing assumptions and sins of omission.

The concept of racism, Jan Nederveen Pieterse explains in *White on Black*, "brings together under one heading very diverse phenomena which have but a single feature in common: discrimination on the basis of allegedly 'racial' characteristics."[4] In order to begin engaging in a serious discussion of race and discrimination in the United States, Cornel West emphasizes that we "must begin not with the problems of black people, but with the flaws of American society—flaws rooted in historic inequalities and longstanding cultural stereotypes."[5] Although few people would deny that those flaws remain bleeding scars on the American social body, their origins and motives are not so obvious.

In a historical inquiry of this type, motives are difficult to discern. One is left with factual evidence and effects, not with authorial intent. A particular problem of representation is that even attributing general characteristics to a race or ethnic group may be racist per se. According to the editorial cartoonist for the *Virginian-Pilot*, John Lawing, "If the cartoonist makes a black look stupid he may be accused of racism. If he makes the black look smart, he may be accused of reverse racism. If he make him neutral, he may be accused of failing to give blacks a significant role."[6] Under that definition, even the attribution of positive characteristics becomes racism. Thus, any form of racial description is inherently racist. The difficulty here resides in accessing intentionality, especially in situations long passed and unavailable for scrutiny and inquisition. Even

though, as Karl Cohen points out, Chuck Jones saw Inki, one of his ethnic characters, as a product of "misplaced innocence,"[7] the cartoon character still emerged as a dominant black stereotype of the late thirties and forties.

A significant difference exists, however, between racial stereotypes and racial types. It is racial typing to recognize existing racial types, such as the humorless Englishman, the Irish drunk, and so on. It becomes stereotyping when a second step is taken, suggesting that all Englishmen lack humor. When every Englishman is portrayed as a sourpuss, the type becomes stereotype. A similar situation happens too frequently with portrayals of African Americans. The actress Marla Gibbs suggests that the problem with the old *Amos 'n' Andy* radio program was not that the types presented on the show were false. The types, she says, were easily recognized by those in the black community. The problem was that these types were allowed to represent the entire black community, ignoring black professionals and other role models.[8] Of all stereotypes, the dominant caricature was Stepin Fetchit, whom Donald Bogle identifies as "the embodiment of the nitwit colored man."[9]

When racist hieroglyphics signal the identity of the individual as a whole, its imagery conjures up all manner of enduring prejudices in the audience. Yet, as Leonard Maltin argues, for the most part, ethnic humor of the twenties and thirties was basically tame and mild.[10] Will Friedwald and Jerry Beck share that point of view: "The only time [stereotypes] could really do any harm was if someone lived in a country town where there were no, say, Irishmen, and the only Irishmen he was familiar with were those in the movies. He might grow up thinking that every Irishman was a drunk, not knowing better and assuming the stereotype of the movies was true."[11] This comic stereotyping reflected the ways in which ethnic groups joked about themselves. "At the time," animation scholar Charles Solomon points out, "most people considered this style of humor both good fun and good taste."[12]

One must remember, the cartoon itself is a sort of graphic slang for this style of humor: mostly it lampoons, pokes fun at, entertains, makes silly, or acts like a deliberately vulgar rube. Its buffoonery makes buffoons of everyone, regardless of ethnic or national identity. With its broad stereotypes, outrageous action, and irreverent humor, the cartoon serves as an index of public attitudes about race. The dangers lie in its nature to (re)present a type, which, to some willing and limited imaginations, can become a stereotypical fact.

Burlesquing Black Representations

Much of the humor found in early cartoons stemmed from the vaudevillian and burlesque stages and turn-of-the-century illustrations and comic strips, born of the Yellow Kid newspapers.[13] For example, R. F. Outcault gave birth to the

juvenile rascal, the Yellow Kid, who first appeared in William Randolph Hearst's *New York Journal*. Stock characters reigned rather than real people. The melting pot of the United States mixed immigrants from many parts of the world together, with everyone ripe with comic potential. Physical stencils made such types readily identifiable for quick, crude, shorthand comic bits. Dr. Lawrence D. Reddick, black scholar and author, maps out a typology of those representations that became "Negro stereotypes in the American mind," including several (such as the savage African, the happy slave, the natural born musician, the chicken and watermelon eater, the mental inferior, and the superstitious churchgoer) that appeared regularly in the animated cartoon.[14] A cartoon instruction book by E. C. Matthews used in the forties propagated this prejudice: "The colored people are good subjects for action pictures: They are natural born humorists and will often assume ridiculous attitudes or say side-splitting things with no apparent intention of being funny. . . . The cartoonist usually plays on the colored man's love of loud clothes, watermelon, crap shooting, fear of ghosts, etc."[15] The obvious racist stereotypes of Matthews's instruction made their way into the history of American animation. At Warner Bros., the idiots who pursue Bugs Bunny include the fat, stupid redneck Elmer Fudd, the bumbling little Hiawatha, and a pokey Stepin Fetchit black who slouches along, blinking as slow as molasses.[16] What we hope to make evident, however, are the iconoclastic productions that emerged from the looney artists of Termite Terrace. While dealing in the visual discourse of oversimplified and formulaic conventions, those racist inventions that Clint C. Wilson and Felix Gutierrez argue are too familiar,[17] Warner Bros. animators tweaked out a slightly subversive variation from the other studios. Yet, it is first important to show how Warner Bros. accommodated the prevailing racist stereotypes in the thirties and forties.

The classic Hollywood studio system during this time defined the range of representations, including stereotypes, that would be conveyed through its products. The quintessential patriarchy of Louis B. Mayer determined who would be permitted to work in the glossy big house of MGM and how they would be imaged. Likewise, the cinematic images invented by the Warner Bros. studio also reflected the philosophy of its executives. Showcasing a Jewish musical-comedian blackface minstrel in 1927, Warner Bros.' inaugural sound film, *The Jazz Singer*, was the prototype for the creative animation division of the studio in its alloy of music, comedy, and race.

Film historian Ethan Mordden argues that all the Warner Bros. movies of the thirties were the same movie: "fast, hip, contemporary, political, urban."[18] This style, explains David Bordwell, was conveyed by the quick cutting and tight editing of the films, in which the average shot length was shorter than its counterparts elsewhere.[19] Consistency of style derived from the cost-efficient producer-unit system employed by Warner Bros. The expectation to produce quick and

dirty programs, driven by economic motives, resulted in a uniform product. Unfortunately, this uniform product would too easily inherit the biases and prejudices of its day. Endemic within the studio system was a silent institutional racism of which the management generally remained ignorant or neglectful.

Surprisingly, Warner Bros. garnered unexpected praise for its progressive representation of blacks in the cinema. *New York Times* critic Bosley Crowther cracked open this topic on June 6, 1943. Crowther protested that cinematic racism constituted "a grave social abuse" and that the film industry stood as a bulwark of this "cruel stigma." Crowther perceived a significant break from this disrespectful racism in the striking "racial equity" of the Warner Bros. films, which "generally had a more liberal and realistic appreciation of Negroes" than the output of the other studios. Rather than an institutionally demeaning or patronizing attitude, dignity and respect were afforded its black characters.[20]

Although Crowther and others may have observed some form of civility toward the portrayal of blacks in live-action cinema, ultimately, cartoons showed little respect to any man or woman. Regardless of race, ethnicity, creed, or physical characteristics, cartoons presented broad caricatures of everyone, such as Clark Gable or Frank Sinatra.[21] To show consideration to whites, Indians, Japanese, German, or blacks would negate the very nature of a cartoon: lampoonery. At the same time, just because a creature happened to be inked black did not necessarily indicate that its color was meant to have racial significance. Blackened faces of mice, bears, monkeys, crows, dogs, and cats (from Otto Messmer's drawings of Felix the Cat to Tex Avery's cartoon *Bad Luck Blackie*, 1949) did not necessarily represent ethnic types. Yet these caricatures were a step away from stereotyping certain characters, even Mickey Mouse, as African Americans. Perhaps the most famous early character evolving in a Darwinian fashion from an ambiguous sort of animal was Hugh Harman and Rudolf Ising's Bosko the Talk-Ink Kid at Warner Bros., who eventually became a recognizable black boy at MGM.[22]

At Warner Bros., Bosko was a cartoony Al Jolson as the Jazz Singer.[23] According to Ising, Bosko "was supposed to be an inkspot sort of thing. We never thought of him as human, or as an animal. But we had him behave like a little boy."[24] A similar question about Bosko's identity was posed in Leonard Maltin's *Of Mice and Magic*: Mickey was a mouse, Felix was a cat, Oswald was a rabbit, but what was Bosko? At his genesis, writes Maltin, Bosko "was in fact a cartoonized version of a young black boy . . . [who] spoke a Southern Negro dialect."[25] For example, in *Bosko's Holiday* (1931), Bosko declares in his intermittent drawl that "I sho' done likes picnics."

Though some facial characteristics and voice types gave evidence to Bosko's status as a black child, few behavioral stereotypes did. He and his girlfriend, Honey, were the most balanced portrayals of blacks in cartoons to that point,

cheerfully romping through the kinds of formulaic coy adventures that Mickey and Minnie had. Clad in a glamorous and slinky gown in *Bosko in Person* (1933), Honey even gets to sing Billie Holiday–type blues, a nonracist, racial tribute to a real person. Animation historian Tom Bertino concedes to this point.

> Occasionally, his racial identity is exploited, as in *Bosko the Doughboy* (1931), in which Bosko's entrance is heralded with an instrumental chorus of "The Kinky Kids' Parade," or in *Bosko the Lumberjack* (1932), where he savors a sandwich by declaring "Dat sho' is fahn!" Otherwise, except for a rare exclamation of "Mammy!" (notably in the earlier pictures), [Harman and Ising] never called attention to Bosko's racial status, and certainly steered him clear of dice and watermelon.[26]

Generally, Bosko received positive portrayals as a spunky and resourceful boy.

However, one telling scene in only Bosko's second cartoon seems to belie such naïveté and guiltlessness on the part of the animators. In *Congo Jazz* (1930), Bosko appears in the jungle with a chimpanzee on one side and a gorilla on the other. What makes the scene eerie is that there is virtually no difference between the faces of the three. Bosko is only identifiable as human in two ways: he is midway in size between the chimp and the gorilla, and he is the one wearing clothes. The monkeylike face conjures up an animalistic genesis, not a transcending *imago dei*, and constitutes one of the most racist and demeaning representations of blacks in film.

In terms of intercultural respect and fair representation, films featuring black characters in jungle scenes represent the worst in Warner Bros. animation. All too often, early cartoons deteriorated into jungle scenes and cannibal episodes. In the midthirties, after the departure of Harman and Ising, Schlesinger was in need of a new "star" to replace Bosko; in came Buddy, a more offensive white counterpart. Incorporating similar jungle imagery as the Bosko shorts, several Buddy cartoons are, in fact, more racist, especially *Buddy of the Apes* (1934), *Buddy's Circus* (1934), and *Buddy in Africa* (1935). *Buddy's Circus* includes tasteless and stupid gags about naked natives with rings in their noses. In one sequence, the ring is even long enough for the wearer to jump rope with it. This black primitive tribe called Ubangi have lips so large that a phonograph record (a "Ubangi-phone") can be squeezed between their lips. Although this gag was based on the true phenomenon of the Ubangi tribe in Africa,[27] it is used as the basis for racial humor in this short. Friedwald and Beck suggest a more apt title for such a cruel and insulting cartoon might be "Buddy's Negro Freak Show."[28]

The fascination with African jungle characters carried over to the audacious, but affectionately rowdy, imagination of Chuck Jones. Jones, however, laughed with his creations and not at them, especially when they were hunted or weak creatures. Inki was created as a cute burlesque of a little cannibal hunter

with a big bone in the topknot of his hair. In five films,[29] Inki is a surreal wildchild. He is frequently rescued by a weird nemesis, a Mynah Bird who hops to the beat of a repetitive and hypnotic rendition of Mendelssohn's overture to "Fingal's Cave." Asked if he enjoyed making the Inki and Mynah Bird cartoons, Jones confessed that his affectionate invention was baffling to everyone including himself. "I didn't understand them. Nobody understood them. Disney brought his writers out and showed them that stupid bird walking around, and he asked, 'What the hell is he doing?' I didn't know."[30] Nevertheless, audiences ate them up.[31]

The explanation for Inki's popularity extends beyond the issue of race, transcending his design as a black caricature. Inki was an Everyman in which the mysterious fourth-dimensional forces of life would intervene. Inki, then, was not a racist stereotype as much as a strangely comic symbol of all humanity, frustrated and rescued by the wonderfully inexplicable. Charles Solomon offers a cogent perspective.

> In a few cartoons, the character's race is more or less ignored, as in Chuck Jones's Minah Bird series. Inki could be any color (or size or sex or species) and it wouldn't affect the films. A samurai, a rabbi, or a Viking could provide equally effective reactions to the understated hopping of the seemingly invincible Minah. The character just happens to be a pygmy blackamoor. . . . But when the ethnicity of the characters becomes the basis for the gags and/or story line, it becomes difficult for contemporary audiences to deal with the cartoons.[32]

Inki's appeal resides in the animator's admiration for the character, not in racist put-downs. In his autobiography, *Chuck Amuck*, Jones acknowledges that in order to be a competent director you "must love what you caricature. You must not mock it."[33] Since animators, like Jones, were minorities, a group oppressed by Machiavellian producers, they could easily identify with other outcasts and dispossessed people. The true object for burlesque and satire was the pompous. The arrogance of Daffy Duck, for example, provided ripe opportunities for animators to exercise their wits. They would rather use their gags to puncture the pretensions of a Leon Schlesinger than an ethnic group. But in the chaotic rush to put out cartoons every week, shorthand ethnic caricatures were easier to use for a quick, cheap laugh.

Gags and Parodies

The Warner Bros. animators built graphic strawmen out of raw cultural material to explore as objects of humor. To tap into some salient physical or cultural attribute was in effect to define, target, and exploit a recognizable comic symbol for a joke. Distortion and exaggeration were the tools of the animation trade.

A fair number of ethnic "gags" were staples in the Warner Bros. cartoon pan-
theon. One was Stepin Fetchit. Avery's *All This and Rabbit Stew* (1941) features
a Stepin Fetchit character drawn with a large balding head, wearing a straw hat
and dragging his gun. His slurring "Well, shut mah mouth, ra-a-bbit tracks" and
"Ah'm gonna ketch me a ra-ha-ha-bbit" mimic the funny, though offensive, drawl
of Fetchit. Stereotypically, he would rather shoot craps than wabbits, praying,
"Dize, do'n fayil me now." Friedwald and Beck try to justify this kind of por-
trayal by explaining that Stepin Fetchit in this film is no more antiblack than
the "moronic, lisping Caucasian" Elmer Fudd, who is "antiwhite."[34] In their opin-
ion, Stepin Fetchit is just a variation of the dumb Fudd type who repeatedly
metamorphosizes into a large sucker. Avery biographer Joe Adamson views the
character quite differently: "The unfortunate blackface caricature spoils a suc-
cession of awfully funny gags."[35] However, the original cartoon is funny, in part
because of the brazenly rude and insulting, though not malicious, representation.

Ising utilized the standard "scared black" gag in *Hittin' the Trail to Hallelu-
jah Land* (1931). Here, dancing graveyard ghosts spook Piggy (a minor star in
the thirties) and his "Uncle Tom" servant. The gag of a total blackout reveal-
ing white eyes and grinning white teeth was used for a variety of characters—
many not even associated with race. In *All This and Rabbit Stew*, Avery highlights
the whites of all three characters' eyes in a bear cave: the bear, a Stepin Fetchit
character, and Bugs Bunny. However, one cannot dodge the frequency of this
gag's relations to a barbed racial pejorative.

In 1938, Friz Freleng directed *Jungle Jitters*, in which the white, ugly queen
of an African jungle tribe wants to marry a traveling salesman; the queen's sub-
jects would rather eat him.[36] While Freleng generally showed restraint in using
racial stereotypes, he did use conventional, albeit derogatory and reproachful,
representations. His tarnishing of the black image was often the stain of easy
wit and crude parody. In *Goin' to Heaven on a Mule* (1934), featuring an all-
black cast, a black Saint Peter welcomes a departed sinner into the gates of "Pair
O' Dice," where he enjoys himself in swinging fashion until he imbibes the for-
bidden fruit of gin and is then cast out. Freleng's *Sunday Go to Meetin' Time*
(1936) finds Brother Nicodemus being dragged by the ear by Mammy (mammies
were ubiquitous in films dealing with black culture) over to the church (churches
were more easily portrayed in predominantly black settings due to the vivacity
of their worship rituals). He then slips off in the opposite direction to try and
steal a few chickens. After a knock on the noggin, he wakes up at his Judgment
in Hades, where, for stealing chickens and watermelons, he is damned by the
devil.

The black comic types, devised by the Warner Bros. cartoon directors, were
designed and written like the subjects of all their cartoons: for grown-ups, for
adult sensibilities, for themselves. In Avery's *The Penguin Parade* (1938), Fats

Walrus entertains audiences with his obvious caricature of Fats Waller, whose own jam-and-jelly image was itself burlesque.[37] When Uncle Tom tells Simon Legree in Avery's *Uncle Tom's Bungalow* (1937), "My body may belong to you, but my soul belongs to Warner Bros.," this conceivably racist line actually thumbs the animator's nose at producer Leon Schlesinger and mocks Mickey Mouse's more traditional retort—"My body may belong to you, but my soul belongs to God"—in *Mickey's Mellerdrammer* (1933).[38]

In addition, Avery's crazy, libidinal gags fit all kinds of characters in a truly egalitarian fashion, black types as well as any other. Although black stereotypes still intruded, his films' aggressive sexual insanity and graphic eroticism overwhelmed any notion of racial issues. Avery's unbridled slapstick democratically dismantled everybody. Here was the artist who virtually exploded the normative conventions of classic filmmaking, a sort of cartoony Brecht. He did not shrink from crossing human and animal in any context. He would literalize clichés to a shocking degree, such as when a frog croaks, he blows his brains out.

Avery's *Wolf and the Showgirl* series at MGM stretched the limits of unadulterated and unrequited lust.[39] The ethnic identity of the horny, suffering Wolf made no difference. In *Red Hot Riding Hood* (1943), the showgirl Little Eva ("got the penthouse suite, and that ain't all she got, yowzuh!"), and her hot rendition of "Carry Me Back to Old Virginny" in *Uncle Tom's Cabaña* (1947) is more of a come-on than a piece of sentimental plantation nostalgia. Uncle Tom, Joe Adamson points out, is "a grand old black man (not so much a caricature as a parody of a caricature)."[40]

However, Avery sometimes blatantly exceeded the boundaries of decency. In Warner Bros.' *A Day at the Zoo* (1939), Avery sketched a mix-up, Buñuelian gag in which a caged monkey persuades the zookeeper that a black visitor should be behind bars and not him. The insulting humor, based on the facial and physical similarity of the cartoon man and monkey, stretches the bounds of good sense as well as good taste. While the nature of satire and avant-garde asserts its prerogative to challenge acceptable civil standards, one cannot excuse cruelty on the grounds that it is comic.

Rural bumpkins were replaced in the late thirties as Warner Bros.' animators began to draw broad caricatures of famous Hollywood comics and musicians.[41] Herein evolved the caricature of the urban hepcat, streetwise, shrewd city folk fond of jazz, sex, gambling, and loud clothes. A mix of the two distinct black cultural styles was evident in certain transitional cartoons. Friz Freleng's playful *Clean Pastures* (1937), a light, mischievous parody of Marc Connelly's Pulitzer Prize–winning *Green Pastures*, features such hep luminaries as Fats Waller, Cab Calloway, Bojangles Robinson, the Mills Brothers, and Louis Armstrong alongside a one-dimensional Stepin Fetchit, cast as a lazy angel assigned to keep

sinners out of nasty nightclubs. The music includes toe-tapping selections from "Sweet Georgia Brown," "Save Me Sister," and other lively rhythm numbers. Another Freleng parody was an all-black version of Goldilocks, *Goldilocks and the Jivin' Bears* (1944), in which three black bears are a jitterbug swing trio. While the energy and jazz of the cartoon keep it amusing, certain images, like a molasses-slow Stepin Fetchit telegram delivery boy, jolt contemporary viewers back to the tension between racial types and racist stereotypes. One realizes that caricature can stretch too far for a cheap laugh.

Bob Clampett and the Art of Parody

The classical cartoon style of Warner Bros. in the Golden Age of animation did exploit racial stereotypes. Yet, its gags played in a realm of surrealism, speed, audacity, self-reflexivity, and lunatic wit. Humor played havoc with all human types, offering equal-opportunity burlesque. One animator elevated this vulgar art of ridicule to the sublime: the incomparably wild and brash Robert Clampett.

Two of Clampett's cartoons from Termite Terrace combine parody with brassy and outrageous examples of the portrayal of blacks (which were surpassed by the mean-spirited or hostile imagery of Japanese and German characters during the war years): *Coal Black and de Sebben Dwarfs* (1943) and *Tin Pan Alley Cats* (1943). With writer Warren Foster, Clampett introduced the preposterously cartoony, no-holds-barred, all-black army version of the Disney classic *Snow White and the Seven Dwarfs* (1937). While Maltin believes its "stereotyped characters and 1940s-style enthusiasm for sex leave many modern-day viewers aghast," he champions its distinctive panache.

> It takes one kind of talent to find new paths for established characters, but it's even more impressive to create whole new worlds within the framework of a six- or seven-minute cartoon. Clampett did both. Many independent filmmakers have labored for years to create a short film, as personal and unique as "Coal Black," which was just one of the dozen shorts Clampett had to put on the assembly line in 1943.[42]

Clampett capitalized on—presumably for black military units stuck in the barracks—overt sexuality and exploited grotesque comic types for a genuinely hilarious and vulgar parody of Disney's sentimental *Snow White*.

The cartoon opens with Mammy telling the story of "Coal Black" in black dialect. (Mammy exclaims, "Well, Hallelujah!" and sings, "I wash all day and I get the blues in the night.") The Wicked Witch, who "was jes as rich as she was mean," hoards rationed tires, sugar, and coffee during the war; drinks "Eli Whitney cotton gin"; and chomps on "Chattanooga Chew Chews."[43] Five of the dwarfs are Fats Waller types, the sixth a Stepin Fetchit, and the seventh a

Dopey imitation. This last dwarf saves the day by smacking the heroine with kissing that is so potent and atomic that it is labeled a military secret. Before that, however, it's all bebopping kinesics and jive talk; Prince Chawmin's zoot suit, thick lips, yellow streak down his back, and front teeth fashioned out of dice coming up seven; and a sexy, laundry-washing, pigtailed woman ("So White") who is to be "blacked out" by a silhouetted film noir company called Murder, Inc. The film is also full of black jitterbugging and the exaggerated gestures of the hepcats.

To become better acquainted with the actual look and feel of hep culture of the time, Clampett took his crew to four or five nightclubs in the black district of Los Angeles before animating the film. "It was the only time," stated Virgil Ross, "we ever did anything like that."[44] Clampett even had the animators rotoscope some footage shot of a jitterbug at these clubs.[45] A review in the *Motion Picture Herald* read: "A satire on 'Snow White' done to black face, set in modern swing, is the best in a long time. It is very funny. EXCELLENT."[46] *Coal Black*'s brazenness earned the film much of its notoriety, but even as shocking as it is for its racial content, the aesthetic and musical brilliance, the unabashed raunchiness, and the pure cartooniness salvage it as a masterpiece for most audiences, even some black audiences.

Thomas Cripps points to how this raucous cartoon created an ambivalence that left black audiences without a consensus of opinion. "Clearly," he writes, "the NAACP was trapped by the ambiguity, complaining of the seven grotesque dwarfs but among themselves, at least, joining in the humor."[47] In addition, the scat songs and jive talk of *Coal Black* flaunted a jazzy parody of Disney's *Snow White* for black audiences. A critical difference between Warner Bros.' hepcat portrayals of race in Clampett's cartoons and the Jim Crow cartoons of Columbia's Heckle and Jeckle was this very celebration of the hot urban music of the emerging black culture. In fact, key black nightclub performers contributed their talents to *Coal Black* and supplied exuberant performances that are unequaled in vitality and comic energy.

Bob Clampett Jr. revealed how his father "was heavily influenced by jazz music." In an insightful letter to Terry Lindvall, Clampett Jr. echoed what Virgil Ross had said:

> [My father] told me of attending a concert at the Shrine which had included the legendary Art Tatum. The musical revue with a black cast Jump for Joy was a major inspiration for *Coal Black*. Hirshfield's book, *Harlem*, was a design influence. As I understand it, my Dad was the first to feature black artists in a cartoon. Dorothy Dandridge's sister Vivianne was the voice of Coal Black, Zoot Watson was the voice for Prince Chawmin, Vivianne's Mother Ruby was the voice of the Nanny. I also remember my father telling me that he met with Louis Armstrong about performing the role of the Prince. He was enthusiastic about the idea, but scheduling conflicts arose.

> My Father did another thing that was unheard of at the time. For Coal Black, he took his animation unit to several nightclubs to get the atmosphere he wanted. Lastly, he had the animators rotoscope to a degree from some footage shot of a Jitterbug.[48]

As Clampett Jr. noted, it was extraordinary that cartoon directors would go to such lengths in researching, as accurately as possible, the material for a seven-minute animated film. Some feature directors do not spend such dedicated labor on more expensive live-action feature films.

The second of Clampett's outrageous parodies, *Tin Pan Alley Cats*, pits a lively, pudgy, and horny Fats Waller (who was also the model for the "sebben dwarfs") character against the moral and religious force of the Uncle Tomcat Mission street evangelists. The musical tags, or what Bordwell calls "leitmotifs,"[49] for this surreal cartoon combine Gospel music and the hotter jazz. The urban salvation army band stands on a street corner in front of a window that announces "Revival," pounding a drum and blowing their horns. They kindly speak, "Peace be unto you, Brother," to the wayward prodigals who pass them by on Saturday night. When the Fats character, a small, round, fat cat, is warned not to go into the Kit Kat Club, that den of iniquity, or "You'll be tempted by wine, women and song," that's enough invitation for him to enter. As Oscar Wilde said, "Temptation is supposed to be tempting." He rushes on in to partake of the carnal pleasures of the flesh.

Like Milton Berle and other white comics of the thirties and forties, Clampett appropriated the music, energy, and gags of the black urban culture to celebrate it and bring it into the mainstream.[50] Like an antic performance purloined from a Los Angeles jazz club, *Tin Pan Alley Cats* showcases a fat mama who quivers, shimmies, and shakes like a bowl full of jelly. Even a piece of chicken, about to be eaten, jumps up and dances. A white-suited Cab Calloway cat blowing a blazing, lickerish trumpet promises Fats, "We're gonna send you right outta this world." After being blasted "outta dis world!" by smoky hot syncopated drums and torrid trumpet music (Eddie Beal and his band), Fats enters Clampett's wacky zoo of grotesque creatures such as an Al Jolson duck that sings "Mammy," and a chained watermelon. Fats is so bewildered he doesn't even know who's talking to him: "Who dat say 'Who dat?'" Quickly repenting, he returns to a pious, revivalistic life, joining the mission musicians singing "Gimme Dat Ol' Time Religion."

Clampett borrowed both the authentic gospel and jazz musical themes of black culture and stylishly celebrated them. For critic Barry Keith Grant, *Tin Pan Alley Cats* even takes on an "overtly moralistic tune."[51] The cartoon's ironic and parodic point is clear: jazz is a music that is wild and sinful, unleashing the nightmarish and chaotic impulses of the mind as well as the body; better to re-

main within the orderly calm of religion and polite music. Clampett's appropriation of these musical and comic motifs stood more as adoring tributes of a truly animated culture than as racist disparagement.

While both *Coal Black* and *Tin Pan Alley Cats* have been censored by the copyright owners, both have achieved great notoriety as examples of classic animation art. Deemed representative of its time, comic marvel *Coal Black* was one of six cartoons from Warner Bros. to have "new prints struck from the original separation negative," while *Tin Pan Alley Cats* was "buried in the Library of Congress time capsule to be opened in the year 2000."[52] In regard to these amazing cartoons, Bob Clampett Jr. argues that their ethnic humor was just one saucy ingredient in the whole creative mix of Warner Bros. animation. The rapid and outrageous style of their comedy treated audiences as discerning adults, alluding to extratextual elements of American popular culture. Slapstick and satire were combined with an "anything goes" attitude to bring cartoon figures, including ethnic ones, into a two-dimensional life.[53]

As in most of Clampett's films, Warner Bros.' representation of blacks was rarely intentionally abusive or dastardly. That it was crude, base, and vulgar, few would argue, but cartoons are an embodiment of irreverence. Where one finds the most heavy-handed and defamatory moments in Warner Bros. cartoons is in the image of the Axis powers. Ironically, the racism of *Coal Black* is most evident in the portrayal of the Japanese. A Murder, Inc. group that refuses to black out "So White" advertises: "We rub out anyone for a price; midgets, half price; Japs, free." Like the other Warner Bros. animators, Clampett rarely broached race in his cartoons, although he was particularly fond of "Rochester" gags—a running joke that seems innocent in light of Jack Benny's prominence at the time. Therefore, his few genuine lapses—such as the Aunt Jemima–like "Black Beauty" of *Book Revue* (1946)—are all the more appalling.[54] Clampett's positive contribution and legacy was his integration of marginalized jazz music into the lowbrow cartoon as a celebration of black culture rather than an exploitation of it.[55]

Conclusion

It seems clear that the representation of blacks in Warner Bros. animated films strongly perpetuated prevailing stereotypes. It also seems clear from the testimony of those in the field that this was not motivated by any personal hatred or animosity, but by a sort of cultural naïveté, a.k.a. institutional racism. Yet, the Warner Bros. cartoons offer an alternative reading with their intentional incorporation of African-American music, comedy, and culture.

One is caught in the ontological dialectic of the mere cartoon. As Roland Barthes repeatedly points out,[56] products of pleasure and fantasy do have ideological

underpinnings—or principalities and powers—behind them. They are rhetorical weapons, even in their naïve intent or form. And yet, they are also poesy, even if only a sort of poetic graffiti. As historically constructed and culturally mediated artifacts, they reflect their times and places of invention and distribution. Not only do their content and style parody and mock culture, but their modes of production are reminders to take them as expressions of the prevailing atmosphere in the making of cartoons and their gags. The general atmosphere for producing cartoons, as Leo Salkin who worked for Lantz in the thirties remembers, "[was] a mood of what the hell, it's okay to say anything that comes to mind, what's important is getting laughs."[57]

The goofy, screwy, wild, and uninhibited style was a basic requirement for anyone who was foolish enough to become an animator. And being of a class of film artists who were the lowliest, the least, the last, and the bottom of the barrel of success, they were less likely to disparage those who lived and struggled with them on the lower levels. There was no intentional conspiracy to attack ethnic groups, only authority figures. In their study of wartime cartoons, Michael Schull and David Wilt also find an absence of malice.

> Contrary to what some may believe, there has never been a conscious effort . . . to stigmatize a particular racial or ethnic group. The adverse portrayals of blacks, Asians, Mexicans, Jews and the like result more from the industry's adoption of cultural stereotypes present in many other media than from actual dislike for a particular race. No production company would deliberately alienate a potential segment of its audience by attacking an entire race or religion.[58]

In contrast, Manthia Diawara contests this view, arguing that Hollywood fixed its image of blackness from D. W. Griffith's *The Birth of a Nation* in 1915. This film constituted "the grammar book for Hollywood's representation of Black manhood and womanhood, its obsession with miscegenation, and its fixing of Black people within certain spaces."[59] Ethnic groups were seen only in relation to the hegemonic center of whiteness.

One must recognize that stock cartoon personifications of blacks carry a palpably obvious danger; many destructive stereotypes do demean and offend, even if they are not maliciously intended. What is often intended as a harmless joke is often received as calculated or tendentious humor. While it is better to throw custard pies back at these errant animation humorists than stones, one must acknowledge James Snead's warning that "more than perhaps any other genre, animated cartoons encourage the rhetoric of harmlessness."[60] Cartoons are not innocuous, mere entertainment, and we cannot camouflage their rhetorical power as mere play.

The problem of black representation in such films is not merely their in-

herent falsity but also their lack of balance. Criticism indicates that ethnic minorities are pictured in a very limited number of types and occupational roles. What is most objectionable here is that the dominance of negative imagery in the past had no positive counterpart; while one can beg excuse on the grounds of a naïve consciousness of such matters, the ubiquitous presence of all types of ethnic humor, and/or a generally innocent intent, a contemporary perspective must repent, even in its laughter, when animation does misbehave and wound segments of an audience. Irene Kotlarz aptly pinpoints the ideological importance of animation, which "can function precisely as an iron fist in the velvet glove of gags and sentimentality."[61] The imprints of the iron fist do persist for a long and painful time. The generalized images of docile, lazy, oversexed, superstitious people who steal and eat chickens and watermelons do translate into the stereotypical currency of a culture; they do establish an imagistic code of discrimination.

After forty years of caricaturing human folly, John Lawing explains how he wrestled with the challenges of being a cartoonist (and animator) who tried to be racially inclusive and democratic in his art:

> An everyman (or everyfool) figure may be designed to represent all of those who evidence the ridiculed behavior or attitude, regardless of race. The problem stems from the moment the cartoonist includes a character who is intended to be a particular race. For example, once a black figure is included in a cartoon, all the other figures suddenly become white—or at least nonblack. Now the character who was intended to show the ridiculousness of a middle-class attitude represents a white or a black middle-class attitude.
>
> If the cartoonist solves his problem by not taking note of ethnic difference, he is criticized for ignoring an important element of our population. If he does include others, he must do so with delicacy and the wisdom of Solomon. If, for instance, the cartoonist decides to include African Americans, he must decide whether they are the givers of the joke or the butt of the joke, or both.[62]

Cartoonists thus seem stuck in a conundrum, vulnerable to accusations of discrimination in their work whenever they represent ethnic types. "It is better to risk such misinterpretations," Lawing argues, "than to neglect race altogether."[63]

The portrayal of blacks in the outlandish Warner Bros. cartoons of the forties was, as Michael Barrier argues, no more grotesque than "the middle-aged white men Clampett lampooned in cartoons like *Draftee Daffy* (1945) and *The Wise Quacking Duck* (1943)."[64] It is important to remember, as Charles Solomon notes, that these Warner Bros. cartoons do reflect an era long gone by: "[It is] not entirely fair to condemn them when they fail to meet contemporary standards. Efforts to censor these films falsify both the history of animation and

American popular culture. The question is how to present these films without further insulting the minority groups that provided the butt of the jokes."[65] One must not deny the presence of warts on the body of American cartoon art. As Friedwald and Beck astutely recognize, "Not to show these [Warner Bros.] cartoons because they have black people in them is truly racist, more racist in fact, than any cartoon ever was."[66]

A parabolic postscript may put our predicament in a more cartoonish perspective. It seems that two related animators, W. B. and W. L., were viewed as the most bigoted, sexist, racist, and abusive filmmakers in all Hollywood. When W. B. died, his cousin W. L. promised a huge sum of money to the priest if he called W. B. a saint during his eulogy. The priest began: "W. B. was one of the most bigoted, sexist, racist, and abusive filmmakers in all Hollywood . . . but compared to his cousin, he's a saint."

Likewise, compared to our actual history of race relations, the Warner Bros. animators were saints.

"Ah Love!
Zee Grand Illusion!"

KIRSTEN MOANA THOMPSON

Ah, my darlink . . . at last we are alone together
[kiss, kiss]. . . l'amour, toujours l'amour [kiss, kiss],
zee grand illusion.

—SCENT-IMENTAL ROMEO (1951)

Pepé le Pew,
Narcissism, and Cats
in the Casbah

Love is indeed the grand illusion in *Scent-imental Romeo*, for oblivious to his own lack of charms, Pepé le Pew, a mephitic Casanova, is molesting yet another hapless victim in the "Tunnel of Love." Compared with the ever popular characters Bugs Bunny, Daffy Duck, Elmer Fudd, Tweety Bird, and other animated creations of Warner Bros.' Termite Terrace, Pepé le Pew had a short-lived celebrity. Numbering only sixteen cartoons in total, the Pepé le Pew series began in 1945 with *Odor-able Kitty* and ended with *Louvre Come Back to Me* in 1962, with all but two cartoons directed by Chuck Jones.[1]

The intellectual and verbal sophistication of Jones's work distinguished his cartoons from other Warner Bros. products. His singular creations Pepé le Pew, Wile E. Coyote, and the Road Runner, and his important contributions to the characters of Elmer Fudd, Bugs Bunny, and Daffy Duck, displayed an erudite field of intertextual allusion and a subtlety of personality that narrativized the least cock of the eyebrow.[2] Whether through elaborate rhetorical play with "pronoun trouble" in the "Rabbit Season" trilogy,[3] or the pantomime histrionics of the Road Runner series, Jones demonstrated a mastery of animated movement, character, and staging throughout his work. With the assistance of writers Michael Maltese and Tedd Pierce and layout artist Maurice Noble, the Pepé le Pew series's visual stylization and wanton verbal humor became Jones's most self-reflexive parody of heterosexual romance.[4]

Characterized by a slyly triadic formula, the series features the romantic hero Pepé, a skunk with an infallible belief in his own erotic appeal; a mise-en-scène echoing with fractured French; and a wretched cat, whose chance encounter with some white paint triggers Pepé's lust for "zee king sized belle femme skunk fatale."[5] These simple prerequisites comically trigger the mock-heroic memoirs

Chuck Jones's 1960 model sheet for Pepé le Pew. Copyright Warner Bros., Inc.

of Pepé,[6] littered with intertextual allusions and quotations from cinema, theater, literature, and popular culture, and dabbed with the occasional spot of perfume. In its self-reflexive staging of an exoticized mise-en-scène of romance, stretching from Paris to New Orleans, from the Casbah to the Sahara, like picaresque variations in a novel by Henry Fielding,[7] the Pepé le Pew series is one of Warner Bros.' most characteristic examples of intertextual display and generic self-consciousness.

Pepé le Pew, the amorous skunk, was modeled on a succession of Pépé Le Mokos. Initiated by Julien Duvivier's French feature *Pépé Le Moko* (1937), the eponymous Pépé reappeared in the Hollywood remake *Algiers* (1938) starring Charles Boyer and Hedy Lamarr, as well as in the rather inconceivable musical version *Casbah* (1948). All three were eventually parodied in Jones's *The Cat's Bah* (1954), a cartoon in the Pepé series notable for its condensation of Pepé le Pew's key character attributes. Combining the charismatic French intensity of Charles Boyer and Louis Jourdan, and the musical talents of Maurice Chevalier (complete with hat and cane in *Scent-imental Romeo*), the musically ambitious Pepé le Pew could launch into "Baby Face" or "As Time Goes By" at the slightest prompting (usually there is none). Boyer, Jourdan, and Chevalier are French examples of a European masculinity constructed in part from the romantic tradition. In their American films, these rhetorically seductive and emotionally ex-

Chuck Jones's 1960 model sheet for Le Cat. Copyright Warner Bros., Inc.

pressive performances of masculinity markedly contrast the taciturn hypermasculinity of American stars like Rock Hudson. These ideological differences between specific formations of American and European masculinity offer the Gallic lover as more emotional, more seductive, and often effeminately aristocratic. Boyer was a suave leading man in French and American cinema, whose star persona was closely linked to his seductive baritone and lugubrious manner.[8] Chevalier, whose career had started in the Folies-Bergère and whose performance style was born of vaudeville, became known for his smooth romantic charm in a string of comic musicals and dramas in France, England, and Hollywood.[9] The absurdity of Pepé le Pew adopting the Hollywood persona of the French lover, a hybrid of Chevalier and Boyer, imperturbable in the face of rejection, unstoppable in his seductive sallies, and unflappable in his smooth delivery, is the central comedic element in the Pepé le Pew series.

As a romantic hero alternately absorbed and bemused by his own narcissistic fantasy, Pepé acts as if he were Don Juan, a dashing seducer in the face of whom all are powerless to resist (in theory). As an idealized projection of heterosexual masculinity, Pepé's character mobilizes contradictory spectatorial identifications around his staging of masculinity; *with* the romantic ego-ideal (Pepé as consummate Lover) yet *against* his indecorous and comical narcissism (Pepé

is a blind fool, and I am not like him). Although Pepé can, with such delightful élan, rehearse his romantic fantasies for us and disavow his epistemologically crippling condition, the fact remains: he is a *skunk*.

This essay looks at the ways in which this dialectical staging of comical narcissism plays with traditional spectatorial mechanisms of identification and disavowal, and discursively intersects with ideological constructions of romantic heterosexual fantasy, masculinity, and the "exotic." Pepé le Pew's tales of romantic failures are comical parodies that accent a romantic phantasmatic operant in cinema and popular culture ("l'amour, toujours, l'amour"), projected onto a newly emergent cultural imaginary of consumer tourism, where love is packaged as part of the mise-en-scène.

The stylistic intertextuality that, as Donald Crafton argues,[10] differentiates Warner Bros. animation from its competition is particularly evident in *Past Perfumance* (1955). Pepé is in search of "Telma Normadge'"'s autograph and manages to sneak onto a French studio lot, where David Butler is shooting *Le Cinéma D'Animal Adventure*. We see visual gags that collapse Hollywood onto this Gallic setting, where caricatures of "Clara Beaux" (La "It" Fille), Mack Sennett's "bathing beauties," and studio extras wander. Pepé spies what he takes to be a female skunk (a cat costumed for a film role), and the chase begins.

Pepé marches onto the set of *Julio et Romiette* declaiming his love to the cat on the balcony:

> Ah, my little much ado about somezing. . . . [*kiss, kiss*] Ah, my leetle lost labor's love.

This comic spoonerization of the dramatic titles of Shakespeare's plays *Much Ado About Nothing* and *Love's Labour's Lost* is typical of Pepé's bungling romantic poses. Indeed, the theatrical premise of the film set is an ideal backdrop for Pepé, given his performative predilections, as he then adopts a whirling succession of classic leading men from Tarzan ("I screech to you with manly love") to Napoleon. The chase leads Pepé into a screening room of the animated potboiler *The Sheik*,[11] where one sniff of Pepé is enough to drive out the audience ("Sacré bleu! Zat peecture stinks") and even the animated actors from the screen (the intertitle of this black-and-white classic warns: "Un Polé cat de pew es en audience! Take it vous on le lam!"). These comedic moments of self-reflexive rupture are typical of the Warner Bros. style.

Zee Lover

Where are you my leetle gumbo of chicken? Your French
fried shrimp is sizzling for you.
—REALLY SCENT (1959)

The incongruous juxtaposition of a mock-heroic lover who is also a skunk (we are always reminded) offers the spectator a comic distanciation from the traditional identificatory positions offered by classical Hollywood narrative. Indeed, as Pepé's rhetorical romancing becomes all the more outrageous, the comedic effect approaches bathos. Through self-reflexive asides and direct address, Pepé alternately performs and deconstructs his role as Gallic lover, foregrounding the Hollywood conventions on which this heterosexuality is constructed ("I am a boy. You are a girl! We have all that in common"—*A Scent of the Matterhorn* [1961]), yet all the while permitting the spectator to both intellectually disavow and simultaneously identify with his patently absurd narcissistic fantasies. Pepé's all-consuming passion for his role is so marked by the comic use of hyperbole and intertextual allusions that the very narrative form registers the constructs "love" and "romance" as suddenly opaque. In its obsessive restaging of anxieties about heterosexuality (emblematically through the threatened miscegenation of cat and skunk), and masculinity (the castration of his repeated failures), the Pepé series parodies masculine heterosexuality as a performative ritual, collapsing the discursive conventions of heterosexual seduction and the chase into one and the same.

Comedic Contingency

Steve Neale and Frank Krutnik note that live-action feature comedy (particularly that of the screwball genre) features a characteristic happy ending for which the motivation (if any) is improbable, fortuitous, or accidental, if not illogical.[12] Even less confined by the obligations of narrative motivation, most Warner Bros. cartoons are nonetheless structured by character chases, usually involving pairs of animals (Tweety and Sylvester, Wile E. Coyote and the Road Runner), in which the chase is a structural synergist for a succession of comedic events, sight gags, wisecracks, and jokes. Unlike the live-action feature film, the Warner Bros. cartoon signals its close with a final gag, a kind of punctuation point or artificial terminus just before "That's All Folks!" and the final iris out. Structured through the circular repetitions and variations of the chase in this way, the final gag is less an end point than a humorous shrug of the shoulders.

However, like live-action comedy, Warner Bros. cartoons do rely on the comic devices of coincidence, absurdity, luck, fortune, or mischance as structuring formulas. Some Warner Bros. cartoons feature a coterie of schemers: Wile

E. Coyote, Sylvester the Cat, or Daffy Duck endlessly plotting with the blue-prints of their Rube Goldberg gadgets. Others, including many Bugs Bunny car-toons (and to some degree even those of Pepé le Pew), showcase the deceivers, those ready to adopt a handy disguise.[13] What distinguishes the Pepé le Pew series is its focus on coincidence as *the* principal narrative catalyst; the "acci-dental" painting that transforms a cat into a skunk[14] must always occur first.[15] If, following Neale and Krutnik, comedy permits the abandonment of causal motivation for comedic effect, the Pepé series, as with much of Warner Bros. animation, thematizes contingency as part of the anticausal logic of the animated universe.

In keeping with this, Pepé always refuses the necessary chastisement that comes with a traditional comedic law; namely, the humiliation and increased self-awareness of the protagonist. According to the Renaissance model of the-atrical comedy, the *peripeteia* (turn/reversal of fortune) and the *anagnorisis* (tran-sition from ignorance to knowledge) signal certain resolutions within a triadic structure.[16] But where Malvolio, by the end of Shakespeare's *Twelfth Night*, may be in sad possession of his complete mortification, the joke with Pepé is that he resists any such knowledge, thereby displacing humiliation with comic disavowal. As Pepé says to the audience in *The Cat's Bah*:

> You know most men would get discouraged right now. Fortunately for
> her, I am not most men.

Pepé instead seals the cartoon with a gag line that reaffirms his commitment to his rakish career. His shrugged "C'est l'amour" seems to defy the final fade-out to black, at the same time ironically pointing to the failures of heterosexual union.

Zee Chase

Zees small coquette, she thinks by running away she can
make herself more attractive to me—how right she eezz.
 —*WILD OVER YOU* (1953)

In a Hollywood animated cartoon whose average length is seven minutes, any narrative content is restricted. As a result, the chase operates as a shorthand code to which character is subservient. Smaller, weaker characters often prove to be the smarter in a particular paired chase, as with Jerry in MGM's *Tom and Jerry* cartoons, or Tweety Pie in his battles with Sylvester. Tom and Sylvester are invariably marked as incompetent and are almost always outsmarted by their opponents. This cross-species chase structures dozens of cartoon series at vari-ous animation studios but predominates in the animation of Warner Bros. The

aggressive interplay of cat versus mouse (Sylvester vs. Speedy Gonzales), rabbit versus hunter (Bugs vs. Elmer Fudd), and chicken versus chicken hawk (Foghorn Leghorn vs. Henery Hawk) is authorized and naturalized by the traditional predatory relationships of nature. Yet with Pepé le Pew, the chase is also ideologically informed by an explicit sexual dimension, addressed to the adult spectator. Pepé is mattter-of-fact about his lascivious intentions; the cat unequivocally horrified at his advances.

As Chuck Jones acknowledges: "It was a matter of eating somebody, like a cat eating a mouse. Nourishment. Sustenance. Survival. Today, if you say that a character is going to eat somebody—well, it has a different meaning. But the skunk Pepé was unique in chase cartoons of the period in the sense that he was after the cat, well, to screw her, I suppose."[17]

Classical Hollywood genre conventions of heterosexual romance are satirized in Pepé le Pew's incongruous desire for a female cat that he assumes to be a skunk.[18] The metaphoric pursuit of love becomes literalized in Pepé's misguided pursuit of a lover he misrecognizes. When faced with the repeated flight of the hapless cat, Pepé's defense is always a discursive one, invoking a romantic paradigm as an explanatory mechanism. In *Scent-imental Romeo*, for example, he says:

> She wants to play at zee lover's chase. It is the leetle girl in her. C'est l'amour. Look petite one, I am zee lover chaser! I chase you!

Pepé's rhetorical explanations are comically familiar as romantic clichés and symptomatic of Pepé's narcissistic personality. He croons to an unconscious cat (overpowered by his fumes) in *The Cat's Bah*: "Sweetheart, Pepé le Pew loves you, / Sweetheart, fortunate, lucky you, / Sweetheart, wake up and you will find, / Pepé has got you on his mind." The song points to Pepé's unbounded narcissism ("Fortunate, lucky you"), and the comic pronoun substitutions he sings add to the hyperbole of that narcissism. As he asks in *Odor-able Kitty*, "Where have I been all your life?"

As part of the chase, the Pepé le Pew series deals directly with the comedy of miscegenation, thematizing an implicit ideological taboo that cross-species coupling (cat/skunk) cannot occur in animation. The potential anxiety that miscegenation triggers is humorously disavowed through the gag premise of the chance event (a cat is accidentally painted with a white stripe on its tail). Any potential miscegenation between skunk and cat lies in Pepé's misreading and misrecognition of the object of desire; through a narcissistic projection of Pepé's own identity onto the Other as the mirror image of himself, a cat can always be misread as a skunk and thus become his object of desire. Whether it is a thespian cat disguised as a skunk in *Past Perfumance*, or a cat used by a burglar to clear out a bank in *Two Scent's Worth* (1955), the mere appearance of a white-striped tail (the key metonymic signifier for the skunk) triggers the amorous

entrance of Pepé. The tension for the spectator, between anticipating just *how* the cat will receive the white stripe, and *which* hermeneutic strategy Pepé will apply in the face of his inevitable rejection, creates the comic variants in the familiar formulas of the Pepé series. Pepé's very misrecognition reinstates the ideological significance of gender difference, here displaced onto species difference. The comical exaggeration of the cat's repulsion for Pepé underscores the ideological contiguities of desire across race and gender difference, with its spectacle of masculinity run amok.

Pepé's casual bouncing hop is the traditional opening sally that marks the onset of the sexual chase. Speed blurs and "mickey mousing"[19] sound effects signal the comic contrast in animated movement between the cat's scrambling attempts to escape and Pepé's leisurely pursuit.[20] The chase's rhythm is then accelerated through the sudden ubiquity of Pepé. Violation of the laws of space and time is central to comic surprise, and it is this reversal of expectations that is comical. Just as Tex Avery thematized ubiquity in his Droopy Dog and Screwy Squirrel series at MGM in the forties and fifties, so does Jones frustrate the cat's every escape route with the implausible placement of Pepé everywhere.

Concomitant with his ubiquity, Pepé adopts many disguises to woo his suitors. In *Odor-able Kitty*, Pepé disguises himself as Bugs Bunny, and in *The Cat's Bah*, he sways snakelike ("El hiss") from a pot in an Ali Baba spoof. In *Scentimental over You* (1947), Pepé pursues a hairless Chihuahua wearing a skunk fur coat; at the end, when she reveals her canine status in a *Some Like It Hot* (1959) moment, Pepé peels off his skunk coat, under which he appears as a dog, only to proclaim, "I too am zee canine."[21] Here, the Other (the female Chihuahua) is finally recognized as different by Pepé only to then appropriate that identity as his own. By collapsing all sense of difference in this way, Pepé places his object of desire in an inescapable conundrum, in which there literally is no way out.

Pepé's relentless pursuit self-reflexively invokes the performative and discursive dimensions of the heterosexual seduction. He greets the surprised Fifi in *Two Scent's Worth* with, "Permit me to introduce myself. I am Pepé le Pew, your lover!" For Pepé, whose hermeneutic strategies are fairly unidirectional and remarkably resistant to any narcissistic wounds, the hammer blow to the head becomes "zee flirt." The cat's resistance only intensifies the hyperbole of Pepé's melodramatic rhetoric. As he says in *Scent-imental Romeo*, "Zis I like! Zee fire! Zee spirit! En guard, pigeon!" Unruffled, Pepé reinterprets any such rejection or flight with an antilogic that suggests the ideological demands of traditional constructions of male heterosexual desire; for Pepé, "no" means "yes," "stop" means "go," and revulsion only engenders more lust. In all, the laws of gravity, space, and time do not coincide with any reliable physics. In this ideologically unstable environment, Pepé's anthropomorphized masculinity follows the comedic laws of contingency and excess, rather than any Newtonian model of *gravitas*.

Zee Language of Love

Queen of Hearts: *Speak in French when you can't think of
the English for a thing.*
—LEWIS CARROLL, *THROUGH THE LOOKING GLASS* (1871)

*Do not come wiz me to zee Casbah, we shall make
beyootiful musics togezzer right here. You are the corn-beef,
I am the cabbage. . . . Ze cab-baj do not run away from ze
corn-beef!*
—PEPÉ LE PEW, QUOTED IN CHUCK JONES, CHUCK AMUCK

*Where have I been all your life? You are the aroma of
spring flowers that bloom in the spring. [kiss, kiss] You are
the fragrance of wondrous and exotic perfumes.*
—ODOR-ABLE KITTY

Jones's mock-heroic Pepé satirizes the discourse of romance through parodic hy-
perbole and comic tautology. Language, as the traditional site of decorum, logic,
and social communication, is an ideological construction. Its intentional witty
misuse (the use of lisps, accents, stammering, or other verbal differences) sig-
nals a typical rhetorical rupturing of normative discourse in the animated genre.
Pepé's comic franglais is addressed to an implied native English speaker, easily
able to recognize the English word beneath the patina of his simulated French.
The franglais Pepé smoothly mutters is a linguistic kind of *red herring*, a comic
obfuscation that apes the sounds and phraseology of a French no more "authen-
tic" than Pepé as Charles Boyer. Like Pepé's mistaken lust for a cat, this linguis-
tic punning relies on a semiotic misrecognition, or slippage. Pepé's incessant
repetition of the "language of love" becomes a meta-textual mumble on the
rhetoric of desire:

> Ah my darlink, how beautiful you are . . . [*kiss, kiss*]. . . . Ah, zee sweet
> nothinks . . . zee sweet somezings.
>
> —*Scent-imental Romeo*

Zee P-U!

The franglais puns in nearly every title of the series are leitmotifs that play on
odor and scent, reinforcing the repulsive dimension of the skunk as Lover, and
thereby opening up the necessary space for the absurdity endemic to comedy.[22]
Of necessity, Pepé's smell is an abstraction in the world of film that can only be
metonymically suggested. His erect tail overdetermines his identity as male
skunk, one inseparable from his feral odor. In each cartoon, the conventional

shot composition customarily begins with Pepé's partial presence: we can only see his tail, fuming green or yellow above the flower tops.[23] Diegetic olfactory repulsion can only be conveyed through sight gags and reaction shots: wilting flowers, a cat's horrified face, and the usual fleeing bystanders and rats (often shown in overhead shots as ants fleeing a building). In *Who Scent You?* (1960), one such overhead shot shows the fleeing figures forming the phrase "e pew!" Pepé's erect tail then points in the cat's screen direction with the fumes racing like a green tsunami to overcome their target. These pungent pheromones disable any cat's resistance with the hyperbole of Pepé's excessive desire; the metonym of smell becomes the metaphor for sex.

Pepé's narcissistic self-absorption is often so great that he cannot even imagine the olfactory revulsion of other characters: "What is this P-U?" he asks, diligently looking it up in a handy dictionary. Sometimes it is the social utility of the skunk's outcast status that is the premise for the formula's exposition. Abused dogs and harassed cats admire Pepé's ability to clear a butcher's shop of people. A male cat in *Odor-able Kitty* ponders: "Why does everyone push me around? I wish I was a skunk. Then they'd leave me alone!" Recklessly applying limburger cheese, garlic, and onions, the cat disguises himself as a skunk and mimics Pepé's butcher shop raid. Unfortunately, his food feasts end in short order, as Pepé spots him and begins an ardent pursuit. In *Odor of the Day* (1948), romance makes way for survival as Pepé and a dog battle over a warm bed indoors. In a rare moment of insight (one of the few in the entire series), Pepé recognizes that he has malodorous powers, and uses his fuming tail like a laser gun to repel the dog. (Unfortunately, the dog's loss of smell from a cold makes him comically impervious.)[24]

But Madame! I 'ave overstoked zee furnace, yes. Madame
control yourself, your conduct is unseemly. . . . Madame!
 —THE CAT'S BAH

Surprisingly, Pepé has also been the object of unwanted desire. He meets a cat in *Really Scent* who had the misfortune to be born with a white stripe on her tail. This cat, "Fabrette," is encouraged by a wildly enthusiastic female voice-over to pursue Pepé: "Look, your ship has come in!" (as Pepé arrives on *La Belle France* ocean liner). Fabrette vainly wants Pepé for his resemblance to *her*, and even tries holding her breath to tolerate his smell. When this fails, Fabrette decides to become as piquant as Pepé with the aid of some limburger cheese. Unknown to Fabrette, Pepé adopts the opposite strategy by "deodorizing" and now cannot tolerate his smelly paramour. These unexpected reversals are comic variations within the Pepé formula; by reversing the spectator's expectations of the traditional attraction/repulsion opposition with visual puns of smell, the sexual comedy is even more explicit.

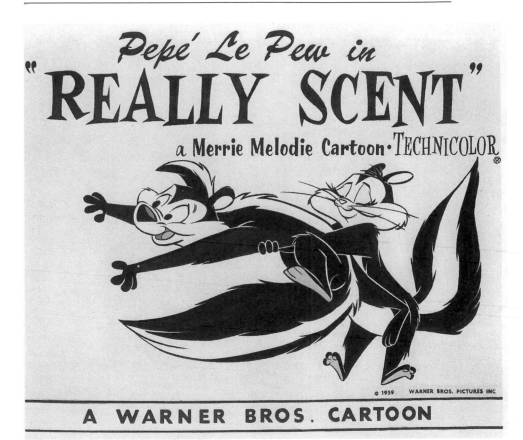

The comic reversal of the Pepé formula: Fabrette lusts for Pepé in *Really Scent* (1959). Copyright Warner Bros., Inc.

Zee Rendezvous

Pepé [addressing a fleeing cat]: *"I call you streetcar because of my . . . [Cat kicks him twice and flees up into the Alps]*
Pepé [shouting]: *Hey Lolita! Intimacy is difficult at this range.*

—*A SCENT OF THE MATTERHORN*

Just as Gallic puns offer comic obfuscation, so too does the textually overdetermined mise-en-scène, for Pepé is nothing if not faithful to this genre's codes with its trysting places: the tunnel of love, the Moulin Rouge, and la tour Eiffel.[25] Indeed in *Scent-imental Romeo*, Pepé remembers that the generic prerequisites of romance require certain props, "Ah, but I forget . . . zee rendezvous"; whereupon he pulls scenery drops from nowhere that become the walls of an intimate dining room with candles and champagne for two. The Gallic influences also

Original animation artwork drawn by Chuck Jones for *A Scent of the Matterhorn* (1961).
Copyright Warner Bros., Inc.

extend to the cartoon credits[26] and the graphic design of the backgrounds which
form the "exoticized" backdrops for Pepé's adventures: Paris in the springtime,
the Sahara, the Matterhorn, or the little village of N'est-ce Pas (Nasty Pass)
nestled in the French Alps.

Come to Zee Casbah

The "exotic" locales for the Pepé le Pew series are drawn from the previously
noted live-action versions of the Pépé Le Moko story, most notably in *Algiers*.
The Hollywood trope of the "mysterious" Casbah in both live-action and ani-
mated cinema invoked orientalism and other exoticizing strategies.[27] As an ideo-
logical discourse, warns Edward Said, orientalism is "more particularly valuable

as a sign of European-Atlantic power over the Orient than it is as a veridic discourse about the Orient."[28] Borrowing from Michel Foucault, Said's work attempts a genealogy of a range of discourses produced within and by imperialist and colonialist structures (specifically of the colonial powers England and France between 1750 and 1939). For Said, orientalism is not so much about Western traditional notions of the Orient, as the ways in which the West produces and constructs notions of the Orient in all its particular sociopolitical and cultural manifestations (including that of the public imaginary). As part of the creation of this imaginary sphere, Hollywood live-action cinema production, through its historically broad geographic and cultural representations, plays a crucial role in vitalizing and sustaining particular historical discursive regimes of the Orient.

In this regard, certain discourses articulated by the live-action romance *Algiers*, in their thematics of loss and imperialist anxieties about racial identity, are then parodically reinserted in the animated Pepé le Pew series. The voice-over for Duvivier's *Algiers* opens on a melodramatic note.

> Where blazing desert meets the blue Mediterranean and modern Europe jostles ancient Africa. A stone's throw from the modern city, the native quarter, known as the Casbah, stands like a fortress above the sea. Its population includes many tribes and races, drifters and outcasts from all parts of the world—and criminals who find this a safe hiding place from the long arm of the law. Supreme on these heights rules one man—Pépé Le Moko.

Here the Casbah is already a rhetorically overdetermined and mythical place. With its heterogeneous population of Gypsies, French colonialists, Italians, and "all the flotsam of Europe," the Casbah is a densely populated and mazelike city within a city. In *Algiers*, Pépé Le Moko longs to leave the Casbah in which he feels entombed, and return to his beloved Paris. He looks wistfully out to the Algiers harbor and dreams of the Champs Elysée. For Pépé Le Moko, France is a fantasy space whose loss is constantly invoked (and which ultimately leads to his betrayal and death at the hands of a woman).

By contrast, in the Pepé le Pew series, France or the francophile colonialist setting is an externalization of American popular cultural clichés of love and romance, where the Champs Elysée, the Eiffel Tower, and the very invocation of the word "Casbah" become visual "postcards" of an imaginary space for illicit romance and seduction. Moreover, with the growth of tourism spurred by the development of jet-propelled aircraft, and the intensification of advertising targeting the newly affluent middle class, Hollywood contributed to this new consumer category in the fifties through the proliferation of romantic comedies set in glamorous tourist destinations.[29] In Pepé le Pew cartoons, the picture postcards that we see of a caricatured Paris, the setting for "romance," denote much

that was new in an American consumer culture. The intertextual combination of Paris, the Casbah, Rome, Naples, and many other exoticized sites within American live-action romances and musicals also created new spaces for the suspension of the ethical norms of heterosexual ideology. Pepé le Pew's polished performance of the charismatic French lover and his adulterous behaviors play with the adult spectator's recognition of the illicit.[30] Paris or the Casbah acts as a kind of phantasmatic projection for Pepé le Pew and, along with him, for mass-consumer romantic fantasies. At the same time, the Pepé le Pew series accents generic conventions of heterosexual romance, in which mass-marketed tourism marked its entry into cultural circulation in the cinema of the fifties.

Narcissistic Fantasy

Opening shot: close-up on champagne cork.
Pepé: *Oh hello there, I am so glad you could come. You are here to interview me about my life, non? Come with me to zee Casbah.*
Dissolve to flashback. Setting: Algiers.

—*THE CAT'S BAH*

This cartoon opens with Pepé's invitation to an unseen journalist (and, by extension, the audience) to enter into its phantasmatic space, as Pepé spins his narcissistic tale featuring himself as romantic hero. Chuck Jones verbalizes the anxieties disavowed by Pepé. "Pepé le Pew was everything I wanted to be romantically. Not only was he quite sure of himself but it never occurred to him that anything was wrong with him. I always felt that there must be great areas of me that were repugnant to girls, and Pepé was quite the opposite of that."[31] Jones points to the identificatory and sadistic pleasures that the Pepé series offers for both himself and the spectator, through its construction of the fearless Pepé as an invulnerable construction of masculinity. In this way, Pepé operates as an ideological safety valve, enabling the spectator to identify with Pepé's automatic assumption of the role of an unflappable, beguiling seducer. At the same time, the Pepé series's sophisticated address to the adult spectator allows the spectator to disavow his/her inevitable rejection with similar savoir faire. Identification is further complicated by Pepé's own narcissistic predilections, for Pepé always falls in love with his mirror image.[32] In *Wild over You*, in a famous visual allusion to *The Lady from Shanghai* (1948), Pepé runs into a cave, where he sees dozens of images of his own (and the cat's) reflection in the ice, and shrieks, "Acres and acres of girls, and they're all mine!" In this crazy mirror house scene, Pepé's repeated misrecognitions of a cat as the reflection of himself are comically hyperbolized. Consider Pepé's opening lament in *Little Beau Pepé* (1952):

*The setting: a remote French post in the Sahara. Pepé enters with two
suitcases.*
Pepé: I am zee broken heart of love. I am zee disillusioned. I wish to
enlist in zee Foreign Legion so I may forget. [*direct address*] A pitiful case,
am I not?

Here Pepé engages in a performative masochism, asserting a mock erasure of his
own identity as a result of some prior romantic heartbreak. In *Little Beau Pepé*,
with its satiric nod to the colonialist setting and heroic masculinity that inform
Beau Geste (1939), the disillusioned Pepé must obliterate the very memory of
that loss by effacing his identity in a faraway locale in the French Foreign Le-
gion (long an option for the lovelorn).

Pepé's rhetorical exaggeration is comical in its generic self-consciousness,
for his career is built on his excessive overidentification as Lover. Like Boyer's
Pépé Le Moko, Pepé le Pew also has a romantic predilection for duels.[33] In *For
Scent-imental Reasons*, Pepé mimes a suicidal despair when he is rejected (fol-
lowed by an "off-screen" gunshot), but this temporary invocation of the melo-
dramatic is merely a pretext for a wisecrack: "Fortunately I meesed." In *Louvre
Come Back to Me*, Pepé competes with an orange tomcat for the love of a cat
with a white stripe. Pepé challenges his rival to a duel, and while the cat holds
its breath, first turning blue and then green, Pepé narrates his imaginary demise
at leisure. The movement between Pepé's direct addresses to the spectator and
his absorption in his romantic role is comical for the spectator, with both an
intellectual recognition (Pepé is a foolish skunk) and an unconscious identifi-
cation (Pepé is a fearless lover).

Through this portrait of the romantic travails of a skunk suffering from de-
lusions of torrid grandeur, this comedy of disavowal positions the spectator in a
dialectic between amused detachment and identification with Pepé's performance
of masculinity. The joke lies in the incongruous mismatch between Pepé's rhe-
torical and anthropomorphized masculinity and the fact that he remains a *skunk*.
The situational comedy is intensified for the spectator by Pepé's excesses in self-
confidence, self-absorption, and rhetorical tautology as he calls for "a female lady
skunk of the fair sex" (to quote from *Who Scent You?*). It is because Pepé's nar-
cissism relies on a strategy of disavowal so hyperbolic and so resilient, that his
performative and constructed masculinity lays bare its ideological repressions.
Here, the role of the joke negotiates the unsettling territory of any castration
anxieties by mediating the reality of rejection through comic disavowal. As Freud
suggests:

Like jokes and the comic, humor has something liberating about it; but
it also has something of grandeur and elevation, which is lacking in the

other two ways of obtaining pleasure from intellectual activity. The grandeur in it clearly lies in the triumph of narcissism, the victorious assertion of the ego's invulnerability.[34]

Pepé's narcissistic resilience effects a comic disruption symptomatic of the comedic disavowals evident in Pepé's persona. The revulsion of the cat's response to Pepé is comically exaggerated (her paws flail, her eyes widen, her cheeks change colors as she holds her breath), yet Pepé's persistence in the face of such revulsion and his concomitant disavowal of any narcissistic wound only intensify our own comic pleasure, thereby offering a humorous negotiation of the ego wounds of reality. We can identify with Pepé as a fantasy figure of desire run rampant, even with his aggressively sadistic humiliation of the cat (whose knowledge of Pepé's repulsiveness we share), yet remain amused by the narcissistic audacity of Pepé's amatory illusions. Freud goes on to say:

> The ego refuses to be distressed by the provocations of reality, to let itself be compelled to suffer. It insists that it cannot be affected by the traumas of the external world; it shows, in fact, that such traumas are no more than occasions for it to gain pleasure. This last feature is a quite essential element of humor.[35]

In Pepé's willfully blind misrecognitions, his self-conscious pursuit of the pursuit itself ("Everyone should have a hobby don't you think? Mine is making love"),[36] and in the multiple rejections that he endures with the tenacity of a professional, any attendant risks to the ego are invoked only to be safely disavowed. Moreover, the joke can operate as an ideological defense, a means to negotiate the contradictions between Pepé's simultaneous rejections and triumphs. As Freud puts it: "Humor is not resigned; it is rebellious. It signifies not only the triumphs of the ego but also of the pleasure principle, which is able here to assert itself against the unkindness of the real circumstances."[37] Despite his coital failure in every cartoon romance, Pepé sustains his philosophical commitment to the conventions of romance, and his own rock-solid belief in his seductive masculinity—the shrugged "C'est la guerre . . . but vivre l'amour."[38] Pepé's enthusiastic performance of his Byronic persona operates dialectically with his direct asides to the cinematic audience: "Beautiful, eez it not?" This oscillation simultaneously acknowledges both the libidinal investments of romantic desire and the fear of rejection that accompanies them.

As Jones states:

> Pepé le Pew presented no problem to me. I needed his self-assurance, his absolute certainty of his male desirability, his calm self-assurance, his logical interpretation of any female peccadillo as simply a loving way to convey her love for him. So Pepé was not a recognition in myself of his

wonderful attributes but an absolute recognition in myself of the absence of those traits. I needed Pepé.[39]

The Pepé le Pew series, a comedy of mistaken identity and sexual failure, accentuates the psychic pleasures offered up to the spectator by Pepé's own formidable libido. Our laughter unconsciously admires Pepé's skill in sustaining his phantasmatic delusions, for his prattling valentines are a colorful spectacularization of heterosexual romance and the generic conventions that inform it. If every Pepé cartoon is ultimately a coitus interruptus, pointing to the impossibility of desire's appeasement, anxiety can always be suspended by comedic distanciation. For as Freud reminds us: "The main thing is the intention which humor carries out. . . . It means: 'Look! Here is the world, which seems so dangerous! It is nothing but a game for children—just worth making a jest about!'"[40] For children and adults, Pepé the irrepressible skunk offers a comic invulnerability to the anxieties of the ego, which are most open to narcissistic wounds when the love of the Other is at stake.

Gendered Evasion

KEVIN S. SANDLER

It's only a cartoon.

—ANONYMOUS (1951)

American Art, to reach the hearts of Americans,
must be happy art.

—PHOTOPLAY (1917)

Bugs Bunny in Drag

Eric Smoodin's *Disney Discourse* and Elizabeth Bell, Lynda Haas, and Laura Sells's *From Mouse to Mermaid* critique the popular belief of Walt Disney cartoons as *monolithic*, as magical sites beyond ideology and reproach.[1] These collections suggest that the world Disney purportedly offers is an eternal "happy place," a safe haven for adults and children alike.[2] With this understanding, pleasure from Walt Disney entertainment is sacred and nonnegotiable. Leave all critical faculties at the door; bring only the "bare necessities." Relax, sit back, and enjoy the "wonderful world" he offers. Cloaked in what Henry Giroux calls "a politics of innocence,"[3] the mass audience can assimilate and legitimize social assumptions and cultural norms—that is, social performance—without ever having to interrogate or repudiate their phantasmatic construction.

A Disney animated film's ability to compel belief that is above suspicion, to embody and reiterate norms, lies in its ability to effect "realness"—to impersonate or give the appearance of a knowable and, therefore, "believable" reality. As Judith Butler explains in *Bodies That Matter*, the effect of "realness" means a performance works, its approximations of ideals are free of scrutiny. For a performance to be unscrutinized, it must not be able to be *read* because reading implies a sense of failure, an exposure of the simulation of reality.

> For a performance to work . . . means that a reading is no longer possible, or that a reading, an interpretation appears to be a transparent seeing, where what appears and what it means coincide. On the contrary, when what appears and how it is "read" diverge, the artifice of the performance can be read as artifice; the ideal splits off from its approximation.[4]

For the Disney audience, the artifice works; realness is transparent.

Since most people go to the movies to be entertained, "realness" in films, especially Disney cartoons, provides spectators with identificatory security and demarcation, not instability and ambiguity. In *Alice Doesn't*, semiotician Teresa De Lauretis concludes that a film's effectiveness or "realness" is directly tied to its ability to please its spectators. This pleasure relates to the question of desire— the desire to know and the desire to see—"and thus depends on a personal response, an engagement of the spectator's subjectivity, and the possibility of identification."[5]

Importantly, De Lauretis adds, films address spectators as members of particular social groups; a stable gender system, according to Eve Kosofsky Sedgwick, being "the single most determinative diacritical mark" of a social group's organization.[6] Certain patterns of gender identification in films, then, must be available to each and all spectators. The spectators' pleasures derive from their ability to "see" and to "know" gender; their desire for these images resides in the affirmation of specific gender roles and the security that purportedly lies in the existence of an interior and organizing gender core. Such "interpolation naïveté" reiterates what Butler calls an "imaginary logic"; in particular, a heterosexual matrix based on the mutual exclusivity of gender, desire, and sex. This imaginary logic, suggests Butler, requires that "if one identifies *as* a given gender, one must desire a different gender."[7]

Mainstream society, states Marjorie Garber in *Vested Interests: Crossdressing and Cultural Anxiety*, desires to see a difference between male and female, to guard against the similarities that might otherwise put one's own position as a gendered subject into question. This difference is an absolute difference, a fundamental, constitutive difference between maleness and femaleness. It is as if, says Garber, "a hegemonic cultural imaginary were saying: if there is a difference, we want to be able to *see* it, and if we see a difference we want to be able to *interpret* it."[8]

A film's popularity and financial success thus depend on these patterns of gender differences being recognized and interpreted by a large number of spectators. If popular cinematic representations of gender did not mirror our "real life" gender representations, they would most likely not produce meanings relevant to our daily lives. Texts would never be popular in the first place if viewers were unable to make sense of their social systems.[9] That the audience knows a character's gendered and sexed identity is crucial to a film's mass appeal because a stable gender identity lies at the heart of viewer subjectivity.

Cultural intelligibility, the ability to interpret your own and another's gender, is a valuable commodity in a gendered world. Those who intentionally transgress gender boundaries—cross-dressers, transvestites, transsexuals, homosexuals, lesbians—cause discomfort to and incur admonishment by those who perform their "own" gender correctly. For many "repeat offenders," failing "to do your

gender right," as Butler puts it,[10] is a punishable offense, a path to seclusion, ostracism, and occasionally death.

However, the existence of a cross-dressing figure, claims Garber, always disrupts binary thinking. One of the main effects of the cross-dresser or transvestite is to indicate a "category crisis," a failure in the social and cultural definitions for the categorical boundaries of masculine/feminine and other binarisms.[11] Cross-dressing denaturalizes, destabilizes, and defamiliarizes sex and gender signs. As a result of this disruption, the categories of male/female and masculine/feminine as either biological or cultural truths or constructions are brought into question.

If a cross-dressing figure always throws categories into crisis by denaturalizing cultural signifiers, the task of popular narratives, then, is to rearticulate and control these signifiers by ultimately erasing, neutralizing, or dissolving such contradictory elements within the confines of a heteronormative structure. It is in this sense that the ability of Disney cartoons to effect unmitigated "happiness" and unqualified popular success partly lies in their ability to reward "real" gender performance and punish gender perversion. One only needs to recall the drag queen Ursula in *The Little Mermaid* (1989), the effeminate Scar in *The Lion King* (1994), or the emasculated Frollo in *The Hunchback of Notre Dame* (1996). Warner Bros. cartoons, on the other hand, take delight in gender transgressions of both their villains and heroes, particularly Bugs Bunny. When Bugs crossdresses as a woman, "realness" exposes itself as artifice. Yet this artifice is only temporary; ultimately gender idealization is secured.

This essay explores how Bugs Bunny cross-dressing cartoons are part of a larger cultural practice in popular culture that reaffirms the appearance of a prior gendered subject. Through the embodiment and textual repetition of the transvestite figure,[12] the cartoons continually reproduce the illusion of a uniform gender core by first denaturalizing and defamiliarizing gender, sex, and sexuality signs. These gender transgressions are subsequently recirculated within a heterosexual discourse by way of comedy and laughter, restabilizing and reinforcing the alignment of "natural" and "normal" gender, sex, and sexuality ideals.

Gender Theory and Anthropomorphism

The problem with "Snow White" is the prince. . . . In
Warner Bros, you don't get representations of humans. I
think they're better for that reason. There's no confusion
about what they're trying to achieve.

—HUGH KENNER, AUTHOR OF CHUCK JONES:
A FLURRY OF DRAWINGS

This study of Bugs Bunny draws on the gender work of Judith Butler, who rejects the dominant and popular belief that gender derives from sex (e.g., male

equals masculine) and that sexuality is an inherent performance deriving from gender (e.g., masculine equals desires woman). In *Gender Trouble*, Butler argues that gender attribution results not from an expression of a "true" masculinity or femininity but from a practice of what masculinity and femininity are purported to be. As a performance, gender is a "doing," a term always in the process of becoming but one never fully constituted or realized.[13]

Yet, over time, according to Butler, identity can become a culturally restricted principle of order, a coherent set of contingent acts that create the appearance of a gendered subject, a natural sort of being. For gender to be seen as "fact" and not an "artificial effect," it requires a performance to be repeated in order to lay claim to its "naturalness," and a compulsion to adhere to societal rules in order to lay claim to its "normality." She sees repetition as the reenactment of a set of meanings already socially established, legitimizing these meanings through their mundane and ritualized expression. Compulsion, for Butler, is a "regulated process of repetition," a set of conditional actions under duress in order to comply with these socially established norms. As its effect, the action of gender produces the phenomenon of a "natural" gender, which the actors—the social audience themselves—come to believe in and perform as truth, while the rule-governed discourses that constitute the subject enable and restrict gender possibilities. Gender can then be viewed, says Butler, as a "stylized repetition of acts," or a series of social strategies for survival.[14]

Regulatory forces that demarcate and differentiate gender also distinguish between *sexualities*. The category of sexuality produces assumptions and prohibitions that are "natural" and "normal" for a gendered subject. Subjects articulate and enact these constructed desires through performances that contribute to the illusion of an interior and organizing gender core; this illusion, according to Butler, is "discursively maintained for the purposes of the regulation of sexuality within the obligatory frame of reproductive heterosexuality."[15] The stability of gender, then, can be defined through what Adrienne Rich calls "compulsive heterosexuality" by a culture that "demands heterosexuality."[16]

Without repetition and compulsion, Butler proclaims, the sexual *subject* also would no longer exist. "The category of 'sex,'" like sexuality, "is itself a gendered category," a fully invested political binary that naturalizes that which is not natural.[17] The linguistic distinction of "sex" divides human bodies into male and female sexes, first installing, then securing and maintaining the cultural and political operation of compulsive heterosexuality.[18] In other words, the terms "man" and "woman" serve only to institutionalize reproductive sexuality and heterosexuality as "authentic" and "natural." Thus, sex and sexuality, along with gender, are all performances that naturalize and normativize the dualist nature of human identity.

If gender identity is a regulated and regulating cultural fiction, gender reality

is created through sustained performances of gender. The performative attributes that accompany these fictions constitute the notions of an essential sex and a true masculinity or femininity. Compulsory heterosexuality sets itself up as the authentic or the original by way of presumption, impersonation, and approximation. In order to reproduce and maintain the illusion of a gendered subject, genders must always be imitating an idealization of themselves, producing the effect of originality.[19] For example, when one performs masculinity, one imitates the expression of masculinity constituted as gender reality. In this sense, gender is an imitation for which there is no original; it is a copy of a phantasmatic idealization. Gender, therefore, is an imitation of an imitation, a copy of a copy, for which there is no original.[20]

Although Butler denies the existence of "natural" genders, she does not deny the priority placed on distinguishing between genders. Butler and Anne Herrmann suggest that we actually read gender through its enactments and that from our reading of gender we attribute sex identity (i.e., perceived anatomy).[21] Women, thus, can actually "perform," or "do," "woman," and men can actually "perform," or "do," "man."[22] In addition, psychologists Suzanne Kessler and Wendy McKenna in *Gender: An Ethnomethodological Approach* (as quoted by Herrmann) revealed in studies that the penis functions as the only essential sign of gender when the gender attribution of a new acquaintance—the first attribution—is made.[23] That the penis is almost always hidden from view is significant; it suggests the penis is assumed to exist in the absence of contradictory cues (i.e., femininity) when presuming gender.

A star, such as Clark Gable, whose clothes hide "his" genitalia, shows no proof of male identity to the viewer, yet we read him as male and masculine. Hip size, shoulder width, breast size, and certainly the exposure of the penis or vagina could further assist in one's gender attribution of Gable. Nonetheless, shirts can hide one's breasts, body building can increase muscle mass and decrease fat tissue, and nudity is still uncommon for most actors (and actresses) in Hollywood films. Other signs must contribute significantly to the gender attribution and differentiation of "male" characters such as Clark Gable from "female" characters such as Marilyn Monroe.

Yet it is the *lack* of signs that assists viewers in reading Clark Gable as "male"; no clues gender him as female. This is so, explains Chris Straayer, because certain costume and makeup styles have historically coded a woman's surface as sexual, immediately announcing her sex at moments of gender attribution.[24] Clothing emphasizing the female body, especially the breasts, immediately signifies "feminine" as well as "female." If gender attribution is essentially sex attribution, the historic absence from view of the penis in cinema, argues Straayer, has allowed the male body an independence from sexual anatomical verifica-

Engendering Bugs Bunny: underwear for him and her. Copyright Warner Bros., Inc.

tion.[25] Clark Gable is read as "male," because "male" is assumed in the absence of female cues.

Popular animated animal characters like Bugs Bunny can be read in a similar fashion as human characters; they are also gendered. The Warner Bros. Studio Stores need only add a ribbon, eyelashes, and breasts to a picture of Bugs Bunny on a box of underwear to create a female Bugs Bunny. Known as anthropomorphism, this process—attributing human characteristics to nonhuman objects—naturalizes and normalizes strictly defined gender norms and heterosexuality by engendering animal characters in exactly the same way we humanize humans. Gender imitation in animal characters does not copy that which is prior in humans since gender already is a fiction; it copies what is already assumed to exist in humans. Anthropomorphism can be viewed, then, as an imitation of an imitation of an imitation, a copy of a copy of a copy. By repeating this imitation, the animators create the illusion of a talking gendered animal while reproducing the illusion of gender itself. Anthropomorphism reiterates the schema of gendered bodies as fact, not fiction, by its imitative nature.[26]

As a result of these imitations and repetitions, similar gender attributions

must exist between anthropomorphized animal characters and human charac-
ters because gender identity lies at the heart of human (i.e., viewer) subjectiv-
ity. Since ungendered subjects, argues Annette Kuhn, cannot be human,[27]
anthropomorphized animal characters, in this view, must be read as either mas-
culine or feminine, male or female, by the spectator. Hence human characters
and anthropomorphized animal characters are both gendered subjects. Bugs
Bunny (who is usually drawn without clothes and displays no conspicuous geni-
talia) and Mickey Mouse (who wears clothes) have an "equal" claim to man-
hood and identity as Clark Gable, whose clothes hide "his" genitalia, his proof
of male identity, from the viewer. Their gender codes are one and the same.

If engendering is essential in the reception of popular texts, what traits pro-
duce an unambiguous gender attribution for animal characters? In "Seduced and
Reduced: Female Animal Characters in Some Warners' Cartoons," Sybil
Delgaudio argues that dress and behavior play important roles in assigning gen-
der to animals in animated cartoons.[28] For Delgaudio, the major difference be-
tween those characters perceived as male or female is the degree and type of
abstraction in their impersonation or imitation of human traits. She says recog-
nizable masculine traits (such as aggressiveness) are diametrically opposed to rec-
ognizable feminine traits (such as passivity) in animated texts. An animal
character becomes immediately recognizable as a "woman," as Delgaudio points
out, by what Molly Haskell calls a "set of external playable mannerisms," whereas
the idea of man is "unlimited as the ocean."[29] Delgaudio gives the following ex-
amples:

> Bugs and Daffy as male rabbit and duck can be seen as trickster, cowboy,
> spaceman, among a thousand roles, whereas Petunia Pig and Daisy (both
> Duck and Rabbit) are reduced to the physiological and emotional
> characteristics associated with the idea of woman, complete with
> makeup, breasts, and susceptibility to seduction.[30]

Delgaudio's point is that gender construction operates similarly in the cartoon
world as in the material world. The simplicity and vastness by which woman
and man are identified, respectively, remain unchanged.

Comic author Mike Benton believes animators' exaggeration of male and
female musculature reproduces and perpetuates gender difference. He says it is
a "sexless exaggeration for men" compared to women.[31] Experimental animator
Veronika Soul, in response to a question concerning what she thought of the
depiction of women in animation, remarked: "The only thing I think of is ste-
reotypes. When a person draws a woman cartoon character, it has all the exter-
nal earmarks of a woman, so nobody can make a mistake and say, ah, that's a
sailboard."[32] Are not breasts, however, a secondary sex characteristic? Anatomi-
cally, both men and women have breasts, so the presence of breasts should

suggest no difference. But culturally, the idealized image of femininity is a woman with large breasts. Large breasts, therefore, imply a gender difference, and from our reading we attribute sex identity to the animal character. As Delgaudio, Benton, and Soul point out, what is visible on the body *is* the site of gender difference.

Although a certain degree of imitation of human traits is necessary for an animal character to appear humanlike—male or female—cartoon characters are still drawings, not flesh and bone. Animation directors can easily alter a character's identity and actions with a touch of an eraser or a dab of paint. The boundaries and constraints of the body of the human actor limit its bodily transgressions. Animators have one luxury the directors of live-action films do not have: they can manipulate the gender performance of their characters. If such gender manipulation is possible, how do popular forms of animated entertainment like the Bugs Bunny cartoons still produce the appearance of a coherent gender core in the face of gender destabilization and denaturalization? How do they perpetually reidealize "realness"?

Femininity in Warner Bros. Cartoons

Did you ever find Bugs Bunny attractive when he put on a
dress and played a girl bunny?
 —*WAYNE'S WORLD* (1992)

The strange thing about the narratives of Warner Bros. cartoons is that they do not preoccupy themselves with gender difference. The cartoons are concerned mainly with the chase between their animal characters.[33] Seduction and sexuality are hardly addressed because they are inconsequential to the pursuit/capture plot of the cartoon. Nonsexualized natural opponents, such as hunter/prey (Elmer Fudd/Bugs), cat/bird (Sylvester/Tweety), and cat/mouse (Sylvester/Speedy Gonzales), are not romantically entangled like the characters in the Walt Disney cartoons (Mickey/Minnie, Donald/Daisy). However, we still anthropomorphize and engender the Warner Bros. characters because of their human actions: Bugs Bunny sleeps in a bed in *Water, Water Every Hare* (1952); he plays sports in *Baseball Bugs* (1946); he is a home buyer in *The Windblown Hare* (1949); and he frequently masquerades as a woman.

Most critics describe any impersonation by Bugs Bunny not coded as recognizably female in terms of his "original" male gendered identity, which they have never contested. Roles not identifiable as "woman" are never the result of Bugs Bunny's impersonation of "man," but an extension of his very own masculine personality and male sexuality. For instance, in *Bugs Bunny: Fifty Years and Only One Grey Hare*, Joe Adamson states that Bugs Bunny transforms "not only

into Groucho, but into cops, kids, geriatric cases, *women*, seamen, foremen, and apparitions of unknown identity" (my emphasis).[34] In other words, see someone as male unless proven female. See someone as male unless prohibited from doing so by recognizable signs of female identity (i.e., femininity). Male is always assumed; female has to be explicitly called for. Bugs Bunny is read as "male" because he exhibits no external characteristics recognizable as "female."

It is not unreasonable to assume, then, that many critics and viewers consider Bugs Bunny "male" since there are no clues that define him as female outside of his transformation into "woman." These corporeal and behavioral distinctions are no different when they are recognized by the interior or diegetic audience (e.g., Elmer Fudd and Yosemite Sam). Elmer and Yosemite Sam construct Bugs Bunny as "female" by the same sartorial codes as the exterior or extradiegetic audience (i.e., viewers and critics). Both interior and exterior audiences see Bugs Bunny as "female" only when he is in the exaggerated, garish garb of the transvestite: makeup, breasts, and a dress.[35] In the presence of these gender characteristics, Rocky (a gangster caricature) confuses Bugs Bunny for a twenties flapper in *The Unmentionables* (1963), and Elmer mistakes Bugs Bunny for a "señorita" in *The Rabbit of Seville* (1950). For the most part, Bugs Bunny assumes the codes of the female gender for the purpose of temporary escape, or, in other words, a gendered evasion.

The codes that signify Bugs Bunny as a "woman" to Elmer, Sam, and the exterior audience during a moment of gendered evasion are no different from the codes used with female characters like Petunia Pig or Daisy Lou Rabbit in their rare appearances in Warner Bros. cartoons. Bugs Bunny's performance as "female" is defined by the same behavioral, corporeal, and sartorial characteristics as those defining Petunia's and Daisy's representation. If Bugs Bunny is not the object of desire or site of sexuality, he is elderly, motherly, unattractive, or desexualized like Granny or Witch Hazel.[36]

Transvestite Parody and Laughter

People have a reluctant admiration for those that don't obey
the rules and do so gracefully. And Bugs is graceful.
 —CHUCK JONES[37]

Transvestism performance, which I call cross-gendering,[38] describes anyone who performs the gender of one sex while a member of the other sex. The effects of these acts may vary, yet they all entail acts of gender, gendered, and gendering performances: "passing" equals temporary misrecognition; "transvestism" equals erotic pleasure; "cross-dressing" equals a lifestyle of passing; "in drag" equals any gender performance involving clothing.[39]

Challenging the classical categories of masculinity and femininity has been a common form of exploitation and profit for the creators of popular Hollywood films. Only through the negotiation and the consent of the masses can a sub-versive figure such as the transvestite function as a mechanism for the natural-ization and normalization of gender identity and heterosexuality. The popularity of many cross-gendering films such as *I Was a Male War Bride* (1949), *Tootsie* (1982), *Mrs. Doubtfire* (1993) and *The Birdcage* (1996) is a result of their being neither uncomfortable, nor culturally disturbing, nor threatening to the mass audience. These films invert gender categories (i.e., the male characters reverse genders in response to perceived social or economic necessities) while evading their constructive nature (gender signs are restabilized by the films' conclusions). Gender reversal films are thus able to reproduce the notion of a "natural" gen-der, maintaining a "comfort level" for their audiences.

In "Redressing the 'Natural': The Temporary Transvestite Film," Straayer identifies gender reversal films as a genre where a character cross-genders tem-porarily for the purpose of necessary disguise. In this genre, which Straayer names the "temporary transvestite film," the transvestite is "compelled" by social and economic forces to disguise himself or herself in order to get a job, escape re-pression, or gain artistic or political freedom. The temporary transvestite film genre allows many spectators a vicarious trespassing of gender boundaries. The endings of temporary transvestite films, however, subsequently resolve any cul-tural conflicts raised by the character's transvestite performance. Films in this genre eliminate an ideological threat through the reinstitutionalization of het-erosexuality in the form of heterosexual union. The continued generic popularity of temporary transvestite films, according to Straayer, lies in their appeasement of the basic contradictions in naturalized gender and sexual behavior "through a common fantasy of overthrowing gender constructions without challenging sexual differences."[40]

Thomas Schatz, in *Hollywood Genres*, refers to a genre's diegetic "natural-ization" as a "problem solving strategy"; its most significant feature is the genre's efforts to solve, even if temporarily, social conflicts of the viewers.[41] If film genres first animate then later resolve cultural conflicts, the temporary transvestite film genre can be said to provide ideological strategies for negotiating failures in gen-der imitation. The transvestite's disruption, exposure, and challenge to the very notion of the "original" and of stable identity must be corrected and the status quo reaffirmed. The temporary transvestite film does not solve the contradic-tions raised by the transvestite figure; instead, the conflict is recast around a het-erosexual discourse which resolves gender instability.

Similarly, Garber refers to the elements I believe comprise Straayer's tem-porary transvestite genre as composing a "progress narrative." Garber argues that any discomfort caused for the audience by the transvestite is "smoothed over

and narrativized by a story that recuperates social and sexual norms, not only reinstating the binary of male/female, but also retaining and encoding" that binary.[42] Or, as Straayer explains it, "the narrative structure of these films almost invariably leads to the (re)institutionalization of heterosexuality after progressing through some 'stage' of unstable gender and ambiguous sexuality."[43] The character's inability to maintain and master his/her disguise eventually reinstates rigid sex roles and heterosexuality, while functioning as comedy for the spectator.

If most popular texts maintain the status quo, any haziness in sexual and gender identity must be purged not only from the characters' imaginations but from the spectators' imagination as well. Audience laughter releases the tension created by the unstable gender embodied by the transvestite. In "Men in Skirts and Women in Trousers, from Achilles to Victoria Grant: One Explanation of a Comedic Paradox," Corinne Holt Sawyer identifies five factors that often operate to create laughter in the transvestite film featuring male cross-dressing:

1. The surprise: a reversal of expectations causes a laugh reaction.
2. The difficulties a man has mastering female garb, such as high heels or girdles.
3. The embarrassments of a disguised male forced to share female discussions in locker rooms or dressing rooms, for instance.
4. The incongruity of men experiencing treatment and attitudes that women have come to expect, such as emotional instability or mechanical ineptness.
5. The disguise is so successful that another man is attracted to the supposed woman.[44]

The humor of these five factors derives from the gender incongruity produced by men performing "women." The feminine or feminized man is always the butt of the joke.

This is so, argues Joan Mellen in Big Bad Wolves, because "transvestism serves to bestow contempt upon women, since the men imitate female behavior with mincing steps, high voices, narcissism, and self-indulgence, a grotesque caricature of the sex."[45] Since behavior and clothing are cultural indicators of gender, transvestite films ridicule femininity when they show feminine dress and behavior as frivolous, superficial, and impractical. The restrictions on comfort (e.g., high heels), movement (e.g., dress), and vanity (e.g., lipstick) that define the concept of "woman" are associated with victimizing men in the narrative. Man's inability to master the "feminine" threatens his masquerade and occasionally exposes it. By ridiculing the man who dresses as a woman, the transvestite comedy performs a corrective function, reassigning and reinstating gender binaries by revealing the absurdity of the feminized man.

The absurdity and laughter associated with transvestite comedy can be traced to the tradition of the "sight gag." According to film theorist Noël Carroll, the sight gag, in juxtaposing incongruous visual elements, provokes spectatorial amusement by the image's alternative interpretations.[46] When applied to a cross-gendering moment, the incongruity lies in the violation of the gender codes of one sex by a member of the other sex so the viewer must read the transgressor in a bi-gendered manner to "get" the joke.

A similar "sight gag" framework exists when the temporary transvestite figure intervenes in another cinematic form: the animated film, especially the Bugs Bunny comedies. Of the 168 Bugs Bunny cartoons released in theaters (from *A Wild Hare* in 1940 to *False Hare* in 1964), 37 function as temporary transvestite cartoons.[47] In 36 of these 37 cartoons—*Backwoods Bunny* (1959) being the only generic discrepancy—the reality behind the transvestite scenario (that Bugs Bunny is in fact a male) contradicts Elmer's (or another foe's) imagined picture of the event (that Bugs Bunny is a female). However, Elmer's interpretation is comprehensible and plausible for the audience, since Bugs Bunny's sartorial and behavioral appearance is consistent with the performative concept of "woman." The interpenetration of these two scenarios is eventually disrupted or interfered with; Elmer's expectations of romance are reversed by the exposure of Bugs Bunny's disguise, this final humiliation serving as the topper to the sight gag.

But these "romantic" scenarios are not the only relationships that interpenetrate and interfere with one another; the spectator's relationship to Bugs Bunny is also incongruous in the temporary transvestite cartoons. Bugs Bunny's gender performance is simultaneously believable to the film's characters and unbelievable to the film's audience, an element Straayer sees as typical of temporary transvestite films.[48] Diegetically, Elmer does not recognize the gender performer or gender performance as imitation; extradiegetically, the spectator recognizes the gender performer Bugs Bunny and "his" performance as imitation. While the exterior audience has prior knowledge of Bugs Bunny's "true" identity, the interior audience is unaware of the disguise.

Viewers, always privy to Bugs Bunny's transvestite disguise in every temporary transvestite cartoon, must read Bugs Bunny as both "male" and "male cross-gendered female" in order to understand the gag. This simultaneous construction enables spectators to interpret the transvestite seduction scene from many available hermeneutic positions. Because of this prior knowledge one could argue that Bugs Bunny's gender becomes much more fluid and ephemeral. He could now be viewed as blurring genders instead of only crossing them, especially during instances when the cross-gendered Bugs Bunny kisses Elmer. Do these particular cartoons succeed in subverting gender norms, or do they reinforce naturalized categories of identity and desire?

The Temporary Transvestite Kiss

Interviewer: There have been some curious on-screen nudges . . . showering
 Elmer Fudd's bald head with kisses . . . dressing up as a woman with
 whom Fudd always falls in love. . . . Could these moments be a kind of
 private code, a signal to the *cognoscenti* that . . .
Bugs Bunny: Young man, it is seldom that I have occasion to quote Daffy
 Duck, but there is only one phrase for that suggestion: *thathhh dethpicable!*[49]

A kiss can occur between Bugs Bunny and Elmer Fudd (or another opponent)
in both nontransvestite and temporary transvestite films. Occasionally, Bugs
Bunny kisses Elmer for no other reason than to demonstrate his superiority and
irreverence. In their book *Looney Tunes and Merrie Melodies: A Complete Illus-
trated Guide to the Warner Bros. Cartoons*, Jerry Beck and Will Friedwald use the
term "wacky" to describe these kisses between Bugs and his pursuers that do not
occur amid a masquerade.[50] The Warner Bros. staff probably interpolated the
wacky kiss into the narrative merely as a gag to temporarily startle, confuse, and
delay Bugs Bunny's pursuers. Whether Bugs kisses Bruno the circus bear in *Big
Top Bunny* (1951) or Elmer in *Wideo Wabbit* (1956), the smooch in nontrans-
vestite cartoons reinforces Bugs Bunny's apparent superiority over his opponents
in the midst of the pursuit. The reaction to these kisses by Bugs's opponents is
always one of embarrassment, easily (yet explicitly and dramatically) brushed
off by a wipe of the lips. This situation is significant enough that the kiss and
response warrant a momentary pause before the pursuit continues. The kiss be-
came one of Bugs Bunny's many gags in the pursuit/capture plot structure of the
Warner Bros. cartoon because, in Mel Blanc's words, "the gag worked, the gag
stayed. That's all there is to it."[51]

But *is* that all there is to it? When pursuit turns to seduction in temporary
transvestite cartoons, the kiss becomes more than just a gag. I once again turn
to Chris Straayer to provide an answer to this question. These temporary trans-
vestite kisses, which she calls "paradoxical bivalent kisses," allow for an assort-
ment of readings because they can imply heterosexuality, homosexuality, and/or
bisexuality. This is because the temporary transvestite film

> constructs a specific configuration that achieves the intersection of
> gender/sex crosscurrents in an equivocal romantic event. In this generic
> system, the conflict between a character's actual sex and the sex implied
> by her/his disguise and performance functions to create simultaneous
> heterosexual and homosexual interactions.[52]

When Bugs Bunny cross-genders as a "woman" and kisses another recognizably
male character, he diegetically passes as a female and extradiegetically passes as
a male. The paradoxical bivalent kiss could be interpreted in various ways: for

example, a male kissing another male or a "female" kissing a male. Kisses that almost touch the lips—which I call "near kisses"—function in the same way. The male character has already committed himself to sharing a kiss with the transvestite. Both kinds of sexual kisses are ambiguous, however, requiring the viewer to experience a cross-gendered moment.

A *gendered* moment, however, is rare in a Bugs Bunny cartoon. Only 4 of the 168 Bugs Bunny cartoons present Bugs Bunny kissing another recognizable female character. These "heterosexual" kisses take place when Bugs Bunny kisses an electronic decoy rabbit (*Grey Hounded Hare*, 1949), Daisy Lou (*Hare Splitter*, 1948), a "female" mechanical robot (*Hair-Raising Hare*, 1946), and Mama Bear (*Bugs Bunny and the Three Bears*, 1944). The infrequency of kissing between recognizable male and female characters further indicates the lack of attention or significance placed on seduction in the Bugs Bunny cartoons outside the intervention of the transvestite figure.

For the most part, Bugs Bunny "plants" kisses on a recognizable male figure either as "himself" or in the guise of the transvestite. When Bugs Bunny is not cross-gendered, he plants kisses on another male character in 28 of the 168 cartoons, initiating the "wacky" or "gag" kiss twenty-five times. The "gag" kiss functions as a ridiculing device to signify the masculine Bugs Bunny's superiority over his "less than masculine" foes. Its regularity reinforces Elmer's position in the Bugs Bunny narrative as the butt of the joke.

In only four cartoons are the roles reversed; the "gag" kiss functions not to ridicule Bugs Bunny's opponents but for the opponents to ridicule Bugs Bunny. Bugs's opponents assume the mocking and taunting role in the cartoon usually reserved for Bugs himself. In *Tortoise Beats Hare* (1941) and *From Hare to Heir* (1960),[53] Cecil Turtle and Yosemite Sam, respectively, kiss Bugs Bunny on the lips. *Hiawatha's Rabbit Hunt* (1941) and *The Hare-Brained Hypnotist* (1942), in which Bugs Bunny also delivers a "wacky" kiss to his opponents, show Hiawatha and Elmer Fudd, respectively, "planting" a kiss on Bugs Bunny. Bugs Bunny even acknowledges this aberration from the genre formula in *The Hare-Brained Hypnotist* by saying to Elmer: "You can't do that. Who's the comedian of this picture?" Since Bugs Bunny's persona varied from director to director, especially in the early to middle forties, it makes sense that three of these four anomalous cartoons were all released approximately two years after the first theatrical Bugs Bunny cartoon. Bugs was still in the developmental stage, exhibiting some but not all of the characteristics associated with him in the post–1948 cartoons.

From Hare to Heir, Tortoise Beats Hare, Hiawatha's Rabbit Hunt, and *The Hare-Brained Hypnotist* are anomalies in relation to the other Bugs Bunny cartoons. As such, I believe they contributed little or insignificantly to altering the overall comedic effect of the other "wacky" kisses or to destabilizing Bugs Bunny's "male" identity.

As for the temporary transvestite cartoons, Bugs Bunny (as transvestite) kisses a recognizable male character only a total of five times out of the thirty-seven cartoons. The "bivalent paradoxical kiss" appears in *Bedevilled Rabbit* (1957), *Frigid Hare* (1949), *Rabbit Fire* (1951), *Rabbit Seasoning* (1952), and *The Unruly Hare* (1945). The "near kiss" appears in three temporary transvestite cartoons: *Bugs Bunny Nips the Nips* (1944), *Hare Ribbin'* (1944), and *What's Opera, Doc?* (1957). The fact that the "near kiss" appears only in temporary transvestite films, and never as a "gag" kiss in nontransvestite films, supports the argument that its presence functions similarly to the paradoxical bivalent kiss. Both allow for simultaneous heterosexual, homosexual, and bisexual readings because Bugs Bunny's transvestite costume is always convincing to the interior audience but unconvincing to the exterior audience.

Yet unlike the classic, heterosexual Hollywood kiss, Straayer argues, temporary transvestite kisses rarely occur as a final scene.[54] Situating the kiss narratively far from the final scene allows the film's closure to resolve any ambiguous sexuality. The paradoxical bivalent kisses in the Bugs Bunny temporary transvestite cartoons operate in a similar fashion; they don't occur in the final scene either. With one exception, the same can be said for even the wacky kisses.[55]

The temporary transvestite kiss can never occur in the final scene of a cartoon because Bugs Bunny must always be gendered male to both the diegetic and extradiegetic audience at the end of a temporary transvestite cartoon. The major difference between the temporary transvestite and nontransvestite cartoon is that Bugs's masquerade does not have to be narratively exposed during the closure of the nontransvestite cartoon. Although Bugs wears women's clothes at the end of the temporary transvestite cartoon *Mississippi Hare* (1949), he has already been exposed to the southern gentleman who fell for his "female" charms. The temporary transvestite cartoons must return Bugs to his "natural" and "normal" gender identity so they can correct any unstable gender or ambiguous sexuality (re)presented by his transvestite disguise. No correction is needed in the nontransvestite cartoons because Bugs is always gendered male in every disguise besides the transvestite.

The ultimate exposure of Bugs Bunny's transvestism subsequently allows the cartoon to (re)institutionalize and restabilize normative sex and gender roles. Hegemonies are rearticulated as "realness" is invariably restored to Bugs, his subject-formation dependent on these negotiations. His performance of "woman" serves as reiteration of gender norms: not only as a gendered idealization of his original male identity but also as a territorializaton of the Other's domain. The temporality and uninhabitality of Bugs as transvestite resignify the domain of homosexuality as *failed heterosexuality*. Through an *allegorization* of heterosexuality, Bugs's cross-gendering does not oppose heterosexuality but, as Butler states, "brings into relief . . . the understated, taken for granted quality of heterosexual

performativity."[56] Thus, the inefficacy of homosexual performance in Bugs Bunny cartoons contains and creates gendered identity, constituting the subject through comedic disavowal and the eventual exclusion of the transvestite.

Backwoods Bunny *as Incidental Bivalency*

Bugs has a dazzling ability to become and do what he wants.
He has no fears for his masculinity.
<div align="right">—SIMON FANSHAWE[57]</div>

One temporary transvestite Bugs Bunny cartoon, however, destabilizes the generic conventions adhered to in other Bugs Bunny temporary transvestite narratives. Robert McKimson's *Backwoods Bunny* diegetically (and most likely, accidentally on his part) exposes the constructive nature of gender and gender performance by failing to reiterate its previous discursive formations. In this cartoon, Elvis Buzzard sets outs to capture a rabbit for his pappy's stew. Unfortunately, Elvis locks his sights on the mercurial Bugs Bunny; try as he may, Elvis is unable to catch him. As one of his ridiculing and escape devices, Bugs crossgenders as a woman. Dressed as a hillbilly female in a tattered orange dress with lipstick and eyelashes, Bugs attracts Elvis's eye.

> *Bugs:* Hello there y'all. Be y'all lookin' for someone, sugar? [*Elvis is smitten by Bugs Bunny's appearance. He starts howling, his tongue hanging out in the process.*] Who y'all lookin' for honey?
>
> *Elvis* [*pointing to Bugs*]: Y'all.
>
> *Bugs:* For little old me? What for, good-lookin'?
>
> *Elvis:* Cuz y'all pretty and y'all got pretty eyes and a real pretty dress, and cuz y'all that there little old rabbit critter I've been fixin' to shoot. [*Bugs reacts in horror. His ears go up.*] And now I'm aimin' to do it, you pretty little thing. [*Bugs yells "Yipes" and the pursuit continues.*]

Backwoods Bunny is the only Bugs Bunny cartoon in which the diegetic inadequacy of the disguise is immediately recognized by both the exterior and interior audiences. As usual, the narrative makes available to the exterior audience the "real" identity of the recognizable feminine character, Bugs Bunny. Yet, this time, the disguise does not fool the interior audience member, Elvis Buzzard.

For this reason, *Backwoods Bunny*'s dialogic destabilization of binary sex and gender distinctions allows for a reading not available in other Bugs Bunny cartoons. Bugs's ability to signal both sexes simultaneously by his inadequate disguise and Elvis's acceptance of this duality exploit the temporary transvestite cartoon's generic elements. This difference makes it impossible for the spectator to laugh at the foolish victim of the gender performance because Elvis

recognizes the performance himself. Elvis does the laughing instead; Bugs *and* the exterior audience are the butts of the joke. What surfaces in this cartoon is not comedy but confusion; confusion over the true nature of sexual desire. Elvis is attracted to a gendered male Bugs Bunny knowing full well Bugs is cross-gendered female. Elvis shows no concern for doing his gender—or, for that matter, any gender—"right." His immediate awareness and exposure of Bugs's disguise undermine and threaten the temporary transvestite genre's corrective heteronormative function.

However, *Backwoods Bunny* never again alludes to Elvis's desire for Bugs Bunny. As in all other temporary transvestite cartoons, the momentary and vicarious fantasy of transgressing gender constructions is subsequently ignored and quickly recirculated back into the generic system. *Backwoods Bunny's* radical though brief departure from the genre is a reminder of how genre and gender are both contingent on repetition and boundary maintenance. Only by echoing prior styles and performances do genres and genders become mobilized. The accumulation of these prior acts, to borrow Butler's phrase, "draws on and covers over" their constitutive conventions.[58] *Backwoods Bunny* may have partly failed to "draw on" previous temporary transvestite discourses of the time, but its very failure to preserve genre categories "uncovers" the illusion that sustains and binds gender categories. Bugs Bunny's identity, like all identities, is forever at risk; they are categories that can only be approximated and never fully "covered over." "Realness" is always at stake, even for Bugs Bunny.

Conclusion

Though functioning as a reidealizing discourse, the transvestite in Bugs Bunny cartoons foregrounds the socially constructed nature of gender difference and subjects it to comment: what appears natural cannot help but reveal itself as artifice. As Bugs is first engendered as a "male" rabbit, then cross-genders from "male" to "female" rabbit or human, only to revert back to his constructed self as "male" rabbit, gender is always destabilized because we are constantly in the process of reading Bugs Bunny's performance as either male or female. The extradiegetic inadequacy of Bugs's disguise allows the exterior audience to recognize and realize that those signs previously signifying gender and sexuality are now false and illusionary. Even though the cartoons' narratives safely return to these rigid demarcations by the final scene, the filmic audience can still vicariously experience a trespassing of society's boundaries through Bugs Bunny's transvestism. Each of the 37 temporary transvestite cartoons supports this claim. But because Bugs Bunny is anthropomorphized or gendered, the 131 other Bugs Bunny cartoons must also succeed in reaffirming and recirculating these hegemonic ideals in order for the cartoons to remain popular with a mass audience.

I believe Bugs Bunny's ability to disguise himself as everything, including "woman," accounts for his enormous popularity over five decades. Since Bugs Bunny is rarely the object of ridicule—contemptuous humor in both temporary transvestite and nontransvestite cartoons is always displaced onto another character—viewers are sutured into subject positions that ultimately identify with Bugs Bunny.

However, anthropomorphism always assumes an identification with contemporary gender configurations, identifications, Butler states, "with a set of norms that are and are not realizable."[59] But Bugs Bunny's bravura and triumph in his cartoons make such irresolvable tensions *appear* socially and culturally possible or "realizable" for the audience. "He is fantasy," says Freleng, "brought into the realm of believability."[60] Thus, viewers can vicariously take pleasure in Bugs's transformation into a "woman," a sumo wrestler in *Bugs Bunny Nips the Nips*, a genie in *Ali Baba Bunny* (1957), or a locomotive engineer in *Wild and Woolly Hare* (1959), without shame, embarrassment, or failure that would accompany such transgressions in the "outside world."

The character of Daffy Duck can serve to illustrate this point. The antithesis of Bugs, Daffy is a social misfit and a failure at constructing a happy life for himself. Jealousy and cowardice obstruct his success. If only he had Bugs's fearlessness and indifference toward others.[61] By not overcoming his fears, Daffy represents the rigid gender and sexual boundaries of society. Bugs Bunny overthrows these demarcations in pursuit of self-happiness. Chuck Jones describes this dialectic in a similar fashion. "Daffy Duck is a rueful recognition of my own (and your own) ineptitudes. Bugs Bunny is a glorious personification of our most dapper dreams. We love Daffy because he is us, we love Bugs because he is as wonderful as we would like to be."[62] Bugs Bunny expresses our own needs as an audience for universal identification and empathy. He fulfills the fantasies we undoubtedly share in the unlimited boundaries of our imaginations, stabilizing our dreams which have no consequence, only consummation.

Selling Bugs Bunny

LINDA SIMENSKY

Warner Bros. and Character Merchandising in the Nineties

THE SYNERGY between the corporate and marketing sides of Time Warner in the growth of the Warner Bros. Studio Stores accounts for much of the revitalization of Warner Bros. animation in the nineties. Considered by many to be the smartest effort to market a studio's characters to the widest possible audience, Warner Bros. Studio Stores' retailing of character merchandise, especially cartoon character merchandise, was a substantial share of the $16.7 billion coming from the retail sales of entertainment licensing in the United States and Canada in 1996.[1] The end of 1997 will see the opening of the 179th Warner Bros. Studio Store (146 domestic, 33 international). An examination of the history and development of the Warner Bros. Studio Stores, as well as their philosophy and approach to product development based on the Warner Bros. cartoons, will provide valuable insights to the increasingly important collaboration between film and television production and their merchandising and licensing departments in the nineties.

Merchandising and animation have been linked since the twenties, coinciding with the inception of animated films, the advancement of consumerism, marketing to children, and the development of mass production. Although both animation and merchandising have been written about extensively as separate entities, hardly any scholarly or popular writing exists about cartoon character merchandising. A cursory glance through the majority of books on animation currently available will turn up a great deal of historical information, discussions of technique, reminiscences of artists and creators, and numerous visuals with little mention of merchandising and licensing. When addressed, they are most often depicted through photos of licensed products, with scant information on the merchandising plans or even merchandising philosophies of the studios.

Perhaps the literary absence of merchandising and licensing was a direct result of critical disdain toward the topic. Merchandising was considered part of the "consumerism" of animation; it was neither an "art" form nor an integral part of the business of animation.[2] Nevertheless, a few books have touched on this topic with success. In *Felix: The Twisted Tale of the World's Most Famous Cat*, John Canemaker discusses Felix the Cat through thoughtful analyses of the character's history, art, ownership issues, and filmography, including an excellent discussion of merchandising and licensing.[3] John Cawley and Jim Korkis's *Encyclopedia of Cartoon Superstars* acknowledges the importance of cartoon merchandising by singling out which characters had licensing plans, noting the year and type of licensing.[4] And in Eric Smoodin's collection, *Disney Discourse*, Richard deCordova discusses the intertwining of Disney and children in "The Mickey in Macy's Window: Childhood, Consumerism, and Disney Animation."[5] Hence, primarily fan and collectors' magazines such as *Animato!* and *In Toon!*, as well as industry magazines such as *Animation Magazine* and *Kidscreen*, have touched on cartoon character merchandising and licensing. Books on collecting cartoon memorabilia, such as Bill Bruegman's *Cartoon Friends of the Baby Boom Era*,[6] rarely address much more than the merchandising items in existence and their estimated collectors' values.

Most companies did not take licensing seriously until the merchandising of *Star Wars* in 1977. The film's licensing effort was so successful that other companies began examining their own licensing efforts and reexamining licensing rights, ownership, and back end distribution.[7] The growth of character merchandising and licensing in the late seventies and eighties, especially the resurgence of animation, can be attributed to the change in management of the Federal Communications Commission (FCC), which had carefully regulated children's television until the late seventies. Mark Fowler, who became chairman in 1981, eliminated many of the existing restrictions that prevented children's programs from becoming advertisements for toys.[8] This new permissiveness permitted the development of shows from existing toys—such as *My Little Pony*, *Pound Puppies*, *Transformers*, *He-Man and the Masters of the Universe*—effectively making children's programming half-hour commercials for toy and licensing lines. People began to despise these programs developed from existing toys because they tended to be of low quality and of dubious benefit to young viewers. The shows were often formulaic and cheaply done; their plotlines and characters sometimes dictated by the toy company. This trend has diminished over the years, but aggressive marketers still have a hand in programming shows seemingly created to sell toys, such as *Biker Mice from Mars*.

The growth of merchandising in the eighties is sometimes given credit for the current boom in animation and the plethora of licensed goods. If merchandised well, not only could a show make back a decent portion (if not all) of the

money spent to pay for its production, but the characters could also become internationally known and licensed. Increased profits led to the desire for and production of more "evergreen" characters, animated characters that can appeal to a large number of people over a long period of time, such as Mickey Mouse or Bugs Bunny. By the nineties, a successful merchandising plan was considered crucial and even necessary by business analysts in the launch of a new show or film (*The Real Adventures of Jonny Quest, Superman, Sailor Moon, The Lion King* [1994]) to help make it a financial success.

The Dawn of Animated Character Merchandising

Entertainment character licensing began with the licensing of comic strip characters in the early years of this century. The first comic strip to be licensed was the Yellow Kid, introduced in 1895 by Richard F. Outcault. The merchandising of animated characters began in the twenties with Felix the Cat but expanded to other characters only slightly through the next few decades. Felix's simple black-and-white image could be found on over two hundred items of merchandise, including toys, dolls, books, clothing, and sporting goods.[9] The cat's appeal was aimed at adults rather than children.[10] The success of the Felix merchandising proved that a significant sum of money could be earned for a popular character from animated films, leading to a source of revenue somewhat unexpected by filmmakers at that time.

Mickey Mouse, the next animated character to receive a licensing push, would eventually become a cultural icon as well as the best known of all the licensed and merchandised personalities. Walt and Roy Disney realized that licensing could lead to greater audiences and profits, so they began Disney character licensing and merchandising in-house around 1929. In 1930, concern about "knock-off" merchandise in international markets led the Disneys to contract with George Borgfeldt Company of New York to merchandise Mickey and Minnie Mouse. Borgfeldt's connections and production plants overseas helped cut down the bootleg merchandise abroad. According to Robert Heide and John Gilman in *Disneyana*, Borgfeldt's imported and American products were distributed throughout the United States through the toy trade. Department stores, five-and-dimes, and gifts shops were flooded with porcelain figurines, tea sets, handkerchiefs, and especially toys, mostly made from the cheapest available merchandise, tin and celluloid. As Mickey Mouse cartoons were exported to Europe, international merchandising followed. By 1932, Disney had created a character merchandising division of Walt Disney Productions to ensure higher-quality merchandise and new alliances with manufacturers, as well as wider distribution. He chose merchandising expert Herman "Kay" Kamen to be the licensing representative in the character merchandising division of Walt Disney Productions.[11]

In the thirties, other studios merchandised their characters: Columbia with Scrappy and Krazy Kat; Fleischer with Betty Boop; Walter Lantz with Oswald the Lucky Rabbit; and Warner Bros. with Porky Pig. These studios would occasionally participate in the merchandising of a character, especially if it was popular, but most of these companies had neither the extensive licensing or merchandising programs nor the organized systems of distribution that Disney had. Still, other than Felix the Cat, all early merchandising, including Disney, was for the most part limited to children's products, such as baby bottles, toys, coloring books, drinking glasses, books, and switchplates. While Disney was making a concentrated effort to create the "Disney lifestyle" through films and products, most companies were more interested in simply making films.[12]

The History of Warner Bros. Character Merchandising

Like Disney, Warner Bros. created now-classic characters that have evolved into cultural icons and have emerged as true entertainment legends enjoyed worldwide by both children and adults. The studio is credited with setting the standard for irreverent, clever humor and inventive quality animation.[13] The list of star characters who came from the studio in the earlier years, and who went on to become licensing and merchandising successes, includes Bugs Bunny, Daffy Duck, Porky Pig, Elmer Fudd, Road Runner, Wile E. Coyote, Foghorn Leghorn, Sylvester and Tweety, Speedy Gonzales, Yosemite Sam, and the Tasmanian Devil.

Unlike Disney, Warner Bros. did not have an organized merchandising plan or a merchandising department soon after it began creating cartoons. From the thirties to the seventies, Warner Bros., like the other cartoon studios, did not consider merchandising as part of the filmmaking process or as a major source of revenue. The first Warner Bros. characters to be merchandised were Bosko and his girlfriend, Honey, in the form of stuffed dolls. According to animation historian and cartoonist Mark Newgarden, Warner Bros. became serious about licensing in the midthirties with Porky Pig, their first "star." Along with his duo partner, Beans, and a host of other now obscure characters (Egghead, Rosebud Mouse, and Blackie), Porky was merchandised in the form of piggy banks, ceramics, rubber toys, and children's books. By 1938, in response to the marketing of Disney cels to the public through the Courvoisier Gallery in San Francisco, Warner Bros. took part in a somewhat unsuccessful cel marketing program along with other studios, selling cels in inexpensive frames at Woolworth's-type chain stores.[14] Producer Leon Schlesinger, who sold the studio to Warner Bros. in 1944, continued overseeing the licensing of the characters until 1948.[15]

Although Porky Pig dominated Warner Bros. licensing in the thirties, it was Bugs Bunny who headlined the licensing effort in the forties and fifties. In the early forties, Bugs Bunny appeared on stuffed plush toys, ceramics, windup toys,

coloring books, rubber dolls, comic strips, watches, and alarm clocks. Other popular Warner Bros. characters also appeared on some merchandise. Even Beaky Buzzard and Sniffles were included on a set of Looney Tunes metal banks. Although Porky remained popular, few Daffy Duck licensees existed until the late forties and fifties when all the popular characters, including Elmer Fudd and Tweety and Sylvester, were licensed. The song "I Tawt I Taw a Puddy Tat" became a big hit, and Mel Blanc recorded children's records based on the Warner Bros. characters.

Although the Warner Bros. studio stopped producing original animation shorts in the late sixties, the cartoons were sold to television and in turn were redirected toward children. At this point, characters began appearing on everything from jelly jar/drinking glasses to Halloween costumes. Beginning in 1963, a Warner Bros. licensing division called LCA, or Licensing Corporation of America, handled the licensing of the animated characters. The company was acquired by DC Comics, which was then purchased by Warner Communications. LCA represented a variety of Warner Communications properties, baseball and hockey properties, and some MGM properties. LCA generated a significant amount of revenue for the era, which was small by today's standards. In 1988, LCA was placed under the management of Warner Bros. studios. Warner Bros. president Terry Semel divided LCA into two divisions: LCA Sports and LCA Entertainment. LCA Sports remained in New York, eventually becoming Time Warner Sport Merchandising. LCA Entertainment moved its headquarters to the West Coast to the Warner Bros. studios in Burbank and installed Dan Romanelli as president of the division. LCA Entertainment became Warner Bros. Consumer Products in 1992.[16]

By the early eighties, new Warner Bros. character merchandise was sparse. If found, the merchandise was usually off model, inexpensive, and geared toward younger children. Marketing style guides given to the licensees featured off-model designs and model sheets from comic book artists in 1969 and not the model sheets from the original cartoons.[17] A random sampling of Bugs Bunny merchandise available around 1983–1985 included pads of paper (Bugs Bunny on cover), bop (punching) bags, pencil tops, candles, socks, erasers, Pez dispensers, puppets, stuffed animals, T-shirts, and children's books. The merchandise was mostly available in five-and-dimes, toy stores, and to those who had access to the Warner Corner, the Warner Bros. store for employees.

The Warner Bros. studio started a new animation division in 1988 to produce daily and later weekly television series. Its first series, *Steven Spielberg Presents Tiny Toon Adventures*, became a syndicated success in 1991 and was followed by *Taz-Mania, Batman: The Animated Series, Steven Spielberg Presents Freakazoid!, Steven Spielberg Presents Animaniacs*, and its spin-off, *Steven Spielberg Presents Pinky and the Brain*. The WB television network first broadcast in 1995

with most of these new shows airing on its youth-targeted block of programming, "Kids WB."

The slight shift in licensing in the later eighties arose from a wave of appreciation of cartoons by an expanding audience base. Baby boomers, while watching older cartoons with their children, realized that cartoons worked on several levels, renewing their appreciation and enjoyment for the cartoons. Cartoons emerged as a group experience at colleges, with students watching them for comfort and nostalgia reasons with others. Furthermore, cable channel Nickelodeon and the Turner Networks (TBS, TNT, and, later, the Cartoon Network) aired cartoons during accessible time periods for children and in time blocks traditionally reserved for adults, leading to increased visibility and larger viewing audiences.

The art world and commercial design world's acknowledgment of cartoon characters as recognizable pop iconography also contributed to the rise of animation fandom. The Warner Bros. Looney Tunes characters surfaced in modern and postmodern design: in the feature *Who Framed Roger Rabbit?* (1988) and in postmodern designs on baseball caps worn at rave dance parties. The demand grew for Looney Tunes character merchandise in novelty and gift shops. Bootleg T-shirts began appearing in urban areas. Cross-licensing Looney Tunes characters with sports team apparel in all four major league associations further boosted demand for product, converging in a Nike/Hare Jordan commercial (basketball's Michael Jordan and Bugs Bunny) during the 1992 Super Bowl.

The Creation of the Warner Bros. Studio Stores

In the late eighties, capitalizing on the resurgence of catalog shopping, Warner Bros. started merchandising its most popular characters by mail through a well-distributed, glossy catalog called the "Warner Bros. Studio Store Catalog." A couple of interesting points became clear: Warner Bros. was targeting adults as well as children, everyday consumers as well as collectors. The earliest catalogs offered a collection of clothing, T-shirts, caps, wristwatches, ties, and other fashion, home, and gift products. Visual and editorial tie-ins to Warner Bros. productions, usually feature films released that season, were also included. Prices were somewhat high, yet the quality of the merchandise was better than that of typical licensed merchandise.

Around the early nineties, Disney (and then Warner Bros.) began marketing directly to an avid public, through the pervasive mall culture, although it still continued to license its characters through licensees.[18] The merchandise being offered at the Disney Store (based in part on the design of its theme park stores) was targeted at children, with some random exceptions like certain T-shirts, caps, wristwatches, and gift items, including candy in glass jars. The same

can be said for the Sesame Street stores, which closed in 1996 after six years of business. Even the short-lived Hanna-Barbera Store (with such characters as Yogi Bear, Scooby Doo, and the Flintstones), which opened in 1990, targeted its merchandise to children, with a small number of limited-edition cels to be purchased by adults, most likely for children.[19]

By the time the first Warner Bros. Studio Store opened in September 1991 at the Beverly Center in Los Angeles, California, Disney stores were widespread in malls across the United States. In 1993, Warner Bros. announced the opening of the Warner Bros. Studio Stores chain, beginning with twenty stores and ultimately increasing to over one hundred stores in the United States, eleven in Europe, and a plan for future stores in Hong Kong and Singapore. Time Warner's 1994 annual report noted that the stores were a success, substantially exceeding mall sales averages for retailers.[20]

Most Warner Bros. stores are situated in malls and shopping centers, with some located in airports. They are roughly twice the size of the Disney stores, averaging approximately 7,000 to 9,000 square feet. The flagship stores are even larger. The one in Manhattan at Fifth Avenue and Fifty-seventh Street occupied almost 30,000 square feet when it first opened. Other flagship stores, ranging from 14,000 to 28,000 square feet, are in London, Berlin, and Glasgow.[21] For the most part, the stores in every city look similar, with some local flavor added. Thus, tourists visiting the shop in a particular city could purchase licensed items that would double as souvenirs from that city, and, in effect, make the store a tourist destination.

The initiators behind the development of the stores include Peter Starrett, president of Warner Bros. Studio Stores, and Dan Romanelli, president of Warner Bros. Consumer Products. Many employees of the Warner Bros. Studio Stores acknowledge that a key visionary behind the stores during the early years was Linda Postell, senior vice president and general merchandise manager of the Warner Bros. Studio Stores until 1995. With her direction and a team of retail specialists, hundreds of products including clothing, jewelry, accessories, sporting goods, collectibles, and artwork were conceived of and developed for exclusive availability through the Warner Bros. stores.

Because the stores are designed to have the feel of contemporary adult apparel and gift stores, children's merchandise is located in the back of average-sized stores and upstairs in the flagship stores. Unlike Disney stores, which run videos directed toward younger children, the Warner Bros. stores have immense video walls running continuous feature film trailers, cartoons, and classic movie clips. These videos work fantastically as promotion, since the visuals are not an imposition but part of the store decoration.[22] In a 1993 Warner Bros. press release, Starrett explained the stores' unprecedented appeal: "We've created a unique setting in which to present a complete shopping and entertainment

View of the flagship Warner Bros. Studio Store on Fifth Avenue and Fifty-seventh Street in Manhattan. Copyright Warner Bros., Inc.

experience. Our interactive displays, presentation areas and multi-media entertainment create an environment that traditional retailers simply cannot duplicate."[23] The stores' design has a high-tech feel, with a bit of Hollywood fantasy and classic movie theater sensibility thrown in. Yet, it also commands a sense of enormity and importance as one travels on the glass elevator or escalators through a panorama of stylized goods in the New York store.

Also considered as attractions in the Warner Bros. stores are art galleries, with each gallery positioned as a "shop-within-a-shop."[24] The art galleries feature original cels, limited-edition cels, collectibles, and designer jewelry related to the Warner Bros. animated characters and DC Comics characters (Batman, Superman). Also featured are contemporary artworks including pop and modern art by James Rizzi, Melanie Taylor Kent, and Roarke Gourley. Placing an art gallery in a retail store was considered an innovation, for animation art was generally not sold along with other licensed merchandise but mainly in animation art galleries. While selling original cels from new Warner Bros. cartoons, the galleries would often show the corresponding shorts, generating interest in those cases where the buyers might not be familiar with the films, such as the 1995 release *Another Froggy Evening*.

The merchandise at the Warner Bros. stores celebrates a range of Warner

Bros. personalities, with an emphasis on the enduring Looney Tunes cartoon characters including Bugs Bunny, Daffy Duck, Tweety and Sylvester.[25] As mentioned, the products not only tend to be of greater quality than most licensed material but also are on model. The merchandise has a sense of humor, similar to the sensibility of the Warner Bros. characters who are known for their irreverence and sarcasm. According to Postell, the merchandise emphasizes "the classic, but with a twist; the traditional, but with an edge."[26]

The Warner Bros. stores (like the Disney stores) encompass both the toy and gift categories, which historically was not a common retailing approach. The toy category, mainly for children, was generally found in toy stores and wherever toys were sold; the gift category, with products historically for purchase by adult shoppers, was limited to either department stores or gift shops. One can find at the Warner Bros. stores an assortment of adult and children's apparel, fashion and home accessories, miscellaneous gifts and toys, animation art, and contemporary collectibles. The merchandise is based on both the Warner Bros. classic characters like Bugs Bunny as well as current ones like Batman and Pinky and the Brain. Prices range from $1.50 for small figurines to over $10,000 for original works of art.

The stores have intriguing dual demographics. Since the classic Warner Bros. characters date back to the late thirties, many adults grew up with the characters and still appreciated them. Thus, the merchandise target audience was broken down so that originally 70 percent, and now 80 percent, of the merchandise would be created for adults between the ages of twenty-five and forty-five who were "self-expressive, entertainment-oriented and have an appreciation for nostalgia."[27] In addition, marketing data showing that adults spent more on discretionary items they bought for themselves than they did for their children, influenced the stores' direction. To increase the number of adult shoppers visiting the stores, items such as coffee mugs, caps, and T-shirts, based on Warner Bros. live-action hit movies such as *Batman* and television shows including *Friends* and *ER*, would make up a small percentage of the merchandise in each store.

Because the typical buyers of cartoon character merchandise did turn out to be adults—either adults purchasing gifts for themselves, or adults purchasing gifts for other adults, or adults purchasing gifts for children—the success of the Warner Bros. plan to target adults proved that the visionaries behind the stores understood their Looney Tunes audience. After all, the original shorts were created for adults.

Warner Bros. continues to license its characters to licensees for inexpensive and standard licensed items sold through separate retail channels, but the merchandise created for the Warner Bros. Studio Stores is exclusive to the chain. Licensing to licensees remains more lucrative for Warner Bros., but the mer-

View of the interior of the flagship Warner Bros. Studio Store on Fifth Avenue and Fifty-seventh Street in Manhattan. Copyright Warner Bros., Inc.

chandise is of different and often lower quality. Representatives from the Warner Bros. stores acknowledge they benefit from the higher-quality merchandise in the stores, for it engenders greater recognition for the company as a brand (and a high-quality brand). According to Karine Jouret, vice president of marketing, "Our stores support the brand by giving it a platform where we can display its quality and excitement."[28] Warner Bros. hopes the interest in characters on merchandise will lead to an increased interest in its cartoons. The obvious advantage for consumers wanting the higher-quality Warner Bros. merchandise is that it is now easy to find it all in one place.

Exclusivity, obviously, is the way to bring people back to the stores repeatedly. Along the lines of exclusivity, the stores have started a more ambitious program of items that are not only exclusive to the Warner Bros. Studio Stores but available for a limited time. One of the first of these products was a limited edition set of *Space Jam* figurines. Other forthcoming merchandise such as limited-edition videos, compact discs, screensavers, and video games will no doubt appeal to a crowd different from the buyers of clothing and housewares.

Character Product Development by the Warner Bros. Studio Stores

When Time Warner first made the commitment to establish the Warner Bros. Studio Stores, it began hiring experienced designers and character artists for in-house product development. Ruth Clampett, formerly of Bob Clampett Animation Art, was recruited to Warner Bros. in 1993 as manager of creative design.

Working mainly with the art gallery division, Clampett, the daughter of Looney Tunes director Bob Clampett, came with a limitless knowledge of the cartoons and of Warner Bros. history. Eventually, she became director of creative design for the Warner Bros. Studio Stores. Much of the following analysis of the creative process behind character product development is based on discussions with Clampett, as well as with graphic designer Peggy Doody, design manager Cathleen Lampl, and character artist Paul McEvoy.

The direction given to the artists came from the highest levels of management. According to Clampett (substantiating early remarks in this essay), when Peter Starrett and Linda Postell started the catalogs and then the stores, they made the decision to develop the highest-quality merchandise, which would separate their merchandise from existing licensed Warner Bros. goods.

Developing the products in-house with design teams has many benefits. A larger vision emanates from the top management down to the rest of the staff, helping to guide the creative process and the development of new products. Producing in-house keeps the stores' current themes in mind and creates the necessary and ultimately apparent synergy between the displays in the stores. The approval process remains internal, which has been an advantage, for it allows greater risk taking and innovation (particularly in the earlier years) by the staff, with direct feedback from management with similar goals and direction.

Merchandise was initially designed out of a studio in New York under Postell before the unit was moved to Los Angeles in 1996. According to Doody, teams were set up in New York to include a design director, a senior designer, a designer, and a junior designer, who would then work with the character artists. The designers and artists had varied backgrounds, although most of the designers had worked at design studios, with many joining Warner Bros. after the Disney stores moved its operations to Los Angeles. One advantage in hiring staff, Clampett finds, is that it is easy to find designers who want to work at Warner Bros. Many character artists and designers do not need much training either, since they are already fans of Looney Tunes and know the characters and cartoons.

In the process of designing the merchandise, each team would be assigned a couple of themes and the design director would determine the direction of each theme, such as the color palette or artistic style. The team would then work together to develop the merchandise concepts, the logo, and the general style of the apparel. The character artist would further set the tone by creating some key drawings. For reference and inspiration, the designers were supplied with resource materials and cartoons. They were free to research their topics, for example, by using libraries for photo research or by purchasing samples. To keep certain characters uniform, designers followed official style guides developed in the early nineties (although they were still free to work from cartoons instead

of style guides for certain characters such as Daffy Duck and Bugs Bunny who have had several designs).

Postell and Starrett saw one major advantage in determining the success of the Warner Bros. stores: they were creating a store full of characters that people liked. One hurdle, however, was that fans knew the characters so well, they would know when a personality was "out of character." Postell and Starrett realized that in the process of developing the merchandise, character consistency must be maintained. Chuck Jones was invited in to talk to the designers about the importance of a character's integrity. During meetings, according to Lampl, ideas often sprang from what the character and its personality represented.[29] The personality of the characters was crucial, agrees McEvoy, since people tended to like Warner Bros. animation because they personally related to specific characters.[30] Since the characters are strong, consistent, and have fully developed personalities, states Doody, it is easier for a designer to work with them and focus on pushing for quality.[31]

Clampett remarks that a major challenge after the stores' initial success was determining how to reinvent the standard licensed merchandise to maintain sales. One technique was to create new themes. Concepts such as the Olympics, the beach, baby merchandise, or characters' anniversaries are used fairly frequently now to keep the store's merchandise fresh and current. Meetings are held to watch cartoons, brainstorm ideas, and plan the themes for whatever sales quarter is in development. For example, in May of 1996, the staff had already determined and were working on the themes to be used for the first quarter of 1997. These themes included Daffy Duck's fiftieth birthday, a Warner Bros. sports shop, golf, soccer, Valentine's Day, garden, DC Comics, and Pinky and the Brain. In addition to the "core" goods, which are the store staples—classic T-shirts, denim shirts, socks, and so forth—the live-action promotions would include a B-movie poster-look shop to support Tim Burton's film *Mars Attacks!* (1996). The stores would also feature a Hanna-Barbera shop, a result of the merger between Time Warner and Turner, which owned Hanna-Barbera. All in all, the Warner Bros. store policy is to change the themes and rotate the merchandise every two months to keep shoppers returning.

Producing practical merchandise was also crucial to the success of the Warner Bros. stores. By producing items such as kitchen or gardening equipment, for instance, or by creating clothing that was cutting-edge and fashion conscious, character licensing moved beyond that of past novelty or cheaply made items to useful and constructive merchandise.

Many Looney Tunes fans remark that nearly everyone loves Bugs Bunny or Daffy Duck, but only the *true* fans know the more obscure characters. In response, Warner Bros. decided to merchandise its secondary characters, who appear in only a few Warner Bros. cartoons, such as Pete Puma, Baby Face Finster, Marvin

Martian, and Gossamer. By merchandising the more obscure characters (actually, they are probably not so obscure, given the number of times they have aired on television and in theaters), the Warner Bros. stores were able to satisfy the more avid Looney Tunes fans, appealing to their needs as well as those of the general consumer.

The process for determining the sale of animation cels and limited editions was also fan oriented. Based on fan requests for cels of certain characters and specific scenes, gallery managers would e-mail the requests to the head of the gallery division. Subsequently, Clampett flew gallery managers to Los Angeles for meetings to make suggestions, brainstorm, and rate ideas for the merchandising of cels. In fact, cels are the only Warner Bros. store items not exclusive to the Warner Bros. Studio Stores, with fifty outside galleries authorized to sell cels.[32]

The glossy fifty- to sixty-page catalogs have continued, now boasting a nationwide mailing list of over 200,000. The catalogs are often seasonally themed; for example, the 1996 summer catalog focused on the Looney Tunes summer Olympic merchandise. Consumers are able to post or phone in orders. Also, the Warner Bros. Studio Stores Internet site features ready on-line shopping (www.studiostores.warnerbros.com).

Warner Bros. versus Disney

Comparisons to the Disney stores are inevitable and underscore many of the conversations about the Warner Bros. Studio Stores. The two chains remain successful and profitable, but retail analysts expect some heated competition in the near future. Both Warner Bros. and Disney stores are currently increasing their number of mall locations. The Disney Stores are now expanding into airports, stadiums and arenas, and train stations with stores smaller than their mall stores. There is incentive for Warner Bros. stores to follow Disney's lead, but Warner Bros. has historically opted for larger stores rather than smaller ones. Ironically, the comparisons have motivated many of the tactical strategies for growth for both Warner Bros. and Disney.

The most noteworthy comparison point is that Warner Bros., for a change, one-upped Disney.[33] According to Tom Barreca, a former vice president of Hanna-Barbera Enterprises, the Warner Bros. Studio Stores are more sophisticated; they succeed in terms of using design to their advantage, with unique store style and product displays as well as great gallery spaces. The stores and the merchandise seem as though they were created *by* fans, *for* fans. The Disney stores, on the other hand, seem created *by* marketers, *for* adults to buy children's gifts. Merchandise, such as simple apparel, toys, and plush items, and novelties, such as pencils, watches, and theme park gift–type items, supplement a color palette,

smaller size, and general product layout geared toward children. This softer, more "Magic Kingdom" type of feel leads ultimately to a more bland and conservative sensibility compared to the Warner Bros. stores' ambience of flippancy. This distinction underscores the different target audiences of the two companies. Unlike the Warner Bros. Studio Stores, Disney initially did not attempt to appeal to an adult consumer base. Only in 1992 did Disney finally realize the need to market to adults in order to continue its relationship with customers from childhood to adulthood.[34]

The differences in development of store merchandise are numerous, remarks Lampl, who worked in the publishing division of Disney in New York before moving over to Warner Bros. From her experience, Disney's material was very story-driven; the products had to make sense with the property. So much corporate control existed that every piece of design artwork was always corrected to be more on model. While the Disney characters had to portrayed in a more wholesome way, she found the Warner Bros. characters more irreverent and interesting to work with. Since the personality of Bugs Bunny was funnier than Mickey Mouse, she noticed that the designers at Warner Bros. seemed to have more fun and freedom than the Disney designers.[35]

The comparisons between the two stores also give journalists an angle for discussing them. In the *New York Times*, Kirk Johnson believes the competition between Warner Bros. and Disney doesn't truly exist. Although the target audiences might seem similar, they actually could be quite different.

> The companies and their starkly different stock of characters, already
> paired in scores of malls, have a complex relationship that owes more to
> Edith Wharton drawing-room drama than Buster Keaton pie-in-the-face
> comedy. They are like two halves of a whole or two sides of the same
> coin. . . . If Disney wants to make you cry, Warner's wants to make you
> laugh. For their stores, it all makes for a kind of built-in no-compete
> clause.[36]

Warner Bros.' Dan Romanelli concurs with Johnson's position as to the nonadversarial nature of Warner Bros. and Disney. "Our businesses, we think, complement each other."[37]

But given their similar locations, and similar product lines, it is hard to imagine there not being competition, despite their claims that each store has its own niche. When the Disney Store opened on Fifth Avenue and Fifty-fifth Street in Manhattan in early 1996, barely two blocks away from the Warner Bros. flagship store, the battle for a share of the same retail dollar commenced and the comparisons continued. This New York Disney Store, in particular, is aggressively targeting the adult animation market previously dominated by Warner Bros. with the creation of new merchandise such as handbags, jewelry, and the

sale of original and newly commissioned cels. With continued competition from Disney, the Warner Bros. Studio Stores have several challenges ahead over the next few years if they wish to maintain their reputation for innovation among studio stores, and compete with the Disney stores for the lead in retail sales.

Creative Barriers and Changes in Direction for the Warner Bros. Studio Stores

Some negatives in working with the Looney Tunes properties have been alluded to earlier in this discussion. The characters are so well known by their fans that sometimes it is difficult to be too creative or innovative with their design. In addition, the spirit the designers must create is not necessarily current enough, sometimes involving a forties and fifties flavor that is dated and outworn. While old-fashionedness doesn't bother most of the designers, some wish they had a little more freedom. The newer characters, such as the Animaniacs, do have a more contemporary feel to the designers, but they rarely work with them unless the show is one of the themes for the quarter.

As with many other innovations, the creative artists involved found that although certain design ideas were approved in 1994, similar ones would not be accepted in 1996. Some designers felt that the edginess that characterized Warner Bros. animation was becoming "watered down," with the more unusual ideas not making it into production. Doody attributed the change to Postell's leaving Warner Bros. (she stayed in New Jersey when the company moved to Los Angeles). Postell's firm opinions about the need to be innovative guided the stores through the earliest years. As the company grew larger and more successful internationally, the creative process became more complicated and less innovative in her absence.[38] Instead of just one person approving merchandising ideas, now many people are involved in the approval process. In-house buyers, not artists like Doody herself, greenlight merchandising ideas for worldwide distribution. Clampett says it is now harder to be innovative and take risks because the stakes are higher. One T-shirt style is a big commitment now.[39] According to Lampl, the corporate feeling of "more, bigger, faster," the intense pressure and limited time schedules, along with the demand for an incredible amount of work to be finished quickly, sometimes get in the way of creativity. She notes that often her team would be in production mode on one theme and would have to start the creative concepting phase on another theme.[40]

Also, the process of designing products for the widest possible audience can be difficult when the merchandise must sometimes appeal to the lowest common denominator. Lampl comments that on occasion the designers would pander to who they "thought" the audience was, rather than creating hipper

merchandise. Soon, they would find themselves designing T-shirts for "the beer-drinking guys in the Midwest," wondering, "Why don't we make merchandise that we would buy?"[41]

Nevertheless, innovative or cautious, Warner Bros. Studio Stores are a success, and Looney Tunes merchandise continue to make money. According to Mark Smyka, editor of *Kidscreen* magazine, the Looney Tunes characters alone ring in $3.5 billion in retail sales around the world each year.[42] An estimated $200 million is through the Warner Bros. stores.[43] And the success of the merchandise has led to unprecedented growth for the division and the stores. In 1995, an International Franchise Operations Division was created to establish more stores through joint ventures with retailers outside the United States.

In addition, Warner Bros. is currently in the midst of an ambitious expansion and reinvention of its New York City flagship store. According to a March 1996 press release, the store was expanding from its 30,000–square-foot, three-floor space to become a 75,000–square-foot, nine-story shopping and entertainment attraction.[44] The store, located in the heart of one of the world's most expensive but also most visited and heavily trafficked retail destinations—Tiffany and Company, FAO Schwarz, Bergdorf Goodman, and Bulgari are its neighbors—has been quite successful.

So what happens when the initial newness of the store concept wears off, and everyone who wants to own cartoon character merchandise has already purchased some? And what if in a few years cartoon character apparel suddenly becomes passé? There is a sense that a saturation of merchandise and a flattening of sales are coming. But many, like Tom Barreca, feel that since Warner Bros. has been successfully innovative so far, it will most likely continue to find ways to keep its brands fresh and exciting. Barreca credits Warner Bros. for its unfailing ability to shake up the character retail industry by trying new product categories, creating unusual collectibles, and designing unusual store layouts and product displays. He surmises that while the Warner Bros. Studio Stores have been mostly about animation, they will most likely begin to branch out more aggressively into live-action properties and television shows, a sort of "retail Darwinism."[45]

The studio will continue to produce new shows, films, and animated shorts, which will generate more interest in the stores. Jerry Beck, animation historian and Warner Bros. cartoons expert, has discovered that the end product for the studio is no longer the animated shorts and television shows rather the products themselves. The shorts and shows, in essence, have become "commercials to bring people to the stores."[46] The characters have become "what you can get at the stores," an echo to the toy commercial disguised as children's programming in the eighties.

Space Jam—A Totally Integrated Consumer
Product Event and Case Study

As Warner Bros. broadened the scope of Looney Tunes into feature animation, one of the first releases was the movie *Space Jam*, which premiered in November 1996. Developed from the successful Hare Jordan ads from Nike, *Space Jam* maintained the same mix of animation and live action as its predecessor. According to *Variety*, Warner Bros. desired three things from *Space Jam*: a franchise that would generate a hoped-for $1 billion in merchandise sales; the introduction of several new animated characters to the Warner Bros. pantheon, including Lola Bunny, Swackhammer, and the "Monstars"; and a springboard for future studio forays into feature animation.[47] Thus, Warner Bros. was now taking the Disney approach to feature films: not only did the films have to be international hits in theaters, but they also needed to be a consumer products bonanza.

To ensure the attainment of these three goals, Warner Bros. spent approximately $125 million on *Space Jam*. This total included roughly $90 million for production and $35 million on promotion, making *Space Jam* among the most expensive films in Warner Bros. history.[48] What Warner Bros. received was a successful feature film which, as of June 1997, had theatrically grossed over $200 million internationally and sold a million copies of the videocassette on its first day of release.[49]

While the new characters have not necessarily become household names, the sale of *Space Jam* merchandise surpassed expectations, generating approximately $1.2 billion for Warner Bros. At the flagship store in New York, the entire first floor was devoted to merchandise from the film. In some instances, collectors had to visit more than one Warner Bros. store, since merchandise was available at some stores and not others. The merchandise was sold for a brief time, mainly during the film's release. The most successful items, according to Ruth Clampett, were toys and other merchandise for children, figurines, and collectible gift items like cookie jars and gallery cels (especially ones signed by Michael Jordan). Some sold out at the beginning of the film's run.[50] Apparel such as T-shirts and other items considered to be badly designed did not sell quite as well. However, the Warner Bros. Studio Stores, with their completed-long-in-advance schedules, rotating displays, and perhaps savvy planning, had moved out all the *Space Jam* merchandise within months after receiving it. While the perpetual movement of merchandise makes sense based on store planning, it also makes it difficult to determine a product's longevity on the shelves.

With *Space Jam*, the studio made what seems to be its single biggest push yet toward establishing brand loyalty toward its name and characters. In terms of synergy, the Warner Bros. marketing division began to have a greater say in what films were produced, and it has been acknowledged by some, and rightly so, that *Space Jam* was mainly a marketing event. Certain critics have noted that

Space Jam functioned simply as a "commercial" to drive people to the Warner Bros. stores. This argument was supported by the film's rush to completion. Although the film began production in 1995, many staff members seemed to feel *Space Jam* may have needed a prolonged production schedule. A former producer on the film thought that the film was rushed due to the merchandising and promotion commitments of a November fifteenth release date, and that it should have had at least another year in production.[51]

Space Jam steered Warner Bros. animation in a completely different direction from that of the Looney Tunes and Merrie Melodies shorts. Its look is edgier, and the voices are done by standup comics rather than the late Mel Blanc, who performed many of the voices in the cartoons children saw on television. Since the classic characters come with a set of expectations about how they will sound and act, some animation industry veterans have expressed concern about the recent handling of the classic characters. Jerry Beck points out that in the early Looney Tunes cartoons, the characters were from separate universes and rarely intermingled; *Space Jam* has the characters all living together in one world.[52] Many viewers were able to recognize the differences between the classic characters' original and updated looks, from the shading and airbrushing of the characters' designs to the slight changes in voice characterization. Strangely, some of the irreverent dialogue in *Space Jam* is about merchandising tie-ins, as if to acknowledge the film's purpose as a marketing tool.

Thus far, the Warner Bros. classic characters have been marketing successes based on their original cartoons, and have not had to depend on recent hit movies to sell merchandise. The industry trade publications, animation critics, scholars, and historians have been carefully watching the release of *Space Jam* to determine the full effects resulting from the redefining of the classic characters. If the initiative is ultimately seen as successful for the studio, the public can expect more films along the same lines with similar merchandising efforts. The next feature film release by Warner Bros., *Quest for Camelot* (1998), is based on original characters and will not have the marketing advantages and character recognizability that *Space Jam* had. It will be interesting to assess how the ancillary divisions handle this initiative, and the extent to which their plans correspond to the Disney model. However, because of *Space Jam*, it may be safe to suggest that Warner Bros. has elevated itself to the Disney level in terms of marketing and licensing for all merchandising efforts in the future

Warner Bros. Merchandise: Cool or Uncool?

One of the remaining issues regarding the Warner Bros. Studio Stores is the issue of oversaturation and its negative effects on the fan base. The Studio Store concept has helped to widen the general fan base by making everyone a collector;

buying cartoon merchandise has become acceptable for adults as well as children and is easy to do. But what impact has the overload of Looney Tunes merchandise had on the longtime collector or fan?

Mark Newgarden, who has worked in the cartoon licensing field as well as collected cartoon memorabilia, has found that he remains more interested in the charm of the older, off-model merchandise that is more challenging to find. He has not purchased anything from the Warner Bros. Studio Stores, although he maintains that the merchandise is nicely rendered. While he has found certain items surprisingly clever, such as the Sylvester goldfish bowl and the Mugsy and Rocky vinyl figures, he has not found a need for them. Newgarden believes most longtime collectors feel there is too much merchandise to collect. Since most collectors are completists, they find collecting through Warner Bros. stores frustrating because they have no chance of keeping up with the stores' turnover of merchandise. Others collectors have determined that the merchandise is too easy to obtain, or that it is sometimes "dumbed down" as gifts for tourists and, therefore, less special and less collectible.[53]

In an editorial piece entitled "Why Classic Warner Bros. Characters Are No Longer Cool (Nor Classic)" in the animation fanzine *Bea & Eff*, Tim Stocoak asks if the characters really belong on everything on which they've been plastered. The general public has continued to buy the Warner Bros. store merchandise, he believes, because it functions as nothing more than trendy and "kitschy cartoon conversation pieces." The demand for more cartoons knickknacks has created a situation where the Warner Bros. characters have become overmerchandised, tired, and "over." Stocoak mentions another fanzine called *Thrift Store*, which contains an article about what will clutter the thrift stores of the future. It names "Warner Bros. cartoon character merchandise, especially anything with the Tasmanian Devil on it."[54] Both Stocoak and Newgarden mention what they considered the worst example of misuse—attempting to make the characters "hip." Examples include depicting the characters dressed in hip-hop/gangsta apparel on oversized clothing[55] or drawn into the logos of sports uniforms. Although such dress may be popular for conformist teenagers, Newgarden finds these appropriations offensive and ugly.[56]

Yet, Jerry Beck maintains that merchandising, as it is marketed currently, will not have a negative effect on the older characters. Rather, the unintended *failure* of overmerchandised features will more likely impact personal identification between classic characters and future audiences. Beck states that the classic cartoons will always remain "hip" as long as they are available for viewing, uncut. Their ability to remain strong for over sixty years proves they can withstand the test of time. The public's emotional connection to Warner Bros. cartoons supports their longevity because characters like Bugs Bunny are "beloved," whereas Disney characters like Mickey Mouse have lasted simply for being iconic

images.[57] Newgarden agrees that other cartoons are often just symbols, while "Bugs Bunny and the Looney Tunes are as close to real characters as cartoon characters can be."[58] Beck suggests Warner Bros. should separate the product lines into classic and new, similar to Disney's remodeling for Mickey and other characters.

The Future in Retailing

Warner Bros. Studio Stores must wrestle with the following questions if they are to adapt to the shifting retail marketplace: How do they keep the merchandise fresh, and the concept of owning it desirable? How much merchandise is too much? If stores and merchandise become oversaturated, will consumers become indifferent and sales flatten out? After the rapid expansion of the stores internationally, what is left in terms of innovation? Will the new stores be even larger, or smaller and more ubiquitous? If more live-action shows are merchandised, will this change the feel of the stores? With what will they fill the nine floors of the store in New York?

The possibility exists for a backlash against limited-edition cels if it ever is determined they have limited investment potential. Such a response could have an effect on the credibility of the Warner Bros. store galleries and the prices of the cels. With actual production cels becoming more rare, the galleries may need to reconsider their focus.

There is the chance, perhaps, that someday the flagship stores will move farther in the direction of entertainment complexes or high-tech theme parks, which would feature not just merchandise but other incentives for the public to enter the building: interactive games, films (especially those exclusive to the stores and featuring amazing special effects), and rides, for example. The stores then become souvenir shops following the experience. The New York flagship store has already moved in this direction; a new theater in the store now shows *Marvin the Martian in the Third Dimension*, a 3–D movie.

The challenges ahead for the Warner Bros. Studio Stores are not so insurmountable, as long as Warner Bros. Television continues to create shows (such as *Animaniacs*, *Superman*, and *Batman*) that are both high quality and marketable. "The challenge," according to Beck, "is simply doing great ideas, concepts, and designs that people will like. Then it doesn't matter if people already have Looney Tunes merchandise."[59]

The issue of competition will no doubt affect many of the decisions made in the future. Disney will no longer be Warner Bros.' only competitor. Other studios are currently creating business plans where the entertainment divisions and production studios of conglomerates will work closely with the studios' licensing divisions to exploit every potential financial opportunity. As MGM,

Cartoon Network, Viacom's MTV and Nickelodeon, Paramount, Sony, and Columbia TriStar develop new and successful characters, the marketplace will become either increasingly competitive or overwhelmingly glutted, with even the most well-orchestrated efforts doomed to failure.

According to the *Los Angeles Times*, perhaps a bigger challenge is each chain competing against itself. "Disney, Sesame Street and Warner all receive fees from other retailers who sell their goods through licenses. But with these three companies selling their wares directly, analysts wonder whether department stores will continue to carry those licensed items."[60] Stores such as Too Cute, which specialized in cartoon character clothing from all the animation studios, closed both its Melrose Avenue store in Los Angeles and its Soho store in New York due to flagging sales. Conceivably, independent stores selling cartoon-related merchandise could only be successful if they are selling antiques and rare, mint-condition merchandise.

Now that Time Warner has merged with Turner and combined animation libraries, there will be philosophical questions to answer regarding the synergy of the Looney Tunes and Hanna-Barbera characters in the Warner Bros. stores. Management will need to determine how to position Hanna-Barbera's limited animation characters amid the classic Looney Tunes characters. With Warner Bros. stores already adding Hanna-Barbera themes into their rotations, the designers and marketing executives will also need to decide if Hanna-Barbera's classics are "worthy" of being combined on merchandise with Warner Bros. classics. It remains to be seen if the two brands of humor and style will mesh well in the context of the stores.

The Warner Bros. Studio Stores will most likely maintain a clear advantage over its competition for the next few years. The executives in charge of the stores are visionaries, managing to innovate and lead, not follow, in the evolution of the studio store concept. Most important, the Warner Bros. cartoon fans are some of the most loyal and energetic fans around (as evidenced by the many sites on the Internet). By producing consistently successful programming with an enduring sense of wit, Warner Bros. should keep viewers and consumers laughing and purchasing for many years to come.

Fans versus Time Warner

BILL MIKULAK

Who Owns Looney Tunes?

On November 1, 1995, the *Hollywood Reporter* ran an article uncovering the existence of an unusual kind of pornography available from the World Wide Web: sexualized versions of well-known cartoon characters. For example, "Warner Bros. 'Tiny Toons,' created by [Steven] Spielberg, is the subject of many drawings, one of which features new lyrics to the show's theme song under the new title 'Teeny Toon': 'We're hot and we're horny, we're showing kinderporny.'"[1] The article further states, "Studio officials at Disney, Warner Bros., and Paramount were all unfamiliar with the site when contacted Tuesday but all said that copyright issues are routinely turned over to the legal department." By November 3, 1995, the Warner Bros. legal counsel, Nils Montan, sent a cease and desist letter to Anthony Hartman, who maintained the mentioned site.[2]

The letter was an opening salvo in what has become a growing battle between a group of fans of Warner Bros. animation and the cartoons' corporate owner, Time Warner Entertainment Company. According to Warner's lawyers, a number of these fans are pirates, guilty of violating intellectual property laws with respect to copyright, trademark, and unfair competition. The corporate lawyers have threatened several individuals with criminal and civil sanctions for works they placed on the Internet. The lawyers have targeted not only creative transformations of characters that they deem pornographic, but any appropriation of the characters, including transcriptions of dialogue and copies of cartoon sounds and images.

Discussions about electronic communication on the Internet tend either to single out threatening individuals or to depict a utopian global village. Thus, the Internet is portrayed as a refuge for predatory pornographers or as a thriving

virtual community. Both portraits oversimplify how Warner Bros. fans partici-
pate in this worldwide computer network.

Many of the fans grew up with Bugs Bunny, Daffy Duck, and other Looney
Tunes characters. They either carried their interest into adulthood or rekindled
it when Warner Bros. first teamed with Steven Spielberg to create a new roster
of characters for the *Tiny Toon Adventures* television show in 1990. Three sub-
sequent shows—*Taz-Mania*, *Animaniacs*, and *Freakazoid!*—further fueled adult
fan interest.

These fans are more than mere passive consumers, they are producers. They
create interpretations, criticisms, artworks, and narratives; they compile detailed
reference works on the cartoons they love. They disseminate their creations with-
out charge on the Internet, sometimes designing elaborate Web sites that are both
informative and attractive. Finally, they are a community—sometimes fractious,
sometimes doting, always enthusiastic about discussing their shared interests.[3]

Members of this community often discuss what they deem appropriate ways
for fans to use cartoon characters. Some fans argue that the source cartoons carry
sexual connotations that Time Warner disavows when it characterizes its prop-
erties as family entertainment. A number of fans, however, also wish to limit
children's exposure to adult-oriented fan works while protecting their own abil-
ity to produce it.

I draw examples of the fans' words and art from research I conducted pri-
marily in spring 1996 into Internet activity by Warner Bros. fans: I monitored
and occasionally contributed to discussions on the Internet Usenet newsgroups
alt.animation.warner-bros, rec.arts.animation, alt.tv.animaniacs, alt.tv.tiny-toon,
alt.tv.tiny-toon.fandom, alt.tv.taz-mania, and alt.fan.furry;[4] I viewed and down-
loaded artwork posted to the newsgroups alt.binaries.pictures.cartoons and
alt.binaries.pictures.erotica.cartoons;[5] I distributed a questionnaire to those
newsgroup readers who expressed interest in contributing their perspectives to
this essay and received twenty responses; I subscribed to an electronic mail dis-
cussion list hosted by a group calling itself the Warner Internet Fan Associa-
tion (WIFA), dedicated to improving the relationship between fans and Warner
Bros.;[6] and I visited fan-created World Wide Web sites and ftp (file transfer pro-
tocol) directories that allow Internet users to download files containing text,
sound, and images.[7]

Sure, But I Never Studied Law

The legal battle between Warner Bros. and fans of its cartoons is just one dis-
pute among many regarding who can legitimately produce, transform, and dis-
seminate culture. The U.S. Constitution implemented copyright as a means to
a socially beneficial end: "To promote the Progress of Science and the useful

Arts, by securing for limited Times to Authors and Inventors the exclusive Right to their respective Writings and Discoveries."[8] The incentive for creators to monopolize the profit from their creations aids society in the long run by fostering innovation.

Gradually, however, U.S. legal doctrine granted corporations legal status akin to individual citizens, providing these entities with the same protections initially accorded to individual authors and inventors. Consequently, the protection of corporate profits has all too often taken precedence over the free circulation of ideas. Successive U.S. copyright acts and their amendments have lengthened the time the monopoly grant is in effect and have added protection for works in additional media such as photographs, moving pictures, and sound recordings.[9]

Trademark law developed in tandem with copyright law to increasingly serve intellectual property owners. According to Jane Gaines:

> Trademark law, a branch of unfair competition law, has evolved from a general philosophy of protection *for the public* against merchants who might deceive them about the true source of the goods or services they purchase. . . . Significant for us, however, is the inversion of this principle in American common law, where the trademark comes to ensure *not* that the public is protected from merchant fraud but that the merchant-owner of the mark is protected against infringers.[10]

U.S. law bases the registration of trademarked names, logos, symbols, and designs on the consuming public's actual use of them and allows registrants to protect them in perpetuity. For example, to the extent that words such as "bugs" and "bunny" attain a secondary meaning in the minds of the public as a cartoon character, the name and physical appearance denoting "Bugs Bunny" may be protected as trademarks.

Also at issue is the challenge that fan artistic production poses to romantic humanist concepts of individual authorship, authenticity, and originality that undergird legal and commonsense notions of intellectual property. For example, Camille Bacon-Smith claims that female fans of *Star Trek* create fan fiction in a milieu that differs markedly from the Western literary tradition of forming canons of masterpieces by geniuses.

> In the fan community, fiction creates the community. Many writers contribute their work out of social obligation, to add to the discourse, to communicate with others. Creativity lies not in how a writer breaks with the tradition of the community's work but in how she uses the language of the group to shed a brighter light on the truth they work to communicate.[11]

Like these *Star Trek* fans, Warner Bros. cartoon fans appropriate characters,

settings, and plots from the studio's accumulated works as a means of building a community. What they create is meant to speak to insiders who share modes of appreciation, knowledge of conventions, and social interactions; it earns no profit and is not meant to defame the Warner Bros. characters. Yet, as I will detail in the following section, Time Warner, as a corporation, claims to bear injury from this work.

Hare-um, Scare-um

The two examples of cease and desist letters I obtained are instructive for their argumentation and targets. Time Warner sent these letters to people who maintained sites that were globally available on the Internet: a World Wide Web site and an ftp directory that offered fan-produced pictures, stories, and reference materials relating to the Warner Bros. animated television programs *Animaniacs* and *Tiny Toon Adventures* as well as Warner Bros.' "Looney Tunes" characters, all of which the lawyers refer to collectively as "the WB Characters."

Nils Montan, legal counsel for Time Warner, demanded that Jonathan Woodward remove from his World Wide Web site,"The Acme Page," everything that could be considered appropriations of the WB characters. This includes exact copies of the characters and transcriptions of their dialogue as well as original works that employ the characters.[12] Dennis Falk received a similar letter regarding his ftp directory[13] from attorney Dennis Wilson, whose firm is retained by Time Warner. Both Woodward and Falk were accused of disseminating material that was pornographic.

Each letter threatens a civil lawsuit for monetary damages and an injunction against future infringements. Each also offers the possibility that the fans could face criminal charges after the lawyers alert law enforcement authorities. In response to these letters, Woodward removed the challenged material from his Web site, and Falk's Internet provider, Netcom On-line Communications, did the same while the company's legal counsel reviewed the matter. Falk has chosen to defend his right to create and display the works.

Although the Time Warner lawyers singled out sites they claimed were pornographic, a number of fans did not agree that Woodward's site contained pornography. Brendan Dunn, for example, stated: "I'd be hard pressed to call anything on Jonathan Woodward's site more than a strong PG. There was nothing explicit there; the strongest it got was stories with implications and innuendo."[14]

The designation of something as pornography is a challenge to its protection under the first amendment by subjecting the material to scrutiny on the basis of obscenity standards laid out in *Miller v. California*.[15] The Communications Decency Act of 1996 was moving through Congress when Montan's letter to Woodward was drafted, and the act became law during the time Wilson's

letter to Falk was. This law criminalizes distribution on the Internet of not only obscene material but also that which is merely indecent. The law arms Warner lawyers with a powerful weapon to back up threats of criminal sanctions. On June 11, 1996, however, the Third Circuit Court of Appeals struck down the "indecency" provision as unconstitutional on the grounds that it violates the right to free speech.[16] The U.S. Department of Justice appealed the ruling to the Supreme Court, which subsequently upheld it.

Although the Time Warner lawyers thus far have only targeted sites they judge to be harboring pornography, they have also acted to control the distribution of material copied from Time Warner's television shows. Personal computer technology now allows users to digitally sample visuals, sound, and video from a variety of sources. Members of the commercial online service provider America Online (AOL) placed many sampled audio and visual files in the service's archives for free downloading until Warner Bros. Online entered into a licensing agreement with AOL to provide officially approved material. As part of the agreement AOL removed pirated sounds and images, and Warner Bros. replaced them with its own selection for subscribers to download for personal use.[17]

Many Internet denizens took notice and removed from ftp directories and Web sites those files that were outright copies of sounds and images. One fan notes, "Most sites that used to offer images now no longer do so due to copyright issues. . . . In the interest of keeping myself totally free from legal burden, I no longer maintain a list of sites."[18] However, many fans still do post messages to Usenet newsgroups because the newsgroups continually delete old messages to save storage space on the host computer servers. This allows such files to circulate widely, but temporarily. By using anonymous remailing services, the sender can protect his or her identity and therefore may escape prosecution.

In addition to sampled sounds and images, Time Warner lawyers demand that transcriptions from the shows be deleted. What the legal counsel takes to be copyright and trademark infringement, the fans consider merely research. Transcripts of dialogue and song lyrics represent fans' dedicated scholarship to master the source texts as thoroughly as possible. For example, fans of *Animaniacs* compile growing lists of the show's song lyrics (Animaniacs Mega Lyric File) and allusions (Cultural References Guide for Animaniacs).[19] The compilers are viewed as experts among the fans. Avid fans study these documents to learn the intricacies of the source shows, much as researchers examine reference works in academic communities. Individuals who access the documents can increase their status within the fan group by employing their knowledge in clever postings to the Usenet newsgroups.

It is precisely this category of appropriation for informational purposes that some fans find most defensible. Ron O'Dell, author of several of the reference files, argues:

> I don't think WB would go after my [Web] page, for instance. There's no
> fan fiction, no fan artwork—just information in the form of episode
> guides, song lyrics, and collected bits of dialogue. Being both less than
> 10 percent of show content, and compiled for academic value, there's a
> far greater chance for my page to succeed in a legal battle than a page
> with stories and artwork—particularly if they're risqué in nature.[20]

O'Dell relies on his understanding of the fair use provisions of copyright law to
protect him from litigation. These provisions appear in the Copyright Act of
1976:

> The fair use of a copyrighted work, including such use by reproduction
> in copies or phonorecords or by any other means specified by that
> section, for purposes such as criticism, comment, news reporting,
> teaching (including multiple copies for classroom use), scholarship, or
> research, is not an infringement of copyright. In determining whether
> the use made of a work in any particular case is a fair use the factors to
> be considered shall include—
> 1) the purpose and character of the use, including whether such use is of
> a commercial nature or is for nonprofit educational purposes;
> 2) the nature of the copyrighted work;
> 3) the amount and substantiality of the portion used in relation to the
> copyrighted work as a whole;
> and
> 4) the effect of the use upon the potential market for or value of the
> copyrighted work.[21]

If copyright violation were the sole issue, O'Dell's files would seem to fall well
within fair use as outlined above.

However, by invoking the stronger protections of trademark law, Time
Warner lawyers could seek to enjoin the use of trademarked names and titles
within these files following precedents established by four cases won by DC Comics against infringers of its "family of Superman" properties.[22] The first three involved commercial entities using recognizable aspects of the Superman oeuvre
to promote their own products, but the last ruled against the Richard J. Daley
College student newspaper because its name, the *Daley Planet*, "was *likely to cause
confusion* and was *likely to dilute the distinctiveness* of the DAILY PLANET trademark."[23] The Illinois court's ruling in favor of DC Comics shows how readily
the courts interpret mental confusion on the part of the consuming public as a
basis for trademark dilution. Our legal system favors the protection of profits
over speech that may potentially reduce those profits.

In contrast to O'Dell, Falk's claim to a fair use exemption from copyright
infringement rests on the creative, parodic, and editorial nature of the stories
and images at his ftp directory.

I am challenging the cease and desist letter, as the material contained in my ftp directory conforms to guidelines of fair use under the U.S. Supreme Court decision, Campbell v. Acuff-Rose, which covers works described as "transformative." Absolutely none of the materials contained in my subdirectories originate from any studios, nor are they modified in any way from pre-existing materials originating from the studios.[24]

Falk also counters Warner's claim of trademark dilution and disparagement:

As for trademarks, being that according to the Trademark Act of 1946, . . . a trademark only applies under an "act of commerce," i.e., in the course of the sale of a product, including advertising, etc., . . . trademark protection does not apply to editorial content.[25]

Falk's defense rests on the way fans make their works available on the Internet at no cost to the recipient. The section of the Trademark Act to which Falk refers makes liable

any person who shall, without the consent of the registrant, . . . use in commerce any reproduction, counterfeit, copy, or colorable imitation of a registered mark in connection with the sale, offering for sale, distribution, or advertising of any goods or services on or in connection with which such use is likely to cause confusion, or to cause mistake, or to deceive.[26]

If courts interpret the gratis distribution of such files to fall within these bounds, Time Warner has a case against the fans, for the Internet is renowned as a global distribution system.

Ample precedent exists for censoring pornographic parodies of cartoon characters. A pornographic version of the Pillsbury Doughboy was enjoined in *The Pillsbury Co. v. Milky Way Productions, Inc.*[27] Walt Disney's legal department has also vigorously protected its intellectual property from such copyright violations. Its lawsuit shut down publication of an underground comic, *The Air Pirates*, which savagely spoofed Mickey and other characters.[28] Disney also filed a suit against a pornographer who included the "Mickey Mouse March" as background music to an orgy scene in the film *The Life and Times of a Happy Hooker* (1975), in which the participants wore nothing but Mouseketeer ears.[29]

Nonetheless, Norman M. Klein notes many appearances of what he calls "anti-Mickeys" in the sixties and seventies.[30] The magazine *The Realist* included in its May 1967 issue a tableau of Disney characters engaging in stripteases, prostitution, sexual assault, fornication, urination, defecation, and drug use, while in the background, Cinderella's castle radiates dollar signs. Anti-Mickeys also showed up in Chicago posters, San Francisco underground comics, and an

antiwar animated cartoon called *Uncle Walt* (1967), which sent Mickey to a graveyard for the Vietnam War.

In sharp contrast to subversive parodies like the anti-Mickeys, the art, fiction, and other writings of the community of Warner Bros. cartoon fans on the Internet display loving attitudes toward the source cartoons. Let us now take a closer look at the members of this community and their fan creations. My focus is on those creations that conflict the most with Warner's own official presentation of its cartoon characters because these stretch the boundaries of legitimate fan self-expression, and in so doing, they both bind and divide the fan community.

I Am the Very Model of a Cartoon Individual

Defining and delimiting Warner Bros. cartoon fandom is well beyond the scope of this essay, for I had access only to the subset of fans communicating over the Internet. Previous studies of media-based fan communities documented individuals who had met face-to-face before communicating at a distance.[31]

I found instead a community whose contact is often restricted to electronic communication via the Internet. Many of the younger respondents to my questionnaire cite their initial exposure to the Usenet newsgroups as making them aware of a larger community of like-minded fans. For example, Ben Carter, a seventeen-year-old student, explains that he saw himself as a fan "[after] seeing 'Puttin' on the Blitz' [an *Animaniacs* segment] (which made me realize that cartoons were not for children), and finding the alt.tv.animaniacs newsgroup." Twenty-year-old student Jeremy Jurrens says his shift into fandom involved "almost religious recording and buying of shows on tape, and just recently, bringing myself to write fan-fiction and have it put on the [Inter]net." Seventeen-year-old student K. Ivan Ruppert claims to have become a fan "after I stumbled onto the Fidonet TOONS echo," which is another online computer network.

Some older respondents do hark back to meetings in person that first gave them a sense of being fans. Thirty-six-year-old computer operator Thomas Safer has regarded himself as a fan for ten years, ever since he began to put together themed presentations from his extensive collection of classic Warner Bros. cartoons. Similarly, thirty-six-year-old animation art restorer Steve Worth mentions "studying design in college and attending activities by the International Animated Film Society. . . . Also, getting the chance to meet some of the artists who made the cartoons was important to me too."

Many respondents tout their collections of cartoons on videotape, laser disc, and, occasionally, 16mm film. They also note the role merchandise, books, and clothing play in contributing to their enjoyment of the cartoons. When they obtain items that are generally unavailable to the public, their pleasure is even

greater. Eighteen-year-old student Julie Decker recalls as particularly triumphant "the day I successfully bribed the McDonald's manager into giving me their display."

Film historian Mark Langer describes animation fans as a taste group whose members he calls "animatophiles." He characterizes the taste group as follows:

> Animatophilia, as a total culture in itself, has participants who are animation company owners and employees, animation scholars, devoted fans and obsessive consumers of animation and its ancillary products. This core is composed of those animatophiles with the highest degree of specialized knowledge about the subject and whose lives revolve around animation. As participants in a partial culture, animatophiles include buyers of animation art, casual fans and other people with an interest in animation beyond that of the total culture.[32]

Langer makes a valuable contribution in positing a gradient of knowledge about cartoons that differentiates the casual fan from the core fan. His description encompasses the many fans who produce informational documents, critically appraise what they watch, and stump each other with trivia questions. However, a number of additional aspects of fandom bear discussion both for their intrinsic interest and for the challenge they pose to Warner Bros. as an intellectual property owner.

Warner Bros. animation fans on the Internet can signal their affinity for the cartoons in a number of ways beyond expressing knowledge and taste. I will focus on three interrelated activities: (1) assuming the personae of particular characters and more generalized anthropomorphized animals in role-playing games; (2) discussing their romantic and erotic interest in particular characters; and (3) creating fiction, songs, poetry, and art that may or may not express the affinities described in the first two areas.

People Are Bunny

Interest in cartoons can overlap with another fan interest: furries. According to the Web page of a furry fan whose screen name is Captain Packrat, "A 'furry' is an animal with human characteristics (i.e., humanoid shape) and/or intelligence. (Also sometimes known as 'anthropomorphs,' 'zoomorphs,' or just 'morphs.')"[33] Captain Packrat describes various types of furries: animals with intelligence (e.g., animals in George Orwell's *Animal Farm*), humanoid animals (e.g., bioengineered animals in H. G. Wells's *Island of Dr. Moreau*), cartoon animals (e.g., Bugs Bunny), animal-like aliens (e.g., Chewbacca in George Lucas's *Star Wars*), and mythological creatures (e.g., centaurs). In furry parlance, cartoon furries are known as "funny animals" to set them apart from the more seriously depicted animal characters in the other categories.

Another Web page author, whose screen name is Telzey Amberdon, gives a second definition of a "furry" as a fan of furry characters.[34] Collectively, these fans call themselves "furfen." One of the ways they congregate electronically is by using a program on the Internet called FurryMUCK, described as "a multi-player text adventure game where the 'game' element has been pretty much removed, replaced with a mostly social environment."[35] Participants assume a "personal furry," which is an alter ego that has the qualities of an animal with which they identify.

The furfen are split between those who are interested in exploring sexual aspects of furriness (the "furverts") and those who are not. According to Telzey Amberdon, "Some people who claim the term 'funny animals' for their subject matter don't necessarily consider themselves 'furry,' though on the surface this might seem to be almost a synonym. This is largely because of the baggage the term 'furry' carries with it, as a number of people see 'furries' [to be] obsessed with the sexuality of their fictitious characters."[36] However, the split is not so clean, because the community of fans who are primarily interested in cartoons is also divided over whether to support those whose interest is sexual.

One of my questionnaire respondents who wishes to remain anonymous informed me of this component of Warner Bros. fandom:

> The existence of people who get turned on by toons seems to have split
> the community into three camps: (1) the people who find anyone
> thinking about 'their' favorite character in a sexual manner distasteful;
> (2) the people who don't really care and have an "if-they-want-to-do-it,-
> let-them" [attitude], and (3) the people who like that kind of thing.
> Because of this there were two newsgroups formed: alt.tv.tiny-toon and
> alt.tv.tiny-toon.fandom. Fandom is the group where more adult discus-
> sions are allowed.

Warner fans who discuss their sexual interest in the cartoons often center on a few female characters such as Babs Bunny and Fifi La Fume on *Tiny Toon Adventures* and Minerva Mink on *Animaniacs*. The television shows sometimes do accentuate the sexuality of these characters, especially the last two, who are updated female versions of the amorous Pepé le Pew and Tex Avery's libidinous Wolf in such MGM theatrical cartoon shorts as *Red Hot Riding Hood* (1943) and *Swing Shift Cinderella* (1945).

The deliberate incorporation of sexual frisson into these cartoons does not escape fans. Take, for example, the following newsgroup exchange:

> Lontra <lontra@netcom.com>: It must be admitted that, of all things
> possible to the perverse mind of man, boinking over watching a happy,
> prancing toon bunny is about as innocent a fetish as can be imag-
> ined . . .

Dennis Falk <quozl@netcom.com>: Some say otherwise, as it's considered 'perversion of innocent cartoon characters'—My ass! With characters like Bugs Bunny, Pepé Le Pew, Babs Bunny (and her gratuitous skirt peeks!) and Fifi La Fume, *amongst others*, it's hard *not* to find some measure of sexuality in many cartoon characters!

Lontra <lontra@netcom.com>: Bugs is especially hot to me. Y'know, I'd go so far as to suggest that Bugs Bunny was the very first blatantly sexual furrymorph. Bugs must've genuinely *shocked* people when they first saw him in 1940! A sassy, nekkid, pert-tailed, seductively-effeminate, cross-dressing rabbit! Holy smoke! Even his name is suggestive: 'Bugs'![37]

Another fan, a financial programmer willing to be identified by his screen name of Nefaria, answered my questionnaire in a similar vein:

I love the wonderful female characters in *Tiny Toons*. Babs Bunny is my favorite of the new batch, since she's incredibly cuddly, playful, mischievous, and an all-around dreamgirl. . . . Some people call me a Drooling Babs Fanboy, which I think is appropriate. Could be because I spend tons of money on Babs goodies.

Nefaria's self-identification as a "Drooling Babs Fanboy" parallels that of gay rights activists who commandeer the derogatory term "queer" to make it a badge of pride. Within various subgroups of media fans, the term "fanboy" has come to embody the worst stereotype of the immature, abnormal, socially challenged fan who is told to "Get a life!" Yet, fans proudly assign themselves this label to express the erotic nature of their attachment to cartoons.

This attachment applies not only to the cartoon characters themselves but to the creative staff behind them as well. For example, Rob Paulsen, the actor who does the voices of Yakko Warner and Pinky on *Animaniacs*, inspired some female fans to compile a list of his credits complete with a "fangirl drool" rating system based on the sideways smiley emoticon [:)]:

=)~ (one drool): Average
=)~~ (two drools): A little better!!
=)~~~ (three drools): Woah, that's the Rob Paulsen I like to see/hear!!!
=)~~~~ (four drools): I am about to pass out from ecstasy into a puddle of
　　my own drool.[38]

Another fan, Jennie Gruber, honored Paulsen's birthday by composing the song "Helloooo Rob! or: The Ballad of the Blithering Fangirls."[39]

Tolerance for expressions of lust wanes among some fans when talk gets too explicit or violates someone's conception of the character's core identity. For example, when Sean Wilkinson posted the question "Anyone else out there getting a vivid mental image of Fifi as a leather-clad dominatrix?" Michael Russell

responded by saying, "As Skippy would say, 'Speeeewwwww.' When I think of the cute 13–year-old skunkette, I see her either in her cheerleader outfit or her puffy posh frock from 'Prom-ise Her Anything.'"[40] To Russell, Fifi's sexual allure is clean scrubbed rather than kinky.

You Ought to Be in Pictures

Fans also express divergent tastes in fan-created art. Fan art (like fan fiction, the subject of the next section) displays a wide range of subject matter, styles, intertextual references, and authorial stances toward the source shows and characters. Erotic fan art is but one subset of Warner Bros. fan art; my focus on sexuality in fans' art is not meant to ignore the bulk of fans who are respectfully chaste in depicting the Warner characters.

Instead, I want to examine how erotic Warner Bros. fan art and fan fiction parallel what Henry Jenkins identifies as female *Star Trek* fans' acts of "textual poaching." He singles out a genre of fan fiction and art called Slash, which depicts such romantic pairings as Captain Kirk and Mr. Spock. The term "Slash" is derived from the shorthand method of referring to such stories as "Kirk/Spock" or "K/S." Jenkins argues:

> Slash represents a particularly dramatic break with the ideological norms
> of the broadcast material, even as it provides a vehicle for fans to
> examine more closely the character relationships drawing them to those
> programs. It allows us a vivid illustration of the political implications of
> textual poaching, the ways readers' attempts to reclaim media materials
> for their own purposes necessarily transform those 'borrowed terms' in
> the process of reproducing them.[41]

The genre of cartoon fan creation that comes closest to Slash is called "spooge," which is a fan term for erotic stories or art. Among *Tiny Toons* fans, this material has a special term: "Bar Soap." A mild example of fan art spooge is the comic strip story "Barbara Ann and the Electric Carrot."[42] It has a TTBS ("Tiny Toons Bar Soap") logo in the upper-left corner that lampoons the program's opening credits. Babs Bunny is shown inserting a battery into a hollow carrot only to reveal that it is an electric toothbrush and not the intimated vibrator. She asks in the last panel, "Well, what did you THINK I was gonna do with it, you FURVERT?!?"

A much more explicit example is the picture "Minerva and Friends."[43] In it, the character Minerva Mink is having sex with Wilford B. Wolf as Newt the dog plasters himself against the window looking on. As well as showing some of Wilford's penis shaft, it includes splashes of semen and vaginal secretions. This was one of the disputed files in Dennis Falk's ftp directory.

The artwork in both of these pictures is true to the characters' original designs and "Minerva and Friends" is exceptionally detailed. It also takes the premise of an actual *Animaniacs* segment, "Moon Over Minerva," to its logical conclusion. That segment features a lusty, well-proportioned Minerva Mink exhibiting the kind of extreme reactions performed by Tex Avery's Wolf. The Minerva character is obviously designed to be older than the adolescent *Tiny Toons* characters. The object of Minerva's desire is the nebbish Wilford B. Wolf, but only when the full moon has transformed him into a rippling hunk of a werewolf. Every passing cloud reverts him back into his sorry, bespectacled self. Thus, the story teases the viewer through a series of frustrating romantic near-misses in classical Hollywood's coy style, so that Minerva never gets to romance Wilford or his alter ego.

What I mean to suggest here is that much sexualized fan art draws on traits that the characters do exhibit in the television shows. As Falk argues in the above newsgroup exchange with Lontra, it is not a "perversion of innocent cartoon characters" because the characters are by no means innocent. Nor is most fans' intent subversive in the way that many of the old anti-Mickey depictions targeted Disney's hypocrisy in cloaking its capitalistic cultural imperialism with Pollyanna pixy dust. Instead, Warner Bros. fans ponder how their favorite characters would act "behind closed doors" following the same biological urges that propel the rest of us. Similarly, fans of recent Disney cartoons have created spooge art of such characters as Ariel from *The Little Mermaid* (1989) and Jasmine from *Aladdin* (1993). These often show the same devotion to the characters as do the Warner fan spooge art.[44]

Fan artist Doug Winger includes verbal commentary to this effect in his depictions of both heterosexual and homosexual sex between *Tiny Toons* characters. He states, "Just as there are different orientations among fans, if we extend the wide variety of sexual desires normally displayed by people to 'toons, they become a truer vision of what they were meant to be in the first place—reflections of us."[45] The image that accompanies the text shows Buster Bunny entering Plucky Duck from the rear. Both are male characters on *Tiny Toon Adventures*. Winger's art was also among the disputed files in Falk's ftp directory.

All the Words in the English Language

Fan fiction (called "fanfic" by the fans) is as varied as fan art in terms of authors' attitudes toward source cartoon characters. Many narratives include playful sexual innuendoes in passing, while others center on explicit sexuality. By emphasizing eroticism, I am being highly selective and perhaps giving short shrift to such aspects of fan fiction as how fans build their sense of community by referring to previous fan stories and placing fellow fans amid the cartoon

characters in the narratives. While spooge may be the most subversive, it is only one genre of fan fiction. Others include parodies of various media texts, stories involving characters crossing over from different shows, and attempts to write episodes suitable for television production.

Outside of spooge fiction, several fans have addressed love between characters without actually describing sexual acts in graphic terms. For example, a subject that has concerned a number of *Tiny Toon Adventures* fan fiction authors is the possibility of romance between lead characters Buster Bunny and Babs Bunny. Kevin Mickel's trilogy "Buster and Babs: No Relation?" "What's in a Name?" and "And That's a Wrap!" answers this question with Buster's proposal of marriage to Babs at a Valentine's Day party months before their graduation from Acme Looniversity.[46] The stories also liberally employ historical tidbits about Warner Bros. and other Hollywood cartoon studios.[47]

Another fan, Nefaria, wrote a story, "Buster's Guide to Unconsummated Romance," that similarly poses questions about the emotional bonds between Buster and Babs. Nefaria inserts a playful dream sequence in which Buster and Babs do "multiply like rabbits" to produce four children while being held captive by the cloyingly sweet Elmyra, but he presents this with circumspection: "Time passes, weeks stretch into months, and the restless bunnies have nothing to do except fulfill Elmyra's wishes. After a little practice, they quickly get the hang of things, and they soon become the proud parents of four charming (?) little rugrats."[48] Nefaria names the offspring after fellow fans and endows them with personalities that caricature those fans.

Other fan writers are much less circumspect in their examination of sexual relations between characters. Dennis Falk's "A Night in Babs' Room" brings Buster and Babs together in cartoony carnal bliss:

> *Babs:* Quick; enter me while I'm still in the mood!
> [*Buster obliges by getting around to her legs and brings them up to her chest. His now aching shaft makes its way to her love tunnel, and slowly inserts it. He notices it is going in smoothly, and she's not only wet, but very warm. This brings his arousal to a near-boiling point.*]
> *Buster:* [*Unnnngh.*] You sure feel good, Babsie! [*Ahh . . .*]
> *Babs:* [OOOOOOOOoooooOOOOh!] FASTER! FASTER!
> [*AaaaaaAAAH!*]
> [*Humphumphumphumphump.*]
> [*SqwEEkasquEEkasquEEkasquEEka.*]
> *Babs* [*cowboy voice*]: "RIDE'EM, COWBOY!!!"[49]

Like the fan art, erotic fan fiction builds on preexisting traits of sexuality within the canon of actually produced shows, but overcomes the barriers the shows erect. Fifi La Fume's character on *Tiny Toon Adventures* is sexually sug-

gestive, but she is always thwarted by her skunk odor. Lee Toop's story, "The Blind Date," features Fifi on a blind date with another skunk, Miguel, a character created to render Fifi's odor irrelevant. Together they share an evening of dining and explicit sex, the latter excerpted in the following:

> Fifi stared at the phone for a moment before Miguel got her full attention back by gently nibbling her clit. She jumped and dropped the phone as her excitement exploded in a shattering orgasm. She screamed as her entire body seemed to erupt into absolute ecstasy, then fell back against the bed, panting for breath.[50]

Both Toop's and Falk's stories were in Dennis Falk's disputed ftp directory.

No Poaching, Not Even an Egg!

These sexually explicit fan creations have divided the community of Warner Bros. cartoon fans on the Internet. In an effort to "keep the porn away from the kiddies!" in one fan's words,[51] the Warner Internet Fan Association instituted a ratings system classing material submitted to it as: (1) suitable for all audiences; (2) for use with discretion; and, (3) appropriate for adults only. When Time Warner served Falk the cease and desist letter, some members of WIFA did not want to defend him. Ron O'Dell argued:

> Quozl's [Dennis Falk's screen name] site isn't something WIFA should be seen to endorse. We know from our past arguments that even the very existence of the material is in a legal gray area (no matter how adamant one side or another might be), and for it to have been openly available is not something we've ever condoned. To say that we do condone it now would diminish WIFA's credibility and tarnish the image of the Class 1 and perhaps Class 2 sites.[52]

As another fan on the Internet put it, "All I know is that I'm glad I'm not the one trying to defend soft-core pornography with someone else's cartoon characters as 'free speech' or 'parody.'"[53] Others stated in response to my questionnaire, "I don't support 'toon porn, but I believe that it's covered under the Constitution." She voiced a common stance of the fans who want legal protection for the material despite their own aversion to it.

Others wish to support all fan creations while avoiding costly legal challenges to Warner Bros. WIFA entertained at least two possible ways to go underground rather than remain visible targets:

> Suggestion #1:
> Make all WIFA sites password only, and distribute passwords via this mailing list. This essentially would put us in the "private distribution" area which is OK, according to the WB Legal position. Effectively, we've

created a "members only" system of "private" distribution. WIFA membership would remain open to all interested, of course, so there would only be a minimal amount of effort necessary to gain access.

Suggestion #2:
Borrowing from Cold War missile strategy, pool all available material to one site. Change the location of this site every week, using coordination via an anonymous remailer. Post the location of the site once it's set up. Essentially, keep the information one step ahead of any cease and desist notice.[54]

These suggestions show how tenacious Warner Bros. fans can be in preserving their community and cultural production in the face of external attacks. WIFA members voted them down, but only after a lengthy exchange of messages about logistics and fans' rights to freely use the Internet. Some individuals are safeguarding their own sites with access restrictions meant to shield themselves from legal liability should children attempt to gain entry.

At the heart of Warner's legal attack on fans' textual poaching is an ideology that privileges a limited range of heterosocial interactions within a mode of media production and animation that must be "suitable" for children in order to be profitable. Time Warner's lawyers see a potential decline in the monetary value of their property if the characters are overrun by sexual connotations in the minds of the consuming public.

Indeed, Warner Bros. has succeeded all too well in making its trademarked characters household terms. As Gaines states:

The very success of public recognition—the goal of promotion, distribution, advertising—produces infringers as well as ordinary fans and potential buyers. What the proprietors of popular signs will always come up against is the predictable and desired result of their own popularity— imitation, appropriation, rearticulation.[55]

Thus, some Warner Bros. fans have transgressed the boundary between authorized acts of consumption and forbidden acts of infringement when their unbridled enthusiasm gains the attention of the corporate lawyers.

These fans challenge Time Warner's narrow interpretation of animation's content and its proper audience. Their activities and creations not only threaten the corporation's profits and commercial "goodwill" but also undermine our society's oligopolistic concentration of cultural production. These fans counter the marginalization of animation as a children's medium, and they appropriate media content to reinflect it with their own meanings. In so doing, they are no longer captive audiences to be sold to advertisers, but cultural bricoleurs who weave their own communal tapestries from the threads provided by entertainment conglomerates.

Hybrid Cinema

NORMAN M. KLEIN

The Mask, *Masques,* and Tex Avery

AFTER HIS GROUNDBREAKING work for Warner Bros. in *Porky's Duck Hunt* (1937), *The Isle of Pingo-Pongo* (1938), *Detouring America* (1939), and *A Wild Hare* (1940), Tex Avery hoped that someone would give him a shot at writing and directing a live-action feature during his tenure at MGM (1942–1955). He imagined Red Skelton comedies, even chatted with and suggested gags to live-action directors.[1] This faint itch to try writing or directing a live-action comedy probably increased after the success of Frank Tashlin's films *The Girl Can't Help It* (1956) and *Will Success Spoil Rock Hunter?* (1957). However, Tashlin was an anomaly among animators. With very few exceptions, animators were classified in the industry as craftspeople, incapable of making a movie ninety minutes long. With the fusion of animation and live-action cinema in the past twenty years, this rule has changed, particularly with animator-directors like Tim Burton, Terry Gilliam, and even the Brothers Quay, but also in borrowings from cartoons since *Star Wars* (1977) or *Who Framed Roger Rabbit?* (1988); and with experimental animation transformed into feature films: *The City of Lost Children* (1995), *Institute Benjamenta* (1996).

The Mask (1994) is a classic case in point: it was made and marketed very much with Tex Avery in mind. According to the press release, "a hundred" gags were lifted directly from cartoons by Avery and by Robert Clampett, in what the special-effects team called "animation takes."[2] That included the famous Avery double takes: eyes bulging priapically; the shriek while body parts explode; the jaw dropping like cement.

From the first scene,[3] Avery's cartoons are the signature of the film. Stanley Ipkiss (Jim Carrey) runs a video of *Red Hot Riding Hood* (1943) on his VCR, while he suffers the humilities of the hapless schlemiel. Then, with Avery on

the brain, he puts on the mask and whipsaws into cartoon medleys reminiscent of Carl Stalling's musical samplings for Looney Tunes. With Dionysian enthusiasm, he howls like Wolfie, whirs like the Tasmanian Devil, bounces like early Daffy.

Many reviews of the film cited the influence of Avery or the Warner Bros. chase cartoon on *The Mask*. Stanley was as "cocky as Bugs Bunny, as frenetic as Daffy Duck," "styled after the cartoon great Tex Avery"; the "cartoon style"; "cartoon boldness"; "textbook cartooning."[4] Jim Carrey's elastic body made him a "biological cartoon of himself," "proud to have achieved a personal career goal by becoming a living cartoon."[5] Then, like Daffy, or even Betty Boop, he zipped through an arpeggio of celebrity impressions, from Desi Arnez as Cuban Pete to Schwarzenegger in *Commando* (1985).

The distributor of *The Mask*, New Line Cinema, promoted this cartoon look, in the press kit, in print ads, in every interview I found. Industry news columns before its release suggested a very strong "word of mouth," the next hit in the subgenre of "cartoony" movies—films that borrow from Warner Bros. animation or by way of comic books. Since *Who Framed Roger Rabbit* or even *Star Wars*, practically every special-effects hit had Warner Bros. "takes" buried somewhere, either as a comic-book gag, or a blackout aside, or a roller-coaster effect, which, as I will explain later, originates with the same branch of entertainment as animation.

Also, Warner Bros. gags had become essential to the nostalgic look of many special-effects films. As the candy-box version of forties "screwball noir,"[6] these films featured nightclubs and Nazis; men in porkpie hats; women dressed like Rita Hayworth or Veronica Lake; bawdy chases reminiscent of wartime cartoons like *Red Hot Riding Hood*.

Of course, I am talking about applied animation: those effects that appear in postproduction. These have come to resemble animation increasingly, starting with computerized motion control in *Star Wars*, then much more layered compositing, and finally much enhanced 3–D animation: quicktime software, computerized flythroughs, texture mapping—a sculptural and architectonic update of cel animation, cartoon layout, and the chase. Today, essentially everyone working in special effects is expected to understand techniques from the chase cartoon. Knowing cartoon cycles[7] and extremes helps the artist time an action sequence or splice in surprises in midaction: the offbeat aside, the wink to the audience.

But with so many levels of slapstick—more collisions and overreactions—the composition tends to get more congested, again like an Avery cartoon. Effects artists are usually asked to add objects or gimmicks, rather than clean up or thin out. Effects enliven the shot, from blue-screen effects to garbage mattes. That means much more visual throwaway than in the usual live-action film. Avery was, of course, a genius at visual throwaway. He littered the corners of

the screen with tiny posters, novelty caricatures on the shelf, puns on the walls. And yet, despite the clutter, he made his chase gags hit like a sledgehammer. His timing was minutely exact. He might cut as little as a single frame, between the top of the screen, from where the object appears, to the point of impact farther down—slam! He was certain that for action sequences, the audience can sense the absence of one twenty-fourth of a second.

Chuck Jones disagrees. He thinks the threshold is more like five frames, perhaps a quarter of a second. Avery and Jones were much like the masters of action films: they knew the rhythm of gleeful violence supremely well; for example, they would add pauses to make the collision stronger, to have characters look less prepared. Only the audience suffers anticipation. The character is caught short by at least one frame.

Special-effects master Donna Tracy has confronted many of the same problems while working on dozens of effects films, from *Star Wars* to *Independence Day* (1996).[8] She often will cut only a few frames from a chase and knows how to add zany cartoon elements where necessary, for contrast—the "balloony" contours (rubbery, too round, less natural), the anarchic use of scale, the upside downness. The slightest alteration, a frame or two, can ruin the movement (the effect), make it wobbly, or suggest a different mass. This is very similar to animation. It requires the same time-consuming minutiae. The computer does not shorten the work, only makes it more thorough. At the same time, a certain anarchy is required for a good action sequence. Like a cartoon chase, it requires the collision of the unlikely, such as mixing media and mood, with surprise pauses, and sudden lurches forward once the final volley begins. All these contraries are then synchronized balletically, to look like a magic act, thanks to the computer.

But beyond techniques in postproduction that resemble cartoon work, there is the subtle influence of the digital work environment itself. Special-effects crews are even more isolated from the studio than cartoon animators were. This breeds a strange ennui, not unlike film editors going thirty hours straight—but at a much slower pace. The result of weeks, even months, might be three seconds of film; five hundred hours to digitally engineer the texture of a tornado or the fidgety ears of alien reptiloids. This is managed without seeing the director much, except through notes brought by the effects supervisor for the film.[9] Indeed, it is *applied* animation. Even more than cartoon work, where at least the actors were animated, the effects team works far away from the hustle and tactile presence of actors and live production.

This distanced milieu tends to enhance a movie plot that often is distanced already—dehumanized—where the dramatic characters tend to be hosts in trouble, elements whose main job is to introduce the tornado or the alien war strikes.[10] As each abstracted shape is harvested slowly on a screen, one cannot

help but feel disengaged from the political or social buzz outside, a kind of sensory deprivation. "After working for weeks on an effect," says Tracy, "all I want to do is smell a real tree."

At the same time, there is the illusion of a bigger cyber universe. Other screens nearby may be on utterly different projects, not for cinema at all. Effects artists have skills that allow them to work in many media: on malls, casinos, theme parks, Web sites, virtual chat lines, TV commercials, music videos, animated features, kid-vid, and incidentally live-action cinema. Therefore, inside an effects studio, one witnesses animation as muscle tissue for a hundred different industries, on a global scale. For a moment this bank of screens seems as exciting as a fully packed world—like a special-effects action ride. But in fact, it is emptied as well, highly undifferentiated. Anything from a bomb to a cyber toy looks the same—detached, innocent—a computer wire frame or a miniature.

This is a workplace far more fetishistic even than the "fun factories" on a movie lot, more like staring at Barbie dolls for months at a time, perfecting the tilt of her breasts or the angle of her smile. The work seems very independent of factory rules. And yet, it is utterly contingent. I would compare it to a crafts environment in the nineteenth century. People work in small teams, as in a shoe factory in 1870 (only without the toxic smells, and with overtime pay, and much more cybernetically polite). It is not Fordist, not an assembly line, perhaps less alienated from the means of production, seemingly more autonomous. And yet, the result is fundamentally industrial—repetitive action, based on severely restricted options, a chain of production controls, including contracts that say the studio owns whatever "creative" ideas are generated. Beneath the ergonomics and cheery carpeting, it is still a factory.

Beside obvious comparisons to Disney in the thirties, one can see similarities to Termite Terrace as well, to worker complaints in the stream of gags about Leon Schlesinger,[11] about contracts, from *You Out to Be in Pictures* (1940) to *Duck Amuck* (1953). Perhaps the model is more a plantation than an assembly line—paternalistic, scattered, but severely controlled.

The mood of the plantation animator will influence the look of special-effects films, much as it adds a pungent irony to Warner Bros. cartoons. Even the plot and structure of special-effects films reflect this mood. Increasingly, the action-ride movie has insular gags, mostly about watching other movies by way of television. The antidramatic structure, with pieces of epic narrative, folkloric narrative, and various magic acts thrown in, resembles the interhierarchical, layered, nonlinear form of production. The seeming immobility of many of the characters suggests a feudalistic world where power is fluid but vast—diffuse—where individual initiative seems possible mostly as a form of caricature.

Consider the similarity of plots in so many of these action films, including *The Mask* and *Independence Day*. They center on disaster as conflict, where an

unprepared world is invaded by special-effects forces of nature, from tornadoes to dinosaurs to digitally enhanced serial killers, or capitalist terrorists with foreign accents, alien warships from an intergalactic economy.

They always have a fetish, like a comic metonym, that stands in for the effects themselves. Would it be a stretch to identify the mask that Stanley wears as the place (metonym) where special effects enter? The device stands in for the cartoon process. It is a special-effects costume, a virtual-reality headset; or a time-travel chute that you wear, like sliding through an MRI at the hospital. The metonym erases your identity, but you wear it like clothing, to generate a few Dionysian gags, then take it off. Clearly, identity is a kind of accessory one wears, like a tattoo or a pierced ear, nose, stomach.

This is not to say that such fetishes/metonyms have not operated as entertainment before. They have been fundamental to how animation has worked for centuries, even before cinema. The effects industry is drawing from the same well as animation. No wonder it relies so heavily on the chase cartoons of Avery, Clampett, Jones, and others.

Brief Background

Briefly, what do I mean by centuries of narrative theory and techniques common to both chase cartoons and effects movies? Obviously, these roots are not at all postmodern. They are closer to preindustrial. Most effects before the computer (and now being rediscovered digitally) borrowed heavily from theatrical devices already old in the nineteenth century. They are animation in real space, very architectural illusions. For example, the trick films of Méliès rely on music-hall gimmickry dating back to medieval carnival, also puppet theater, magic lantern effects since the Counter Reformation, the wizardry of Renaissance theatrical machines, as well as mannerist trompe l'oeil and anamorphosis. Many of these already had entered the home as well, through popular illustration since Dürer, then mass illustration with the steam engine, along with trick gizmos like zoetropes. That is why I am convinced that special effects in casinos, baroque churches, and the movies have a common heritage.

Another crucial point to remember is that both special effects and animation have been part of the same industry for generations. Special effects simply emphasize that precinematic architectural aspect of animation, as in trick entertainment, circuses, magic acts, music halls, and costume masque—again, animation in real space, as in Méliès's shorts or even McCay's vaudeville act with Gertie the dinosaur.

In the United States, Willis O'Brien became the key figure in the emergence of special effects, first in the feature *The Lost World* (1925) and then of course with *King Kong* (1933). He transferred what was called "trick work" (as

in trick photography and double exposure) into a genre of Hollywood film-making.[12]

But the transition was inevitable anyway. After 1927, with the coming of sound, more film was shot indoors. The need for in-camera effects grew enormously, particularly for very elaborate glass mattes and rear projection. These crafts were supposed to be "below the line" generally, hidden rather than exaggerated. They came to be classified within the industry as "animation" because the mattes used techniques similar to cartoon watercolor background, to layout. Similarly, by the midthirties, models became more essential, not only for live action but also for tabletop animation in Fleischer cartoons, or as visual aids for Disney animators, to help them draw their characters turning. However, since many of these live-action effects were not designed to be perceived, applied animation was barely noticed until the last twenty years—after *Star Wars* essentially. Except for the occasional book on masters of the stop-motion miniature (O'Brien or Ray Harryhausen), special effects were relegated to chapters in how-to books for amateurs or manuals for professionals, mostly on cinematography.

But that has irrevocably changed. Applied animation has been retooled as software, for interactive entertainment across the media, even in malls, theme parks, a year-round consumerist carnival. It is simply the architectural version of the animated, more about the shopper as spectator, more about rides than conflict.

Like an amusement park in 1900, or even like the Vatican in 1510 for that matter (illusionistic masterpieces of Michelangelo and Raphael), animation-in-real-space is once again an interactive journey where the audience is a central character. Character animation is simply a variant of this interactive form.

Special-effects environments, what we today call "interactive," were essential to the urban plan of Renaissance and baroque cities, in the design of plazas, in the domed interiors, even the illusions painted on the walls. To repeat, then, this form of "architectonic" story appears in theater, illustration, circus, any number of entertainments that feed into what we now call animation.

Animation has always been fundamentally an "interactive," not a dramatic form of story; the characters are dominated by, or at cartoon war with, the effects. It is more like an epic form, about worlds rising and falling, characters as types within the whole, or as elements like machine parts designed to move the spectacle along. These spectacles are narratives about environments, not characters, at risk; about folklore, carnival, the caricature of community in commedia dell'arte. For example, one source that continues to fascinate me is the Renaissance machines used for effects in theaters (similar to the gears and levers used in fortifications). They cranked up illusions from below stage and through the ceiling. Inside such a machinelike magic, the characters remain more stylized,

even with comic masks on their faces or dancing in masques.[13] Centuries later, cartoon characters are stylized in similar ways; they are masks with bionic or rubbery bodies—anarchic phantasms, more like revelers in a masque than dramatic characters, ducks amuck.

That means if you work with animation (as in *Duck Amuck*, where Daffy is lost in the apparatus of the movie), you are drawing on an architectural mode of story quite different from Bazinian space,[14] not simply illusionistic but a caricature of the stage (movie staging). This anarchic architectural illusion is littered with self-reflexive, intertextual gags; they speak to the audience the way a stand-up comedian does, or a TV talk show does, or a TV commercial. Much on TV, therefore, derives from roots similar to animation, to the navigated "epic" journey of the audience through a special-effects space.

The Warner Bros. chase is an accelerated version of this journey, developed from 1937 to 1958. The contract player (represented by Bugs) is prey to Elmer (dumb boss). Bugs is hunted and haunted, then cheerfully takes his revenge, in alliance with the audience, who are brought into the story with direct address, signs, and winks. In *Red Hot Riding Hood*, the contract players complain to their boss that they are sick and tired of their scripts. They refuse to do painfully sentimental "mellerdrammer." Instead, they want a masque on Hollywood Boulevard. Then, from a special-effects point of view, Avery navigates the audience through a madly improvised space, very upside down, where gravities meet and are made to collide. But it is also similar to trompe l'oeil domes where the sky appears to be collapsing on the spectator—a special-effects masque.

Here is how Steve Williams, the special-effects supervisor on *The Mask*, saw this Avery gimmick: First, he called the project "an animation acting model rather than a visual effects model," more like making cartoon comedy flat, rather than mixing an animated element inside a story closer to dramatic structure, as they had with *Jurassic Park* (1993) immediately before.[15] *The Mask* apparently was a relief after the tedium of building T-Rex.

In other words, animation as a story form felt freer, but also truer to the potential of visual effects, if allowed to mature into its own aesthetic.

> Director Chuck Russell set a new standard in that he allowed us to play
> with cut lengths of scenes in order to improve the flow of the animation
> once it was composited (timing like a chase cartoon essentially). . . .
> This was not commonplace before *The Mask*, but now it is. . . . [After
> hoping for years to try Avery gags on an f/x film:] For ten years I've
> wanted to make someone's, ANYONE'S, eyes bulge.[16]

Beyond our love of chase cartoons, what makes elemental stories emotionally captivating when they appear as live action? What is the vocabulary? We understand that there is not much time for dramatic development between characters, except as stock pantomime; or as dramatic shorthand, a quick "Hello,

what's my conflict?" and on to the chase. That is what passes for dramatic struc-
ture in *The Mask*, in many of the best special-effects films—as in the best fairy
tales, the best chase cartoons.

However, despite the pubescent spirit or thudding redundancy in many of
these films, their sheer impact can be breathtaking. Most critics isolated Carrey
as the good cartoon ("smokin'"), and the rest as the *blague* or blah of the story.
Reviewers identified with Carrey inside his appliances, makeup, and computer
enhanced body, but not as a man in dramatic conflict. Donna Tracy says much
the same: "The cartoony look of Jim Carrey in *The Mask* brings feelings to us
about our own lives, not about his life in the story. We feel the exclusion of our
own emotions. We feel ourselves hiding our emotions and content so much, as
he does."[17]

Stanley's "character" is a shell, controlled by outside forces, as if animation
stood in for an ancient special-effects machine. He is trapped inside an appara-
tus that forces him to explode like an animated cartoon, a parodic allegory about
determinism. His frenzy under the cartoon mask is not so much about intimacy
as it is about being trapped inside an apparatus.[18] The mask is a container, like
all animated effects really, another allegory about determinism.

Dramatic narrative, by contrast, is very much about free will, about indi-
vidualism.[19] If Stanley were in a dramatic story, it might be "Dr. Jekyll and Mr.
Hyde," though this story also reprises regularly in special effects, most recently
in *The Nutty Professor* (1996).

To sharpen this distinction, I will pause for a few sentences on Jekyll/Hyde,
clearly a trope that is almost mythic for many "dark metamorphosis" stories in
graphic novels and comics.[20] What does Robert Louis Stevenson's dramatic nar-
rative suggest? Clearly it is a tale about the moral dilemma of releasing self-
control, as in Edgar Allan Poe, Mary Shelley's *Frankenstein*, and dozens of others
from popular English literature. But it is also a response to the burgeoning growth
of London in the 1890s, to slums, prostitution, the flammable mixing of classes,
the invading proletariat, the revenge of the declining gentry. Let us say that
Jekyll's torment is an allegory about the end of the myths of the entrepreneur:
the cowboy who cannot head west; the detective going alone down mean streets;
Stevenson's pirates killing for gold; Jekyll the scientist overextending his reach.
The hero makes mistakes out of free will or even out of greed, refusing to take
an honest profit or to stop before breaking God's law.

Drama, in its nineteenth-century variant, is often a businessman's idea of
predestination and salvation; that soon it will be too late for free enterprise, that
the proletariat will overwhelm the natural order of profit and loss. To stretch
the point, as a matter of contrast with animation today: dramatic narrative, as
we in the West have developed it since 1820 or so, revolves around capitalist
myths about the individual struggling to survive as an entrepreneur.

Animation, even in its preindustrial forms, tends toward stories about the reification of the apparatus itself, the mechanized leviathan beyond the individual. Again, this is a feudal model more than an industrial one. Characters, like folk heroes, tend to be more *elemental* within the apparatus, and less dramatic, not necessarily dimmer or shallower, simply different.[21] Their relationship to the magic effect, to the gag, the magic potion, reminds the audience that this is a journey into developmental moments in their own life. The character is supposed to be empty, to be filled by the audience's sensibility.

To avoid overstating my case—overclasifying—let me add that all this is a matter of degree.

A: The dramatic story exaggerates the internal dialectic of character.
B: The elemental story emphasizes the conflict around the apparatus itself; it is much more about power, spectacle, and presence.

Special effects are a hybrid of the two. However, in the mix, each tends to erase the other, leading to a very diminished sense of character. Perhaps this amounts to an allegory about diminished individualism, that the self, as an industrial myth about freedom, cannot survive the effects of the electronic workplace.

The Need for New Theory about Hybrid Cinema

Critics, and, I must admit, film theorists, as a rule still ignore the elemental form of story that is inherent to animation, and therefore, they often get flustered by the special-effects film. For example, let us sort through some of the reviews of *The Mask* at the time of its release.

> *The Mask* underscores the shrinking importance of conventional storytelling in special-effects-minded movies, which are happy to overshadow quaint ideas about plot and character with flashy up-to-the-minute gimmickry.
> —Janet Maslin, *New York Times*[22]

> Some of the shocks are amazing: like pinpricks on your hand, only fun. There's no script to speak of, and the other characters hardly matter.
> —David Denby, *New York*[23]

> The plot's a throwaway. You've got to get on board, or move out of the way.
> —Jeff Giles, *Newsweek*[24]

The responses were much the same with *Independence Day*, which indeed was a bit blunt, a very cynical film, filled with all the hot-button effects, but at least

making fun of itself. Still, I saw it from the first row and wasn't bored, no more than if I had been dragged five miles by a runaway bus—which brings me back to a recurring theme: one of the most common terms used in production of these films is "the ride." As Donna Tracy explains: "The ride is more important than the story. The ride is the story."

What we need to understand is that the ride is an allegory about the audience, about the shocks of globalized economic arrangements, about new forms of visuality, and fundamentally about the collapse of private and public space— all of these wrapped into a cartoon *bildung*,[25] without any interior life, in fact bluntly displaying characters incapable of interiors.

In other words, we see a simulation of self as a movie effect. Forget Baudrillard's nostrums for a moment.[26] Simulation (copies without originals) as a device in moviemaking merely announces the folkloric or elemental use of character; then enables the immersive journey, where we, the audience, cannot distinguish between inside and outside, where our identity is invaded by special effects; yet, in some ergonomic way, we are comfortable with our self-erasure (or are we?). It is a grim allegory indeed. No wonder critics resent it. Beneath the blithe and thrilling, there is a warning, the invasion of self, loss of intimacy, loss of private boundaries.

But we must take these films more seriously, even though they are so misanthropic in the way they hawk their hype. I could sidestep the entire problem by taking the high road and using experimental animation as the model, for example: stop-motion masterpieces by Starevich, Borowczyk, Rybczynski, Svankmejer, and then the ambient journeys by the Brothers Quay. By Hollywood standards, these films are systematically antidramatic, simply outside the range of pop dramatic narrative. But that approach, a lofty formalism, would do no good. It avoids more than it defends. Animated "action" films like *The Mask* present a very different set of parameters. Unlike a Quay film, they are a category fundamental to the mainstream, immensely popular, even dominant in the nineties. They are built out of a new form of cinematography that has taken the global film market by storm, led to glittery articles on the animation industry in the *New York Times*, the *Wall Street Journal*, and a buzz in the art world that amazes me. This buzz has become a windfall to film schools and dozens of new animation programs in colleges, even in high schools now. Every major studio is investing hundreds of millions of dollars to ramp up for more special-effects films like *The Mask, Forrest Gump* (1994), *Independence Day*, and *The Lion King* (1994). That means effects above and below the line, for lighting, stunts, locations. The gold mine for licensing special effects in toys, games, clothing, and virtual-reality malls is greater than what animated films have earned before, very much like cartoon licensing, but on an astronomical level. *The Lion King* alone earned over $1 billion in clear profit, the most lucrative consumer object ever made. What do you think Henry Ford would have done?

Nevertheless, I am convinced that we are not witnessing the collapse of movie culture as we know it—dramatic structure—but the gaudy birth of a hybrid form. And animation, particularly the chase cartoon, is the key to understanding how this hybrid can mature (one hopes). We need to outgrow our postmodern cynicism and concentrate more on inventing a modernist poetics for the computer era.

The glamour of special effects reminds us that consumerism has matured. It is now integrated as a partner in the industrial economy. Disney is on the DOW. Time Warner has absorbed Turner. Not since the late feudal era that gave birth to animation, has power, entertainment, and salvation been concentrated in precisely the same place—the same screen, so diffuse yet so omnipotent. Indeed, hybrid cinema is merely reminding us that in the "New World Order," public and private, work and leisure, capital and information are being hybridized.

What's more, this electronic feudalism is allegorized by the mood inside a special-effects studio. Something as fissionable as the industrial revolution of the nineteenth century is upon us, promising us cable, remote control, and special effects in return for declining real income in the "New World Order." What presence and engagement, what fresh films and books, do we intend to make of this trade-off?

These flashy special-effects films will be teaching the future what we thought of our mess, just as trick cinema teaches us today about the impact of electricity and locomotives in 1900. In other words, one could argue that films like *The Mask* speak more directly, or at least more problematically, about the impact of computer capitalism than CD-ROMs or the Internet, than the entire telephonic, hypercard boosterism that is called cyberspace.

In 1994, Richard Corliss wrote of *The Mask*: "By obeying the insane pace, wild exaggeration, mock cheerful tone and inside references that today define much of a movie and TV entertainment, Avery practically invented pop culture's Postmodernism."[27] While I'm not comfortable with the overripe term "postmodernism" (I'm more a modernist, I suspect), Corliss is on the right track. Movies that hark back to the televisual, like *The Mask*, rely on vocabulary developed by Avery and the chase cartoon; I find that cartoons help explain a great deal about the semiotics of television narrative, since cartoons have their roots in theater, which leads to television as well. Animation has always been hybridized, in its marketing, scripting, production, and reception. And now, live-action cinema is turning into a kind of animation.

Recently, George Lucas said that digital effects can bring assembly-line efficiency to moviemaking. Through digital libraries, like painted backdrops of New York City in studio lots of the thirties and forties, the process of building a movie can be integrated, not split off between the shoot and digitalized postproduction.

There will be "no aesthetic advantage in shooting on location anymore."[28] Digital content will become reusable, like old cartoons. The era when digital effects shift from a service industry to production has arrived.

James Cameron repeats in various interviews, as if he were a master animator at his light table: "Anything you can imagine can be done. If you can draw it, if you can describe it, we can do it." His version of the collapse of public into private has arrived—as story—on the image-capture stage that he used for *True Lies* (1994). "In Digital Hollywood you won't even be able to trust your eyes."[29] The special-effects films, for all their gaudiness, have become the portable cathedrals for this integrated, weirdly disengaged feudal civilization.

Notes

Introduction: Looney Tunes and Merry Metonyms

1. Bill McAllister, "Post Office Jumps at Help from Bugs," *Washington Post*, May 17, 1996.
2. "Bugs Bunny Postage Stamp Unveiled at Warner Bros. Studio Store Grand Re-Opening," *United States Postal Service—Postal News*, October 23, 1996, http:www.usps.gov.
3. Elizabeth Bell, Lynda Haas, and Laura Sells, "Introduction: Walt's in the Movies," in *From Mouse to Mermaid: The Politics of Film, Gender, and Culture*, ed. Elizabeth Bell, Lynda Haas, and Laura Sells (Bloomington: Indiana University Press, 1995), 3.
4. For more information on *Der Fuehrer's Face* and other wartime cartoons, see Michael S. Schull and David E. Wilt, *Doing Their Bit: Wartime American Animated Short Films, 1939–1945* (Jefferson, N.C.: McFarland, 1987).
5. Henry A. Giroux, "Memory and Pedagogy in the 'Wonderful World of Disney,'" in *From Mouse to Mermaid*, ed. Bell, Haas, and Sells, 48.
6. In Bell, Haas, and Sells's "Introduction," they write: "The working title for this book was *Doing Disney: Critical Dialogues in Film, Gender, and Culture*. When we corresponded with Disney personnel to gain access to the Disney archives in Buena Vista, California, we were informed that Disney does not allow third-party books to use the name 'Disney' in their titles—this implies endorsement or sponsorship by the Disney organization" (1).
7. Giroux, "Memory," 44–47.
8. Ibid., 48.
9. Jim Collins, "Batman: The Movie, Narrative: The Hyperconscious," in *The Many Lives of the Batman*, ed. Roberta E. Pearson and William Uricchio (New York: Routledge, 1991).
10. Ibid., 175.
11. Ibid., 167.
12. Eileen R. Meehan, "'Holy Commodity Fetish, Batman!': The Political Economy of a Commercial Intertext," in *The Many Lives of the Batman*, ed. Pearson and Uricchio, 47–48.
13. Ibid., 58–59.
14. Ibid., 56.
15. Lynn Spigel and Henry Jenkins, "Same Bat Channel, Different Bat Times: Mass

Culture and Popular Memory," in *The Many Lives of the Batman*, ed. Pearson and Uricchio, 133–134.

16. Mike Barrier and Milton Gray, "Bob Clampett: An Interview with a Master Cartoon Maker and Puppeteer," *Funnyworld* 12 (summer 1970): 23.

17. "Bugs Bunny, Carrot Crunching Comic," *New York Times*, July 22, 1945.

18. Bell, Haas, and Sells, "Introduction," 4.

19. Mike Barrier," Of Mice, Wabbits, Ducks, and Men: The Hollywood Cartoon, *AFI Report* 5 (summer 1974): 22.

20. Steve Schneider, *That's All Folks!: The Art of Warner Bros. Animation* (New York: Henry Holt, 1988), 21, 23.

21. Friz Freleng also directed Warner Bros. cartoons during the Avery-Clampett-Tashlin period except when he left to work for MGM for a year and a half during the late thirties.

22. Chuck Jones, "The Road Runner and Other Characters," *Cinema Journal* 8 (spring 1969): 14.

23. Joe Adamson, *Bugs Bunny: Fifty Years and Only One Grey Hare* (New York: Henry Holt, 1990), 64.

24. Marc Eliot, *Walt Disney: Hollywood's Dark Prince* (New York: Carol Publishing, 1993), 199–200.

25. Adamson, *Bugs Bunny*, 65.

26. John Kricfalusi, the creator of Ren and Stimpy, also acknowledges the deviltry of Bugs Bunny cartoons during this period. In *Wackiki Rabbit* (1943), Kricfalusi notes the gags revolve around Bugs Bunny taking advantage of two guys who are starving on a deserted island. See Kricfalusi's excellent three-part assessment of early Chuck Jones cartoons, focusing on his Bugs Bunny ones, in *Animation Magazine*, July–August 1994, October–November 1994, and January 1995.

27. Will Friedwald, "Suppressed Duck," *Village Voice*, December 19, 1989, p. 102.

28. George W. Woolery, *Children's Television: The First Thirty Five Years, 1946–1981, Part 1: Animated Cartoon Series* (Metuchen, N.J.: Scarecrow, 1983), 54.

29. Jones, "The Road Runner and Other Characters," 10, and Lloyd Rose, "Our Greatest Invisible Actor, *Atlantic Monthly*, December 1984, p. 124.

30. Lloyd Rose, "Bunny Redux," *Voice Literary Supplement* 88 (September 1990): 23.

31. Jones, "The Road Runner and Other Characters," 10.

32. Quoted in Dan Glaister, "Value of the Dolls," *Guardian* (London, England), March 21, 1997.

33. Http://www.spacejam.com/cmp/jamcentral/prodnotesframes.html.

34. Matt Zoller Seitz, "Defamation of Cartoon Characters," *New York Free Press*, December 4, 1996.

35. In ibid., Zoller Seitz adds: "The coup de grace comes when [Bugs] and Daffy are surprised by Jordan's growling watchdog and cower in fear until Jordan's children come in and rescue them. What the hell is going on here? Since when is Bugs Bunny intimidated by a watchdog?"

36. Mike Clark, "Bugs and Michael But Little Magic," *USA Today*, international ed., November 18, 1996.

37. Richard Corliss, "Air Meets Hare," *Time*, November 25, 1996.

38. Quoted in Bruce Handy, "101 Movie Tie-Ins," *Time*, December 2, 1996, p. 78.

39. The phrase "entertainment retailing" is quoted from Peter Starrett, Warner Bros. worldwide retail operations president. See Paul Willistein, "It's a Looney Tune World at Trump Plaza," *Morning Call* (Atlantic City, N.J.), August 14, 1994.

40. Kirk Johnson, "What's Up, Bugs? It's Mickey!" *New York Times*, March 15, 1996.

41. Richard Corliss, "What's Hot, Doc? Retail!" *Time*, May 8, 1994, p. 66.

42. Anna Holmes, "Hare Mail," *Entertainment Weekly*, May 23, 1997, p. 10.

43. Bob Miller, "The New Looney Tunes," *Comics Yearbook*, no. 1 (1992): 23–24. In the

early nineties, Van Citters also directed the cartoon *Rock-a-bye Rabbit* in which Yosemite Sam has a baby daughter. Unfortunately, the cartoon was filmed in pencil test only. Production of the cartoon was suspended in 1992. In all likelihood, it will never be completed.

44. Quoted in Woolery, *Children's Television*, 54.

45. Schneider, *That's All Folks!* 133.

46. For a list of edited Warner Bros. cartoons, please see Dave Mackey's article in the magazine *FPS*, no. 1 (November 1991) or access it on the World Wide Web at http://www.cam.org/~pawn/WARNERCUTS.html. Also consult "Looney Tunes—Censored!" at www.megalink.net/%7Ecooke/looney/ltcuts.html.

47. Before being bought by Turner, MGM/UA owned the rights to many of the pre-1949 Looney Tunes and Merrie Melodies. With the merger of Turner and Time Warner in 1996, Time Warner now owns the rights to all Looney Tunes and Merrie Melodies shorts.

48. "The Golden Age of Looney Tunes" is a four-volume set of five laser discs each of pre-1949 cartoons. The first volume is also available on ten separate VHS videotapes. *Bugs Bunny Nips the Nips* was on videotape number 7 and laser disc volume 1. Although volume 3 has a laser disc side entitled "Politically Incorrect," racially insensitive cartoons—such as *Coal Black and de Sebben Dwarfs* (1943), *Clean Pastures* (1937), and *Tin Pan Alley Cats* (1943)—are not included on this side or anywhere else in the four volumes. For more information on the collection, see Barbara Saltzman, "That's Not All, Folks: More Golden Looney Tunes," *Los Angeles Times*, October 23, 1992.

49. Tony Burton, "That's All, Japanese Folks, from Bugs the 'Racist,'" *Daily Mail*, February 28, 1995.

50. Susan Elizabeth Dalton, "Bugs and Daffy Go to War," in *The American Animated Cartoon*, ed. Danny Peary and Gerald Peary (New York: Dutton, 1980), 161.

51. Slowpoke Rodriguez, a player from the Speedy Gonzales series, appears twice in *Space Jam*, but also without any dialogue.

52. The five films I am referring to here are *The Bugs Bunny/Road Runner Movie* (1979), *Friz Freleng's Looney Looney Looney Bugs Bunny Movie* (1981), *Bugs Bunny's Third Movie: 1001 Rabbit Tales* (1982), *Daffy Duck's Movie: Fantastic Island* (1983), and *Daffy Duck's Quackbusters* (1988).

53. Quoted in Greg Critser, "Bugs' Hollywood Agent," *Bugs Bunny Magazine* (1990): 54.

54. Handy, "101 Movie Tie-Ins," 78.

55. Quoted in Andy Meisler, "Steven Spielberg Promises: 'Th-Th-That's Not All Folks,'" *New York Times*, July 8, 1990.

56. Quoted in Joe Adamson, "You Couldn't Get Chaplin in a Milk Bottle" (interview with Tex Avery), *Take One* 2 (January–February 1970): 10.

57. Quoted in Charles Fleming, "What's Up with Chuck Jones? Lissen, Doc, and He'll Tell You," *New York Times*, August 9, 1992.

58. Edwin McDowell, "Cruise Line Will Cut a Disney Link," *New York Times*, October 7, 1993.

59. The Space Jam Web site, www.spacejam.com, actually refers to this place as "Looney Tunes Land," although no place has ever existed in prior Looney Tunes cartoons.

60. Greg Ford remembers that a Looney Tune–type land interested Warner Bros. prior to *The Bugs Bunny/Road Runner Movie* in 1979. Regarding a never-completed compilation feature called *Hareport*, Ford remarks, "[Warner Bros.] wanted me to put Yosemite Sam and Tweety and all these characters into a compilation picture. I thought, gee whiz, these characters don't even belong in the same *frame*." See Miller, "The New Looney Tunes," 25.

61. The quote is from *Bugs and Thugs* (1954).

62. *Bugs Bunny's Creature Features*, available on home video, also contains Ford and Len-

non's *The Duxorcist* (1987) and *Night of the Living Duck* (1988), both starring Daffy Duck.

63. Quoted in Miller, "The New Looney Tunes," 28.

64. Quoted in ibid.

65. Quoted in Richard Thompson, "Duck Amuck," *Film Comment* 11 (January–February 1975): 43.

66. *Blooper Bunny* was scheduled to be released in 1991 with *Rover Dangerfield*, but the idea was discarded. A twenty-second scene of *Blooper Bunny* is now part of the opening credits to the syndicated *Bugs and Daffy* show. This dance number sequence was the only footage privy to a mass audience before *Blooper Bunny's* premiere in 1997.

67. The press release for *Blooper Bunny* from June 10, 1997, reads: "Cartoon Network bookends its 48–hour Bugs Bunny Marathon with the world premiere of *Blooper Bunny*, a 1991 Bugs Bunny theatrical short that has never been aired anywhere in the world."

68. See Bruce Eder, "Duck Bill," *Village Voice*, December 1, 1987, p. 82; Bill Barol and Jennifer Foote, "A Duck Amuck, One More Time," *Newsweek*, November 30, 1987, p. 83; Steve Dougherty, "A Spluttering Duck Redux: Daffy," *People Weekly*, January 18, 1988, pp. 30–32; Jerry Beck, "The Return of Daffy Duck," *Animation Magazine* 1 (December 1987); Jefferson Graham, "Looney Tunes Ducks Back into Theaters," *USA Today*, November 18, 1987; Jami Bernard, "That's Not All Folks!" *New York Post*, November 10, 1987; Jami Bernard, "That's Not All Folks!" *New York Post*, September 22, 1988; Martin Kassindorf, "Daffy Duck Dips a Toe in New Waters," *Newsday*, November 20, 1987; Joseph Gelmis, "There's Even a Cartoon," *Newsday*, September 23, 1988; Moira Baily, "At 50, with a New Picture, Daffy Is Still a Wild Duck," *Orlando Sentinel*, December 4, 1987; Phantom of the Movies, "Hangin' Out with These Guys Is Murder," *New York Daily News*, September 28, 1988; Phantom of the Movies, "Fowl Play: Tasty Serving of Bijou Duck," *New York Daily News*, December 2, 1987; Jonathan Rosenbaum, "Quack to the Future," *Chicago Reader*, September 8, 1988; Richard Corliss, "Daffy's Back: A Cartoon Legend Shines Again," *Time*, January 18, 1988.

69. Quoted in Miller, "The New Looney Tunes," 26.

70. Glenn Anton, "Old Melodies . . . New Toons," *In Toon!* 7 (winter 1996–1997): 12. Chuck Jones Film Productions (CJFP) also produced *Another Froggy Evening*, which screened at the Telluride Film Festival in August of 1995 but has seen only a limited release theatrically. CJFP is currently awaiting the release of *Father of the Bird* with Sylvester and a new character, Cornbread. *From Hare to Eternity*, with Bugs Bunny and Yosemite Sam, was released straight to video.

71. Posted in rec.arts. animation and reposted at www.megalink.net/%7Ecooke/looney/ltnews.html.

72. Ted Johnson, "Bugs Bunny's Career Riding on 'Space Jam,'" *Variety*, November 4–10, 1996, p. 4.

73. Barrier, "Of Mice, Wabbits, Ducks, and Men," 22.

74. Turner owned the rights to all the color cartoons prior to September 1, 1948, plus all the black-and-white Merrie Melodies except *Sittin' on a Backyard Fence* (1933), *Pettin' in the Park* (1934), *Those Were Wonderful Days* (1934), *Goin' to Heaven on a Mule* (1934), *How Do I Know It's Sunday?* (1934), *Why Do I Dream These Dreams?* (1934), *The Girl at the Ironing Bound* (1934), *The Miller's Daughter* (1934), *Shake Your Powder Puff* (1934), *Rhythm in the Bow* (1935), and *Into Your Dance* (1935). Warner Bros. owned the remaining cartoons, while both claim to have owned *Odor of the Day* (1948). The ownership distinction, nowadays, is irrelevant, for after the merger of Time Warner and Turner in 1996, the libraries were combined.

75. Chuck Jones, *Chuck Amuck: The Life and Times of an Animated Cartoonist* (New York: Avon, 1989), 89.

76. Ibid., 93.

A Short Critical History of Warner Bros. Cartoons

1. Richard Barrios, *A Song in the Dark: The Birth of the Musical Film* (New York: Oxford University Press, 1995).
2. Manny Farber, "Short and Happy," *New Republic*, September 20, 1943, p. 394.
3. *Freleng Frame-By-Frame* prod. and dir. Greg Ford, writ. Ronnie Scheib, Donovan Publishing Co., 1994, videocassette.
4. The quote is from *Super Rabbit* (1943).
5. The quote is from *The Great Piggy Bank Robbery* (1946).

From Disney to Warner Bros.: The Critical Shift

1. Kristin Thompson points out that critics who "treat the animated film as an important form have often done so by comparing certain films with other, culturally accepted art forms; a UPA cartoon is seen as being like a Picasso or Modigliani painting." See "Implications of the Cel Animation Technique," in *The Cinematic Apparatus*, ed. Teresa de Lauretis and Stephen Heath (New York: St. Martin's Press, 1980), 112. For an example, Isobel C. Sagar compares the UPA productions to the works of Matisse, Dufy, Klee, and Mondrian. See "The UPA Cartoons," *Films in Review* 2 (November 1951): 36–37.
2. David Bordwell, *Narration in the Fiction Film* (Madison: University of Wisconsin Press, 1985), 232.
3. Gregory A. Waller, "Mickey, Walt, and Film Criticism from *Steamboat Willie* to *Bambi*," in *The American Animated Cartoon*, ed. Danny Peary and Gerald Peary (New York: Dutton, 1980), 49–57. See also "Europe's Highbrows Hail 'Mickey Mouse,'" *Literary Digest*, August 8, 1931, p. 19.
4. David Low, "Leonardo da Disney," *New Republic*, January 5, 1954. Reprinted in *New Republic*, November 22, 1954, pp. 42–43.
5. Sergei Eisenstein, *Nonindifferent Nature* (Cambridge, England: Cambridge University Press, 1987), 389.
6. Jean Charlot, "But Is It Art?," *American Scholar* 8 (summer 1939): 263, 268, 270. (This article also appears, in slightly different form, as the chapter "A Disney Disquisition," in Charlot's *Art from the Mayans to Disney* [New York: Sheed, 1939], 268–280.)
7. Paul Nash, "The Colour Film," in *Footnotes to the Film*, ed. Charles Davy (London: Lovat, 1938; New York: Arno, 1970), 129, 130. Nash's comparison of early Disney cartoons to the drawings of William Blake should remind us that some early critics of animation were no more immune to appealing to the more established arts to justify a preference for a film or filmmaker than were early critics of live-action films.
8. Ibid., 129–130 and 132.
9. Ibid., 130.
10. Charles Davy, "Postscript: The Film Marches On," in *Footnotes to the Film*, ed. Davy, 319.
11. Alberto Calvacanti, "Comedies and Cartoons," in ibid., 85.
12. Gilbert Seldes, "Disney and Others," *New Republic*, June 8, 1932, pp. 101–102. Not all critics of the thirties and forties praised the work of Disney's studio. See, for example, Calverton's review of *Snow White* and Kracauer's condemnation of *Dumbo*: V. F. Calverton, "Cultural Barometer," *Current History* (June 1938): 45–47; Siegfried Kracauer, "Dumbo," *The Nation*, November 8, 1941, p. 463.
13. Steve Schneider, *That's All Folks!: The Art of Warner Bros. Animation* (New York: Henry Holt, 1988), 17–18; Richard Corliss, "Warnervana," *Film Comment* (November–December 1985): 11–13, 16–19.
14. Richard Winnington, *Film: Criticism and Caricatures, 1943–53* (New York: Barnes, 1976), 129.

15. Manny Farber, "Short and Happy," *New Republic*, September 20, 1943, p. 394. See also Farber's "Saccharine Symphony—*Bambi*," *New Republic*, June 29, 1942. Reprinted in Peary and Peary, eds., *The American Animated Cartoon*, 90–91.

16. Waller, "Mickey, Walt, and Film Criticism," 57.

17. Frances Clark Sayers, "Walt Disney Accused" (interview), *Horn Book Magazine* 41 (December 1965): 602–611. These comments were made originally in a letter by Frances C. Sayers to the *Los Angeles Times*; this letter is reprinted in its entirety, followed by an interview with Sayers, in the *Horn Book Magazine*. The letter is also quoted and discussed in "'Too Long at the Sugar Bowls': Frances C. Sayers Raps Disney," *Library Journal*, October 15, 1965, p. 152.

18. Richard Schickel, *The Disney Version* (New York: Discus, 1969), 169.

19. Ibid., 170.

20. The criticisms of Disney's work in the late forties and fifties generally note an artistic decline at the studio rather than condemn the entire body of work. Typical comments include "Disney's newest [work] is not his best" and "[A] mechanical slickness appears to be replacing the kindness and warmth which once infused Disney's creations." See, respectively, Kenneth MacGowen, "Make Mine Disney: A Review," *Hollywood Quarterly* I (1945–46): 376–377, and Gerald Pratley, "The Cartoon's Decay," *Films in Review* 2 (November 1951): 34–36.

21. Schneider, *That's All Folks!* 19.

22. Quoted in Rob Medich and Sally Weltman, "Major/Minor," *Premiere*, June 1990, p. 108.

23. Schneider, *That's All Folks!* 64.

24. John Mason Brown, *Seeing Things* (New York: McGraw, 1946), 97.

25. Schickel, *The Disney Version*, 173.

26. Schneider, *That's All Folks!* 20–21, 44. See also Frank David Martarella, "Animated Cinema," *America* (March 8, 1969): 271–273.

27. Kracauer notices this problem in his review of *Dumbo*, in which narrative motivation is provided for occurrences (such as a flying elephant) that required no such motivation in the shorts. Kracauer compares this situation to the predicament faced by slapstick comedy with the advent of feature-length films: "The turn to a realistic style is fostered by the full-length cartoon which requires a story. One is reminded of the old comedies; they too have suffered from their extension to feature length" ("Dumbo," 463). Gilbert Seldes, too, remarks on "the immense superiority of the simpler form" of the short cartoon compared to feature-length comedy in "Disney and Others," 101—102.

28. Thompson, "Implications of the Cel Animation Technique," 110; Jonathan Rosenbaum, "Dream Masters I: Walt Disney," *Film Comment* (January–February 1975): 66.

29. Rosenbaum, "Dream Masters I," 66 and 68; Corliss, "Warnervana," 12.

30. Schickel, *The Disney Version*, vii.

31. Rosenbaum, "Dream Masters I," 65.

32. Ibid., 69. For an early account of the rigid production organization at Disney, see Paul Hollister, "Genius at Work: Walt Disney," *Atlantic Monthly*, December 1940, pp. 689–701.

33. Calvacanti, "Comedies and Cartoons," 84.

34. Nash, "The Colour Film," 128.

35. Sergei Eisenstein, *Eisenstein on Disney* (London: Methuen, 1988), 2.

36. Howard Junker, "The Art of Animation," *The Nation*, February 28, 1966, pp. 249–250. Mike Barrier argues, on the other hand, that Disney's animators were given a great deal of freedom that, combined with Walt Disney's "absolute control over stories," resulted in a situation in which the directors "could not impose their personalities on the cartoons as Jones and Clampett and the others would a few years later."

See "Of Mice, Wabbits, Ducks, and Men: The Hollywood Cartoon," *AFI Report* 5 (summer 1974): 25.

37. Martarella, "Animated Cinema," 272.
38. Roy Armes, *Film and Reality* (Middlesex, England: Penguin, 1974), 128.
39. Donald Barr, "The Winnowing of Pooh," *Sunday Herald Tribune Book Week*, October 31, 1965, p. 45.
40. Rosenbaum, "Dream Masters I," 66.
41. Ernest Callenbach, "Animation," *Film Quarterly* 17 (spring 1964): 16.
42. Robert Benayoun, "Animation: The Phoenix and the Road-Runner," ibid., 24–25.
43. Schneider, *That's All Folks!* 30.
44. Joe Adamson, "Well, for Heaven's Sake! Grown Men!" *Film Comment* (January–February 1975): 18.
45. Patrick McGilligan, "Robert Clampett," in *The American Animated Cartoon*, ed. Peary and Peary, 152.
46. David Bordwell, *Narration*, 232.
47. Jay Cocks, "The World Jones Made," *Time*, December 17, 1973, p. 77.
48. Joe Adamson, "Heck Allen" (interview), *Film Comment* (January–February 1975): 73.
49. Quoted in Win Sharples, "Titan of Termite Terrace," *American Film* (May 1976): 79.
50. Ibid.
51. Ronnie Scheib, "Tex Arcana: The Cartoons of Tex Avery," in *The American Animated Cartoon*, ed. Peary and Peary, 114.
52. Jonathan Rosenbaum, "Dream Masters II: Tex Avery," *Film Comment* (January–February 1975): 70–73. Rosenbaum also compares Avery's cartoons to the work of Hitchcock, Sennett, Chaplin, Kafka, Ernst, and Magritte.
53. Quoted in John Canemaker, "The Hollywood Cartoon," *Filmmakers Newsletter*, April 1974, p. 34.
54. Joe Adamson, *Tex Avery: King of Cartoons* (New York: Da Capo, 1975), 68, 13, 94.
55. Ford discusses "Brechtian distancing" in the Avery cartoons but warns against attributing this to any conscious attempt at "Brechtian distancing," pointing out that these "devices of distanciation" are those of Avery, not Brecht. See Greg Ford, "Warner Brothers," *Film Comment* (January–February 1975): 93, and Canemaker, "The Hollywood Cartoon," 34. Many other critics have discussed Avery's "Brechtian" distancing devices; see, for example, Richard Thompson, "Meep Meep!" *December* 13, no. 2 (1971). Later reprinted in *Film Comment* (May–June 1976): 37–39ff. and in *Movies and Methods*, ed. Bill Nichols (Berkeley: University of California Press, 1976), 126–135.
56. Schneider, *That's All Folks!* 52; Canemaker, "The Hollywood Cartoon," 33.
57. J. Hoberman, "Welcome to the Manic Kingdom," *Village Voice*, July 31, 1978, p. 37.
58. Thompson, "Meep Meep!" 129.
59. Ibid., 131.
60. For a discussion of how Jones structured the plots of the Road Runner cartoons, see Greg Ford and Richard Thompson, "Chuck Jones" (interview), *Film Comment* (January–February 1975): 21–38.
61. Thompson, "Meep Meep!" 133.
62. Cocks, "The World Jones Made," 77.
63. David Bordwell, *Making Meaning* (Cambridge: Harvard University Press, 1989), 97.
64. Schickel, *The Disney Version*, 158–159, 146.
65. Patrick MacFadden, "Letting Go," *Film Society Review* 4 (September 1968): 24–25.
66. For examples of other more or less symptomatic analyses of Disney's cartoons, see the following essays in Peary and Peary, eds., *The American Animated Cartoon*: Robert Sklar, "The Making of Cultural Myths: Walt Disney," 58–65; Peter Brunette, "Snow White and the Seven Dwarfs," 66–73; Michael Wilmington, "Dumbo,"

76–81. For examples of symptomatic analyses of Warner Bros. cartoons, see Sybil Delgaudio, "Seduced and Reduced: Female Animal Characters in Some Warners' Cartoons," in *The American Animated Cartoon*, ed. Peary and Peary, 211–216; Jane Gaines, "The Wolf and the Showgirl," in *Cinema Examined*, ed. Richard Dyer MacCann and Jack C. Ellis (New York: Dutton, 1983), 283–297.

67. Richard Thompson, "Duck Amuck," *Film Comment* (January–February 1975): 39–43.

68. Michael Gould, *Surrealism and the Cinema (Open-Eyed Screening)* (New York: Barnes, 1976), 140–147.

69. Colin L. Westerbeck, Jr., "The Disney Virgin," *Commonweal*, June 4, 1976, p. 367.

70. Ibid., 368.

71. J. Hoberman, "Reflex Action," *Village Voice*, May 1, 1984, p. 50.

72. David Bordwell and Kristin Thompson, *Film Art: An Introduction*, 3rd ed. (New York: McGraw-Hill, 1990), 347–352.

73. Jack Ellis, *A History of Film* (Englewood Cliffs, N.J.: Prentice-Hall, 1979), 214–215.

Charlie Thorson and the Temporary Disneyfication of Warner Bros. Cartoons

1. In a letter to his brother, Joseph Thorson, on April 29, 1937, Charlie enthused that he was going to be in "on the ground floor of the new MGM animation department. . . . They offered me a four-year contract at an increase of my present salary." At the time, he was working for Harman-Ising Studios. The letter is in the Joseph Thorson collection, National Archives of Canada. Ottawa, Ontario.

2. "Thorson on Looney Tunes," *Hollywood Reporter*, July 16, 1938, p. 2. The news release is somewhat tardy and the headline misleading. Existing records indicate he worked almost entirely on Merrie Melodies cartoons. According to Steve Schneider, Looney Tunes was the showcase for Warner Bros.' stars such as Bosko and Porky Pig. Until the late thirties, Merrie Melodies was a series of "one-shot" cartoons, featuring no continuing characters, but obligated to include a performance of a chorus of at least one Warner Bros.–owned song. By the early forties, the studio no longer upheld this distinction. See Steve Schneider, *That's All Folks!: The Art of Warner Bros. Animation* (New York: Henry Holt, 1988), 38–40.

3. Leon Schlesinger was an independent producer who financed his own productions and sold them to Warner Bros. When he sold his studio to Warner Bros. in 1944, Jack Warner installed Eddie Selzer as producer.

4. In addition to *Flowers and Trees* in 1931–1932 (until 1934, Oscars were awarded for movies released between August 1 and the following July 31), Disney won awards for *The Three Little Pigs* (1933, won in 1932–1933), *The Tortoise and The Hare* (1934), *Three Orphan Kittens* (1935), *The Country Cousin* (1936), *The Old Mill* (1937), *Ferdinand the Bull* (1938), *The Ugly Duckling* (1939), *Lend a Paw* (1941), and *Der Fuehrer's Face* (1942). MGM won the Oscar in 1940 for *The Milky Way*. Warner Bros. finally captured one in 1947 for *Tweetie Pie*.

5. In 1938, Warner Bros. released forty animated shorts; Fleischer, thirty-eight; and Disney, eighteen. In 1939, the numbers were forty-four, nineteen, and thirteen, respectively.

6. Freleng left in October 1937 for a position with MGM, where he, in fact, worked with Thorson on *Poultry Pirates* (1938). Freleng returned to Warner Bros. in April 1939. Tashlin left in early 1938 and returned in late 1942.

7. For a discussion of the major differences between Disney and Warner Bros. and the changing popular/critical responses to both, see Timothy R. White, "From Disney to Warner Bros.: The Critical Shift" in this anthology.

8. Ariel Dorfman and Armand Mattelart, *How to Read Donald Duck: Imperialist Ideol-*

ogy in the Disney Comic, trans. David Kunzle (New York: International General, 1975), 62.

9. Colin MacLean, "Searching for Quasimodo—Does That Name Ring a Bell?" *Reader's Showcase* 4 (August 1996): 16. See also Robert Haas, "Disney Does Dutch: *Billy Bathgate* and the Disneyfication of the Gangster Genre," in *From Mouse to Mermaid: The Politics of Film, Gender, and Culture*, ed. Elizabeth Bell, Lynda Haas, and Laura Sells (Bloomington: Indiana University Press, 1995), 72–85. For the editors of *From Mouse to Mermaid*, Disneyfication is associated with the clean, civilized, homogenized, sanitized, and innocent. In the acknowledgments, they say that the book has made their friends and family endure "the Disneyfication of our friendship and of our lives" (xi).

10. For a fuller discussion of Disney's aesthetics, see Frank Thomas and Ollie Johnston, *Disney Animation: The Illusion of Life* (New York: Abbeville Press, 1981); Norman M. Klein, *Seven Minutes: The Life and Death of the American Animated Cartoon* (London: Verso, 1993); and Richard Neupert, "Painting a Plausible World: Disney's Color Prototypes," in *Disney Discourse: Producing the Magic Kingdom*, ed. Eric Smoodin (New York: Routledge, 1994), 106–117.

11. Thorson participated in at least seven of these story conferences. His first recorded attendance was at an undated story conference in October 1935. His last story conference was on April 21, 1936. For more information, see story conference records at the Disney Archives in Burbank, California. I am grateful to David R. Smith for his assistance there.

12. For an account of the process of selecting a design for Bugs Bunny, see John Province, "Termite Terrace Tenancy: Virgil Ross Remembers," *Animato!* 19 (winter 1990): 17.

13. The term "left-handed plumber" is from Paul Hollister, "Genius at Work: Walt Disney," *Atlantic Monthly*, December 1940, p. 695. Reprinted in *Disney Discourse*, ed. Smoodin, 23–41.

14. Previously, Jones and Dalton were animators; Hardaway, a writer and gag man.

15. Like cels and storyboards from the period, model sheets were also discarded; the remaining ones are in the hands of former employees and collectors dispersed around the globe. Thorson himself, concerned ever since his days at Disney that he was not getting credit for his work, kept many preliminary sketches and photostats of his art. But because he moved around so much and lost things in transit, even Thorson's own collection is incomplete. What is left is in the hands of his son, Dr. Stephen Thorson. The elder Thorson's model sheets are easily identifiable by his precise drawing style, and his printed instructions are even more revealing. Charlie usually makes very distinctive curves on the second leg of his *h*, *m*, and *n*. His *v*, *w*, and *y* also have a curving leg, and his *t* (occasionally his *e* and *f*) has a curved-up topline. Other telltale features are his *r* (with its angled leg penetrating its top loop), his *s* (with its larger top than bottom), and *c* (which continues its counterclockwise swirl almost into a *g*).

16. Mike Barrier and Bill Spicer, "An Interview with Chuck Jones," *Funnyworld* 13 (spring 1971): 9.

17. Leonard Maltin, *Of Mice and Magic: A History of American Animated Cartoons* (New York: New American Library, 1980), 239.

18. Ibid., 240.

19. There is a high probability that he did provide the model sheets, but I have been unable to locate any.

20. Thorson's emphasis on the careful details of physiognomy may have pointed Jones in the direction of what Richard Thompson calls Jones's "eloquent depiction of facial expression," Jones's later inimitable trademark. See Richard Thompson, "Duck Amuck," *Film Comment* (January–February 1975): 39.

21. "I'm reminded of the work you did on Little Hiawatha—the work incidentally which put the storyboard across and really impressed Walt. As I remember, Merril DeMares took most of the bows." Handwritten letter dated March 26, 1950, from Walt Kelly to Charlie Thorson in the personal collection of Dr. Stephen Thorson. In a letter to his brother, Joe, dated April 29, 1937, Charlie had bragged about his work on *Little Hiawatha*: "I designed all the characters in this picture and contributed most of the gags and thoughts on which the story was constructed. In other words, I'm almost entitled to call it my picture." The letter is also in the Joseph Thorson collection, National Archives of Canada.

22. The animals are exact duplicates of the ones that appeared in *Snow White and the Seven Dwarfs*. As I mentioned before, many of the Silly Symphonies from 1934 to 1938 were used as testing grounds for Disney's first feature. So the animals in *Little Hiawatha* were in a sense "auditioning."

23. The character design for Little Hiawatha and the animals—especially one of the baby bunnies, downplays the usual distinctions between people and animals. Close-ups and cross-cutting constantly reinforce the fact that Hiawatha and the bunny think and feel the same.

24. Hugh Kenner, *Chuck Jones: A Flurry of Drawings* (Berkeley: University of California Press, 1994), 32.

25. Ibid.

26. The winning song in the cartoon is credited to Hardaway and Schlesinger.

27. "Pinto" Colvig, the actual voice of Goofy and a longtime friend of Thorson's, supplied all the voices for the film.

28. Thorson may even have had a role in the genesis and writing of the film since he was an inveterate train hopper and hitchhiker all his life, spending most of 1918 as a penniless hobo in the Canadian West. This may also be true of *Busy Bakers* and its main character, Mr. Swenson. Thorson's first wife's father, a tireless jack-of-all-trades, was named Sveinsson, anglicized variously (even by himself) as Swanson or Swenson. As well, among Thorson's personal effects is a series of rough pencil sketches for a story called "Inki and Dinki," about a black African boy and monkey; these undated drawings may have served as the inspiration for an unmade Inki cartoon or, indeed, as the starting point for the entire Inki series.

29. Thorson's collection contains magnificent preliminary sketches of six of the seven Disney dwarfs.

30. The Dalton-Hardaway unit, in existence for barely more than a year, is the least understood unit at Warner Bros. It was disbanded when Freleng returned from MGM; Dalton returned to animating, Hardaway to gag writing. Hardaway quickly joined Thorson at Fleischer Studios and then went on to Walter Lantz Studios.

31. See, for instance, Joe Adamson, *Bugs Bunny: Fifty Years and Only One Grey Hare* (New York: Henry Holt, 1990), 51.

32. Quoted in ibid., 51.

33. In a letter to Edward Seltzer (sic) dated April 29, 1949, Charles Thorson wrote: "Shortly after coming to work for Leon, I was approached by Ted (sic) Pierce, who was then head of your story unit, and I was requested to produce a rabbit similar to one I had previously drawn for my own collection and which he had seen." From the personal collection of Dr. Stephen Thorson along with a reply from Selzer dated "May Third, 1949."

34. That the writing was indeed Thorson's can be verified by all of the misplaced and absent apostrophes in a lifetime of letter writing.

35. See, respectively, the filmography for Warner Bros. in Maltin's *Of Mice and Magic*, 49, or Jerry Beck and Will Friedwald, *Looney Tunes and Merrie Melodies: A Complete Illustrated Guide to the Warner Bros. Cartoons* (New York: Henry Holt, 1989), 388.

36. Thorson letter to Seltzer (sic), April 29, 1949.

37. What the two model sheets have in common is the distinctive Disney/Thorson baby face. Desmond Morris used the Givens's Bugs as an illustration of baby-faced cartoons on the BBC/TLC Television series *The Human Animal*, program number five. He pointed out that the baby-faced features were "the domed head, large eyes with big pupils, the soft jaw-line, the chubby cheeks, the tiny nose and, above all, the flattened face." While the features do not seem an entirely accurate description of Givens's Bugs, they encapsulate precisely the kinds of creature facial features Thorson perfected.

38. Barrier and Gray, "Bob Clampett," 19.

39. Thorson also did the model sheets for at least one other film by Avery: *Dangerous Dan McFoo* (1939). It is noteworthy for its more modern use of color and for its glamorous female dog character—the Lady known as Lou—who has a voice like Katharine Hepburn. This was one of Thorson's favorite characters. It should also be noted that Avery's famous MGM character Droopy Dog is almost an exact duplicate of a character drawn and named by Thorson: Droopy Drawers, the slow-drawling boxing announcer in Disney's *Toby Tortoise Returns* (1936). A Droopylike character based on the dog that Thorson designed for *Toby Tortoise Returns* appears as one of the construction workers in Freleng's Academy Award–nominated Merrie Melodie *Rhapsody in Rivets* (1941). So Thorson's designs may have circulated throughout the studio.

40. Interestingly, the design for Hiawatha looks like Elmer Fudd, but it is said to be a caricature of Disney artist Ward Kimball. Whether Thorson participated on this cartoon is unknown, but unlikely. Thorson also did the character design for Hardaway and Dalton's *Porky the Giant Killer* (1939). The direction is wrongly attributed to Freleng in Maltin's *Of Mice and Magic*.

41. "Children's Books Lure Bugs Bunny Creator," *Toronto Telegram*, March 29, 1949.

42. Charles Thorson, *Keeko* (Chicago: Wilcox and Follett, 1947). The book reached a seventh printing in 1963. A second book, *Chee-Chee and Keeko*, was released by the same publisher in 1952. Some full-color drawings also exist for two other proposed books, about Ooki the Eskimo and Zookie the Zulu, who looks exactly like Inki. Ill health and a variety of other misfortunes prevented their completion.

43. Thorson letter to Seltzer (sic), April 29, 1949.

From Vaudeville to Hollywood, from Silence to Sound: Warner Bros. Cartoons of the Early Sound Era

1. For instance, in 1930, Disney produced ten Silly Symphonies and nine Mickey Mouses. In 1931, there were ten Silly Symphonies and twelve Mickey Mouses.

2. Warner Bros. made Bosko cartoons from 1930 until late 1933, when Bosko was replaced by Buddy. When they left Warner Bros. in 1933, Harman and Ising took the rights to Bosko with them to MGM, where he died a slow, painful death.

3. Steve Schneider, *That's All Folks!: The Art of Warner Bros. Animation* (New York: Henry Holt, 1988), 39.

4. Leonard Maltin, *Of Mice and Magic: A History of American Animated Cartoons*, revised ed. (New York: New American Library, 1987), 226.

5. Norman M. Klein, *Seven Minutes: The Life and Death of the American Animated Cartoon* (London: Verso, 1993), 29.

6. Early actualities, including both travelogues and the work of early pioneers like the Mélie's brothers, have received scant attention in most film histories and are usually treated as "crude efforts" with little relation to what came after them. This is in part because they do not fit easily into the teleological models adopted by most film histories, which emphasize how each step in film history logically leads to the next step. Similarly, early thirties cartoons fail to fit into cartoon histories, which usually attempt to trace a clear linear development from crude silent efforts toward the

"perfected art" of Disney and later Warner Bros. efforts. The musical cartoons of the early thirties can seem to many cartoon historians like an unfortunate sidetrack in this genealogy.

7. Henry Jenkins, *What Made Pistachio Nuts? Early Sound Comedy and the Vaudeville Aesthetic* (New York: Columbia University Press, 1992), 162.

8. For an analysis of sound conventions in early Warner Bros. cartoons, see Scott Curtis, "The Sound of Early Warner Bros. Cartoons," in *Sound Theory, Sound Practice*, ed. Rick Altman (New York: Routledge, 1992), 201–202.

9. Klein, *Seven Minutes*, 68–74.

10. Freleng was known to have been an unofficial "third partner" in the Harman-Ising equation. Among the early sound cartoons discussed in this essay alone, Freleng received screen credit as either the top animator or else the sole animator on *Sinkin' in the Bathtub* (1930), *One More Time* (1931), *You Don't Know What You're Doin'* (1931), *Goopy Geer* (1932), *The Queen Was in the Parlor* (1932), *One Step Ahead of My Shadow* (1933), *We're in the Money* (1933), and *Shuffle Off to Buffalo* (1933). Freleng was also a key contributor to Harman and Ising's Bosko the Talk-Ink Kid test reel and was widely acknowledged to have "ghost-directed" *Shuffle Off to Buffalo* under the Harman-Ising aegis.

11. Among the many Warner Bros. cartoons from the studio's Golden Age that allude to vaudeville traditions as an explicit thematic or structural reference point are Tex Avery's *Hamateur Night* (1939); Chuck Jones's *Case of the Missing Hare* (1942) and *One Froggy Evening* (1955); Robert McKimson's *What's Up, Doc?* (1950); and Friz Freleng's *Dog Daze* (1937), *Yankee Doodle Daffy* (1943), *Stage Door Cartoon* (1944), *The Gay Anties* (1947), *Back Alley Oproar* (1948), *Curtain Razor* (1949), *High Diving Hare* (1949), and *Show Biz Bugs* (1957).

12. Klein, *Seven Minutes*, 19, 22.

13. Lightning sketch artists were entertainers, often in vaudeville shows, who showcased their gift for rapidly making comical drawings. Monologists gave extended lectures, often accompanied by slides.

14. Klein, *Seven Minutes*, 23.

15. Ibid., 29.

16. Jenkins, *What Made Pistachio Nuts?* 78.

17. For more on the international Felix the Cat craze, see John Canemaker, *Felix: The Twisted Tale of the World's Most Famous Cat* (New York: Pantheon, 1991). See also Linda Simensky's essay in this anthology for a history of character merchandising in the United States.

18. Schneider, *That's All Folks!* 34.

19. Quoted in Maltin, *Of Mice and Magic*, 228.

20. See Douglas Gilbert, *American Vaudeville: Its Life and Times* (New York: Whittlesey, 1940), and Eddie Cantor and David Freedman, *My Life Is in Your Hands* (New York: Blue Ribbon, 1932).

21. Audience member Norman Steinberg, quoted in Robert W. Snyder, *The Voice of the City: Vaudeville and Popular Culture in New York* (New York: Oxford University Press, 1989), 120.

22. In fact, much of the music in these cartoons would not fit under our understanding of jazz, sounding more like precursors of big band swing. However, the term "jazz" clearly covered a larger terrain in the thirties.

23. See Jenkins, *What Made Pistachio Nuts?* 68, and Gilbert, *American Vaudeville*, 251–292.

24. Jenkins, *What Made Pistachio Nuts?* 68–69, 92–94.

25. Rick Altman, *The American Film Musical* (Bloomington: Indiana University Press, 1987), 204–205, 207.

26. See Gilbert, *American Vaudeville*. On the training of film audiences in new etiquette,

see Miriam Hansen, *Babel and Babylon: Spectatorship in American Silent Film* (Cambridge: Harvard University Press, 1991), particularly 23–59.

27. Hansen, *Babel and Babylon*, 25–28.

28. Richard Dyer, "Entertainment and Utopia," in *Genre: The Musical—A Reader*, ed. Rick Altman (New York: Routledge and Kegan Paul, 1981, 1986), 184.

29. Eric Smoodin, *Animating Culture: Hollywood Cartoons from the Sound Era* (New Brunswick, N.J.: Rutgers University Press, 1993), 45.

30. For a sense of the variety of activities at the theater in the twenties, see Richard Koszarski, *An Evening's Entertainment: The Age of the Silent Feature Picture, 1915–1928* (New York: Scribner, 1990), 34–61, 163–190.

31. See Claudia Gorbman, *Unheard Melodies: Narrative Film Music* (Bloomington: Indiana University Press, 1987), 42.

32. Sigmund Freud, "The Uncanny," *The Standard Edition of the Complete Psychological Works of Sigmund Freud*, trans. James Strachey, vol.17 (London: Hogarth Press, 1955), 226.

33. Peter Wollen, "Cinema/Americanism/the Robot," in *Modernity and Mass Culture*, ed. James Naremore and Patrick Brantlinger (Bloomington: Indiana University Press, 1991), 49.

34. Quoted in ibid., 48.

35. Ibid., 47.

36. Cecilia Tichi, *Shifting Gears: Technology, Literature, Culture in Modernist America* (Chapel Hill: University of North Carolina Press, 1987).

37. Michael Wassenaar, "Strong to the Finich: Machines, Metaphor, and Popeye the Sailor" *Velvet Light Trap* 24 (fall 1989): 21, 25 (his emphasis).

38. Ibid., 30.

39. Quoted in Miriam Hansen, "Of Mice and Ducks: Benjamin and Adorno on Disney," *South Atlantic Quarterly* 92 (winter 1993): 31.

40. Quoted in ibid., 42.

41. Ibid.

42. Donald Crafton, *Before Mickey: The Animated Film, 1898–1928* (Cambridge: MIT Press, 1982), 11.

43. James Lastra pointed out this anthropomorphizing to me.

The Image of the Hillbilly in Warner Bros. Cartoons of the Thirties

1. The quote is from Edward Campbell, "Plantation Film," in *Encyclopedia of Southern Culture*, ed. Charles Wilson and William Ferris (Chapel Hill: University of North Carolina Press, 1989), 922.

2. *New York Journal*, April 23, 1900.

3. J. W. Williamson, *Hillbillyland: What the Movies Did to the Mountains and What the Mountains Did to the Movies* (Chapel Hill: University of North Carolina Press, 1995), 38–39. Williamson's substantive work suggested the idea for this essay by identifying the thirties Warner Bros. cartoons discussed herein. See also Williamson's *Southern Mountaineers in Silent Film: Plot Synopses of Movies about Moonshining, Feuding, and Other Mountain Topics* (Jefferson, N.C.: McFarland, 1994).

4. Paul Webb was born in 1902 in Towanda, Pennsylvania, and studied at the Academy of Fine Arts in Philadelphia. His *Esquire* cartoons were syndicated nationally to newspapers, and *Comin' around the Mountain*, the Abbott and Costello film of 1951, is loosely based on his book of the same title.

5. Williamson, *Hillbillyland*, 41.

6. Gary Best, *The Nickel and Dime Decade: American Popular Culture during the 1930s* (Westport, Conn.: Praeger, 1993), x.

7. Ibid., xii.

8. Walter Lantz's *Hill Billys* (1935), an earlier use of the hillbilly stereotype in a Hollywood cartoon, is not dealt with here because it would dilute the focus on a single studio, and it is difficult to locate.

9. Wade Austin, "The Real Beverly Hillbillies," *Southern Quarterly* 19 (spring–summer 1981): 83–94. See also Linnell Gentry, *A History and Encyclopedia of Country, Western, and Gospel Music* (Nashville: McQuiddy Press, 1961), 171–175. In addition, see Williamson, *Hillbillyland*, 48–49. Other Warner Bros. cartoons also feature mountain music, notably Rudolph Ising's *I Like Mountain Music* (1933), in which celebrity caricatures on magazine covers come to life to sing the film's title song.

10. Gilbert Seldes, "American Humor," in *America as Americans See It*, ed. Fred J. Ringel (New York: Harcourt Brace, 1932), 350.

11. Williamson, *Hillbillyland*, 42.

12. Ibid., 20.

13. For example, the fights between the Hatfields and McCoys, the most famous feuding families in the United States, were largely separated by the Tug Fork of the Big Sandy River, the boundary line between Kentucky and West Virginia.

14. One historical note: The difficulty the cartoon sheriff faces by taking sides in mountain feuds has its basis in fact. Local authorities often moved cautiously between feuding families because they were caught in the middle, trying to enforce the law, and felt threatened and frequently outgunned by the feudists. See John Ed Pearce, *Days of Darkness: The Feuds of Eastern Kentucky* (Louisville: University of Kentucky Press, 1994).

15. *The Hurricane* (1937) was a United Artists release of a Sam Goldwyn production, and though it featured no box office heavies, it reportedly cost $1.75 million to make, including a $300,000 hurricane sequence.

16. According to Will Friedwald and Jerry Beck: "It is generally acknowledged today that the Sons of the Pioneers, featuring Bob Nolan and Roy Rogers, provide the country singing in this cartoon, which leads one to suspect that they might have also provided the hillbilly harmony in *Egghead Rides Again* (1937), *Naughty Neighbors* (1938), and possibly others." *The Warner Brothers Cartoons* (Metuchen, N.J.: Scarecrow Press, 1981), 55.

17. Arkansas became a member of the Confederacy on May 6, 1860, and so the Ozark mountain hillbilly, a common variety, is also a southerner. Oddly enough, most Arkansas mountain people favored remaining in the Union.

18. Given that the film is in black and white, the depiction of the warring clans throughout as groups of black barnyard animals versus white barnyard animals being crooned into cooperation adds racial overtones to the film, which may be more apparent to postwar audiences.

19. Porky's first appearance was Freleng's *I Haven't Got a Hat* (1935); Petunia was introduced in Frank Tashlin's *Porky's Romance* (1937).

20. Neither the male or female mouse in *Plane Crazy* was named when the film was released; however, subsequent Disney publications identify the early female mouse as Minnie. See, for example, *Walt Disney Magic Moments*, a collaboration by Ercole Arseni, Leone Bosi, and Massimo Marconi (Milan: Arnoldo Mondadori, 1973).

21. Norman Polmar and Thomas B. Allen, "Non Aggression Pact," in *World War II: America at War, 1941–1945* (New York: Random House, 1991), 584.

22. Pearce, *Days of Darkness*, 1.

23. Ibid., 8.

24. Karl Cohen, "Racism and Resistance: Black Stereotypes in Animation," *Animation Journal* 4 (spring 1996): 47. Cohen notes that racial stereotypes ended at Lantz in 1943, at Disney in 1946, at MGM in 1953, at Terrytoons in 1954, and Paramount/ Famous Studios in 1958.

25. Terry Cooney asserts that "after mid-decade, one attitude did become relatively fixed [in the movies]—a positive and increasingly emotional support for the idea of effective government and democracy." In *Balancing Acts: American Thought and Culture in the 1930s* (New York: Twayne, 1995), 8.

The View from Termite Terrace:
Caricature and Parody in Warner Bros. Animation

For their support and encouragement I thank John Canemaker, Norman Klein, Dan MacLaughlin, Charles Musser, Susan Ohmer, and Alissa Simon. I gratefully acknowledge the enthusiasm and generosity of Richard May. Thanks also to Mike Barrier for his comments and additions to the original draft.

1. Carl Stalling's score reinforces the identification; it slips into the "Merrie Melodies" theme for a few bars during Schlesinger's appearance.
2. Steve Schneider, *That's All Folks!: The Art of Warner Bros. Animation* (New York: Henry Holt, 1988), 39.
3. For example, Mr. and Mrs. Schlesinger and sixty guests celebrated their thirtieth anniversary at the Trocadero. "The thirtieth being Pearl, the entire service was in keeping. Abalone shells were used for place cards, upon which were attached pearl necklaces for the women and pearl cuff-links for the men." (*The Exposure Sheet*, June 9, 1939, p. 2.)
4. The word "cariature" originated in the seventeenth century from Italian and French terms meaning "to overload" or "charge," as in "to charge a weapon."
5. According to Martha Goldman Sigall, the original Harman and Ising studio was on Hollywood Boulevard above a drugstore. The original Termite Terrace bungalow was on Sunset near Bronson (*Film Daily*, April 1, 1928; July 29, 1928). The new 1933 studio—which was not much of an improvement over the old one, Sigall says—was on Van Ness at Fernwood. The old Termite Terrace continued to be leased by Schlesinger and was used as storage for props and materials. The new studio was divided between two buildings: a smaller one near the original building (some sources say it *was* the same building) where Ray Katz (Schlesinger's brother-in-law) supervised Looney Tunes production, and a larger one where the Merrie Melodies animators were supervised by Henry Binder. According to Friedwald and Beck, this division of labor had been discontinued by 1943. The larger building also housed Schlesinger's plush front office, while the studio portion was "kind of a warehouse." The staff personalized their work spaces with partitions, funny decorations, and conversation pieces—like the chicken foot Michael Maltese nailed to his desk.
6. Chuck Jones, *Chuck Amuck: The Life and Times of an Animated Cartoonist* (New York: Avon, 1989), 272.
7. For a good example of lens reflection, see *Little Beau Porky* (1936). The reuse of cels was a major cost-cutting strategy. According to Sigall, water-based Grumbacher tempera was used for the painting so it could be washed off after photography. A cel was marked each time it was used. After six times it became a blank "slip cel," used to interleave the newer painted cels so the paint would not stick or chip. The studio was not air-conditioned, so sticking was a serious problem in the summer.
8. A good example is *Bacall to Arms* (1946) which reedits several scenes from *She Was an Acrobat's Daughter* (1937).
9. See Will Friedwald and Jerry Beck, *The Warner Brothers Cartoons* (Metuchen, N.J.: Scarecrow Press, 1981) for a complete survey.
10. The model sheet is reproduced in Schneider, *That's All Folks!* 53.
11. Quoted in Jerry Beck and Will Friedwald, *Looney Tunes and Merrie Melodies: A Complete Illustrated Guide to the Warner Bros. Cartoons* (New York: Henry Holt, 1989), 46.

12. See Charles Solomon, "Animation Goes to War," in *Enchanted Drawings: The History of Animation* (New York: Knopf, 1989), 112–123; also Michael S. Shull and David E. Wilt, *Doing Their Bit: Wartime Animated Short Films, 1939–1945* (Jefferson, N.C.: McFarland, 1987).

13. Thanks to Ben Shenkman for his telephone interviews, February 17 and 18, 1993.

14. *The Exposure Sheet*, March 3, 1939, p. 1. Freleng "has signed a five-year contract and will direct Merrie Melodies. Bugs Hardaway will be head of the story department, and Cal Dalton will return to his first love—animation."

15. Ibid., March 4, 1940, p. 1.

16. Ibid., August 11, 1939, p. 4.

17. Jim Heimann, *Out with the Stars: Hollywood Nightlife in the Golden Era* (New York: Abbeville Press, 1985), 183–185.

18. Richard deCordova, *Picture Personalities: The Emergence of the Star System in America* (Urbana: University of Illinois Press, 1990).

19. *The Exposure Sheet*, which grew from six to fourteen pages, was published twice a month from January 6, 1939, to November 27, 1940. I am grateful to Martha Goldman Sigall for depositing a copy of her run of the newsletter at the Wisconsin Center for Film and Theater Research.

 Authorized by Binder, and paid for by Schlesinger, the newsletter was by no means an independent voice for the staff. It was primarily a social communication, reporting on group activities, marriages, baby showers, and, especially, the studio sporting events. There were also poems, jokes, romantic gossip, and "overheard in the hall" type features. The "Background" column contained valuable biographical sketches of the staff—from directors to office boys. Despite editor Dave Mitchell's requests for "uncensored" news, views, and cartoons, only the most benign criticism of the studio entered the columns. Nevertheless, it is the best timely source, aside from oral histories, of the day-to-day operation of the studio during an important period.

 According to Sigall, it was discontinued when Jack Warner discovered that it was being mimeographed on equipment in a Warner Bros. office. However, the escalation of union activities preceding the 1941 strike and lockout must have been another factor. The newsletter is an excellent example of the benevolent paternalism that typified the preunion administration of both the Schlesinger and Disney studios; the articles fostered an impression of a charitable management that hosted Christmas parties, tolerated goofing-off, bowled with the employees, etc.—creating the illusion of a big happy (nonunion) "family."

20. Anonymous, "The Typical Schlesinger Employee," *The Exposure Sheet*, January 20, 1939.

21. Heimann, *Out with the Stars*, 176–179, includes several photographs of the club.

22. Schneider, *That's All Folks!* 32. Schlesinger's top animation supervisor was Freleng, who, in 1937, was making $250 per week. He was hired by MGM for $375 per week. (Schneider, *That's All Folks!* 65.)

23. I am grateful to Martha Goldman Sigall for her telephone interview, June 25, 1992, and for many other kindnesses. She grew up behind Schlesinger's Pacific Art and Title studio and, as a little girl, ran errands for the title artists. The women airbrushed title cards, did some limited advertising animation, and sometimes let Martha do a little fill-in painting. Schlesinger learned that the fourteen-year-old girl was hanging about the studio and told her to "study art, and when you need a job, I'll give you one." Out of high school, in 1936, Goldman reported back to Schlesinger, who remembered her and hired her at $12.75 per week. This was just after the move from Termite Terrace and just before Mel Blanc was hired. Goldman worked in Ink and Paint for seven years, then moved to Graphic Films, just before the sale to Warner Bros.

24. Anonymous, "Ode to a Loan Company, or Lament of a Story Man," *The Exposure Sheet*, January 20, 1939, p. 3.

25. Ibid., January 20, 1939, p. 4.
26. Ibid., March 31, 1939, p. 1.
27. John McGrew was president of the Camera Club, which had fifteen members (ibid., May 26, 1939, p. 1). Bob Holdeman chaired the art exhibition committee (ibid., March 4, 1940, p. 1). One gathers from comments that the show was not well attended by the employees.
28. Ibid., June 6, 1939, p. 5. The question mark was in the original extract.
29. Ibid., June 23, 1939, p. 5.
30. Ibid., January 20, 1939, p. 2.
31. Dave Mitchell, "The Queen Can Do No Wrong," ibid., May 26, 1939, p. 2.
32. Schneider, *That's All Folks!* 39.
33. *The Exposure Sheet*, February 12, 1940, p. 1.
34. Jeff Lenburg, *The Encyclopedia of Animated Cartoons* (New York: Facts on File, 1991), 449–450. *Tweetie Pie* (1947) was Warner Bros.' first Academy Award winner.
35. Ernst Kris, *Psychoanalytic Explorations in Art* (New York: International Universities Press, 1952), 175, 183.
36. Ibid., 203.
37. Richard Terdiman, *Discourse/Counter-Discourse: The Theory and Practice of Symbolic Resistance in Nineteenth-Century France* (Ithaca, N.Y.: Cornell University Press, 1985), 66.
38. Schneider, *That's All Folks!* 89.
39. Mike Maltese, "Cel Silly," *The Exposure Sheet*, September 15, 1939, p. 4. Original spelling and punctuation.

Darker Shades of Animation: African-American Images in the Warner Bros. Cartoon

1. Ed Guerrero, *Framing Blackness: The African American Image in Film* (Philadelphia: Temple University Press, 1993), 190.
2. Peter Noble, *The Negro in Films* (London: Knapp, Drewett and Sons, 1937), 230.
3. Irene Kotlarz, "The Birth of a Notion," *Screen* 24 (March–April 1983): 21.
4. Jan Nederveen Pieterse, *White on Black* (New Haven: Yale University Press, 1990), 50.
5. Cornel West, *Race Matters* (Boston: Beacon Press, 1993), 3.
6. John Lawing, interview with author Terry Lindvall, December 1993.
7. Karl Cohen, "Racism and Resistance: Black Stereotypes in Animation," *Animation Journal* 4 (spring 1996): 48.
8. Quoted in Will Friedwald and Jerry Beck, *The Warner Brothers Cartoons* (Metuchen, N.J.: Scarecrow Press, 1981), x.
9. Donald Bogle, *Toms, Coons, Mulattoes, Mammies, & Bucks: An Interpretive History of Blacks in American Films* (New York: Continuum, 1973), 55.
10. Leonard Maltin, *Of Mice and Magic: A History of American Animated Cartoons* (New York: New American Library, 1980).
11. Friedwald and Beck, *The Warner Brothers Cartoons*, x.
12. Charles Solomon, *Enchanted Drawings: The History of Animation* (New York: Knopf, 1989), 145.
13. For a more detailed discussion of vaudeville's contribution to early sound cartoons, see Hank Sartin's essay in this anthology.
14. L. D. Reddick, "Educational Programs for the Improvement of Race Relations," in *The Black Man on Film: Racial Stereotyping*, ed. Richard A. Maynard (Rochelle Park, N.J.: Hayden, 1974), 16. See also Maynard's introduction, vi, and Noble, *The Negro in Films*, 11–12.
15. E. C. Matthews, *How to Draw Funny Pictures* (Chicago: Drake, 1928), 64.

16. For Elmer, see *Wabbit Twouble* (1941) or *The Unruly Hare* (1945) among others; for Hiawatha, see *Hiawatha's Rabbit Hunt* (1941); for Stepin Fetchit, see *All This and Rabbit Stew* (1941).

17. Clint C. Wilson II and Felix Gutierrez, *Minorities and Media* (Beverly Hills: Sage, 1985), 71.

18. Ethan Mordden, *The Hollywood Studios* (New York: Knopf, 1988), 236.

19. David Bordwell, Janet Staiger, and Kristin Thompson, *The Classical Hollywood Cinema* (New York: Columbia University Press, 1985), 62.

20. Reprinted in Bosley Crowther, "Cleaving the Color Line," in *The Black Man on Film: Racial Stereotyping*, ed. Richard A. Maynard (Rochelle Park, N.J.: Hayden, 1974), 56.

21. Caricatures of real movie personalities were commonly borrowed for shorthand cartoon gags. Certain Warner Bros. artists would poke fun at Clark Gable's overgrown ears, or some other distinctive mark on Edward G. Robinson, Bette Davis, or Humphrey Bogart; other artists, like T. Hee, would find black actors fair game. Cab Calloway and Jimmy Durante shared caricatured honors behind crooning roosters, Frank Sinatra and Bing Crosby ("the Old Groaner"), in Frank Tashlin's *The Swooner Crooner* (1944). Eddie "Rochester" Anderson did his own voice (as did Jack Benny) for a cartoon mouse version of himself in Robert McKimson's *The Mouse That Jack Built* (1959). Gestures, mannerisms, and voice could be easily imitated for comic effect. Even a distasteful joke like an exploding cigar turning Bogart into a black-faced Rochester would be used in Robert Clampett's *Bacall to Arms* (1946). Cartoons mimicked a parallel treatment of blacks in feature films, but here victims could be reduced to a happy, broad scribble. While many regarded these representations as good-natured spoofs in which people were caricatured and not race, one still notes the lack of variety among black models. For the role of these caricatures in self-reflexive cartoons, see Terry Lindvall and Matthew Melton's "Toward a Postmodern Animated Discourse," *Animation Journal* 3 (fall 1994): 44–63.

22. Steve Schneider, *That's All Folks! The Art of Warner Bros. Animation* (New York: Henry Holt, 1988), 34–40. Harman and Ising split with producer Leon Schlesinger in mid-1933 because Schlesinger refused to increase the budget of the cartoons. From 1934 to 1938, Harman and Ising released Bosko at MGM, who there evolved from a monkey-type boy to a human black child. Harman and Ising had limited success at MGM with such cartoons as *Bosko and the Cannibals* (1937), where Bosko was a more superstitious "colored boy" with sepia skin, kinky hair, and realistic little-boy features, like overalls. In addition, he had picked up slang in a lower black English dialect, using what Tom Bertino calls perfect "dem-dese-and-dose" English. See Bertino's "Hugh Harman and Rudolf Ising at Warner Brothers," in *The American Animated Cartoon*, ed. Danny Peary and Gerald Peary (New York: Dutton, 1980), 109. Harman at MGM would also produce his "Black Frog" cartoons.

23. Curiously enough, one of the flagship characters on the Nickelodeon cable channel's Looney Tunes program is this same Bosko, ever smiling and doing a soft shoe number.

24. Schneider, *That's All Folks!* 34.

25. Maltin, *Of Mice and Magic*, 221.

26. Bertino, "Hugh Harman," 106.

27. In a personal interview with BBC documentary filmmaker Andrew Quicke, he recounts a documentary film of the thirties showing the Ubangi practice of slitting and stretching the lips with wooden discs of increasingly larger size. To show the size of the stretched lips, the cameraman had one Ubangi woman insert two large film canisters in her lips. Andrew Quicke, interview with author Terry Lindvall, April 1, 1993.

28. Friedwald and Beck, *The Warner Brothers Cartoons*, 25.

29. They are *Little Lion Hunter* (1939), *Inki and the Lion* (1941), *Inki and the Minah Bird* (1943), *Inki at the Circus* (1947), and *Caveman Inki* (1950).

30. Quoted in Joe Adamson, "Interview with Chuck Jones," in *The American Animated Cartoon*, ed. Peary and Peary, 132.
31. Jones also directed *Angel Puss* (1944), in which a black boy, L'il Sambo, suffers under the mistaken notion that he is being haunted by a dead cat's ghost.
32. Solomon, *Enchanted Drawings*, 146.
33. Chuck Jones, *Chuck Amuck: The Life and Times of an Animated Cartoonist* (New York: Avon, 1989), 101.
34. Friedwald and Beck, *The Warner Brothers Cartoons*, xi.
35. Joe Adamson, *Tex Avery: King of Cartoons* (New York: Da Capo, 1975), 216.
36. The title is also from a 1934 Willie Whopper cartoon, where the polished liar tells a tall tale about how he was almost eaten by cannibals.
37. Adamson, *Tex Avery*, 211.
38. For more specific information on Disney and race, see Thomas St. John, "Walter Elias Disney: The Cartoon as Race Fantasy," *Ball State University Forum* 24, no. 3 (1983): 64–70; David Williams, "Whatever Happened to Sunflower?" *Animator* 28 (October 1991): 13; Alex Wainer, "Reversal of Roles: Subversion and Reaffirmation of Racial Stereotypes in *Dumbo* and *The Jungle Book*," *Sync: The Regent Journal of Film and Video* 1 (fall 1993): 50–57.
39. These films include *Red Hot Riding Hood* (1943), *Swing Shift Cinderella* (1945), *Wild and Wolfy* (1945), *Uncle Tom's Cabaña* (1947), and *Little Rural Riding Hood* (1949).
40. Adamson, *Tex Avery*, 101.
41. For a detailed discussion of rural hillbilly types in Warner Bros. cartoons, please see Michael Frierson's essay in this anthology.
42. Maltin, *Of Mice and Magic*, 246.
43. In-jokes cascade throughout *Coal Black*, such as a tribute to Citizen Kane's rosebud lips and the mean queen disguised as Jimmy Durante.
44. Schneider, *That's All Folks!* 77.
45. Bob Clampett, Jr., letter to author Terry Lindvall, May 3, 1990, p. 2.
46. *Motion Picture Herald*, January 13, 1943.
47. Thomas Cripps, *Making Movies Black* (New York: Oxford University Press, 1993), 197.
48. Clampett, Jr., letter to author Terry Lindvall, 2.
49. Bordwell et al., *The Classical Hollywood Cinema*, 303.
50. Mel Watkins maps out the undercurrents of black American humor in his significant study of the crucial role of the comic spirit in African-American history; see *On The Real Side: Laughing, Lying, and Signifying—the Underground Tradition of African-American Humor that Transformed American Culture, from Slavery to Richard Pryor* (New York: Simon and Schuster, 1994).
51. Barry Keith Grant, "Jungle Nights in Harlem: Jazz, Ideology, and the Animated Cartoon," *Popular Music and Society* 13 (winter 1989): 45–57.
52. Clampett, Jr., letter to author Terry Lindvall, 2.
53. The grotesque portrayal of Italian Benito Mussolini—especially as the fawning toady of Hitler who makes a "silly Axis" of himself in *The Ducktators* (1942)—and the crude, bestial, and psychopathic stereotyping of the Aryan Nazi, point to Warner Bros.' animators as equal-opportunity satirists.
54. Patrick McGilligan, "Robert Clampett," in *The American Animated Cartoon*, ed. Peary and Peary, 156. Clampett, argue Jim Korkis and John Cawley, was even more notorious for trying to outwit the censors by sneaking sex into cartoons. In *Cartoon Confidential* (Westlake, Calif.: Malibu Graphics, 1992), 34.
55. For a negative portrayal of blacks and jazz culture, see the Walter Lantz cartoon *Scrub Me Mama with a Boogie Beat* (1941).
56. See Roland Barthes, *The Pleasure of the Text*, trans. Richard Miller (New York: Hill and Wang, 1975).

57. Leo Salkin, "Working for Walter Lantz in the 30s," in *The Art of the Animated Image*, ed. Charles Solomon (Los Angeles, AFI, 1987), 55. Legendary animator Shamus Culhane also protested the alleged bigotry of animation's ethnic caricatures. "Poking fun at somebody's background was not an attempt to be scornful or to make the person feel inferior, but was a continuation of our derisive feelings about the whole ethnic problem. While these terms (Jewboy, Mick, Wop) will make present-day liberals shudder, in those days it was merely good-natured banter, and nobody dreamed of taking offense. . . . I would not call it xenophobic, because there was no malice involved." Shamus Culhane, *Talking Animals and Other People* (New York: St. Martin's Press, 1986), 41.
58. Michael S. Schull and David E. Wilt, *Doing Their Bit: Wartime American Animated Cartoons, 1939–1945* (Jefferson, N.C.: McFarland, 1987), 41. Schull and Wilt offer a representative list of twenty-six cartoons produced during World War II that dealt with images of blacks. These cartoons ranged from Bugs Bunny doing an Al Jolson imitation (*Any Bonds Today*, 1941) and Eddie "Rochester" Anderson caricatures to vocational images of blacks as maids, nannies, mammies, nurses, or soldiers. The occupational roles for cartoon blacks were limited indeed.
59. Manthia Diawara, *Black American Cinema* (New York: Routledge, 1993), 3.
60. James Snead, "Trimming Uncle Remus's Tales," in *White Screens/Black Images: Hollywood from the Dark Side*, ed. Colin MacCabe and Cornel West (New York: Routledge, 1994), 84.
61. Kotlarz, "The Birth of a Notion," 22.
62. John Lawing, interview with author Terry Lindvall, May 10, 1990.
63. Ibid.
64. Michael Barrier, quoted in *The 50 Greatest Cartoons*, ed. Jerry Beck (Atlanta: Turner, 1994), 103.
65. Solomon, *Enchanted Drawings*, 147.
66. Friedwald and Beck, *The Warner Brothers Cartoons*, xi.

"Ah Love! Zee Grand Illusion!": Pepé le Pew, Narcissism, and Cats in the Casbah

Thanks go to David Kalal, Roy Grundmann, and Kevin Sandler, who offered comments and suggestions.

1. The Pepé Le Pew series: *Odor-able Kitty* (1945), *Scent-imental over You* (1947), *Odor of the Day* (Arthur Davis, 1948), *For Scent-imental Reasons* (1949), *Scent-imental Romeo* (1951), *Little Beau Pepé* (1952), *Wild over You* (1953), *The Cat's Bah* (1954), *Past Perfumance* (1955), *Two Scent's Worth* (1955), *Heaven Scent* (1956), *Touché and Go* (1957), *Really Scent* (Abe Levitow, 1959), *Who Scent You?* (1960), *A Scent of the Matterhorn* (1961), and *Louvre Come Back to Me* (codirector Maurice Noble, 1962). Pepé has cameos in *Fair and Worm-er* (Jones, 1946) and *Dog Pounded* (Freleng, 1954). *Odor of the Day* is atypical in its formula, as Pepé does not romantically pursue anyone. The cartoon features a skunk battling a dog for a warm bed indoors and has no dialogue until the very end. Pepé may have been a standard-issue skunk design that Art Davis chose for this picture.

According to Chuck Jones, Michael Maltese and Tedd Pierce were influential in Pepé's creation. Pierce was the writer on *Odor-able Kitty* and cowrote *Scent-imental over You* with Maltese. See Chuck Jones, *Chuck Amuck: The Life and Times of an Animated Cartoonist* (New York: Avon, 1989), 119–129. *For Scent-imental Reasons* was the only Pepé cartoon to win the Academy Award. The Pepé cartoons are difficult to locate on video, because the only character video collection, *Pepé Le Pew's Skunk Tales*, is on moratorium for the present. Pepé cartoons can also be found on

Longitude & Looneytude (laser disc), and the *Looney Tunes Video Show*, Vols. *2 and 3* (VHS).

2. Jones's use of subtle characterization is most evident in Bugs Bunny's wry asides; see, for example, the "Rabbit Season" trilogy.

3. The trilogy includes *Rabbit Fire* (1951), *Rabbit Seasoning* (1952), and *Duck! Rabbit! Duck!* (1953).

4. Depictions of heterosexual desire had a varied history in the American animated form, with self-conscious sexual narratives notable in the Fleischer brothers' *Betty Boop* (1932–1939) and Tex Avery's *Wolf and the Showgirl* series (1943–1949).

5. The quote is from *Wild over You.*

6. The Pepé le Pew series's simplicity in terms of its structural formula and characterization may be one reason for its short life span; while there are exceptions to the series's restricted formula, these variations are rare and appear mostly in the late fifties, just before the series' demise. Some exceptions to the traditional formula are in the first cartoon, *Odor-able Kitty*, in which Pepé is "unknowingly" attracted to a male cat, and in *Really Scent*, where he is the object of unwelcome desire from Fabrette, a female cat.

7. See Henry Fielding, *Tom Jones* (orig. pub. 1749). The Pepé series shares much with the self-reflexive narrative structures of the eighteenth-century novel as developed by Fielding, Samuel Richardson, et al. As with Fielding, the Pepé series uses direct address, narrative self-reflexivity, satire, and parody in picaresque stories of seduction and sexual conquest—or its failure.

8. See, for example, *Gaslight* (1944) with Ingrid Bergman, *Conquest* (1937) with Greta Garbo, and *The Earrings of Madame de . . .* (1953) with Danielle Darrieux.

9. Some of his most famous work included *The Love Parade* (1929), *Love Me Tonight* (1932), *The Merry Widow* (1934), *Love in the Afternoon* (1957), and *Gigi* (1958). Chevalier's initial connection with animation was a result of his personal friendship with Walt Disney. Disney had persuaded Chevalier to make his last feature film *Monkeys, Go Home!* (1967), with the Disney studio. In 1970, Chevalier came out of retirement at age eighty-two to sing the title song for Disney's *The Aristocats* (1970), as a sign of his respect for the deceased founder. "I would not have done it for anybody else and for any kind of money, except the honor of showing my love and admiration for the one and only Walt." Cited in John Grant, *Encyclopedia of Walt Disney's Animated Characters* (London: Octopus, 1987), 261. *The Aristocats*, like the Pepé le Pew series, uses a similar graphic design and phantasmatic construction of Paris and French culture.

10. See Donald Crafton's essay in this anthology.

11. This animated film-within-a-film is of course a fictive parody of *The Sheik* (1921) and *The Son of the Sheik* (1926), both featuring Rudolph Valentino.

12. See Steve Neale and Frank Krutnik, *Popular Film and Television Comedy* (New York: Routledge, 1990), 26–42.

13. The sophistication of Pepé's character does not compare with that of Bugs Bunny's wisecracks or even Daffy Duck's elaborate failures as a schemer or a parodic hero. For Daffy as schemer, see Jones's "Rabbit Season" trilogy; for Daffy as parodic hero, see *The Scarlet Pumpernickel* (1950), *Drip Along Daffy* (1951), and *Duck Dodgers in the 24th and 1/2 Century* (1953). The absurdity of the Pepé le Pew series's humor is predicated on Pepé's supreme self-confidence.

14. The main exception to the series rule is *Odor-able Kitty*, in which Thomas the cat deliberately paints himself as a skunk in order to obtain food.

15. For example, the often-repeated Golden Rule of Bugs Bunny cartoons is that Bugs must always be provoked or threatened before he humiliates his opponents. See Chuck Jones, *Chuck Amuck*, 211–212.

16. The Evanthian model consists of:

 1. Protasis (exposition)

 2. Epitasis (complication)

 3. Catastrophe (resolution)

Catastasis (a further element of complication) is a Renaissance variant that amplifies the Epitasis. See Neale and Krutnick, *Popular Film and Television Comedy*, 27.

17. Quoted in Greg Ford and Richard Thompson, "Chuck Jones," *Film Comment* 11 (January–February 1975): 35.

18. The first Pepé le Pew cartoon, *Odor-able Kitty*, however, featured a male cat, thus combining implicit miscegenation with homosexuality.

19. The term "mickey mousing" derives from the innovations of the Disney studio in sound technology. It refers specifically to sound that mimics or denotes movement on screen, usually in a 1:1 relationship of movement and musical beat. A typical example is when a character falls down and the musical accompaniment exactly "mimics" the movement on screen (e.g., with a glissando on a harp, or a cymbal crash).

20. The contrast between pursuit and escape is mimicked in the animation: Pepé hops with all four legs simultaneously off the ground, while the cat's movement is much faster, with legs scrabbling to escape.

21. In a privileged aside to the audience, he then tops the gag by slipping off his dog disguise to reveal his skunk "body" underneath, in a further dizzying displacement of gender signifiers.

22. See note 1 above for a list of punning titles.

23. For extended expositions of smell gags, see the opening sequence of *Louvre Come Back to Me*, where Pepé's smell actually *causes* the accident that paints the cat like a skunk. See also the opening sequence from *A Scent of the Matterhorn*, in which a succession of flowers and insects wilt before Pepé's odors.

24. Arthur Davis, an animator, directed this cartoon, which could explain its uniqueness in the Pepé le Pew series.

25. The site of the "rendezvous," the characteristic meeting place for lovers, becomes the rhetorical joke. See Pepé's comment in *For Scent-imental Reasons*: "Zis leetle love bundle . . . now she is seeking for us . . . a trysting place" (an aside to the audience: "touching is it not?"). Note that in *Scent-imental Romeo*, Pepé again invokes the discourse of romantic love, where the hero must fight another to obtain the love of the heroine. With the joke alluding to the romantic traditions of honor and the duel, Pepé promises the man he has mistakenly kissed in the Tunnel of Love, "You shall hear from my second, sir."

26. See, for example, the opening credits in *A Scent of the Matterhorn*.

27. For an understanding of the term "orientalism," see Edward Said, *Orientalism* (New York: Random House, 1978).

28. Ibid., 6.

29. See, for example: *Roman Holiday* (1953), *Mogamgo* (1953), *Gigi* (1958), *It Started In Naples* (1960), *Paris When It Sizzles* (1964). The Hope-Crosby "road" pictures were broad parodies of such romantic comedies set in "exotic" locales.

30. At the end of *Odor-able Kitty*, Pepé (or Henry as he was then known) is hauled away by his wife and kids, even as his French accent is also revealed to be a fraud. His constant spoonerisms and rhetorical tautologies could also lead us to suspect that his whole romantic persona (and even French accent) is a sham. It is this overt staging of the patently "inauthentic" as a caricature of the "authentic" that ineluctably destabilizes traditional currencies of "realism" dominant in live-action cinematic paradigms. The Warner Bros. animated universe celebrates the creation of such a patently "unreal" and parodic space, through its recurrent self-reflexivity.

31. Quoted in Joe Adamson, "Interview with Chuck Jones," in *The American Animated Cartoon*, ed. Danny Peary and Gerald Peary (New York: Dutton, 1980), 130.

32. In this, of course, the Greek myth of Narcissus is relevant. A beautiful youth, Narcissus, falls in love with his own reflection and outrages Aphrodite by preferring his image to the nymph Echo. He is changed into the flower that lives near water, for love of its reflection, and therefore bears his name. In an uncanny visual allusion in *The Cat's Bah*, la Femme Pussée flees Pepé le Pew through the desert. Arriving at an oasis, she stares at her reflection in the pool, only to be startled by its mirror image (pan over reflection to Pepé standing by pool) and the words "Allo, baby." This shot presents an allegorical condensation of the series's psychoanalytic discourses; the mirror image of the self is a central trope of Pepé's desire, for he will always fall in love with his doubled image.

33. Pépé Le Moko in *Algiers* is said to have escaped from France because of his involvement in a duel over a woman. He has been in the Casbah in Algiers for two years, on the run from the French authorities.

34. Sigmund Freud, "Humor" (1927), in *Art and Literature*, vol. 14 of the *Penguin Freud Library*, ed. Albert Dickson, trans. James Strachey (London: Penguin, 1985), 428.

35. Ibid., 429.

36. The quote is from *A Scent of the Matterhorn*.

37. Freud, "Humor," 429.

38. The quote is from *Scent-imental over You*.

39. Jones, *Chuck Amuck*, 264.

40. Freud, "Humor," 432–433.

Gendered Evasion: Bugs Bunny in Drag

I thank Darlene Hantzis, Sharon Russell, Paul Younghouse, and Kirsten Moana Thompson for their assistance with the ideas that inform this essay.

1. The introductions to both anthologies specifically address the question of Disney as monolith. See Eric Smoodin, ed., *Disney Discourse* (New York and London: Routledge, 1994), 17, and Elizabeth Bell, Lynda Haas, and Laura Sells, eds., *From Mouse to Mermaid: The Politics of Film, Gender, and Culture* (Bloomington: Indiana University Press, 1995), 5.

2. Bell, Haas, and Sells, *From Mouse to Mermaid*, 3.

3. Henry A. Giroux, "Memory and Pedagogy in the 'Wonderful World of Disney,'" in ibid., 43–61.

4. Judith Butler, *Bodies That Matter* (New York: Routledge, 1993), 129.

5. Teresa De Lauretis, *Alice Doesn't* (Bloomington: Indiana University Press, 1984), 136.

6. Eve Kosofsky Sedgwick, "Epistemology of the Closet," in *The Lesbian and Gay Studies Reader*, ed. Henry Abelove, Michele Aina Barale, and David M. Halperin (New York: Routledge, 1993), 58.

7. Butler, *Bodies That Matter*, 239.

8. Marjorie Garber, *Vested Interests: Cross-dressing and Cultural Anxiety* (New York: Routledge, 1992), 30.

9. For a more detailed discussion, see John Fiske, *Reading the Popular* (Boston: Unwin Hyman, 1989), 1–12.

10. Judith Butler, *Gender Trouble* (New York: Routledge, 1990), 140.

11. Garber, *Vested Interests*, 16.

12. In my master's thesis (from which this essay is derived), I refer to Bugs Bunny diegetically as a transvestite and extradiegetically as a cross-dresser. However, here, for simplicity's sake, I use only "transvestism" to describe Bugs's performance of "woman." I also acknowledge that the categorization of the terms "transvestite" and "cross-dresser" denies their unstable nature. As a result, I unfortunately reproduce the discursive structure of gendered ideology I seek to destabilize, since "transvestite" and "cross-dresser" presume an "original" sexed identity. However, I find I must

resort to these terms to reveal the illusion of a coherent gender core. Some may view this appropriation as a shortcoming. Yet, I adopt "transvestism" and "cross-dressing" with an understanding that the language that serves the naturalization and normalization of gender is the same language that can simultaneously destabilize gender norms.

13. Butler, *Gender Trouble*, 25.
14. Ibid., 24, 33, 32, 140, 145, 141, 140.
15. Ibid., 136.
16. Adrienne Rich, "Compulsory Heterosexuality and Lesbian Existence," in *The Lesbian and Gay Studies Reader*, ed. Abelove, Barale, and Halperin, 228.
17. Butler, *Gender Trouble*, 112.
18. Ibid., 113.
19. Judith Butler, "Imitation and Gender Insubordination," in *Inside/Out: Lesbian Theories, Gay Themes*, ed. Diana Fuss (New York: Routledge, 1991), 21.
20. Butler, *Gender Trouble*, 31.
21. See Anne Herrmann, "'Passing' Women, Performing Men," in *The Female Body: Figures, Styles, Speculations*, ed. Laurence Goldstein (Ann Arbor: Univsity of Michigan Press, 1991), 178–189.
22. Butler, *Gender Trouble*, 145.
23. Herrmann, "'Passing' Women, Performing Men," 181.
24. Chris Straayer, "The She-man: Postmodern Bi-sexed Performance in Film and Video," *Screen* 31 (summer 1990): 262–280.
25. Ibid., 262.
26. For more on anthropomorphism and schemata, see my "Pogs, Dogs, or Ferrets: Anthropomorphism and 'Animaniacs,'" *Animation Journal* 6 (fall 1997): 44–53.
27. Annette Kuhn, "Sexual Disguise and Cinema," *The Power of the Image* (London: Routledge and Kegan Paul, 1985), 52.
28. Sybil Delgaudio, "Seduced and Reduced: Female Animal Characters in Some Warners' Cartoons," in *The American Animated Film: A Critical Anthology*, ed. Danny Peary and Gerald Peary (New York: Dutton, 1980), 211–216.
29. Molly Haskell, "Woman in Pairs," *Village Voice*, April 28, 1975, p. 77.
30. Delgaudio, "Seduced and Reduced" (211). Daisy Rabbit made her only appearance in *Hare Splitter* (1948).
31. Quoted in Mike Antonucci, "A Super Dilemma," *Detroit Free Press*, March 12, 1993.
32. Quoted in Barbara Halpern Martineau, "Women and Cartoon Animation, or Why Women Don't Make Cartoons, or Do They?" in *The American Animated Film*, ed. Peary and Peary, 284–285.
33. The Pepé le Pew cartoon series, about an amorous skunk who believes he is irresistible to women, was the only series at Warner Bros. after 1940 that was primarily preoccupied with gender difference and sexual pursuit. However, as Kirsten Moana Thompson makes clear in this anthology, the series foregrounded the phantasm of heterosexual romance, which itself is informed by the reiterative power of gender discourse. Audience laughter at Pepé's unwavering delusions of romance, I believe, derives from the same unconscious identification with the protagonist that propels the laughter in the Bugs Bunny temporary transvestite cartoons. As comic disavowals, these cartoons help negotiate what Thompson calls "misreadings and misrecognitions" of desire.
34. Joe Adamson, *Bugs Bunny: Fifty Years and Only One Grey Hare* (New York: Henry Holt, 1990), 21–22.
35. Delgaudio, "Seduced and Reduced," 213.
36. *Bugs Bunny and the Three Bears* (1948) embodies this dichotomy. In this cartoon, Mama Bear is at first an elderly, unattractive figure with sagging breasts and a whiny voice. Bugs Bunny seduces her to prevent Papa Bear from killing him. Mama Bear

so loves the sexual objectification she receives from Bugs Bunny, that she joyfully becomes (i.e., conforms to) what she (i.e., the animators) think Bugs Bunny wants her to be: the happy hooker, the blonde bombshell, the bathtub beauty. These figures are all character types that, at one time or another, Bugs Bunny has performed as a transvestite in other cartoons (Delgaudio, "Seduced and Reduced," 216). However, Mama Bear does not retract her advances after she successfully saves Bugs from harm. She wants him. Bugs, in fact, becomes the object of desire and the site of sexuality, a position he rarely finds himself in.

The narrative, though, disallows Mama Bear an enactment of this role. At the end of the cartoon, Bugs runs off into the distance screaming, as Mama Bear with open, loving arms pops out of his hole. Not only does her "unfeminine" appearance clash with her "sexual" behavior, but her "mother" role conflicts with her "seductress" role. Mama Bear can only occupy one role or the other. The Bugs Bunny cartoons can be seen, then, to support a heterosexual, patriarchal discourse that portrays a "woman's" role in only two ways: either as love object or as asexual subject for masculine-recognized characters like Bugs Bunny.

37. Quoted in Simon Fanshawe, "Wabbit, Wabbit, Wabbit," *Evening Standard* (London, England), October 20, 1994.

38. I choose the word "cross-gendering" in place of "cross-dressing," "transvestite," and "passing" because these terms, though acts of gender performance, still assume the existence of an original gender, sex, and sexuality prior to their performance. Their definition and usage rely on those categories already in cultural circulation. Cross-gendering, on the other hand, recognizes the fluidity and phatasmatic nature of gender *without* an original form. The materiality of human bodies cannot be understood apart from the regulatory norms called gender, sex, and sexuality. As Judith Butler states, "sex" is not just what one has; it is the amalgamation of norms "by which the 'one' becomes viable at all" (*Bodies That Matter*, 2). Additionally, this essay focuses only on comedic forms of male-to-female cross-gendering in Warner Bros. Bugs Bunny cartoons. I make no claim for this essay's application to tragic forms of cross-gendering and female-to-male cross-gendering; however, I am sure many arguments here could apply.

39. I define these terms more closely in my master's thesis through the work on transvestism by Esther Newton, Marjorie Garber, Anne Herrmann, and Robert Stoller. Not surprisingly, theorists disagree about the sexual identity of these actants because their gender is constantly being denaturalized and renaturalized by their performances. Equally unsurprisingly, the anatomical identity of these actants precedes their ability to act in these ways. Yet, Butler's radical point is that women can actually perform, or "do," "woman." If men can "do man," and women can "do woman," the actant can become whatever he or she wants. Without critical acceptance of Butler's notion of the constructed and constructive nature of gender, it is no wonder such confusion and dissension exists over the terminology to describe actants who cross-gender.

40. Chris Straayer, "Redressing the 'Natural'": The Temporary Transvestite Film," *Wide Angle* 14 (January 1992): 36–55; the quote is on 36.

41. Thomas Schatz, *Hollywood Genres* (New York: McGraw-Hill, 1981), 30–31.

42. Garber, *Vested Interests*, 69.

43. Straayer, "Redressing," 44.

44. Corinne Holt Sawyer, "Men in Skirts and Women in Trousers, from Achilles to Victoria Grant: One Explanation of a Comedic Paradox," *Journal of Popular Culture* 21 (fall 1987): 2.

45. Joan Mellen, *Big Bad Wolves* (New York: Pantheon, 1977), 242.

46. Noël Carroll, "Notes on the Sight Gag," in *Comedy/Cinema/Theory*, ed. Andrew S. Horton (Berkeley: University of California Press, 1991), 27.

47. These cartoons are: *The Wabbit Who Came to Supper* (1942), *Bugs Bunny Gets the Boid* (1942), *Bugs Bunny Nips the Nips* (1944), *Hare Ribbin'* (1944), *Stage Door Cartoon* (1944), *Herr Meets Hare* (1945), *The Unruly Hare* (1945), *Hare Trigger* (1945), *Hare Conditioned* (1945), *Hair-Raising Hare* (1946), *Easter Yeggs* (1947), *Haredevil Hare* (1948), *Hare Splitter* (1948), *Hare Do* (1949), *Mississippi Hare* (1949), *Bowery Bugs* (1949), *Long Haired Hare* (1949), *Knights Must Fall* (1949), *The Windblown Hare* (1949), *Frigid Hare* (1949), *Which is Witch?* (1949), *Hillbilly Hare* (1950), *Bushy Hare* (1950), *The Rabbit of Seville* (1950), *Rabbit Fire* (1951), *Water, Water Every Hare* (1952), *Rabbit Seasoning* (1952), *Southern Fried Rabbit* (1953), *Hare Trimmed* (1953), *Robot Rabbit* (1953), *Napoleon Bunny-part* (1956), *Bedevilled Rabbit* (1957), *What's Opera, Doc?* (1957), *Backwoods Bunny* (1959), *Bill of Hare* (1962), *The Unmentionables* (1963), and *Dr. Devil and Mr. Hare* (1964).

 In my master's thesis, I performed a content analysis of the rabbit's gender characteristics, sexuality, and instances of transvestism. I concluded that 37 of the 168 cartoons feature Bugs Bunny as a temporary transvestite after looking at the following seven areas:

 1. The attribution of Bugs Bunny as "he" or any other term with male denotation. Does Bugs Bunny or any other character ever refer to him by any female gender terms?

 2. The purpose of Bugs Bunny's strategic use of cross-gendering as a "woman" in front of Elmer Fudd and other characters. Does he receive pleasure by appearing and behaving like a "woman," or is he trying to disguise himself for the purpose of survival?

 3. Bugs Bunny's sartorial, corporeal, and behavioral appearance when recognized as a "woman" by Elmer Fudd and other characters.

 4. The times when Bugs Bunny kisses a man, either as "himself" or as a "transvestite."

 5. The exposure of Bugs Bunny's transvestite or nontransvestite masquerade by either Elmer Fudd or another character.

 6. The closure of each cartoon. Do the endings resolve the contradictions and confusion embodied by the transvestite?

 7. The number of generic elements shared by Straayer's temporary transvestite genre and the Bugs Bunny temporary transvestite cartoons. Are all eleven elements present in the cartoons I studied? (For these eleven elements, see the following note.)

48. Straayer identifies eleven generic elements in the temporary transvestite film: the narrative necessity for disguise; adoption by a character of the opposite sex's specifically gender-coded costume (and often its accessories, makeup, gestures, behaviors, and attitudes); the simultaneous believability of this disguise to the film's characters and its unbelievability to the film's audience; visual, behavioral, and narrative cues to the character's "real" sex; the transvestite character's sensitization to the plight and pleasures of the opposite sex; references to biological sex differences and the "necessary" cultural separation of the sexes; a progression toward slapstick comedy and increased physicality; heterosexual desire thwarted by the character's disguise; accusations of homosexuality regarding the disguised character; romantic encounters that are mistakenly interpreted as homosexual or heterosexual; an "unmasking" of the transvestite; and finally, heterosexual coupling. See Straayer, "Redressing," 38.

49. Quoted in Kevin Jackson, "The Original Bunny Hilarious," *Independent* (London, England), April 14, 1990.

50. Jerry Beck and Will Friedwald, *Looney Tunes and Merrie Melodies: A Complete Illustrated Guide to the Warner Bros. Cartoons* (New York: Henry Holt, 1989), 117.

51. Mel Blanc and Philip Bashe, *That's Not All Folks!* (New York: Warner, 1988), 91.

52. Straayer, "Redressing," 43.

53. From *Hare to Heir* is the only cartoon in which Yosemite Sam kisses Bugs Bunny. Fault must be ascribed to director Friz Freleng, who not only eschews Bugs's persona after twenty years of "directing" him, but also forsakes the Chuck Jones manifesto, "Bugs must always be provoked." No longer playing the role of the innocent bystander, Bugs Bunny now is the instigator of the confrontation with Yosemite Sam. Representing a company that selected Sam to receive a million pounds if he is a "worthy person of mild temperament," Bugs deliberately makes Sam's life miserable so the company does not have to pay the sum. Sam's temper repeatedly causes deductions to be made to the reward. In a moment of despair, he obsequiously kisses Bugs to prevent the further dwindling of funds. It is important to note that Freleng was not alone during this period in using Bugs Bunny in more atypical roles. Bugs plays a fighter pilot in Gerry Chiniquy's *Dumb Patrol* (1964) and stands in for the Road Runner, who has "sprained a giblet" in Chuck Jones's *Hare-Breadth Hurry* (1963).
54. Straayer, "Redressing," 44.
55. Only in *Hiawatha's Rabbit Hunt* (1941) does the "wacky" kiss appear as the final gag. This cartoon allows Bugs's enemy to have the last laugh. Bugs is the comic victim. However, *Hiawatha's Rabbit Hunt* was produced in the formulative years of Bugs Bunny, creating anomlies in the Bugs Bunny cartoons of the early forties which rarely occurred in the fifties or early sixties when Bugs Bunny's character became more uniform.
56. Butler, *Bodies That Matter*, 235–237.
57. Fanshawe, "Wabbit, Wabbit, Wabbit," 28.
58. Butler, *Bodies That Matter*, 227.
59. Ibid., 126.
60. Quoted in Adamson, *Bugs Bunny*, 8.
61. I thank Darren Abrahams for bringing this point to my attention on a squash court in London.
62. Quoted in Adamson, *Bugs Bunny*, 9.

Selling Bugs Bunny: Warner Bros. and Character Merchandising in the Nineties

I thank the following people for their invaluable assistance in preparing this discussion: Ruth Clampett, Peggy Doody, Mark Newgarden, Liz Gardner, Jerry Beck, Tom Barreca, Cathleen Lampl, Jean MacCurdy, Tom Knott, and Scott Maiko.

1. Jura Koncius, "Getting Reel," *Detroit News*, July 19, 1997.
2. Bill Mikulak, fellow contributor to this anthology, discusses the canonization of animation as an art form in "Mickey Meets Mondrian: Cartoons Enter the Museum of Modern Art," *Cinema Journal* 35 (spring 1997): 56–72.
3. John Canemaker, *Felix: The Twisted Tale of the World's Most Famous Cat* (New York: Pantheon, 1991).
4. John Cawley and Jim Korkis, *The Encyclopedia of Cartoon Superstars* (Las Vegas: Pioneer, 1990).
5. Richard deCordova, "The Mickey in Macy's Window: Childhood, Consumerism, and Disney Animation," in *Disney Discourse*, ed. Eric Smoodin (New York: Routledge, 1994).
6. Bill Bruegman, *Cartoon Friends of the Baby Boom Era* (Akron, Ohio: Cap'n Penny Productions, 1993).
7. Back end distribution is when the creator, producer, writer, or other talent takes part in receiving a percentage of earnings from the ancillary activities of a show.
8. James Twitchell, *Preposterous Violence* (New York: Oxford University Press, 1989), 265.
9. Canemaker, *Felix*, 4.

10. Ibid., 66.
11. Robert Heide and John Gilman, *Disneyana* (New York: Hyperion, 1995).
12. Jerry Beck, interview with author, Los Angeles, California, September 7, 1996.
13. "Warner Bros. Animation: 65 Years of History" [accessed June 24, 1996], available from Internet: <URL: http://pathfinder.com/@@TLVtSAYAuvWCRWF/KidsWB/history.html>.
14. Mark Newgarden, interview with author, Atlanta, Georgia, June 24, 1996.
15. Steve Schneider, *That's All Folks!: The Art of Warner Bros. Animation* (New York: Henry Holt, 1988), 88.
16. "Warner Bros. Worldwide Consumer Products," file (one sheet) faxed by Warner Bros. Consumer Products Press Department to author.
17. A model sheet has visual interpretations of a character drawn from different angles. It is used by animators as a reference for the proper design of the character. When artists deviate from these model sheets, the results are considered to be "off model." That many 1980 licensing artists were using off-model model sheets underscored the indifference Warner Bros. had toward licensing at this time.
18. Richard Corliss, "What's Hot, Doc? Retail!" *Time*, May 9, 1994, pp. 65–66.
19. Hanna-Barbera experimented with two stores in Los Angeles area malls, but they closed shortly after opening.
20. "Time Warner Inc. 1994 Annual Report" [accessed June 24, 1996], available from Internet: <URL: http://pathfinder.com/@@nzS5eAYA8ests@S3/Corp/official word/ar/arfilm.html>.
21. Liz Gardner, "Flagship Warner Bros. Studio Stores Fact Sheet" (Burbank, Calif.: Warner Bros. Worldwide Retail Public Relations, 1993), 1.
22. Beck, interview.
23. Liz Gardner, "Warner Bros. Studio Stores Bring Glamour and Excitement of Entertainment Industry to Consumers Nationwide" (Burbank, Calif.: Warner Bros. Worldwide Retail Public Relations, 1993), 1.
24. Liz Gardner, "Warner Bros. Studio Store Galleries Showcase the Art of Animation and the Whimsical World of Looney Tunes in a Unique Blending of Fine Art and High Style" (Burbank, Calif: Warner Bros. Worldwide Retail Public Relations, 1993), 1.
25. Gardner, "Warner Bros. Studio Stores Fact Sheet," 1.
26. Liz Gardner, "Take a Piece of Hollywood Home: Pay a Visit to Warner Bros. Studio Stores" (Burbank, Calif.: Warner Bros. Worldwide Retail Public Relations, 1993), 2.
27. Gardner, "Warner Bros. Studio Stores Fact Sheet," 2.
28. Brian McCarthy, "The Entertainer," Index (Burbank, Calif.: Warner Bros. Worldwide Retail Public Relations packet, 1996), 51.
29. Cathleen Lampl, telephone interview with author, June 27, 1996.
30. Paul McEvoy, interview with author, Burbank, California, May 2, 1996.
31. Peggy Doody, phone interview with author, June 26, 1996.
32. Ruth Clampett, interview with author, Burbank, California, May 2, 1996.
33. Tom Barreca, phone interview with author, June 20, 1996.
34. Lisa Backman, "Store Wars; Disney and Warner Bros. Battle It Out in the Newly Opened Brandon TownCenter," *Tampa Tribune*, February 19, 1995.
35. Lampl, interview.
36. Kirk Johnson, "What's Up, Bugs? It's Mickey!" *New York Times*, March 15, 1996. The article then proceeds to discuss several prominent New Yorkers in terms of whether they are Warner Bros. or Disney personality types: "New York City's Mayor, Rudolph W. Guiliani, for example is a classic Warner Brothers: high energy, sometimes abrasive, often unpredictable. Former Mayor David N. Dinkins, by contrast, with his deceptively placid demeanor, was Disney all the way."
37. Ibid.
38. Doody, interview.

39. Clampett, interview., May 2, 1996.

40. Lampl, interview.

41. Ibid.

42. Mark Smyka, "The Warner Way," *Kidscreen*, July 1996, p. 56.

43. Johnson, "What's Up, Bugs?"

44. Peter B. Carzasty and Liz Gardner, "Warner Bros. Studios to More Than Double the Size of Its New York City Flagship Store" (Burbank, Calif.: Warner Bros. Consumer Products Public Relations, March 5, 1996), 1.

45. Barreca, interview.

46. Beck, interview.

47. Ted Johnson, "WB's Toon Targets Ride on 'Space' Case," *Variety*, August 26–September 1, 1996, pp. 11–12.

48. Kate Meyers, "Court Jester," *Entertainment Weekly*, November 22, 1996, p. 52.

49. According to the *Hollywood Reporter* [online], *Space Jam*, as of June 16, 1997, grossed $90,384,232 domestically in seventeen weeks and three days.

50. Ruth Clampett, phone interview with author, July 1, 1997.

51. Ted Johnson, "WB's Toon Targets," 11–12.

52. Beck, interview.

53. Mark Newgarden, phone interview with author, September 21, 1996.

54. Tim Stocoak, "Why Classic Warner Bros. Characters Are No Longer Cool (Nor Classic)," *Bea & Eff* (fanzine), summer 1996, pp. 14–15.

55. Ibid.

56. Newgarden, interview.

57. Beck, interview.

58. Newgarden, interview.

59. Beck, interview.

60. Don Lee, "These Characters Mean Business: Disney, Warner Bros. and Sesame Street Retail Stars," *Los Angeles Times*, October 1, 1992.

Fans versus Time Warner: Who Owns Looney Tunes?

1. Scott Hettrick and Jeffrey Daniels, *Hollywood Reporter* [online], November 1, 1995 [cited March 15, 1996], available from LEXIS-NEXIS, Dayton (Ohio). The original *Tiny Toon Adventures* theme song lyrics are "We're tiny, we're toony, we're all a little looney. And in this cartoony we're invading your TV."

The World Wide Web uses hypertext links to allow Internet users to browse from one electronic document to another seamlessly, although the documents may reside thousands of miles from the user and from each other. Web documents may include text, images, sounds, motion pictures, virtual reality landscapes, and embedded software programs. My citations of electronic documents are modified for *Chicago Manual of Style* endnote style from the International Organization for Standardization Draft International Standards 690–2 [online Web page], May 1996 [cited June 25, 1996], available from Internet: <URL: http://www.nlc-bnc.ca/iso/tc46sc9/standard/690–2e.htm>. Citation information regarding the Internet may be obsolete at press time.

2. Karen Heyman, "War on the Web," *NetGuide*, February 1996, excerpted in: KeV Beeley <kev-wifa@faboo.demon.co.uk>, "Little Article about the Warners and Us . . . ," WIFA (Warner Internet Fan Association) [online discussion list posting], June 26, 1996, available from Internet: <subscribe@acmelabs.com>.

3. I have chosen to correct the spelling and grammar of fans' online communication. Because people often use the medium for conversation rather than publication, many give their writing little editorial attention.

4. Usenet—the word is a contraction of "User's Network"—consists of thousands of discussion groups (also called newsgroups) that are named according to a hierarchy

of subject divisions. The groups I monitored were within the overall subject headings of recreation (rec.) and alternative (alt.). When Internet users subscribe to a group, they may read articles posted by other subscribers and post their own articles to the group.

5. To download is to copy an electronic file from a remote computer to one's own computer.

6. Electronic mail discussion lists are like Usenet newsgroups in allowing Internet users to read articles from other subscribers and to post their own articles to the group as a whole. However, articles on e-mail discussion lists are not posted to an electronic bulletin board like newsgroups, but deposited directly into one's electronic mailbox.

7. Ftp (file transfer protocol) directories store computer files, which may be downloaded from one computer to another over the Internet.

8. U.S. Constitution, art. 1, sec. 8, clause 8.

9. Jane M. Gaines, *Contested Culture: The Image, the Voice, and the Law* (Chapel Hill: University of North Carolina Press, 1991), 49–50.

10. Ibid., 211 (Gaines's italics).

11. Camille Bacon-Smith, *Enterprising Women: Television Fandom and the Creation of Popular Myth* (Philadelphia: University of Pennsylvania Press, 1992), 57.

12. Nils Victor Montan, vice president, senior intellectual property counsel, Warner Bros., to Jonathan Woodward, November 8, 1995 [online copy cited June 26, 1996], available from Internet: <URL: http://www.io.com/~woodward/@cme/served.txt>.

13. Dennis L. Wilson to Dennis M. Falk, June 7, 1996, quoted in full in: Dennis M. Falk <quozl@netcom.com>, "Now *I've* Been Served!" WIFA [online discussion list posting], June 10, 1996, available from Internet: <subscribe@acmelabs.com>.

14. Brendan Dunn <bdunn@cco.caltech.edu>, "Re: WB Legal Strikes Again," alt.tv.animaniacs, alt.tv.tiny-toon, alt.tv.tiny-toon.fandom, alt.tv.taz-mania, alt.animation.warner-bros, rec.arts.animation, alt.binaries.pictures.cartoons, alt.binaries.pictures.erotica.cartoons [online Usenet newsgroups posting], February 29, 1996, archived postings available from Internet: <http://www.dejanews.com>.

15. *Miller v. California*, 413 U.S. 15, S.Ct. 2607, 37 L.Ed.2d 419 (1973).

16. The consolidated cases *American Civil Liberties Union v. Janet Reno*, no. 96–963, and *American Library Association v. U.S. Department of Justice*, no. 96–1458.

17. For discussion of the licensing arrangement between AOL and Warner, see Scott Hettrick, "Warner Stays on Course on AOL," *Hollywood Reporter* [online], December 12, 1995 [cited March 15, 1996], available from LEXIS-NEXIS, Dayton (Ohio).

18. Will Bell <wbb@netcom.com>, "ALT.ANIMATION.WARNER-BROS Frequently Asked Questions (Version: 1.0 1995/03/01)" [online text file cited February 28, 1995], available from Internet via anonymous ftp to rtfm.mit.edu:/pub/usenet/animation-warner-faq.

19. Ron O'Dell <keeper@cats.ucsc.edu>, "Animaniacs Mega Lyric File (AMLF)" [online text file], available from Internet: <URL: http://www2.cruzio.com/~keeper/AMLF.html>; Will Bell <wbb@netcom.com>, "Cultural References Guide for Animaniacs (CRGA)" [online text file], available from Internet via anonymous ftp to ftp.netcom.com:/pub/wb/wbb/animaniacs>.

20. Ron O'Dell <keeper@cats.ucsc.edu>, "My Comments on Recent Proposals," WIFA [online discussion list posting], March 21, 1996, available from Internet: <subscribe@acmelabs.com>.

21. Copyright Act of 1976 (1988 ed. and supp. 4), sec. 107.

22. *Detective Comics, Inc. v. Powers*, 465 F.Supp. 843, 201 U.S.P.Q. 99 (1978); *Detective Comics, Inc. v. Crazy Eddie, Inc.*, 205 U.S.P.Q. 1177 (S.D.N.Y. 1979); *Detective Comics, Inc. v. Filmation Assoc.*, 486 F.Supp. 1273 (S.D.N.Y. 1980); *Detective Comics, Inc. v. Board of Trustees*, no. 81C, 2402 (N.D. Ill., filed June 17, 1981).

23. Gaines, *Contested Culture*, 224 (Gaines's italics).

24. Dennis M. Falk <quozl@netcom.com> to Margaret, Netcom online communications system security administrator <nc0022@netcom.com> [electronic mail], June 13, 1996, quoted in full in: Dennis M. Falk <quozl@netcom.com>, "Re: Copyright Infringement Complaint," WIFA [online discussion list posting], June 13, 1996, available from Internet: <subscribe@acmelabs.com>. Falk refers to *Campbell v. Acuff-Rose Music, Inc.*, 510 U.S. 569, 114 S. Ct. 1164 (1994).

25. Dennis M. Falk <quozl@netcom.com> to Margaret, Netcom online communications system security administrator <nc0022@netcom.com> [electronic mail], June 20, 1996, quoted in full in: Dennis M. Falk <quozl@netcom.com>, "Re: Copyright Infringement Complaint," WIFA [online discussion list posting], June 20, 1996, available from Internet: <subscribe@acmelabs.com>.

26. Trademark Act of 1946 ("Lanham Act"), rev. 1994, subsec. 3, sec. 1114.

27. *The Pillsbury Co. v. Milky Way Productions, Inc.*, 215 U.S.P.Q. 124 (N.D. Ga. 1981).

28. *Walt Disney Productions v. The Air Pirates*, 581 F.2d 751 (9th Cir.) 1978. See Maureen Orth, "Lewdy Tunes and Merry Maladies," *Village Voice*, April 6, 1972, pp. 23ff., for coverage of the early stages of the case.

29. Paul L. Montgomery, "Disney Files Suit on Sex-Film Song," *New York Times*, February 1, 1975.

30. Norman M. Klein, *Seven Minutes: The Life and Death of the American Animated Cartoon* (London: Verso, 1993), 249.

31. See Bacon-Smith, *Enterprising Women*; Henry Jenkins, *Textual Poachers: Television Fans and Participatory Culture* (New York: Routledge, 1992). A more recent study, Andrea MacDonald, "Uncertain Utopia: Science Fiction Media Fandom and Computer Mediated Communication," in *Theorizing Fandom: Fans, Subcultures and Identity*, ed. Cheryl Harris and Alison Alexander (Hampton Press, forthcoming), tracks the migration of *Quantum Leap* fans to computers to show that the fans reinforce and expand on the group's internal hierarchies of social power when making the shift.

32. Mark Langer, "Animatophilia, Cultural Production, and Corporate Interests: The Case of 'Ren & Stimpy,'" *Film History* 5 (June 1993): 127. The term "animatophilia" resonates with the terms "furryphilia" and "toonophilia" which fans use, though their usage includes the connotation of sexual attraction to the characters as well.

33. Captain Packrat <captpackrat@sisna.com>, "Captain Packrat's Fur Central" [online Web site], updated June 24, 1996 [cited June 26, 1996], available from Internet: <URL: http://www.sandiego.sisna.com/captpakrat/>.

34. Telzey Amberdon <telzey@qrc.com>, "Greywolf's Furry FAQ" [online Web site], updated June 1, 1994 [cited June 24, 1996], available from Internet: <URL: http://tachyon.qrc.com/~telzey/fuzzball/../misc/furryfaq.htm>.

35. Amberdon, "Greywolf's Furry FAQ." FurryMUCK available from Internet: <URL: telnet://furry.org, port 8888>.

36. Amberdon, "Greywolf's Furry FAQ."

37. Dennis M. Falk <quozl@netcom.com>, "Re: Confessions of a Furry Toonophile," alt.fan.furry, alt.sex.furry, alt.sex.toons, alt.sex.disney, alt.tv.tiny-toon.fandom [online Usenet newsgroups posting], March 24, 1996; Lontra <lontra@netcom.com>, "Re: Confessions of a Furry Toonophile," alt.fan.furry, alt.sex.furry, alt.sex.toons, alt.sex.disney, and alt.tv.tiny-toon.fandom [online Usenet newsgroups posting], March 24, 1996, archived postings available from Internet: <URL: http://www.dejanews.com>. I edited and spliced together this exchange to preserve how the successive postings quote previous postings when responding to them.

38. Karen Tindall <kjtdot@aol.com>, "Presenting the L.A.R.R.Y. [List About Rob's Roles (Yay!)]," alt.tv.animaniacs [online Usenet newsgroup posting], March 10, 1996, archived postings available from Internet: <URL: http://www.dejanews.com>.

39. Jennie Gruber <ozgals@aol.com>, "SONG BREAK!: Helloo Rob!" alt.tv.animaniacs

[online Usenet newsgroup posting], March 12, 1996, archived postings available from Internet: <URL: http://www.dejanews.com>.

40. Michael Russell <mrussell@ix.netcom.com>, "Re: Closed Captioning Bloopers (was Re: Freakazoid theme)," alt.tv.tiny-toon.fandom [online Usenet newsgroup posting], March 14, 1996, archived postings available from Internet: <URL: http://www.dejanews.com>. His posting quotes an earlier posting from Sean Wilkinson <swilkinson@mail.techplus.com>. Wilkinson actually made the comment as a joke after seeing an episode of *Tiny Toon Adventures* starring Fifi; he noticed that "Dakota sobbed" was mistranscribed in the closed caption as "to quote de Sade." The character Russell mentions, Skippy, is a young squirrel who lives with his cantankerous aunt, Slappy Squirrel, in *Animaniacs*."

41. Jenkins, *Textual Poachers*, 221.

42. El Rico, "Barbara Ann and the Electric Carrot" [online computer graphic file name: E-CARROT.GIF], 1995 [cited June 21, 1996].

43. Wakko Warner (pseudonym), "Minerva and Friends," [online computer graphic file name: mnrvasex.gif], [cited June 23, 1996].

44. This point was brought to my attention by Juan F. Lara in an electronic mail message to me on August 6, 1996.

45. Doug Winger, "toonsex2.gif" [online computer graphic file name: toonsex2.gif] 1994 [cited June 23, 1996].

46. Kevin Mickel's <HKUriah@aol.com>, "Buster and Babs: No Relation?" "What's in a Name?" and "And That's a Wrap!" [online text file], 1994 [cited March 22, 1996], available from Internet: <URL: http://home.aol.com/HKUriah>.

47. An example of Mickel's ingenuity comes in the story "What's in a Name?" in which a rabbit appears in Acme Acres calling himself Bug's Bunny. He looks like the early version of Bugs drawn by Bugs Hardaway. He claims that Bugs Bunny is really Texas Rabbit (i.e., Tex Avery's) and merely an imposter. He wins a court case that strips Bugs of his identity. However, Buster and Bugs figure out how to turn the tables on this rabbit in the following excerpt:

> From his vantage point up on the catwalk, Buster shouldered his Acme Strait Jacket Ejecting Bazooka and fired it at Bug's, neatly trapping him in one of its fabric projectiles. Climbing down one of the ropes to the stage, Buster walked over to Bug's and said, "Give it up, you faker. It's over."
>
> "You can't do this to me! I'm Bug's Bunny. I'll sue!"
>
> "I don't think so," said Buster as he took ahold of Bug's ears.
>
> "What are you doing?" demanded Bug's.
>
> "Pulling off your disguise," said Buster, and he gave the ears a hard yank, pulling the entire rabbit face mask off of a very angry looking Daffy Duck.
>
> "Curses," muttered Daffy with disgust, "foiled again. Okay, Buthster, how'd you know?"
>
> "I read it in a book," said Buster.
>
> "Read what?"
>
> "That Friz Freleng once said that Bug's Bunny was, 'just Daffy Duck in a rabbit suit.'"

48. Nefaria <Nefaria@aol.com>, "Buster's Guide to Unconsummated Romance" [online text file cited March 22, 1996], available from Internet: <URL: http://home.aol.com/HKUriah>.

49. Dennis M. Falk <quozl@netcom.com>, "A Night in Babs' Room" [online text file] 1993, 1994 [cited June 21, 1996], available via anonymous ftp to ftp.netcom.com/pub/qu/quozl/TTBS.

50. Lee Toop <leetoop@portal.ca>, "The Blind Date" [online text file], 1995 [cited June 21, 1996], available from Internet via anonymous ftp to ftp.netcom.com/pub/qu/quozl/TTBS.

51. Rex Wheeler <rexw@fuzzy.com>, "Are We on the Right Track?" WIFA [online discussion list posting], March 15, 1996, available from Internet: <subscribe@acmelabs.com>.

52. Ron O'Dell <keeper@cats.ucsc.edu>, "Re: Proposal Votes," WIFA [online discussion list posting], June 11, 1996, available from Internet: <subscribe@acmelabs.com>.

53. Robert A. Jung <rjung@netcom.com>, "Re: Mass Stupidity (Was: Re: FALH Update: NOW IT'S *WAR!!*)," alt.animation.warner-bros, rec.arts.animation, alt.tv.animaniacs, alt.tv.tiny-toon, alt.tv.tiny-toon.fandom, alt.tv.taz-mania [online Usenet newsgroups posting], March 14, 1996, archived postings available from Internet: <URL: http://www.dejanews.com>.

54. Brendan Dunn <bdunn@cco.caltech.edu>, "Possible Plans for the Future," WIFA [online discussion list posting], March 18, 1996, available from Internet: <subscribe@acmelabs.com>.

55. Gaines, *Contested Culture*, 232.

Hybrid Cinema: The Mask, *Masques, and Tex Avery*

1. From an interview with cartoon writer Heck Allen, in Joe Adamson, *Tex Avery: King of Cartoons*, (New York: Da Capo Press, 1975), 149.

2. Press kit, New Line Cinema, *The Mask*. For example, p. 8: "utilizing cartoons antics made popular by Tex Avery and Chuck Jones and applying them to Jim Carrey. . . . Anything you see in these cartoons we will be mimicking. . . . his eyes will bug out, his chin will drop to the floor, his head turn into a wolf and he'll let out a big wolf whistle."

3. Since many readers probably know this film, I decided to summarize it briefly as an endnote: Stanley Ipkiss, a humble schlemiel, is transformed by a mystic mask into a gyrating, explosive, aggressive, sentimental dionysian alter ego. The film is essentially a Jekyll/Hyde story built around Stanley's passion for the woman he loves, and rivalry with the gangster who wants her.

4. Stanley was as "cocky as Bugs Bunny," review in Jody Duncan, "From Zero to Hero," *Cinefex* 60 (1994): 48; "in the cartoon style," in *Variety*, July 28, 1994; "cartoon boldness," in ibid., August 1, 1994; "textbook cartooning," in *Los Angeles Times*, July 23, 1994.

5. Jim Carrey as "biological cartoon of himself," review in *Pulse*, August 1994, p. 78; Carrey "proud to have achieved a personal career goal," in *Los Angeles Times*, July 23, 1994. See also *New York Times*, July 24, 1994: "Jim Carrey is turned into a Tex Avery cartoon."

6. "Screwball noir" is a term I use in *Seven Minutes: The Life and Death of the American Animated Cartoon* (London: Verso, 1993), to indicate the parallels between the chase cartoon (1937–1957) and trends in live-action Hollywood: screwball comedies and film noir. The mordant, hapless ironies of noir and the layered broad humor of screwball comedy combine in the chase cartoon—a formulation unique to animation for the most part, but now reappearing as live action in comic noirs of the eighties and nineties. Examples include *Who Framed Roger Rabbit?*, *Lethal Weapon* (1987), and *The Mask*.

7. Animation cycles are the building blocks for movement and gags in cartoons, the "cycle" of an action—a walk, a jump, a grin—to be mapped out frame by frame. The cycle tends toward the extreme in this movement, which also emphasizes the caricatural extreme necessary for a gag to work: the extreme that exaggerates a walk; or the paranoia in a double take; the extreme in a leer; the hungry or horny overreaction.

8. I conducted a series of interviews with Donna Tracy, 1994–1996.

9. The effects supervisor is the only person on the team who meets regularly with the director.

10. "Element" is another term from *Seven Minutes*. My point is that animation relies on characters, or elements, who "function" in the Proppian sense of the fairy tale, who carry the action along more than perform as dramatic personae.

11. See Donald Crafton's essay in this anthology for further discussion.

12. For example: Carl Louis Gregory, *Motion Picture Photography* (New York: Falk, 1927). Tracing the history of how special effects are handled in industry books is very revealing; that is, they come up after sound, after color, after cinemascope, after early digital techniques.

13. The masque is a theater with dance that incorporatesd the audience into the performance. One example is the masques during the court of James I, in the early seventeenth century, which relied very heavily on special effects. For our purposes here, masque is a form of "animated" entertainment that draws the audience into a theatricalized festival in some way, into a navigated journey through a space, but as a play, a standup, an elaborated direct address, a formalized call-in show, where costuming of some sort is involved. Chat lines, particularly the 3–D kind, have the spirit of masque, a reification of power and community that is very controlled underneath its outward freedoms. Masque is not the same as carnival, which tends to be much more anarchic, more scattered, where the audience actually helps design the script of the story and the space.

14. André Bazin's theories on the dialectic between the cinematic space and the real space where the film is shot, or perceived as real, have framed many debates that essentially obscure the role of animation. With animation, the "real" space is the apparatus that builds, the handmade, the hand operated; or even the space where the tricks are made; it is much more about the chain of production that made the film, and about the "ride" that the audience takes inside the scripted space.

15. Press kit, Industrial Light and Magic, *The Mask*.

16. Ibid.

17. For parallels in the working process of classic animators, besides the interviews by Joe Adamson at UCLA Special Collections, see Chuck Jones, "The Making of *Duck Dodgers*," *Millimeter* (February 1987). This article not only shows how clearly Jones understood the relationship between the viewer and Daffy and Bugs, but also details how he designed a film (art directed in mock cinemascope by Maurice Noble) that became a working model for George Lucas. Also see articles on the visceral response in animation effects, for example, the classic piece by Mike Barrier, "Of Mice, Wabbits, Ducks, and Men: The Hollywood Cartoon," *AFI Report* (summer 1974): "The best cartoons by Jones, Clampett and Avery are exhilarating because they invite a *physical* response" (25). Physical as in a ride movie.

18. I am referring, of course, to Beaudry and Metz here, to the presence of the machine within the experience of cinema and the making of cinema. I also consider Renaissance theatrical machines as apparatus, have used the sixteenth-century term *machina versatilis* (in *Seven Minutes*), but have since developed the problem far beyond that rudimentary reference. My latest theories on *machina versatilis* involve the role of the computer as cybernetic device, and the architectonic program in any "scripted" space, as I call it, as well as the tradition of magic itself—the handmade control of the natural. Thus, apparatus is practically an ontological journey through the European and American fascination with the mechanical in animation (even Benjamin on baroque theater, etc.). No wonder special-effects films make such a fuss of apparatus in their stories. But to reinforce what I say in the main text: apparatus—in animation—is always *also* a self-reference to how production went for the film or play that is shown, to the way power operates in the movie business or the theater.

19. One form of nineteenth-century dramatic narrative is melodrama, where the torque of these capitalist metonyms is given the pathos of a horror tale about salvation. I discuss melodrama in *Seven Minutes*, only briefly. Its fundamental importance in femi-

nist theory, particularly about television, simply would collapse the subject of this essay.

20. Black Horse, publisher of *The Mask*, has since sold a number of its characters for films (*Los Angeles Times*, July 31, 1994, Calendar), much like the licensing of literally dozens of characters since Batman first appeared in 1937.

21. I develop the principle of elemental characters in my opening chapter for *Seven Minutes*, essentially a structuralist model. But let me explain in the terms I use with my animation students: If you were making a special-effects film about Little Red Riding Hood, and the actress came to you asking, "What is my motivation?" how would you respond? The students always answer, "To go to Grandma's house." They are surprised that this is a kind of correct answer for special effects and animation, for Avery's *Red Hot Riding Hood*, and other films.

 Little Red Riding Hood is a cipher, not so much uncoded as missing her dramatic interior, an absence filled by the memories of childhood of the audience, who in turn complete her emotional journey. The audience, therefore, navigates the story, which had better be architecturally superb, use mixed effects that are highly charged and playful, and timed well.

 Then I might show my students the feature *The Company of Wolves* (1984), deal with it step by step, the uneasy mix of drama and folklore; or *Beauty and the Beast* (1946), a more stately, theatrical balance. The folkloric is elemental. It is difficult to merge with the dramatic.

 And, of course, someone always brings up Brecht's notion of epic theater, as similar, but applied to different ends, using the disjunction between drama and the elemental as a distancing effect. Other examples come up, then exercises and story ideas from the students, and so on.

22. Janet Maslin, "Wild Card in a Game of Dirty Tricks," *New York Times*, July 29, 1994.

23. David Denby, "Honey I Blew Up the World," *New York*, August 15, 1994.

24. Jeff Giles, "Star-Driven to the Box Office," *Newsweek*, August 8, 1994.

25. *Bildung*, in German: an enlightening journey that is essentially a story as well; associated with Goethe in particular, also a reminder of the strategies in eighteenth-century theater (and staging) that generated the romanticist novel.

26. Here I am obviously referring to Baudrillard's essays on simulation since 1981, and his book *Forget Baudrillard*. I should add that his emphasis on simulation as a nihilistic debacle that we have to endure cheerfully does not quite square with my research. My sense is that simulation is a highly structured narratized relationship, where fantasies about power and audience are played out, quite literally, as in the animated space, and now in these special-effects films. It also is very much a preindustrial form of navigated space, hardly the exclusive domain of poststructuralism since 1970; nor does Baudrillard ever pretend that it is, of course.

27. Richard Corliss, "Like *The Mask*? Try Tex Avery's Cartoons," *Time*, August 8, 1994, p. 58.

28. Colin Brown, "Cost Effective," *Screen International*, March 1, 1996. See also the interview with Dennis Muren, senior visual-effects supervisor at Industrial Light and Magic, in *Omni*, November 1993; on page 114, he says that with stop-motion animation, once it was digitalized, "you could get your shots without it being too screwy and complicated," more like an assembly line kept inside a single building.

29. Quoted in Laurie Hooper, "Digital Hollywood," *Rolling Stone*, August 11, 1994, p. 75.

List of Contributors

DONALD CRAFTON is chair of the Department of Communication and Theatre at the University of Notre Dame. He has published numerous articles and is the author of *Before Mickey: The Animated Film, 1889–1928* (1982), *Emile Cohl, Caricature, and Film* (1990), and *The Talkies: American Cinema's Transition to Sound, 1926–1931* (1997).

BEN FRASER is an associate professor of communication at Regent University, Virginia Beach, Virginia, and the director of the Center for Faith and Culture.

MICHAEL FRIERSON is an associate professor in Broadcasting/Cinema at the University of North Carolina at Greensboro. He teaches film production, history, and theory, and has produced short clay-animated films for the Children's Television Workshop and Nickelodeon. He is the author of *Clay Animation: American Highlights, 1908 to the Present* (1994), which won the McLaren-Lambart Award from the National Film Board of Canada for the Best Scholarly Book on Animation for 1995.

NORMAN M. KLEIN is a professor at the California Institute of the Arts and teaches at the Art Center College of Design and the School of Cinema-Television at the University of Southern California. He wrote *Seven Minutes: The Life and Death of the American Animated Cartoon* (1993), *The History of Forgetting: Los Angeles and the Erasure of Memory* (1997), and is currently at work on a history of special effects from the Renaissance to the present, entitled *Vatican to Vegas*.

TERRY LINDVALL is a former film professor at Regent University who was demoted

in 1993 to university president. He has published *Surprised by Laughter: C. S. Lewis and the Comic Spirit* (1996) and numerous articles on animation, film, and cultural studies. He is currently writing *The Silents of God: Religion and Silent American Film.*

BILL MIKULAK received his Ph.D. from the Annenberg School of Communication at the University of Pennsylvania, where he completed a dissertation titled "How Cartoons Became Art: Exhibitions and Sales of Animation Art as Communication of Aesthetic Value."

BARRY PUTTERMAN is a freelance film and television critic living in New York City. His book-length critical survey of Warner Bros. cartoons was printed in *Griffithiana*, vol. 16–17 in June 1984. His latest book, *On Television and Comedy*, a collection of essays on comedic forms and genre conventions, was published in 1995.

KEVIN S. SANDLER is a lecturer in the Film and Video Studies Program at the University of Michigan and completing his doctorate on censorship and the American motion picture ratings system at Sheffield Hallam University in Sheffield, England. He won the 1995 Society of Animation Studies Student Essay Contest and has published articles in the *Hitchcock Annual* and *Animation Journal*.

HANK SARTIN earned his Ph.D at the University of Chicago, completing a dissertation on Warner Bros. cartoons and Hollywood. He teaches film at the University of Notre Dame and is also a film reviewer for several publications in Chicago.

LINDA SIMENSKY is vice president of original animation at the Cartoon Network and the president of ASIFA-East, the New York chapter of the International Animated Film Society. She is the founder of the New York chapter of Women in Animation, a member of the editorial board of *Animation Journal*, and a freelance writer for various publications including the Internet-based Animation World News. She has also taught courses on the animation industry at the School of Visual Arts in New York.

KIRSTEN MOANA THOMPSON is a Ph.D candidate in the Cinema Studies Department at New York University. She has taught the history of classical animation at NYU and the New School. She is the coeditor, with Terri Ginsberg, of *Perspectives on German Cinema* (1996). Her teaching and research interests include animation, cultural studies, and the genres of horror and melodrama.

GENE WALZ is the author of many articles on animation and on Canadian film. He is currently completing a book on Charlie Thorson and editing an anthology of essays on Great Canadian Films. Past president of the Film Studies Association of Canada, he is an associate professor of film and Provost of University College at the University of Manitoba, Winnipeg, Canada.

TIMOTHY R. WHITE received his B.A. from Oakland University and his M.A. and Ph.D. from the University of Wisconsin-Madison. He is presently a senior lecturer of film studies in the Department of English Language and Literature at the National University of Singapore. He has published in *Film History, Cinema Journal, Kinema, Topics in English Language and Literature, Asian Cinema,* and *Film Criticism,* from which his essay in this collection is reprinted. He also wrote chapters in Tino Balio's *Hollywood in the Age of Television* (1990) and John Lent's *Issues in Asian Cartooning* (forthcoming). His main areas of research are animation and Southeast Asian cinema.

Index

Page numbers in italics refer to illustrations.

Abner Countrymouse, 53–54
Adamson, Joe, 44, 45, 128, 129, 161
L'Age d'Or, 45
Ain't She Tweet, 35
Aladdin, 205
Alaskey, Joe, 22
Algiers, 138, 149
Ali Baba Bunny, 34, 171
Alice Cans the Cannibals, 72
Allen, Heck, 45
All This and Rabbit Stew, 1, 128
"already said," 5, 9
Altman, Rick, 73–75, 77
Amazing Panda Adventure, The, 21
Amos 'n' Andy, 73, 104, 123
Animaniacs, 13, 20, 176, 186, 191, 194,
 197, 200, 202–206
Another Froggy Evening, 13, 179, 224n70
anthropomorphism: of animated charac-
 ters, 160–161; of Bosko, 30; in
 caricature, 105; in descriptions of
 sound, 84–85; in early Looney Tunes,
 80; as gender imitation, 159–161, 171;
 of Internet "furries," 201; in Pepé
 series, 151; in Silly Symphonies, 52–
 54, 230n23
Any Bonds Today? 3, 240n58
Aristocats, The, 241n9

audiences, 5, 14, 78–79, 171, 215; and
 character merchandising, 174, 180,
 185–186; diegetic and extradiegetic,
 73–77, 162, 165, 169–170
auteurism, 43–46, 66, 83
Avery, Fred "Tex," 6, 14, 33, 39, 47, 64,
 144, 202; as auteur, 45; compared to
 Buñuel, 45; A Feud There Was, 92–95;
 influence on The Mask, 209–211, 215,
 253n2; influence on Tashlin, 45; move
 to MGM, 32; racism in cartoons of,
 129; Warner Bros. tenure of, 31–32; on
 timing, 211

Babs Bunny, 202–206
Baby Bottleneck, 33
Baby Buggy Bunny, 14
Bacall to Arms, 78, 107, 238n21
Backwoods Bunny, 88, 99, 165, 169–170
Bad Bugs Bunny Show, The, 1, 2, 12
Bad Bugs Bunny Show 2, The, 1, 11
Bad Luck Blackie, 125
Bambi, 47
Barbera, Joe, 35. See also Hanna-Barbera
Barrier, Mike, 134, 226n36
Barthes, Roland, 133–134
Baseball Bugs, 34, 161
Batman, 179, 180; as cultural memory, 5–
 6; as icon, 5–6; merchandising of, 5, 12
Batman (1989), 5, 21, 180

Batman: The Animated Series, 176, 191
Beanstalk Bunny, 34
Beany and Cecil, 34
Beau Geste, 151
Beavis and Butthead, 20
Beck, Jerry, 123, 126, 128, 136, 166, 187, 189, 190
Bedevilled Rabbit, 168
Beetlejuice, 12
Bell, Elizabeth, 4, 6, 154
Benjamin, Walter, 82–83
Benny, Jack, 108–109, 238n21
Bertino, Tom, 126
Betty Boop, 60, 210
Big Snooze, The, 16, 34, 114–115, 118
Big Top Bunny, 166
Billboard Frolics, 30, 105
Binder, Henry, 101, *102*, 112, 113
Bingo Crosbyana, 106
Birdcage, The, 163
Birds Anonymous, 35
Birth of a Nation, The, 86, 134
Birth of a Notion, The, 107
Blanc, Mel, 32, 65, 97, 103, 176, 189
Blooper Bunny, 17–22
body: of animated hillbilly, 87, 92; of Bosko, 72, 125; of Bugs Bunny, 61–63, 116; as gender signifier, 158–159; of Inki and Hiawatha, 57–58; recognizable gender traits of, 160–161; typology of early cartoon characters, 71
Bogle, Donald, 123
Book Revue, 133
Bordwell, David, 39, 44, 46, 47–48, 124, 132
Bosko: blackface tradition of, 72–73, 125; in *Bosko the Talk-Ink Kid*, 29–30, 72, 125; creation of, 29–30, 72; merchandising of, 175; move to MGM, 30, 238n22; on Nickelodeon, 12; resemblance to Mickey Mouse, 30, 72–73, 125
Bosko and the Cannibals, 238n22
Bosko in Person, 126
Bosko's Holiday, 125
Bosko the Doughboy, 126
Bosko the Lumberjack, 126

Box Office Bunny, 9, 21, 37
Boyer, Charles, 138–139, 145, 151
Brave Little Bat, The, 64
Buddy, 12, 31, 32, 72, 126
Buddy in Africa, 126
Buddy of the Apes, 126
Buddy's Circus, 126
Bugs Bunny: in *The Big Snooze*, 114–115; character descriptions of, 7–8, 61, 63, 64, 137, 215; compared to Mickey Mouse, 6, 7, 34, 61, 160, 174, 185, 190–191; creation/creator of, 32, 65–66; evolution of, 61, 63; in *The Exposure Sheet*, 119; Freleng on, 171; gendering of, 159–162, 165–171; golden rule of, 241n15; as icon, 4, 6, 7, 190–191; Internet fan fiction about, 252n47; Jones on, 162, 171; and kissing, 14, 166–169; and *The Mask*, 210; merchandising of, 175–176; most memorable cartoons of, 35; naming of, 61; in Nike "Hare Jordan" commercial, 8, 18, 177, 188; as postage stamp, 1, 3, 9; public service announcements with, 3; racism in cartoons of, 1, 11–12, 124, 128; similarity to Disney's Max Hare, 61, 63; Thorson development of, 61, 62, 63; as trademark, 9, 195; as transvestite, 156, 162, 165–171, 203; violence in cartoons of, 7; in *What's Cookin' Doc?*, 116; in World War II, 3, 6, 7, 12, 32–34, 41
Bugs Bunny and the Three Bears, 167, 244n36
Bugs Bunny Goes to War (video collection), 12
Bugs Bunny Nips the Nips, 1, 4, 11–12, 168, 171, 223n48
Bugs Bunny/Road Runner Movie, The, 36
Bugs Bunny/Road Runner Show, The, 9
Bugs Bunny Show, The, 35
Buñuel, Luis, 45–46
Buster Bunny, 205–206, 252n47
Busy Bakers, 60, 230n28
Butler, Judith, 154–158, 170, 245n38, 245n39

Cagney, James, 104, 109

Canemaker, John, 173
Cantor, Eddie, 72, 73, 84, 104
Captain and the Kids, The, 49
Carpool, 21
Carroll, Noël, 165
Carrotblanca, 13, 14, *15*, 21
Cartoonist's Nightmare, A, 118
Cartoon Network, 18–21
Casbah, 138
Cat Feud, 9
Cat's Bah, The, 138, 143, 144, 146, 150, 243n32
Cats Don't Dance, 21
censorship, 9–12, 133; and shelving of *Blooper Bunny*, 17; web sites on censored Warner Bros. cartoons, 223n46
character designer, definition of, 52–53
Chariots of Fur, 13, 21
Chevalier, Maurice, 82, 138–139, 241n9
Cholodenko, Alan, 4
Chuck Jones Film Productions (CJP), 21–22, 224n70
City of Lost Children, The, 209
Clampett, Robert, 6, 12, 33–34, 72, 114; and African-American representation, 130–133; compared to Jones, 34; and Daffy Duck, 33–34; hiring of, 31; on Thorson, 63
Clampett, Robert, Jr., 131–132, 133
Clampett, Ruth, 181–182, 184, 188
class: caricature representations of, 102–103, 118; distinctions revealed in *The Exposure Sheet*, 110–117; and hillbilly persona, 89–90, 99–100
Clean Pastures, 129–130, 223n48
Clock Cleaners, 48
Coal Black and de Sebben Dwarfs, 1, 12, 130–132, 133, 223n48
Cohen, Karl, 99, 123
colorization, 9
Commando, 210
Congo Jazz, 73, 126
Coo-Coo Nut Grove, 104, 108
Country Cousin, The, 49, 53–54, 60
Crafton, Donald, 70, 83, 140
Crosby, Bing, 104, 105–107, 116
Crowther, Bosley, 125

Curious Puppy, The, 54
"cuteness," 52, 58, 61, 63, 65

Daffy Duck: attempted reanimating of *The Scarlet Pumpernickel*, 9–10; in *Blooper Bunny*, 17; in *Daffy Duck in Hollywood*, 114–115; in *Duck Amuck*, 17; introduction of, 32; Jones on, 171; and *The Mask*, 210; merchandising of, 176; new 1980s shorts of, 21; with Leon Schlesinger, *16*
Daffy Duck and Egghead, 32
Daffy Duck in Hollywood, 32, *114*, 114–115, 119
Daffy Duck's Quackbusters, 21
Daisy Lou Rabbit, 162, 167
Dalton, Cal, 53, 60–61, 66
Dames, 75
Dangerous Dan McFoo, 56, 231n39
Davis, Art, 108
Day at the Zoo, A, 12
deCordova, Richard, 173
De Lauretis, Teresa, 155
Delgaudio, Sybil, 160, 244n36
Der Fuehrer's Face, 4
Detouring America, 209
Diawara, Manthia, 134
Disney, Walt, 43, 46, 103, 127, 174
Disney: Academy Awards of, 49, 115, 228n4; and "anti-Mickeys," 199–200; in *The Bad Bugs Bunny Show*, 1; books about, 4, 221n9; compared to Warner Bros., 6, 8, 12, 14, 17, 19, 33, 38–48, 49–66, 103, 112, 129, 156, 161, 175, 184–186, 189, 200; and "cuteness," 52, 58, 61; early appraisals of, 38–41; early product merchandising and, 174; and erotic Internet art, 205; and European art cinema, 42–43; as a factory, 43, 212; gender perversion in, 156; ideology of, 4–6, 51, 154, 175, 205; and innocence, 4–7, 47, 154, 156; labor troubles at, 113; legal battles of, 199; and memory, 5–6
Disneyfication, 15, 49–66, 229n9; in *Busy Bakers*, 60–61; in *The Country Cousin*, 53–54; in *The Curious Puppy*, 54; definition of, 51; in *Hobo Gadget Band*,

Disneyfication (*continued*)
 60; in *Little Lion Hunter*, 57; in *Naughty
 But Mice*, 54; in *Old Glory*, 55, 57
Disney Store, 8, 14, 177; compared to
 Warner Bros. Studio Store, 178, 180,
 184–186, 188–189
Donald Duck, 112
Doody, Peggy, 182, 183, 186
Dorfman, Ariel, and Armand Mattelart,
 51
Draftee Daffy, 135
Droopy Dog, 144, 231n39
Duck Amuck, 17, 46, 47, 48, 212, 215
Duck! Rabbit! Duck! 8, 34
Ducktators, The, 12, 239n53
Dumbo, 38, 226n27
Duxorcist, The, 21
Dyer, Richard, 77

Eco, Umberto, 5
Egghead, 32, 63, 95, 96
Eisenstein, Sergei, 39, 43, 45, 47
Elmer Elephant, 49
Elmer Fudd, 8, 15–16, 64, 124, 137, 176,
 215; in *The Big Snooze*, 114–115;
 compared to Stepin Fetchit, 128;
 evolution from Egghead, 32, 63, 95;
 and kisses, 162, 165–167; Thorson
 influence on, 63–65
Elmer's Candid Camera, 61
Exposure Sheet, The, 110–115, 119–120,
 236n19

False Hare, 165
Fantasia, 33, 38, 47
Farber, Manny, 33, 40–41
Fast and Furryous, 35
Father of the Bird, 224n70
Felix the Cat, 71, 72, 125, 173, 174–175
femininity: cross-dressing as ridicule of,
 164–165; in hillbilly cartoons, 92;
 recognizable traits of, 160–161; and
 reproduction, 107
Feud There Was, A, 63, 88, 92–96, 98
Fifi La Fume, 202–204, 206–207
Fleischer Bros., 1, 6, 40, 49–51, 60–61, 65,
 80–81, 107, 214
Flip the Frog, 30

Flowers and Trees, 49
Flying Down to Rio, 97
Foghorn Leghorn, 35
Ford, Greg, 15–17, 21, 36, 45, 223n60,
 227n55
Ford, Henry, 43, 80, 212, 218
Forrest Gump, 218
For Scent-imental Reasons, 35, 151
42nd Street, 75
Foster, Warren, 33, 34, 35
Foucault, Michel, 149
Fractured Leghorn, A, 35
Freakazoid! 13, 176, 194
Freleng, Isadore "Friz," 7; on Bugs Bunny ,
 171; as Harman-Ising animator, 29–30,
 67–69, 232n10; racist cartoons of,
 128–129; stint at MGM, 51, 228n6,
 108; *When I Yoo Hoo*, 90–92
Fresh Hare, 1
Freud, Sigmund, 79–80, 117–118
Friedwald, Will, 7, 123, 126, 128, 136,
 166
Frigid Hare, 168
From Hare to Eternity, 224n70
From Hare to Heir, 167, 247n53

Gable, Clark, 101, 108, 125, 158–160
Gaines, Jane, 195, 208
Gander at Mother Goose, A, 64
Garber, Marjorie, 155–156, 163–164
gender, 154–171; attribution, 158–161;
 category crisis of, 156; construction of
 as natural, 157–158, 163–164, 168–
 169; cross-gendering, 162–163;
 cultural intelligibility of, 155–156; and
 performance, 154–158; transgressions
 of, 155–156. *See also* sexuality
Girl at the Ironing Board, The, 30
Girl Can't Help It, The, 45, 209
Giroux, Henry A., 4–5, 154
Givens, Bob, 61, 63
G-Men, 100
Godard, Jean-Luc, 44–46
Goin' to Heaven on a Mule, 128
"Golden Age of Looney Tunes" (video
 and laser disc collection), 11, 223n48
Goldilocks and the Jivin' Bears, 130
Gone With the Wind, 86

Goopy Geer, 73, *74*
Goopy Geer, 73, 74, 77
Granny, 162
Great Big Bunch of You, A, 71, 73, 79, 82, 83
Great Depression, 84, 87–88, 89–90, 93–94
Great Piggy Bank Robbery, The, 33
Grey Hounded Hare, 167
Guerrero, Ed, 121
Gulliver's Travels, 65
Guns and Guitars, 89

Haas, Lynda, 4, 6, 154
Hair-Raising Hare, 34, 167
Hanna, Bill, 35
Hanna-Barbera, 178, 183, 192
Hansen, Miriam, 76, 82
Happy Harmonies, 30
Hardaway, Ben "Bugs," 32, 53, 60–61, 66
Hare-Brained Hypnotist, The, 167
Hare Force, 7
Hare Jordan. *See* Nike "Hare Jordan" commercials
Hareport, 223n60
Hare Ribbin', 168
Hare Splitter, 167
Hare-um Scare-um, 61, 62
Harman, Hugh, 29–31, 67–68, 72, 238n22
Haskell, Molly, 160
Heckle and Jeckle, 131
Hendricks, Bill, 36
Herrmann, Anne, 158
Herr Meets Hare, 1
heterosexuality: compulsive, 157–158; in erotic Internet fan art, 205; idealization of in Pepé cartoons, 139–153; performance of, 157, 243n12; and Porky and Petunia Pig, 95–97; reinstitutionalization of, 163–164, 168–169. *See also* sexuality
Hiawatha's Rabbit Hunt, 64, 116, 167, 247n55
High Diving Hare, 35
Hillbilly Hare, 88, 99
Hittin' the Trail to Hallelujah Land, 128
Hobo Gadget Band, 60
Holiday for Drumsticks, 88

Hollywood Steps Out, 101, 102–103, 107–109, 111, 115, 118
Holt Sawyer, Corinne, 164
homosexuality: in erotic Internet fan art, 205; as failed heterosexuality, 168–169; in *A Feud There Was*, 93, 94; in temporary transvestite cartoons, 166–167
Honey (Bosko's girlfriend), 72, 125–126, 175
hooks, bell, 121
House Party, 121
How Do I Know It's Sunday? 30
humor: absence of in *Backwoods Bunny*, 169–170; and caricature, 101–109, 116–117, 125–127, 129, 151, 238n21; of franglais in Pepé cartoons, 145–146; Freud on, 117–118, 151–153; from hillbilly culture, 89–90, 129; in *The Mask*, 209–210; in transvestite films, 164–165
Hunchback of Notre Dame, The (1996), 51, 156
hybridization, 5–6, 217–220

I Haven't Got a Hat, 32
imperialism, 51, 148–150, 205
Independence Day, 211, 212, 217, 218
Inki, 57–59, 63, 123, 126–127
Inki and the Lion, 57, 64
Institute Benjamenta, 209
Invasion of the Bunny Snatchers, 15–16, 28, 36, *37*
Ising, Rudolf, 29–31, 67–68, 72, 125, 238n22
Isle of Pingo-Pongo, The, 209
It's Got Me Again, 49
I Was a Male War Bride, 163
Iwerks, Ub, 30

Jazz Singer, The, 29, 124
Jenkins, Henry, 6, 69, 70; on "textual poaching," 204–208
Jolson, Al, 29, 67, 72, 83, 104, 105, 124, 125, 126, 132, 240n58
Jones, Chuck, 7, 9–10, 21–22, 183; anecdotes of, 28; animated creations of, 137; as auteur, 44–46; on Bugs

Jones, Chuck (*continued*)
Bunny, 162; on Bugs Bunny and Daffy Duck, 171; on caricature, 127; compared to Clampett, 34; compared to Resnais, 46; Disneyfication in the cartoons of, 53–60; hiring of, 31; on Inki, 123, 126–127; on Pepé le Pew, 143, 150, 152–153; on Termite Terrace, 103; Thorson's influence on, 53–60, 66; on timing, 210
Jordan, Michael, 8, *10*, 14, 177, 188
Jungle Jitters, 128
Jurassic Park, 215

Kelly, Walt, 57
Kenner, Hugh, 4, 59, 156
Kentucky Feud, 86
Kentucky Kernals, 87
Kentucky Moonshine, 87
King Kong, 213
King of Jazz, The, 73
Klein, Norman, 68–69, 70, 199
Knighty-Knight Bugs, 35
Koko the Klown, 30, 72
Kracauer, Siegfried, 226n27
Kricfalusi, John, 222n26
Krutnik, Frank, 141–142
Kuhn, Annette, 160

Lady from Shanghai, The, 150
Lady Known as Lou, The, 56
Lady, Play Your Mandolin, 73–74, 77
Lampl, Cathleen, 182, 183, 185, 186
Langer, Mark, 200
Last Year at Marienbad, 46, 48
Lawing, John, 122, 135
Lend a Paw, 116
Lennon, Terry, 15, 17, 21, 36
Levin, Gerald, 8
licensing. *See* merchandising
Licensing Corporation of America (LCA), 176
"limited animation," 35
Lion King, The, 19, 156, 174, 218
Little Beau Pepé, 35, 150–151
Little Hiawatha, 49, 57–59, 64, 230n21, 230n22
Little Lion Hunter, 57–59

Little Mermaid, The, 156, 205
Little Red Riding Rabbit, 7, 34
Lola Bunny, 8, 9, 188
Lolita (1962), 45
Looney Tunes: Walter Benjamin on, 82–83; caricature in, 92, 101–109, 118–119, 125–127, 129, 212, 238n21; cels, 18, 184, 191; censorship of, 9–12, 133; chase structure of, 141–144, 161, 166, 211, 215–216; "classic" characters of, 8–9, 14–15, 20–21, 37, 180, 183, 189–192; colorization of, 9; compared to *Space Jam*, 8, 14, 37; copyright and trademark infringement of, 196–200; corporate image of, 9–10, 20, 28, 37; and creation of Bugs Bunny, 65–66; Disneyfication/homogenization of, 8, 14–15, 17–18, 20, 49–66; dolls and mannequins in, 79–84; early criticism of, 33, 68–69; future of, 20, 28, 190–192; gags in, 65, 91, 93–94, 96, 103, 126–133, 141–142, 145–148, 165–169, 210–211; gender in, 160–162; ideology in, 6–12, 77, 133–135, 143–144, 150–151; improvisation in, 79–82; introduction of color in, 33; and Internet fan fiction, 195–196, 205–207; and Internet role-playing, 201–204; invocation of Great Depression in, 84, 93–94; irreverent nature of, 7, 9, 14, 17, 19, 31–32, 39–40, 63–65; jazz in, 72–73, 129–133; marketing and merchandising of, 8, 12–14, 20–22; memory of, 9, 18; morality of, 14; newly released, 21–22; popularity of, 7, 34; pornographic representation of characters in, 193, 196–197; race in, 72–73, 75, 121–136, 141, 143–144, 238n21; self-consciousness in, 16–17, 94, 114–115, 144, 151; sexuality in, 47, 107, 137–153, 202–208; similarity to Silly Symphonies, 30, 67; stamps of, 1, 3; timing and rhythm in, 33, 211; vaudeville in, 69–73, 232n11; violence in, 9, 47; during World War II, 34, 96–98, 106–107, 240n58. *See also* Merrie Melodies; Warner Bros.
Lost World, The, 213

Louvre Come Back to Me, 137, 151
Lucas, George, 219

McKimson, Robert, 7, 33, 34
Malibu Beach Party, 107–109
Maltese, Michael, 33, 34, 35, 112, 119, 137
Maltin, Leonard, 55, 68–69, 70, 123, 125
Mama Bear, 167, 244n36
Mars Attacks! 183
Marvin the Martian in the Third Dimension, 191
masculinity: in absence of feminine cues, 161–162; European constructions of, 138–139; in hillbilly cartoons, 92; as performance, 151–152; as phallic power, 107; recognizable traits of, 160–161
Mask, The, 209–210, 212, 215–219
Mattelart, Armand, and Ariel Dorfman, 51
Max Hare, 61, 63
Maxwell, Max, 29
Meehan, Eileen R., 5
merchandising, 172–192; of Batman, 5; and children's television, 173; of Felix the Cat, 174; literature on, 173; of Looney Tunes, 12–14; and special effects, 218; and sports apparel, 177, 190; themes at Warner Bros. Studio Stores, 183
Merrie Melodies, establishment of, 30, 67–68. *See also* Looney Tunes; Warner Bros.
MGM, 1, 30, 32, 35, 38–39, 40, 41, 45, 125, 144
Michigan J. Frog, 9
Mickey Mouse: and "anti-Mickeys," 199–200; Walter Benjamin on, 82–83; cartoons of, 6, 47, 67; compared to Bugs Bunny, 6, 7, 34, 61, 160, 174, 185, 190–191; and confusion at Warner Bros., 28; difference from Sniffles and Abner, 54; early attempts at merchandising of, 174; as icon, 4, 6, 40, 190–191; with Minnie Mouse, 14, 97, 126, 161, 174; as model for Bosko, 30, 72–73, 125; satire of, 129; special

Oscar for, 49; in *Steamboat Willie*, 83; typology of, 71, 125. *See also* Disney
Mickey's Garden, 40
Mickey's Mellerdrammer, 129
Mighty Hunters, 59
Minerva Mink, 204–205
Minnie Mouse, 14, 97, 126, 161, 174
Mississippi Hare, 168
modeling, 55, 57–58, 60, 65
Modern Times, 81
Moonshiner, The, 86
Mountain Music, 89
Mr. Deeds Goes to Town, 100
Mrs. Doubtfire, 163
Mr. Smith Goes to Washington, 100
Mynah Bird, 33, 57, 59, 127

Natural Born Killers, 1
Naughty But Mice, 54
Naughty Neighbors, 88, 90, 92, 96–98
Neale, Steve, 141–142
Never Ending Story II: The Next Chapter, The, 21
Nickelodeon (cable channel), 12
Night of the Living Duck, 21, 36
Night Watchman, The, 59
Nike "Hare Jordan" commercials, 8, 18, 177, 188
Noble, Maurice, 137
Nutty Professor, The (1996), 216

Odor-able Kitty, 137, 143, 144, 145, 146, 241n6, 241n14, 242n30
Odor of the Day, 146, 240n1
Oklahoma, 75
Old Glory, 41, 55, 57
One More Time, 71
One Step Ahead of My Shadow, 70–71
Oswald the Lucky Rabbit, 71, 72, 125, 175
"otherness": in caricature, 118–119; as exotic, 147–150; of hillbilly, 90; in Pepé cartoons, 143–144, 147–150; in temporary transvestite cartoons, 168–169

"paradigmatic disarray," 6, 11, 17, 20, 28
Past Perfumance, 140, 143

Peary, Danny, and Gerald Peary, 4
Penguin Parade, The, 128
Pepé le Pew, 137–153, 202, 240n1, 244n33; cartoon formula of, 137–138, 241n6; deodorization of, 14, 146; intertextuality in cartoons of, 140; memorable cartoons of, 35; miscegenation anxiety in cartoons of, 141, 143–144, 242n18; modeled on Boyer, Chevalier, and Jourdan, 138–139
Pépé Le Moko, 138
performance: in blackface, 72–73; in musical cartoons, 79–83; and "realness," 154–155, 168–170; of sex/sexuality/gender system, 157, 243n12; vaudeville, 69–71
Persona, 46
Petrified Forest, The, 116
Petunia Pig, 95–98, 162
Pierce, Tedd, 33, 34, 61, 137
Piggy, 75–77, 128
Pigs in a Polka, 33
Pillow Book, The, 1
Pinky and the Brain, 13, 176, 180
Pinocchio, 60
Plane Crazy, 97
Pocahontas, 51
political incorrectness, 1, 4, 10–11, *13*, 223n48
Popeye, 80–81
popular culture: African American representations in, 121–124, 133–136; gendered subject in, 156, 163; hillbilly imagery in, 86–87, 98–99; hillbilly music in, 88–89; jazz in, 132
Porky Pig: colorization of, 9; creation of, 32; merchandising of, 175; in *Naughty Neighbors*, 95–98; in *Old Glory*, 41, 55, 57
Porky's Duck Hunt, 32, 61, 209
Porky's Hare Hunt, 32, 61
Postell, Linda, 178, 180, 182, 183, 186
Presto Change-o, 61
Public Hero Number One, 100
Pullet Surprise, 21

Queen Was in the Parlor, The, 71, 73, 74
Quest for Camelot, 189

Rabbit Fire, 8, 34, 168
Rabbit of Seville, The, 162
Rabbit Seasoning, 8, 34, 168
"Rabbit Season" trilogy, 8, 34, 137, 241n2
race, 12, 121–136; in *Alice Cans the Cannibals*, 72; and Amos 'n' Andy, 73; and blackface, 72–73, 75, 84, 124, 125, 131, 238n21; in Bosko cartoons, 30, 125–126; and jungle imagery, 126–127; and miscegenation, 141, 143–144, 242n18; in plantation films, 86; problematics of representation of, 122–123, 127, 134–136, 240n57; racial types and stereotypes, 123, 124, 129–130, 134. *See also* racism
racism: in *All This and Rabbit Stew*, 128; in Bosko cartoons, 12, 125–126; in Buddy cartoons, 12, 126; in *Bugs Bunny Nips the Nips*, 11–12; in *Coal Black and de Sebben Dwarfs*, 1, 130–132; in Inki cartoons, 58, 63, 123; in *One Step Ahead of My Shadow*, 70–71; in representations of Japanese, 12, 133; in *Song of the South*, 4; in studio system, 124–125; and Stepin Fetchit, 123, 124, 128, 129, 130; in *Tin Pan Alley Cats*, 132–133
Rainbow Riley, 87
Really Scent, 141, 146, *147*, 241n6
Red-Headed Baby, 79, 81–83
Red Hot Riding Hood, 129, 202, 209, 210, 215, 255n21
Ren and Stimpy, 19
Resnais, Alain, 46–48
Rhapsody in Rivets, 33
Rhythm on the Range, 89
Rich, Adrienne, 157
Richie Rich, 21
Road Runner, 7, 35, 137; and European art cinema, 46
Robin Hood, 19
Rock-a-bye Rabbit, 223n43
Romanelli, Dan, 12, 176, 178, 185
Roman Legion Hare, 35
Roman Scandals, 84
Rose, Lloyd, 7
Ross, Virgil, 131
Rover Dangerfield, 224n66
R.U.R., 80–81

Sahara Hare, 35

Said, Edward, 148–149

Sanders, Deion, 13

Scarlet Pumpernickel, The, 10

Scent-imental over You, 144

Scent-imental Romeo, 137, 138, 143, 144, 145, 147

Scent of the Matterhorn, A, 35, 141, 147, 148

Schatz, Thomas, 163

Scheib, Ronnie, 45

Schlesinger, Leon, 16, 29–34, 41, 49, 51, 53, 66, 101–103, 108–115, 126, 175, 212

Schneider, Steve, 6, 9, 41, 42, 44, 110, 228n2

Schull, Michael, 134

Scribner, Rod, 33

Sedgwick, Eve Kosofsky, 155

Sells, Laura, 4, 6, 154

Selzer, Eddie, 28, 34, 65, 115

sexuality: in Avery cartoons, 47, 129; in Clampett cartoons, 130–131; and gender, 157; Internet fan interest in, 202–208; in Pepé le Pew cartoons, 137–153; as reproduction in *Swooner Crooner*, 107. *See also* gender

Shanty Where Santy Claus Lives, The, 79, 83

Shenkman, Ben, 107–109

She Was an Acrobat's Daughter, 78, 116–117, *117*, 118–119

Shooting of Dan McGoo, The, 45

Show Biz Bugs, 35, 36

Show Boat, 86

Silly Symphonies, 6, 7, 30, 40, 47, 49, 52, 67. *See also* Disney

Simpsons, The, 19

Sinatra, Frank, 104, 105–107, 125

Sinkin' in the Bathtub, 67, 68

Sister Act, 121

Six Flags theme parks, 12, 13

Skeleton Dance, 47

Sleeping Beauty, 47

Slowpoke Rodriguez, 223n51

Smoodin, Eric, 4, 78, 154, 173

Sniffles Takes a Trip, 59–60

Sniffles the Mouse, 53–54, *55*, 63, 64, 65, 176

Snow White and the Seven Dwarfs, 38, 42, 49, 52, 60, 113, 116, 130–131, 156, 230n22

Solomon, Charles, 123, 127, 135–136

Some Like It Hot, 144

Song of the South, 4

South Park, 20

Space Jam: compared to *Blooper Bunny*, 17–19; compared to *Invasion of the Bunny Snatchers*, 15–16; compared to Looney Tunes, 8, 14, 28, 37, 189; compared to Nike "Hare Jordan" commercials, 8; conflict in, 14–15; downplaying of Speedy Gonzales in, 12; and Hollywood, 10; limited edition figures, 181; marketing of, 8; merchandising of, 188–189; Slowpoke Rodriguez in, 223n51

Speaking of the Weather, 105

spectatorship, 74–78, 139–140, 150–151, 155

Speedy Gonzales, 12

Spielberg, Steven, 13–14, 194

Spigel, Lynn, 6

Spitfire, 87

Stalling, Carl, 31–32, 103–104

Star Is Born, A (1937), 116

Starrett, Peter, 178–179, 182, 183

Star Trek, 196–197, 204

Star Wars, 173, 201, 209, 210–211, 214

Steamboat Willie, 29, 67, 83

Stepin Fetchit, 123, 124, 128, 129, 130

Stop, Look, and Hasten, 35

Straayer, Chris, 158–159, 163, 165, 166, 246n48

Sunday Go to Meetin' Time, 128

Superior Duck, 21

Super Rabbit, 7, 34

Swing Shift Cinderella, 202

Sylvester and Tweety: merchandising of, 176; most memorable cartoons of, 35; as opponents, 142; as stamps, 3, 9

Sylvester and Tweety Mysteries, 14

Tashlin, Frank, 6; compared to Godard, 45; influence of Avery on, 45; temporary parting from Warner Bros., 51, 228n6

Taylor, Frederick Winslow, 80
Taz-Mania, 176, 194
Tazmanian Devil, 190
temporary transvestism, 163–171
Termite Terrace, 30, 103, 212, 235n5
Thomas, Frank, 41
Thompson, Kristin, 43, 47–48, 225n1
Thompson, Richard, 45
Three Caballeros, The, 42
Thunder Road, 86
Time Warner. *See* Warner Bros.
Tin Pan Alley Cats, 132–133, 223n48
Tiny Toon Adventures, 13–14, 20, 22, 176, 193–194, 202–206
Toby Tortoise Returns, 49, 61
To Have and Have Not, 78, 107
Tokio Jokio, 12
Tom and Jerry, 41, 142
Tom Thumb in Trouble, 59
Tootsie, 163
Tortoise and the Hare, The, 64
Tortoise Beats Hare, 64, 167
True Lies, 220
Turner, Inc., 11, 18, 28, 219, 224n74
Tweety, 14
Tweety Pie, 35
Two Scent's Worth, 143, 144

Ugly Duckling, The, 39, 115
Uncle Josh at the Moving Picture Show, 76
Uncle Tom's Bungalow, 129
Uncle Tom's Cabaña, 129
Uncle Tom's Cabin, 86
Uncle Walt, 200
United States Postal Service (USPS), 1, 3, 9, 13
Unmentionables, The, 162
Unruly Hare, The, 168
UPA, 39

Van Citters, Darrel, 9, 21, 36–37, 223n43
Vertigo, 45

Wabbit Twouble, 34
Walky Tawky Hawky, 35
Waller, Thomas "Fats," 129, 130, 132
Waller, Gregory, 41
Warner, Harry, 28
Warner, Jack, 116

Warner Bros.: Academy Awards complaint, 115–116; and auteurism, 44–47; books about, 4; character merchandising history, 175–177; character product development, 181–184; compared to Disney, 6, 8, 12, 14, 17, 19, 33, 38–48, 49–66, 103, 11, 129, 156, 161, 175, 184–186, 189, 200; compared to Godard and Antonioni, 44; corporate policy of, 12; early appreciation of, 40–41; entrance into television, 35; and European art cinema, 44–48; as family entertainment, 14, 17; hiring of Thorson at, 49–50, 53; industrial conditions at, 83, 101–104, 109–115, 212; legal battles, 193–198, 207–208; logistics of, 7; merger with Turner, 28, 183. *See also* Looney Tunes; Merrie Melodies
Warner Bros. Movie World, 13, 14
Warner Bros. Studio Store, 8, 14, 177–192; *Blooper Bunny* cels at, 18; compared to Disney Store, 178, 180, 184–186, 188–189; and creative barriers, 186–187; merchandising secondary characters, 183–184; merchandising themes, 183; postage stamp unveiling at, 1; as tourist destination, 178, 187, 191; underwear available at, *159*
Warner Bros. Studio Store Catalog, 13
Warner Corner, 176
Warner Internet Fan Association (WIFA), 194, 207–208
Wassenaar, Michael, 80–81
Water, Water Every Hare, 161
Wayne's World, 161
WB Network, 9, 176
Webb, Paul, 87, 92
We're in the Money, 73, 79
West, Cornel, 122
What's Cookin' Doc? 116
What's Opera, Doc? 168
What's Up, Bugs? 22
When I Yoo Hoo, 88, 90–92, 98
White Men Can't Jump, 121
Who Framed Roger Rabbit? 36, 177, 209, 210
Who Scent You? 146, 151

Wideo Wabbit, 166
Wild and Woolly Hare, 171
Wild Hare, A, 32, 61, 165, 209
Wild over You, 150
Wile E. Coyote, 13, 14, 137
Will Success Spoil Rock Hunter? 209
Williamson, J. W., 86–87, 90
Wilt, David, 134
Windblown Hare, The, 161
Wise Quacking Duck, The, 135
Witch Hazel, 162
Wolf and the Showgirl (Avery series), 129, 202

Wollen, Peter, 80
Woods Are Full of Cuckoos, The, 104–105
Woolery, George W., 7
Wynken, Blynken, and Nod, 49, 64

Yellow Kid, The, 124, 174
Yosemite Sam, 162, 244n53
You Don't Know What You're Doin', 74, 75–77
You Ought to Be in Pictures, 16, 212

Zoom and Bored, 35